AFTER THE PRE-RAPHAELITES

MANCHESTER
UNIVERSITY PRESS

THE BARBER INSTITUTE'S
CRITICAL PERSPECTIVES
IN ART HISTORY SERIES

Forthcoming titles

Gendering landscape art
Steven Adams and Anna Greutzner-Robins

Manifestations of Venus
Caroline Arscott and Katie Scott

Critical Kitaj
James Aulich and John Lynch

Cubism
David Cottington

Art and the Academy in the nineteenth century
R. C. Denis and Colin Trodd

Sixties avant-gardes: Art in British culture 1958–75
Simon Faulkner

The architecture of the museum: Symbolic structures, urban contexts
Michaela Giebelhausen

Facing the public: Portraiture in the aftermath of the French Revolution
Tony Halliday

Modernities and identities in English art 1860–1914
David Peters Corbett and Lara Perry

After modern sculpture: Art in the United States and Europe, 1965–70
Richard Williams

Already published

Art and the nation: exhibitions and the London public 1847–2001
Brandon Taylor

After the Pre-Raphaelites

Art and Aestheticism in Victorian England

EDITED BY
ELIZABETH PRETTEJOHN

Manchester University Press

Published by Manchester University Press
Oxford Road, Manchester M13 9NR, UK
http://www.man.ac.uk/mup

British Library Cataloguing-in-Publication Data
A catalogue record for this book is available from the British Library

ISBN 0 7190 5405 2 *hardback*
 0 7190 5406 0 *paperback*

First published 1999

06 05 04 03 02 01 00 99 10 9 8 7 6 5 4 3 2 1

Typeset by
D R Bungay Associates, Burghfield, Berks

Printed in Great Britain
by the Alden Press, Oxford

Contents

MORALITY

Illustrations

Notes on contributors

Caroline Arscott is Lecturer at the Courtauld Institute of Art, University of London. Her forthcoming publications include 'Representations of the Victorian city' in *The Cambridge Urban History of Britain*, vol. III. ed. M. Daunton (Cambridge, Cambridge University Press) and 'The invisible and the blind in Tissot's social recitals' in *Seductive Surfaces* ed. K. Lochnan (New Haven and London, Yale University Press, published for the Paul Mellon Centre for Studies in British Art). She is a member of the Editorial Group of the *Oxford Art Journal*.

Robyn Asleson is Research Associate for British Art at the Huntington Library, Art Collections, and Botanical Gardens in San Marino, California. She is writing the comprehensive catalogue of the Huntington's British paintings collection and has organised exhibitions, publications, and conferences on eighteenth-century British art and theatre. She will soon publish a new study of the life and art of Albert Moore.

Colin Cruise is Senior Lecturer in Art History at Staffordshire University. He has published essays on Simeon Solomon and Forrest Reid and is working on a book on Aestheticism and religion.

Whitney Davis is John Evans Professor of Art History at Northwestern University, Evanston, Illinois, U.S.A. He is the author of *Drawing the Dream of the Wolves: Homosexuality, Interpretation, and Freud's 'Wolf Man'* (Indiana University Press, 1995) and *Replications: Archaeology, Art History, Psychoanalysis* (Penn State University Press, 1996).

Kate Flint is Reader in English Literature at Oxford University, and Fellow of Linacre College. She is the author of *The Woman Reader 1837–1914* (Oxford, Oxford University Press, 1993) and of *The Victorians and the Visual Imagination* (Cambridge, Cambridge University Press, forthcoming), as well as of numerous articles on nineteenth- and twentieth-century painting, literature and cultural history.

Alastair Grieve is Reader in the History of Art at the University of East Anglia. He finished his Ph.D. on 'The Art of D. G. Rossetti' in 1968 at the Courtauld Institute, and contributed to the Tate Pre-Raphaelite exhibition (1984). His recent publications include 'Millais and Ruskin at Glenfinlas' (*Burlington Magazine*, April 1996), and he is currently collaborating with Dr M. MacDonald on a book on Whistler's Venice.

Michael Hatt is Honorary Research Fellow at Birkbeck College, University of London. He has published articles on various aspects of nineteenth-century American art and culture, and is currently completing a book on the male nude.

Anne Koval is Assistant Professor at Queen's University, Kingston, Canada. She is co-author (with Ronald Anderson) of *James McNeill Whistler: Beyond the Myth* (London, John Murray, 1994) and author of *Whistler in His Time* (London, Tate Gallery Publishing, 1994). She is currently working on an article on Whistler's portrait of Thomas Carlyle. She also writes on Canadian and British contemporary artists.

Elizabeth Prettejohn is Associate Senior Lecturer in Art History at the University of Plymouth. She is author of *Interpreting Sargent* (London, Tate Gallery Publishing, 1998) and *Rossetti and His Circle* (London, Tate Gallery Publishing, 1997), and co-editor (with Tim Barringer) of *Frederic Leighton: Antiquity, Renaissance, Modernity* (New Haven and London, Yale University Press, published for the Paul Mellon Centre for Studies in British Art, 1999).

Alison Smith is Senior Lecturer in Art History at Sotheby's Institute, London. She is the author of *The Victorian Nude: Sexuality, Morality, and Art* (Manchester, Manchester University Press, 1996) and various articles on Victorian art.

Robin Spencer was the first Chair of the Department of Art History, St Andrews University, Scotland. He was curator of *James McNeill Whistler* (Nationalgalerie, Berlin, 1969) and of *Eduardo Paolozzi, Recurring Themes* (Edinburgh, 1984), and co-author of *The Paintings of James McNeill Whistler* (New Haven and London, Yale University Press, published for the Paul Mellon Centre for Studies in British Art, 1980). He has been a Fellow of Jesus College, Cambridge, and a Leverhulme Fellow of St Andrews University, where he was Director of the Krazy Kat Archive.

Acknowledgements

The editor would like to thank the many institutions and individuals who have helped in the preparation of this book, particularly Malcolm Gee, Paul Usherwood, Hilary Underwood, Maxine Maindonald, Allen Staley, the Schools of Humanities and Art & Design at Staffordshire University, and St Deiniol's Library, Flintshire. Vanessa Graham and Louise Edwards have been expert and sympathetic editors. Special thanks are due to Charles Martindale for his help and encouragement.

Introduction

Elizabeth Prettejohn

To art, that is best which is most beautiful; to science, that is best which is most accurate; to morality, that is best which is most virtuous.

Algernon Charles Swinburne

A GREAT DEAL has been written on Aestheticism in Victorian literature. Linda Dowling's bibliography of 1977, *Aestheticism and Decadence*, lists 599 books and articles, and there has been no slackening of interest since that date.[1] Yet the equivalent phenomenon in the visual arts has a minuscule scholarly literature.[2] The discrepancy seems strange, especially because both literary and art historians position Aestheticism as the direct descendant of Pre-Raphaelitism, a movement in which the importance of painting is taken for granted. Furthermore, the visual arts are conspicuous in literary Aestheticism. Not only do works of visual art make vivid subjects for critical and imaginative writing, such as Walter Pater's description of the *Mona Lisa*, Algernon Charles Swinburne's sonnets on the ancient sculpture of the *Hermaphrodite*, or Oscar Wilde's *The Picture of Dorian Gray*.[3] Visual experience is also central to conceptions of the aesthetic approach to life, as in the famous 'Conclusion' to Pater's *Renaissance*: 'A counted number of pulses only is given to us of a variegated, dramatic life. How may we see in them all that is to be seen in them by the finest senses?'[4] Here 'seeing' is more than a casual expression; blending receptivity with discrimination, seeing is the model for the aesthetic critic's approach to both art and life. Wilde, too, offers a pair of compelling visual images to sum up his lecture of 1882 on 'The English Renaissance of Art' – the sunflower and the lily, both of them flowers, which are symbols of pure beauty in philosophical aesthetics.[5] These texts are familiar to all students of literary Aestheticism. Yet the paintings and sculptures associated with Aestheticism remain relatively obscure.

This volume aims to relocate visual art from the periphery to the centre of our debates on Victorian Aestheticism. Admittedly Victorian writing on the aesthetic remains prominent in nearly every chapter. Some chapters reinterpret the most familiar figures of literary Aestheticism, such as Swinburne, Pater and Wilde, while concentrating on their engagement with the visual arts. Others introduce a new range of literary texts – the aesthetic treatises of David Ramsay Hay, the

lectures on art of Edward John Poynter, the theories of perception in the work of the psychologist James Sully, and the art journalism of the later Victorian period. But the emphasis throughout the volume is on the visual arts themselves, and in particular on the fine arts of painting and sculpture.

It is perhaps unsurprising that Aestheticism in painting remains ill-defined; often it is treated simply as a belated variant of Pre-Raphaelitism. However, a similar vagueness is startlingly evident in accounts of literary Aestheticism. If there is any consensus, it is that Aestheticism as a category is exceptionally elusive. From R. V. Johnson's introductory text of 1969 to Jonathan Freedman's study of 1990, critics acknowledge the difficulty of pinning down the meanings of the term. As Freedman puts it: '"Aestheticism" is one of those terms in literary criticism that are impossible fully to define.'[6] Reviewing critical usages of the labels 'Pre-Raphaelitism', 'Aestheticism', 'Decadence' and 'Fin-de-Siècle' in an article of 1974, Ruth Z. Temple comes to a forthright conclusion: 'Aesthetic as a label for a literary movement had better be discarded. There was no movement.' A few sentences later, she extends this prohibition to painting.[7]

Temple is certainly right to note that the label 'Aestheticism' can seem more difficult to pin down than 'Pre-Raphaelitism'. The Pre-Raphaelite Brotherhood was a distinct historical entity, formed by seven particular men at a precise date, 1848, and accompanied by manifesto statements that make its initial aims reasonably clear. By contrast there was no formal grouping of artists or writers who declared allegiance to 'Aestheticism', 'art for art's sake', or any of the related slogans used in the Victorian press. Nor has there been a consensus about the date at which Aestheticism emerged; some scholars place it towards the later 1860s, others locate it earlier or later. Accordingly, R. V. Johnson prefers to call it a 'tendency' rather than a 'movement'.[8] In art history it has never been rigorously distinguished from 'late Pre-Raphaelitism' or 'second-phase Pre-Raphaelitism'. Perhaps, then, it would be preferable to abandon the term 'Aestheticism', and to concentrate instead on the diverse later metamorphoses of Pre-Raphaelitism.

Yet there are compelling reasons for retaining the label 'Aestheticism', not least the persistence of the term in literary criticism. All labels for periods and movements are constructs deployed to suit the purposes of those who use them; the resilience of this one, despite the reservations so frequently expressed, suggests that it fulfils important functions in our accounts of the arts in the later Victorian period. One of these is historical convenience: we need a term to describe the developments in the arts 'after the Pre-Raphaelites', developments that Victorian writers identified but were initially reluctant to name.[9] The new trends were characterised, from the beginning, as moving away from the Pre-Raphaelite concerns with 'nature' and 'reality', towards a frank acknowledgement of art's difference from 'real' life. Moreover, it may have been in the realm of painting that such shifts were first observed and classified. The earliest account of the new tendencies in painting was that of Sidney Colvin, published in the *Fortnightly Review* in October 1867. Colvin's article, entitled 'English painters and painting in 1867',

presents a sweeping survey of the entire British school, but it singles out a tiny band of artists 'whose aim, to judge by their works, seems to be pre-eminently beauty'. For Colvin, these artists are not only superior to the rest of the English school, but different in kind; they are the only ones to 'set the true end of art before their eyes'. Although in 1867 more than 700 artists exhibited at the Royal Academy alone, only nine qualify for inclusion in Colvin's elite. He groups the first three under the rubric 'beauty without realism'; they are Frederic Leighton, Albert Moore and James McNeill Whistler. Next he considers artists of imagination or passion: Dante Gabriel Rossetti, Edward Burne-Jones and Simeon Solomon. Finally he mentions a more diverse group: George Frederic Watts, Arthur Hughes and the landscape painter George Heming Mason.[10]

Colvin's article also provides the artists with an aesthetic philosophy:

> Pictorial art addresses itself directly to the sense of sight; to the emotions and the intellect only indirectly, through the medium of the sense of sight. The only perfection of which we can have distinct cognizance through the sense of sight is the perfection of forms and colours; therefore perfection of forms and colours – beauty, in a word – should be the prime object of pictorial art. Having this, it has the chief requisite; and spiritual, intellectual beauty are contingent on this, are something thrown into the bargain.[11]

As early as 1867, then, one critic was able to advance a credible theory of the aesthetic in visual art. The later formulations of Pater, for instance in his essay of 1877 on 'The School of Giorgione', or of Whistler's 'Ten o'clock' lecture, are now more famous, but no more radical in their assertion of the autonomy of visual art. Colvin also associated his theory with a finite cast of characters. But he did not confer a name or label on the new 'movement'; his phrases, 'beauty without realism' and 'the art whose aim is beauty', never gained wide currency. Later in 1867, however, Swinburne introduced the term 'art for art's sake' in his extended essay on William Blake.[12] The next year this phrase was repeated by Pater in the final section of his essay on 'Poems by William Morris'.[13] The passage became famous – or notorious – in 1873, when Pater reprinted it as the Conclusion to his volume *The Renaissance*, seen as scandalous for its apparent advocacy of the life of the senses over moral responsibility. The journalist Tom Taylor also used the term 'art for art's sake' in 1868, in a criticism of the paintings of Leighton; this usage was casual, but may have been influential, for it moved the term from the esoteric writings of Swinburne and Pater into the realm of everyday art journalism.[14] These early instances of the term 'art for art's sake' occur in diverse contexts, but all of them associate the term with the same artistic groupings Colvin had stressed in 1867. Both Swinburne and Morris were intimates in the circle around Rossetti; in the late 1860s the circle around Leighton and his close friend, G. F. Watts, seems to have been equally associated with the new term 'art for art's sake'.

In the 1870s, though, the term 'art for art's sake' was gradually superseded by 'Aestheticism'.[15] When Pater revised *The Renaissance* for the fourth edition of 1893,

he removed many phrases that had provoked criticism; his alteration of 'art for art's sake' to 'art for its own sake' seems minute, but may indicate that the phrase had become controversial. By then Aestheticism had moved from elite artistic circles to the realms of fashion, satire and the popular press. The satires of George Du Maurier, in his illustrations for *Punch* in the late 1870s, and of Gilbert and Sullivan, in the operetta *Patience* of 1881, Oscar Wilde's lecture 'The English Renaissance of Art', first delivered in New York in 1882, and Walter Hamilton's popular account, *The Aesthetic Movement in England* of 1882, are conspicuous signs of the shift.

In Victorian writing, then, we find a variety of terms for naming the trends in the arts after the Pre-Raphaelites: 'beauty without realism', 'art for art's sake', 'Aestheticism', 'Aesthetic Movement'. In his lecture, designed to introduce recent developments in English art to American audiences, Wilde used the terms 'aestheticism' and 'aesthetic movement' casually and without capitalisation, in addition to his own designation 'English Renaissance'. This terminological confusion in Victorian writing helps to explain the frustration of later scholars. Nonetheless there are important distinctions among the various terms. 'Art for art's sake' was strongly associated with experimentalism in the 'high' arts of painting and poetry in the 1860s, and probably with the more oppositional or controversial developments in those art forms. 'Aesthetic Movement', by contrast, became associated with the decorative arts, interior design and fashion, stressed in Wilde's lecture and especially in Hamilton's book. 'Aesthetic Movement' has continued to denote the more popularising and fashionable aspects of Aestheticism in the visual arts, which in a strange reversal of the usual art-historical protocol have received greater attention in the twentieth century than the high art forms of painting and sculpture. However, the concern of this volume is not with the 'Aesthetic Movement', but with the relatively neglected areas of painting and sculpture. Accordingly the writers here prefer the term 'Aestheticism'. It should be stressed, however, that the aim is not to reify the term 'Aestheticism'. It is proposed here as a label for designating certain aspects of later Victorian art that interest us, not as a historical claim that these artistic developments constituted a 'movement', still less an 'avant-garde movement'.

If twentieth-century accounts have often emphasised the wider diffusion of the 'Aesthetic Movement', that is a sign of the powerful impact of Wilde's lecture and Hamilton's book. Both offered lucid and engaging narratives of the developments up to 1882; to a great extent they set the agenda for subsequent accounts. Indeed, the indebtedness of later writers to the texts by Wilde and Hamilton may help to account for the widespread twentieth-century perception of the 'Aesthetic Movement' as fashion conscious or trivial, a matter of affectation in dress, manners and interior design. This is reinforced by the more general usage of the term 'aestheticism', to denote a frivolous or positively irresponsible elevation of art above the serious concerns of political and social life. (In this volume 'aestheticism' with a small initial letter will be used to denote the general art theory, while the capitalised 'Aestheticism' will be used to denote the developments in Victorian art.)

The *Oxford Dictionary of Art* offers a contemptuous definition of 'aestheticism' in its more general sense: 'A term applied to various exaggerations of the doctrine that art is self-sufficient and need serve no ulterior purpose, whether moral, political, or religious'.[16] Victorian Aestheticism is only one among these 'exaggerations', although it is evidently the most egregious: *Patience*, Pater, Wilde and Whistler are prominent in the dictionary entry, and Clive Bell's 'formalism' follows as the only twentieth-century art theory to take up the notion. A more rigorous analysis appears in Peter Bürger's *Theory of the Avant-Garde*, where aestheticism is considered as a general phenomenon rather than a specific movement in Victorian England. Nonetheless it is located in a historically specific moment, when art's institutional separation from life in advanced bourgeois society reaches its logical extreme: 'Although art as an institution may be considered fully formed toward the end of the eighteenth century, the development of the contents of works is subject to a historical dynamics [*sic*], whose terminal point is reached in Aestheticism, where art becomes the content of art.'[17] In Bürger's theory, the extreme dissociation of art from social reality in aestheticism is a necessary precursor to the radical attempt of the twentieth-century avant-garde to reintegrate art and 'the praxis of life'. Nonetheless, his account can be taken as a reassertion of the moral bankruptcy long attributed to aestheticism, but now reformulated in the more politicised terms of critical theory in the early 1970s.

The standard English usage of the same word to denote both a historical movement in Victorian art and literature and a more general art theory can be confusing, but it is not coincidental. Even the popular historian Walter Hamilton began his account of the Aesthetic Movement with a thumbnail sketch of the history of aesthetic philosophy since the introduction of the term 'aesthetic' in a work of the 1750s, *Aesthetica*, by the German philosopher Alexander Baumgarten. Twentieth-century accounts of Victorian Aestheticism have sometimes borrowed Hamilton's move, to associate the historical movement with the philosophical discipline.[18] In older accounts, it was assumed that German aesthetic philosophy influenced English Aestheticism through the intermediary of the French theory of '*l'art pour l'art*', the doctrine associated particularly with Théophile Gautier and Charles Baudelaire (avowed intellectual mentors of English writers such as Swinburne) and translated into English as 'art for art's sake'. Recently a number of writers on literary Aestheticism have begun to stress more direct links to German philosophical aesthetics, particularly through Pater, who brought great sophistication to his readings of the German texts.[19] A similar reorientation is needed for Aestheticism in the visual arts. For instance, the early letters of the German-educated Leighton contain references to Hegel and Lessing,[20] and it seems likely that the artists in both the Rossetti and Leighton circles were more familiar with German art theory than we can easily detect, in the Germanophobic climate of English scholarship since the First World War.

There is, then, an additional historical reason for retaining the label 'Aestheticism'. Victorian Aestheticism, in the visual arts as well as in literature, can

be seen as deeply informed by philosophical aesthetics in both its German and French varieties. Victorian phrases such as 'the love of beauty for its own sake', 'purely artistic', 'art as such' can seem vague to twentieth-century readers, but they may instead be rigorously grounded in aesthetic philosophy; this has become apparent in some studies of literary Aestheticism and the argument can be extended to the visual arts. Indeed the distinction of Victorian Aestheticism may be its thoroughgoing attempt to realise the speculative notion of the 'purely aesthetic' in the concrete forms of works of art and literature. By contrast the French doctrine of '*l'art pour l'art*', as it is used for instance by Gautier, is less an intentional quality of works than a critical approach, used to isolate the 'purely artistic' element in any work of art from its other attributes.[21]

This suggests that the label 'Aestheticism' may be important for reasons beyond narrowly historicist considerations. The dismissive entry in the *Oxford Dictionary of Art* acknowledges, in the last sentence, that 'the more moderate form of the doctrine, in which it is held that aesthetic standards are autonomous, and that the creation and appreciation of beautiful art are "self-rewarding" activities, has become an integral part of 20th-cent. aesthetic outlook'. If Victorian Aestheticism represents a serious engagement with fundamental issues in aesthetic philosophy, as elaborated from Baumgarten through Immanuel Kant to the post-Kantian tradition, it may offer important perspectives to aesthetic debates that have not yet lost their relevance at the end of the twentieth century. In particular, Aestheticism may serve as a crucial counterpoise to the 'modernist' approaches to aesthetic questions that have dominated art-historical writing for most of the twentieth century. Recent critiques of the 'modernist' presuppositions of our art-historical discourse have unmasked its tendency to privilege the series of French 'avant-garde' movements, from Impressionism to Cubism and beyond.[22] Yet alternative models have been slow to emerge. Despite some notable attempts to expand the range of artists and works considered in our enquiries,[23] the most interesting recent developments in art history have generally applied new critical methods to the familiar giants of the art-historical canon, overwhelmingly French in the historiography of late-nineteenth-century art. Victorian Aestheticism offers a different possibility: a highly sophisticated exploration, in concrete works of art and literature, of aesthetic questions that are not preformulated in the terms of 'Modernist' orthodoxy.

The authors of this volume use diverse methodologies both to reinterpret the most familiar figures in Victorian Aestheticism, such as Rossetti, Whistler, Burne-Jones and Albert Moore, and to introduce figures who have not previously been prominent in the literature on Aestheticism, such as Poynter, Solomon, Edward Clifford, Whistler's disciples of the 1880s and the sculptors of the late Victorian period.[24] Some chapters are primarily historical in emphasis; new research on the Whistler faction at the Society of British Artists in Chapter 4, the sources of Moore's proto-'formalism' in Chapter 5, responses to the first Grosvenor Gallery exhibition in Chapter 7, and the complex debates about both female and male nudes in Chapters 10 and 11, are intended in part to expand the information

available to students of later Victorian art. However, the volume is not a history of Aestheticism in art; at the time of writing we can only begin to sketch out possible fields of enquiry. Instead the chapters offer diverse perspectives on the range of theoretical and artistic concerns evident in the visual art associated with Aestheticism.

According to traditional definitions such as the one in the *Oxford Dictionary of Art*, 'aestheticism' as a general doctrine involves a rigorous separation of art from the concerns of 'real' life, and this seems to be confirmed in certain manifesto statements of Victorian Aestheticism. In an extended digression on aesthetics in his *William Blake*, Swinburne expresses the idea with polemical vigour: 'Handmaid of religion, exponent of duty, servant of fact, pioneer of morality, [art] cannot in any way become; she would be none of those things though you were to bray her in a mortar.' Later he simplifies his scheme into three incommensurable spheres: 'To art, that is best which is most beautiful; to science, that is best which is most accurate; to morality, that is best which is most virtuous.'[25] Wilde is more flowery, but he too uses three basic categories: 'Philosophies fall away like sand, and creeds follow one another like the withered leaves of autumn; but what is beautiful is a joy for all seasons and a possession for all eternity.'[26] In each of these passages, art's independence is defined relative to non-artistic alternatives that in general outline conform to the categories systematised in the crucial source for modern aesthetics, Kant's three Critiques. On the one hand art is distinguished from 'science' – shorthand for rational or conceptual knowledge, which Swinburne associates with 'fact' and 'accuracy', and Wilde with 'philosophies'. On the other hand art is distinguished from 'morality' – shorthand for ethical practice, which Swinburne elaborates as 'religion' and 'duty', and Wilde denotes simply as 'creeds'. Sidney Colvin's early definition of a pure pictorial art, quoted above, draws on the same tripartite scheme when it distinguishes painting's address to the senses from the 'intellect' (associated with conceptual knowledge) and the 'emotions' or the 'spiritual' (associated with morality and religion). It soon became a critical commonplace to distinguish works associated with Aestheticism as pertaining specially to the artistic, as opposed to the moral or intellectual spheres. In 1876, for example, Margaret Oliphant wrote of Leighton and Poynter in a routine journalistic account of the Royal Academy exhibition: 'They have put aside all the anxious expedients of realism, the struggle for probability and harmony with ordinary rules, and at the same time the moral or intellectual meaning for which the art of painting once used to strive. Beauty alone, and for herself, boldly conventional, daringly disjoined from the actual, and even the possible, is their idol and aim.'[27]

All of these examples stress art's difference from other spheres of human endeavour; yet in these cases, and countless others that might be cited, the autonomy of art could only be asserted in relation to the alternative spheres of science and morality. To distinguish its own 'purely artistic' sphere, Aestheticism needed simultaneously to mark its relations to the other spheres. The three sections of this volume therefore address not only questions conceived in Aestheticism as internal

to the sphere of art, but art's dealings with the alternative spheres of science and morality.

In the first section, 'Art', an important concern is alliances among artists – alliances that were constantly shifting but provided opportunities for shared explorations of artistic theory and practice. The chapters explore diverse patterns of alliance, from close partnerships between individuals (Whistler and Swinburne, in Chapter 3), through circles defined by egalitarian cameraderie (in the Rossetti circle, Chapter 1) or self-conscious discipleship (of Whistler, Chapter 4), to more diffuse relationships based on sharing artistic motifs and practices (Chapter 2). Chapter 1, by Alastair Grieve, opens the section by exploring the earliest formulations of an 'art for art's sake' aesthetic in the circle around Rossetti at the beginning of the 1860s. Chapter 2 asks whether we can imagine a notion of the work of art distinctive to Aestheticism, and proposes that Pater's essays, as well as certain paintings also associated with Aestheticism, can be called 'aesthetic' works of art in a rigorous sense. In Chapter 3, Robin Spencer considers the creative partnership of Whistler and Swinburne as an alternative 'progeny for modernism' to the more familiar partnership of Manet and Baudelaire. In Chapter 4, Anne Koval shows that in the 1880s the 'Whistler faction' at the Society of British Artists modelled their discipleship on a self-consciously French model of group identity; this emphasises by contrast the diffuse and elusive character of the wider participation in Aestheticism.

The questions raised in the first section are perhaps inevitable in a book on Victorian Aestheticism, as are the major figures involved – Rossetti, Whistler, Swinburne and Pater. In the second section, 'Science', a more unconventional range of issues emerges; the authors show that explorations of the 'purely aesthetic' impinged on an array of traditional and new sciences ranging from psychology, physiology and anatomy to the philosophical 'science' of aesthetics itself. Indeed the discussions hint at an anomaly in the very notion of a philosophy of beauty; to define the aesthetic as a non-conceptual realm is in a sense to conceptualise it. As Robyn Asleson argues in Chapter 5, the traditional conception of a 'pure art' as tending towards abstraction may depend upon a variety of 'scientific' methods of schematising natural forms, involving mathematics, geometry, proportion and perspective. She presents a new view of Albert Moore – formerly considered the most unintellectual of artists – as well-versed not only in mathematics and geometry, but in theories of musical harmony and proportion. In Chapter 6, Caroline Arscott explores the disagreement between John Ruskin and Poynter about the science of anatomy. Her analysis of Poynter's painting *The Catapult* of 1868 draws on the physical sciences to conclude in an account of taste: 'at this formative stage of the Aesthetic Movement, Poynter understood art to be a kind of conversion mechanism that accesses the rough energy of working-class labour and transforms it into a force that appeals to the tasteful element among the bourgeoisie'. Kate Flint, in Chapter 7, is concerned with the science of perception, in a period when the disciplinary boundaries between psychology, philosophy and physiology were

intriguingly flexible. The distinction, in the work of the Victorian psychologist James Sully, between 'clear' and 'obscure' perceptions draws on an issue crucial to philosophical aesthetics since Baumgarten's theorisation of the aesthetic as 'confused' perception in opposition to the 'distinct' ideas of scientific analysis. However, Sully elaborates these ideas in the context of the latest research on physiological optics. Moreover, Sully's understanding of perception, as involving both 'clear' and 'undefined' elements, provides a theoretical justification – startling, for many late-twentieth-century readers – for regarding the hard-edged painting of Burne-Jones as aesthetically superior to the suggestiveness of Whistler's *Nocturnes*.

The final section, 'Morality', seems at first thought straightforward; students of Aestheticism have generally agreed in seeing it as a revolt against Victorian bourgeois morality. Yet the chapters in this section suggest that the notion of revolt is too simple; ethical and religious issues were not so readily disentangled from purely aesthetic ones. In Chapter 8, Colin Cruise explores the conjunction of Aestheticism and religion in the personal style as well as the artistic activities of Oscar Wilde. He considers the subject of the Annunciation together with its symbol, the lily, resonant from Rossetti's earliest paintings to its blasphemous transformation in Wilde's *Salomé*. In Chapter 9, Whitney Davis examines the responses of John Addington Symonds to the works of two painters: Edward Clifford, a virtually forgotten artist whose work Davis discusses for perhaps the first time in the twentieth century, and Simeon Solomon, increasingly emerging as a crucial figure in Aestheticism. For Symonds, the two artists' works represented morally opposed aspects of homoerotic art: 'where Clifford could not quite acknowledge the sin from which homoerotic purity can be saved, Solomon could not quite acknowledge the homoerotic purity from which sin can be evolved'. In Davis's account, the 'image in the middle' that might achieve a homoerotic synthesis remains unmakeable within modern culture as Symonds conceived it. The final chapters demonstrate the complexity of perhaps the most conspicuous Victorian conflict between art and morality, the debates surrounding the representation of the nude. Both Alison Smith in Chapter 10 and Michael Hatt in Chapter 11 question old assumptions about Victorian attitudes to the female and male nude; in many ways the female nude emerges as the more contentious of the two. Smith reinterprets the notorious campaign of 1885 against the female nude in art, conducted in the letters pages of *The Times*. Intriguingly the word 'purity', used so often to denote the autonomy of the aesthetic, becomes the rallying cry for moralists in the nude debate. Hatt addresses similar issues surrounding the male nude in sculpture, but with different results; he shows that the male nude could serve as a positive ideal of masculinity, not only in the fine art of sculpture but in the sculptural conception of the male body in the physical culture movement of the 1890s. Indeed it was the extravagantly clothed body of the aesthete, rather than ideal male nudity, that raised questions of homosexuality and decadence. Yet as Hatt concludes, these boundaries between ideal and deviant masculinity were never fixed; the idealised sculptural nude 'cannot help but provoke the homoerotic'.

Together the three sections demonstrate the range of Victorian explorations of the aesthetic realm, and its complex relations to the other putative spheres of human thought and action. But the Kantian spheres are not proposed as an exhaustive way of categorising the aesthetic; many issues cut across the divisions. Indeed, one issue figures significantly in all three sections – sexuality, at times unambiguously heterosexual, as in Grieve's account of the Rossetti circle, at others unambiguously homoerotic, as in Davis's discussion of Symonds's art criticism. In other cases the distinctions between homosexual and heterosexual prove elusive, as in the images of Bacchus and Venus in Pater's writing, or the connotations of the sculptural male nude as Hatt describes them. The emphases on sexuality and eroticism, throughout the volume, perhaps demonstrate an occlusion or gap in the Kantian aesthetic system. As the individual chapters show, sexuality crosses the Kantian borders in the most unpredictable ways.

Sexuality has always been an important concern in writing on Aestheticism. In the 1960s, interest focused on the heterosexual experimentalism of figures such as Rossetti, but much of the most important recent work has centred on the homoerotic. As Hatt points out, 'The connections between Victorian Aestheticism and the emergence of the homosexual in the social and cultural arena are well-known and well-documented.' Indeed, writing on Victorian Aestheticism now offers the potential for an interesting reversal of scholarly precedent, in which the 'straight' aspects of Aestheticism are threatened with marginalisation. However, this volume shows that 'homosexual' and 'heterosexual' variants of Aestheticism need not be segregated – indeed that they should not. Solomon's images of beautiful men cannot be considered in isolation from Rossetti's images of beautiful women,[28] while in Cruise's chapter Oscar Wilde offers the feminised symbol of a bunch of lilies, with impeccably masculine chivalry, to Lily Langtry.

Sexuality is perhaps the most important unifying thread throughout the volume, from Rossetti's *Bocca Baciata* of 1859 in Chapter 1, to the male nudes of the 1890s in Chapter 11. In a sense eroticism here replaces the old catchphrase, 'beauty', as the defining characteristic of Aestheticism in the visual arts. We might see this as exposing the word 'beauty' as a Victorian euphemism. In that case the aestheticist notion of a 'pure art' would be compromised, if not positively hypocritical. Claiming to present 'free' disinterested beauty, in the Kantian sense, the artists were in fact offering carnal pleasure. On the other hand, we might characterise eroticism as the most powerful way to engage the senses, the human faculty uniquely associated with the aesthetic as opposed to the intellectual or moral spheres since Baumgarten's *Aesthetica*. In that case sexuality and eroticism might be counted crucial aspects of a 'pure art' project.

Twentieth-century art history has ordinarily adopted more puritanical models for 'pure art' – in particular modernist abstraction, where sensuous pleasure in line and colour is apparently rigorously divorced from human sexuality. Perhaps this helps to account for the equivocal art-historical status of Victorian Aestheticism. On the one hand it is the closest British approximation to an art of pure form;

Whistler, in particular, has often been enlisted as the most significant Victorian precursor to twentieth-century modernism. Even Clive Bell was willing to concede some such role to Whistler, however grudgingly: 'ill-mannered, ill-tempered, and almost alone, he was defending art, while [his enemies] were flattering all that was vilest in Victorianism'.[29] On the other hand, most of the other artists associated with Aestheticism have seemed too close to 'vilest Victorianism'. On the 'formalist' assumptions of Bell and much twentieth-century art history, the formal simplicity of works such as Whistler's *Nocturnes*, purged of descriptive detail (plate 18), has been much easier to approve than the 'literary' and symbolic complexity – and perhaps the erotic intensity – of such pictures as Rossetti's *Venus Verticordia* (plate 9) or Solomon's *Bacchus* (plates 51, 52).

In the last decade or two, formalism has gone dramatically out of art-historical fashion – indeed its reputation in current art history is no less ignominious than 'vilest Victorianism' was for Bell. That might be an encouraging sign for the study of Victorian Aestheticism, and indeed the authors of this volume for the most part reject formalist interpretations of the works they consider. Spencer reinterprets Whistler's work as sharing the expressive emphases of Swinburne's poetry; Grieve suggests that the most 'literary' aspects of Rossetti's paintings, far from detracting from their 'pure art' credentials, are central to the artist's practice in Aestheticism. Yet Aestheticism is deeply implicated in formalism. Despite his antipathy to the Victorian period, Bell's pronouncements, in his influential 'formalist' manifesto of 1914, *Art*, are compulsively reminiscent of Aesthetic writing about art:

> What quality is common to Sta. Sophia and the windows at Chartres, Mexican sculpture, a Persian bowl, Chinese carpets, Giotto's frescoes at Padua, and the masterpieces of Poussin, Piero della Francesca, and Cézanne? Only one answer seems possible – significant form. In each, lines and colours combined in a particular way, certain forms and relations of forms, stir our aesthetic emotions.[30]

Bell's description of 'significant form' can readily be compared with Sidney Colvin's wording fifty years earlier: 'perfection of forms and colours – beauty, in a word – should be the prime object of pictorial art', Indeed, the *Oxford Dictionary of Art* must be correct to note the derivation of Bell's 'formalism' from nineteenth-century Aestheticism, even though the idea might have appalled Bell himself. The simultaneous closeness and distance between Aestheticism and formalism helps to account for the strange mixture of attraction and repulsion that has characterised twentieth-century views of Aestheticism. Aestheticism is embedded in the discourses that hold it in contempt.

Bell's inventory of the diverse works capable of stirring our aesthetic emotions immediately recalls Pater's lists of aesthetic objects in the Preface and Conclusion to *The Renaissance*: 'the picture, the landscape, the engaging personality in life or in a book, *La Gioconda*, the hills of Carrara, Pico of Mirandola'.[31] Indeed, such inventories recur in surprisingly different contexts throughout the chapters of this

volume – in Grieve's quotations from Gautier's scandalous novel, *Mademoiselle de Maupin*, in the descriptions of the Grosvenor Gallery interiors quoted by Flint, in Cruise's account of the erotic imagery of Wilde's *Salomé*. Such lists are not trivial. Pater, who was profoundly versed in German and French aesthetics, used them as the concrete examples that, in Kantian and post-Kantian aesthetics, are necessary in the absence of a conceptual definition of art. The lists enumerate the various objects of sensuous pleasure in lieu of authorising a rule for taste.

Despite the superficial similarity, Bell's list is more prescriptive than Pater's or the others associated with Aestheticism; Bell's selection of 'tasteful' objects has an unpleasant counterpart in his exclusion of the vulgar, including virtually all of Victorian art. His criterion of 'significant form' thus becomes a pre-emptive rule. Pater, by contrast, rejects the possibility of a 'universal formula' in order to seek the distinctive 'virtue' of each object of aesthetic pleasure. In this sense the apparent doctrinal vagueness of Aestheticism might be reinterpreted as an openness to the varieties of aesthetic experience that, in the absence of a 'universal formula', have no necessary limits. On that view, the expansion from high art into the more diversified realm of the 'Aesthetic Movement' need not be seen as commercialisation or trivialisation; instead it may be a consequence of Aestheticism's refusal to prescribe limits for aesthetic pleasure.

We might then value Victorian Aestheticism, no longer as an equivocal precursor to formalism, but as an antidote to the narrow conception of the aesthetic that the formalist doctrines of the twentieth century tended to enforce. The extreme reaction against formalism in current art history has often involved a repudiation of the aesthetic in general. In recent literary criticism, by contrast, there has been an increasing tendency to reinterpret Aestheticism as a significant exploration of aesthetic issues whose relevance has not diminished in the twentieth century. This volume aims to reintegrate the visual arts in these discussions of our own time. It is in the context of such discussions that the label 'Aestheticism' remains valuable, despite disputes about its precise meanings – or perhaps because of them. If Aestheticism were easy to encapsulate in a 'universal formula', it might be of merely antiquarian interest. Our attempts to pin it down, either as a movement or as an idea, may prove futile, yet their value may be, in Pater's words, 'in the suggestive and penetrating things said by the way'.[32]

Notes

1 L. Dowling, *Aestheticism and Decadence: A Selective Annotated Bibliography* (New York and London, Garland, 1977). For more recent writing on literary Aestheticism see for example J. Freedman, *Professions of Taste: Henry James, British Aestheticism, and Commodity Culture* (Stanford, Stanford University Press, 1990); L. Chai, *Aestheticism: The Religion of Art in Post-Romantic Literature* (New York, Columbia University Press, 1990); R. Dellamora, *Masculine Desire: The Sexual Politics of Victorian Aestheticism* (Chapel Hill and London, University of North Carolina Press, 1990).

2 The best general introduction, including both fine and decorative art, has long been out of print: R. Spencer, *The Aesthetic Movement: Theory and Practice* (London and New York, Studio Vista / Dutton, 1972). Only the decorative arts are covered in E. Aslin, *The Aesthetic Movement: Prelude to Art Nouveau* (New York, Praeger, 1969). The only general survey currently in print is a non-scholarly work marred by numerous factual errors: L. Lambourne, *The Aesthetic Movement* (London, Phaidon, 1996). A few recent works on literary Aestheticism also address the visual arts; see especially J. B. Bullen, *The Pre-Raphaelite Body: Fear and Desire in Painting, Poetry, and Criticism* (Oxford, Clarendon, 1998); K. A. Psomiades, *Beauty's Body: Femininity and Representation in British Aestheticism* (Stanford, Stanford University Press, 1997).

3 See R. L. Stein, *The Ritual of Interpretation: The Fine Arts as Literature in Ruskin, Rossetti, and Pater* (Cambridge, Mass., and London, Harvard University Press, 1975).

4 W. Pater, *The Renaissance: Studies in Art and Poetry*, ed. D. L. Hill (Berkeley and London, University of California Press, 1980), p. 188.

5 O. Wilde, 'The English Renaissance of Art' (1882), reprinted in J. W. Jackson (ed.), *Aristotle at Afternoon Tea: The Rare Oscar Wilde* (London, Fourth Estate, 1991), p. 27. The flower is the key example of 'free beauty' in a founding text of modern aesthetics, I. Kant, *The Critique of Judgement* (1790), trans. J. C. Meredith (Oxford, Clarendon, [1911] 1952), para. 16, p. 72.

6 Freedman, *Professions of Taste*, p. 3. Cf. R. V. Johnson, *Aestheticism* (London, Methuen, 1969), pp. 9–10, 46.

7 R. Z. Temple, 'Truth in labelling: Pre-Raphaelitism, Aestheticism, Decadence, Fin de Siècle', *English Literature in Transition*, 17:4 (1974) 218–19.

8 Johnson, *Aestheticism*, p. 46.

9 See for example P. G. Hamerton, 'The reaction from Pre-Raphaelitism', *Fine Arts Quarterly Review*, 2 (May 1864) 255–62. By 1865 W. M. Rossetti, one of the original members of the Pre-Raphaelite Brotherhood, was convinced that Pre-Raphaelitism had been superseded by newer developments; see W. M. Rossetti, 'Mr. Madox Brown's exhibition, and its place in our school of painting', *Fraser's Magazine*, 71 (May 1865) 602–3.

10 S. Colvin, 'English painters and painting in 1867', *Fortnightly Review*, n.s. 2 (October 1867) 473–6.

11 Ibid., p. 465.

12 A. C. Swinburne, *William Blake: A Critical Essay* (London, John Camden Hotten, dated 1868 but issued late in 1867), pp. 91, 101.

13 [W. Pater, published anonymously], 'Poems by William Morris', *Westminster Review*, n.s. 34 (October 1868) 312.

14 T. Taylor, 'Among the pictures: part II', *Gentleman's Magazine*, n.s. 1 (July 1868) 151. Taylor also began to use the term in his widely read art criticism for *The Times*.

15 This shift has received little attention; see however N. Shrimpton, 'Pater and the "aesthetical sect"', *Comparative Criticism*, 17 (1995) 61–84

16 I. Chilvers and H. Osborne (eds), *The Oxford Dictionary of Art* (Oxford and New York, Oxford University Press, 1988) 6.

17 P. Bürger, *Theory of the Avant-Garde*, trans. M. Shaw (Manchester and Minneapolis, Manchester University Press / University of Minnesota Press, 1984), p. 49. Jonathan Freedman sees English Aestheticism as different from 'its Continental counterparts',

and closer to Bürger's notion of a genuine avant-garde; see Freedman, *Professions of Taste*, pp. 11–14.

18 See for example Lambourne, *Aesthetic Movement*, p. 10, where Baumgarten's title is misspelled. Baumgarten had coined the term 'aesthetic' in his MA dissertation of 1735; see H. Reiss, 'The "naturalization" of the term "ästhetik" in eighteenth-century German: Alexander Gottlieb Baumgarten and his impact', *Modern Language Review*, 89:3 (1994) 645.

19 See especially F. C. McGrath, *The Sensible Spirit: Walter Pater and the Modernist Paradigm* (Tampa, University of South Florida Press, 1986).

20 Mrs R. Barrington, *The Life, Letters and Work of Frederic Leighton*, 2 vols (London, George Allen, 1906), I, pp. 93–4, 103–4.

21 See T. Gautier, 'Du beau dans l'art', *Revue des Deux Mondes*, 19 (1847) 887–908, in particular Gautier's analysis of Shakespeare's *Othello* in the light of '*l'art pour l'art*', p. 900.

22 See for example N. McWilliam, 'Limited revisions: academic art history confronts academic art', *Oxford Art Journal*, 12:2 (1989) 71–86.

23 Feminism has made important contributions by calling attention to neglected women artists; see for example D. Cherry, *Painting Women: Victorian Women Artists* (London, Routledge, 1993); J. Marsh and P. G. Nunn, *Pre-Raphaelite Women Artists*, exh. cat. (Manchester, Manchester City Art Galleries, 1997).

24 A key figure who is not covered here is Frederic Leighton. See however T. Barringer and E. Prettejohn (eds), *Frederic Leighton: Antiquity, Renaissance, Modernity*, Yale Studies in British Art No. 5 (New Haven and London, Yale University Press, 1999).

25 Swinburne, *William Blake*, pp. 90, 98.

26 Wilde, 'English Renaissance', p. 21.

27 [M. Oliphant, published anonymously], 'The Royal Academy', *Blackwood's Edinburgh Magazine*, 119 (June 1876) 759.

28 See C. Cruise, '"Lovely devils": Simeon Solomon and Pre-Raphaelite masculinity', in E. Harding (ed.), *Re-framing the Pre-Raphaelites: Historical and Theoretical Essays* (Aldershot, Scolar, 1995), p. 195.

29 C. Bell, *Art* (London, Arrow Books, [1914] 1961), p. 171.

30 Ibid., p. 23.

31 Pater, *Renaissance*, p. xx.

32 Ibid., p. xix.

ART

Rossetti and the scandal of art for art's sake in the early 1860s

Alastair Grieve

SWINBURNE THOUGHT that his belief as a young man in the doctrine of art for art's sake stemmed from 'the morally identical influence of Gabriel Gautier and of Théophile Rossetti [*sic*]'.[1] It was probably Dante Gabriel Rossetti who introduced him to Théophile Gautier's novel *Mademoiselle de Maupin*, published as early as 1835, the Preface to which is the key manifesto of the doctrine.[2] In its profession of a total lack of concern for Christian morality in favour of the pursuit of beauty for its own sake, the Preface is excitingly shocking. Passages from it are worth quoting at some length for their relevance to the scandalous ideas found in Rossetti's circle in the early 1860s which are the subject of this chapter.

It starts: 'One of the most ridiculous things in the glorious epoch in which we have the good fortune to be alive is undoubtedly the rehabilitation of virtue.... The fashion to-day is to be virtuous and Christian'.[3]

It continues:

> Nothing is really beautiful unless it is useless; everything which is useful is ugly, for it expresses some need and the needs of man are ignoble and disgusting, like his poor and feeble nature.... For myself ... I am among those to whom the superfluous is necessary, – and I prefer things and people in inverse ratio to the services that they perform for me. Instead of some useful, everyday pot, I prefer a Chinese pot which is sprinkled with mandarins and dragons, a pot which is no use to me at all, ... I should very happily renounce my rights as a Frenchman and as a citizen to see an authentic picture by Raphael, or a beautiful woman naked.... for pleasure seems to me the goal of life and the only worthwhile thing in the world. God has ordained it, He who created women, perfumes, light, beautiful flowers, good wines, frisky horses, greyhounds and angora cats...[4]

And in the novel itself, the hero makes plain his pagan worship of visible beauty:

> I prefer a pretty mouth to a pretty word, and a well-formed shoulder to a virtue, even a theological virtue; I should give fifty souls for a dainty foot, and all poetry and poets for the hand of Giovanna of Aragon or the brow of the Virgin of Foligno. – I adore above all things beauty of form; – beauty, for me, is visible Divinity, palpable

happiness, heaven on earth. – There are certain undulations, certain subtle curves of
the lips, certain slants of eyelids, certain inclinations of the head, certain elongations
of ovals which ravish me beyond all expression and fascinate me for hours on end....
I love rich brocades, splendid materials with thick, massive folds; I love big flowers
and scent-boxes, the transparency of running water and the gleaming brilliance of
fine weapons, thoroughbred horses and those big white dogs that you see in the
pictures of Paolo Veronese. – I'm a real pagan about this.... – I do not understand
mortification of the flesh which is the essence of Christianity.... I am in entire accord
with the Greeks' wild enthusiasm for beauty.
[...]
Christ has not come for me; I am as pagan as Alcibiades and Phidias.... – I find Earth
as beautiful as heaven, and I think that virtue lies in formal perfection.
[...]
What is physically beautiful is good, everything that is ugly is bad. – If I saw a beau-
tiful woman, even if I knew that she had the wickedest soul on earth, that she was
adulterous and a poisoner, I swear I shouldn't mind in the least, and it wouldn't in
any way prevent me from taking pleasure in her, provided I found the shape of her
nose attractive.[5]

Swinburne, in a poem he contributed by invitation to a memorial volume at
Gautier's death in 1872, said of *Mademoiselle de Maupin*:

This is the golden book of spirit and sense,
The holy writ of beauty[6]

To compare an artist's work to the aesthetics expressed in the novel was, for
Swinburne, the highest praise. In his *Notes on Some Pictures of 1868*, for example,
he says of Albert Moore: 'His painting is to artists what the verse of Théophile
Gautier is to poets; the faultless and secure expression of an exclusive worship of
things formally beautiful.'[7] And of Rossetti's *Lilith* he writes: 'Were it worth her
while for any word to divide those terrible tender lips, she too might say with the
hero of the most perfect and exquisite book of modern times – "Mademoiselle de
Maupin" – "Je trouve la terre aussi belle que le ciel, et je pense que la correction
de la forme est la vertu."'[8]

Swinburne believed that Gautier's ideas were identical to those of Rossetti and,
as mentioned above, he acknowledges their dual influence in leading him to an art
for art's sake aesthetic.[9] Swinburne had come into Rossetti's circle in 1857, when
Rossetti and a group of friends were painting murals in the Oxford Union. The
two became close in the summer of 1860, when the artist made a fine drawing of
the young poet (plate 1).[10] From October 1862 to early 1864 Swinburne lodged,
on and off, in Rossetti's house at 16 Cheyne Row.[11]

Shocking ideas, akin to Gautier's, can be found in the circle at Oxford already
in 1857. The subject of Rossetti's Union mural was inappropriate for its setting,
the chamber where the future leaders of Britain practised their debating skills, for
it showed the adulterous love between Lancelot and Guinevere and the triumph

of women's beauty over Christian purity. Guinevere is Eve, for she holds an apple, but she is posed in the position of Christ crucified. Swinburne records the group of Union painters and their friends proposing, to the shock of visitors, Paradise as a rose garden full of beautiful, amorous women.[12] Later, in October 1861, Rossetti used Swinburne as an appropriate model for a drawing (Surtees 125) of a lover adoring his mistress against a background of schematic hearts and kisses, in a scene reminiscent of their envisaged Paradise, which he intended as a frontispiece for his book of translations of *The Early Italian Poets*.[13] Birkbeck Hill remembered the group at Oxford insisting that a murderess should be excused the death penalty because she was beautiful.[14]

For Swinburne, the archetypical evil beauty was Lucrezia Borgia. In about 1861 he wrote the unpublishable *Chronicle of Tebaldeo Tebaldei* about her, where he states: 'A beautiful soft line drawn is more than a life saved; and a pleasant perfume smelt is better than a soul redeemed.'[15] His enthusiasm for her probably infected Rossetti who, in 1858–59, changed a drawing from a *Richard III* subject to one of *Lucrezia Borgia* and in 1860–61(?) painted her washing her hands after poisoning her husband.[16] (Val Prinsep records that one of the few operas Rossetti

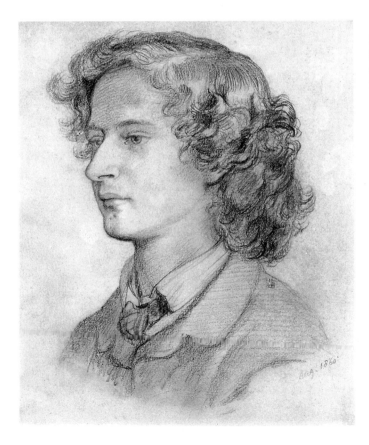

1 Dante Gabriel Rossetti, *Algernon Swinburne*, 1860, pencil, 23.5 x 19.7 cm

liked was *Lucrezia Borgia* with Grisi in the title role.[17]) As well as Lucrezia Borgia, they admired the alluring and deadly wife of Potiphar in J. C. Wells's drama *Joseph and His Brethren*, and Sidonia, the sorceress from Meinhold's *Sidonia von Bork, die Klosterhexe*, Rossetti making a drawing in 1860 of *Joseph Accused before Potiphar* (Surtees 122) and Burne-Jones, in the same year, producing his watercolours of *Sidonia* and *Clara von Bork* (Tate Gallery).[18] These beautiful women were aggressively sensual and wilful in their aims.

Women's purity had been the subject of Rossetti's first major oil, but from 1857 he stresses women's physical beauty and sensual allure. In *A Christmas Carol* (Surtees 98), painted in the winter of 1857–58 and retouched in the summer of 1859, a queen has her long hair dressed.[19] Her attendants brush and scent it while she performs music, so suggesting a mingling of the senses that, not surprisingly, attracted Swinburne who made this watercolour the subject of a poem which he published in *Poems and Ballads* in 1866. During the years 1858–60, Rossetti made

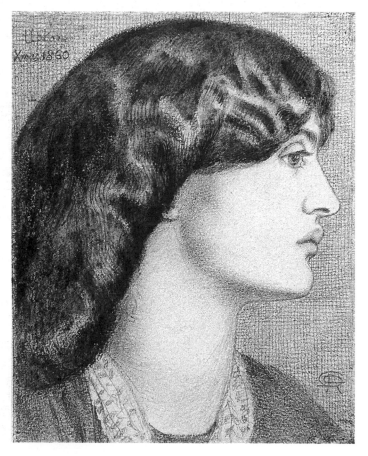

2 Dante Gabriel Rossetti, *Jane Morris*, 1860, pencil and Indian ink, 22 x 17.8 cm

several drawings of women famous for their beauty: Annie Miller, Ruth Herbert, Fanny Cornforth, Elizabeth Siddal, Jane Morris (Surtees 354, 325, 286, 476, 365; plate 2). He stresses their hair, lips, eyes, throats, glorying in their physical beauty like the hero of *Mademoiselle de Maupin*. In 1859, he made a beautiful woman's face the subject of an experiment in oil, *Bocca Baciata*, exhibited the following year at the Hogarth Club (plate 3).[20]

Bocca Baciata is an important picture which led to many other bust-length pictures of women by Rossetti and by other artists in his circle: for example, *The Irish Girl* by Ford Madox Brown, shown at the Hogarth Club in 1861, *La Veneziana*, shown at the Royal Academy in the same year, by Joanna Boyce (for whose brother Rossetti painted *Bocca Baciata*), *Hope* of 1862 by Edward Burne-Jones, *Vivien* of 1863 by Frederick Sandys.[21]

The Hogarth Club, where Rossetti showed *Bocca Baciata* and Brown *The Irish Girl*, was an avant-garde group to which many of the artists in Rossetti's circle

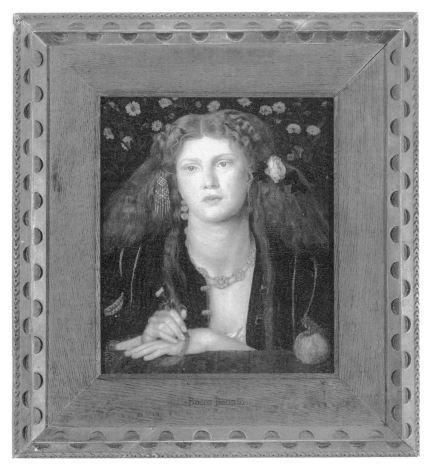

3 Dante Gabriel Rossetti, *Bocca Baciata*, 1859, oil on panel, 32.2 x 27.1 cm

belonged. It lasted from April 1858 to December 1861.[22] Frederic Leighton was
also a member and he probably shared the ideals of Rossetti and his friends to some
extent at this time. It is possible that the series of bust or three-quarter length
paintings he had made from the Roman model Nanna Risi in Rome in 1858–59,
three of which were shown at the Royal Academy in 1859, influenced Rossetti.[23]
The compositions of Leighton's paintings are, however, unlike those of Rossetti
and his circle in that his figures turn in space, recalling Raphael's High Renaissance
works, while *Bocca Baciata* and the pictures that follow it are flat and 'primitive'.
Leighton showed 'small painted heads' at the Hogarth Club in 1860 when Rossetti
exhibited *Bocca Baciata*.[24]

William Holman Hunt saw their exhibits there and on 12 February 1860 wrote
to his High Anglican patron Thomas Combe expressing his admiration for
Leighton but deep and pained unease over Rossetti's picture:

> I will not scruple to say that it impresses me as very remarkable in power of execu-
> tion – but still more remarkable for gross sensuality of a revolting kind peculiar to
> foreign prints.... I would not speak so unreservedly of it were it not that I see Rossetti
> is advocating as a principle the mere gratification of the eye and if any passion at all
> – the animal passion to be the aim of art. for my part I disavow any sort of sympa-
> thy with such notion....[25]

Hunt's interpretation is right; Rossetti's painting is sensual. Its title, *Bocca Baciata*,
means 'a kissed mouth' and comes from a line by Boccaccio, 'Bocca basciata non
perde ventura, anzi rinnuova come fa la luna' ('a kissed mouth does not lose its
freshness but renews itself like the moon'), from *The Decameron*, last line of the
seventh tale told on the second day, a carnal tale about an irresistible Eastern
woman who makes love to eight men before her marriage to a ninth, as a virgin.[26]
Rossetti persuaded his friend G. P. Boyce, who shared at least some of Fanny
Cornforth's favours with him, to commission the picture as a portrait of her on 23
July 1859.[27] On 5 September Rossetti wrote to Boyce that it had taken on 'a rather
Venetian aspect', and on 13 October Boyce recorded in his diary that Rossetti 'has
painted a splendid portrait of Fanny for me (according to commission) in late 16th
century costume'.[28] So, though a portrait of a contemporary woman, the picture
was intended to recall the Venetian Old Masters.

In a letter written in November of the same year, 1859, Rossetti discusses the
breakthough he had achieved with this picture, the change from his usual practice
of using watercolours for small scenes to working in oil at 'rapid flesh painting', and
he remarks: 'among the old good painters, their portraits and simpler pictures are
almost always their masterpieces for colour and execution'.[29] Possibly he had an
example in mind among the Venetian Old Masters, Giovanni Bellini's *S. Dominic*
(1515), which had entered the South Kensington Museum in 1856 (plate 4). At any
rate the composition of *Bocca Baciata*, a bust-length figure behind a parapet against
a flat background, is based on this kind of model. The marigolds behind Fanny's
head were perhaps suggested by the schematic flowers behind S. Dominic in

Bellini's painting. Swinburne, and Gautier, would have appreciated the exchange of the ascetic saint's face for the beautiful, sensuous Fanny Cornforth's.

The influence of Venetian painting, an important strand in the art for art's sake aesthetic from *Mademoiselle de Maupin* onwards, is strongest in Rossetti's work during the first half of the 1860s, though he had been interested in the Venetian school from a much earlier date. He had written his sonnet on Giorgione's *Fête Champêtre* in October 1849 and the ideas he expressed there – synaesthesia, the link between music and the tactile senses, the sensation of coolness and satiety, of which Gautier would have approved – were to be influential on Swinburne, who praised the sonnet after seeing the picture in the Louvre in 1861, and again on Pater in his famous essay 'The School of Giorgione' (1877).[30] Perhaps in the early 1850s, though possibly later as their subjects correspond closely to passages in Ruskin's *Modern Painters V* of 1860 (quoted below, p. 28), Rossetti made two drawings in which he compares the Florentine and Venetian traditions (Surtees 694, 695). One shows the monk Fra Angelico kneeling to paint a Madonna, inspired by a fellow monk's Bible reading, the other shows Giorgione painting a beautiful Venetian woman, at whom he gazes intently, while friends and a black servant look on in admiration (plate 5).

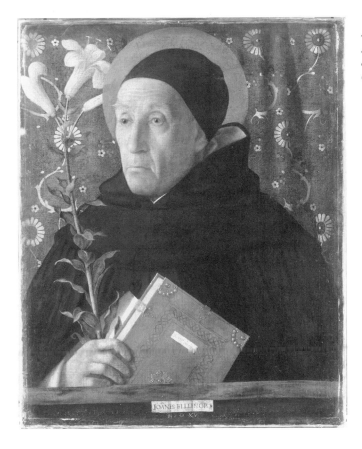

4 Giovanni Bellini,
S. Dominic, 1515,
oil on canvas,
62.9 x 49.5 cm

The Venetian influence is certainly strongly marked by about 1860. The influence of both Tintoretto and Veronese is evident in the centre section of the Llandaff triptych (Surtees 105) on which Rossetti was working from November 1859 to the summer of 1861. The commission for this had come through Ruskin, and Ruskin's praise of the Venetians, especially Tintoretto's *Adoration of the Magi* in the Scuola di San Rocco, was no doubt influential too.[31] On a visit to Paris in June 1860 Rossetti greatly admired the enormous, luxurious Veronese, the *Marriage Feast at Cana*.[32] He wrote that he much preferred the sense of 'flesh, blood and slight stupidity' in it to the earnest realism in, for example, Holman Hunt's *Christ in the Temple*.[33] The illustrations Rossetti made for his sister's *Goblin Market*, published in March 1862, recall Titian's *Madonna and Child with S. John the Baptist and S. Catherine*, which entered the National Gallery in 1860.

The *Goblin Market* illustrations take up the theme of women's hair, spread to show its beauty, which is always important for Rossetti but becomes a positive fetish at this period. Pictures done a little later, showing a beautiful woman, modelled on Fanny Cornforth, indolently and narcissistically dressing her hair, betray a clear debt to the Venetians in the Louvre. For example *Fazio's Mistress* (Surtees 164) of 1863, *Lilith* (Surtees 205) started in 1864, which Rossetti described to a friend simply as 'my picture with the hair', and *A Woman Combing Her Hair* (Surtees 174; plate 6), also of 1864, recall Titian's *Woman at Her Toilette*.[34] Possibly now, more probably later, Rossetti obtained a photograph of this Titian, which he

5 Dante Gabriel Rossetti, *Giorgione Painting*, *c.* 1853?, pen and brown ink, and ink wash, 11.1 x 17.8 cm

mounted in an album and which he, or Frederic Shields, who came to own the album on Rossetti's death, entitled 'Titian's Mistress' (plate 7).[35] A photograph of Titian's *Allegory of Alfonso of Avalos*, the composition of which influenced Rossetti's *The Beloved*, is also mounted in the album. There are, as well, several photographs of paintings by Raphael, including the *Giovanna of Aragon* so much admired by Gautier.

Rossetti's taste for Venetian art was shared by the three men who lodged in his Cheyne Walk house for short periods from October 1862. George Meredith and Rossetti's brother, William Michael Rossetti, had visited Venice in 1861 and 1862 respectively, and they both wrote appreciatively of its painting at this time.[36] Swinburne, as mentioned above, looked at the Venetian pictures in the Louvre in 1861 and again in 1863, and in 1864, in the Uffizi, admired the *Venus of Urbino*.[37] Burne-Jones, still close to Rossetti though not a lodger at Cheyne Walk, had made copies in Venice in 1862 for Ruskin from Veronese and Tintoretto.

All these men were struck by the Venetian emphasis on sensual beauty. Swinburne, for example, writes of the Venetians in distinction to the other Italian schools in his 'Notes on designs of the Old Masters at Florence':

> It is not by intellectual weight or imaginative significance that these Venetians are so great. That praise is the proper apanage of the Milanese and the Roman schools – of Michael Angelo and Leonardo. Those had more of thought and fancy, of meaning

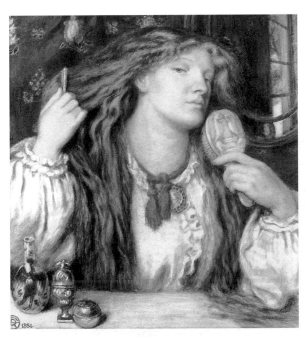

6 Dante Gabriel Rossetti, *Woman Combing Her Hair*, 1864, watercolour, 36.2 x 33 cm

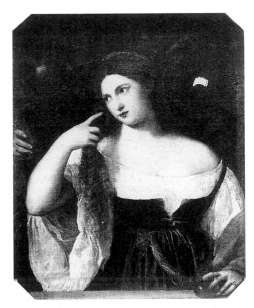

7 Photograph of *Woman at Her Toilette* by Titian (Louvre, Paris), inscribed in pencil 'Titian's Mistress', from an album which belonged to Rossetti

and motive. But since the Greek sculptors there was never a race of artists so humbly and so wholly devoted to the worship of beauty.[38]

Swinburne, Ruskin and Burne-Jones likened Rossetti's pictures of this time to Titian's, Swinburne, for example, writing to Seymour Kirkup: 'They recall the greatness, the perfect beauty and luxurious power of Titian and of Giorgione.'[39] Burne-Jones, on seeing a specimen of Titian's handwriting, was struck by its similarity to Rossetti's, and it is likely that the circle saw echoes of Titian's way of life in Cheyne Walk.[40] Just as Titian used, they thought, his mistress for his paintings, so Rossetti used his. Fanny Cornforth was the model for most of the works of this time, while Swinburne was, perhaps, a latter-day Aretino.

The type of female beauty admired by Rossetti at this period is much more physically powerful than that found in the *Books of Beauty*, which Holman Hunt states the young Pre-Raphaelites had so much disliked.[41] Yet there is a kinship and in some ways the wheel has come full circle. The women portrayed in the engravings in the *Books of Beauty*, edited by the Countess of Blessington in the

8 *Vincenza*, engraving by H. Robinson after a painting by E. T. Parris, *Heath's Book of Beauty for 1836*

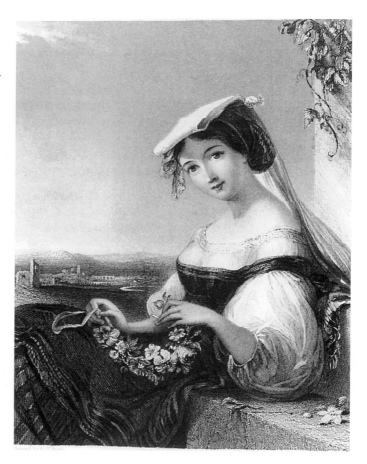

1830s and 1840s, were chosen to appeal to the snobbishness and prurience of the British middle class. They vary from the demure to the wickedly inveigling, from the aristocratic English lady to the Italian peasant girl (plate 8), from the wealthy Lady Egerton, bedecked with jewels and lace, to the cast-off kept woman, Agnes, who is to drown herself in the Serpentine.[42] Like the women portrayed by Rossetti, they are exceptionally beautiful but, unlike his women, they all have small, delicate features and slight forms. The women in Rossetti's paintings and drawings have emphatic features, assertive poses, and no class identity. They are confident in their beauty and especially confident that their beauty will attract men. They dress their hair, apply scent, parade their jewels and flowers, as provocation. Rossetti arranges them behind parapets, in enclosed rooms, as seductresses. Lady Lilith, for example, entraps men, his sonnet written for the picture in 1866 tells us, by the 'bright net' of her hair, her 'shed scent, / And soft-shed kisses and soft sleep'.[43] Originally, *Lilith* had Fanny Cornforth's face but the picture was repainted at a later date, like many others of this period, and the more 'ideal', less sensual features of Alexa Wilding were substituted.[44] Part of Swinburne's praise of *Lilith*, linking it to *Mademoiselle de Maupin*, was quoted above.

Rossetti's most Swinburnian image is *Venus Verticordia* (Surtees 173; plate 9), also of 1864 though repainted at a later date.[45] Venus, the original model for whom was described by William Allingham as 'almost a giantess', is shown as the cause of the Trojan War, a destructive woman.[46] She has been given the golden apple by Paris and holds the dart of love which will make Helen love him. While painting this, Rossetti wrote gleefully to Madox Brown that he was going to put a halo behind the goddess's head as he believed the Greeks used to do it.[47] We find the same scandalous fusion of the pagan and Christian in much of Swinburne's contemporary verse, such as 'Hymn to Proserpine' and 'Laus Veneris', written in 1862 and published in *Ballads and Sonnets*:

Alas, Lord, surely thou art great and fair.
But lo her wonderfully woven hair!
And thou didst heal us with thy piteous kiss;
But see now, Lord; her mouth is lovelier.
 'Laus Veneris', verse 5

Wilt thou yet take all, Galilean? but these thou shalt not take,
The laurel, the palms and the paean, the breasts of the
 nymphs in the brake;
 'Hymn to Proserpine', lines 23–4

Ruskin was disturbed and excited by Swinburne's poetry. In December 1865, he commented privately on the poet's recitation to him of 'the wickedest and splendidest verses ever written'.[48] At the same time, he had similar reservations over Rossetti's treatment of the flowers in *Venus Verticordia*, confessing to the artist: 'They were wonderful to me, in their realism; awful – I can use no other word – in

their coarseness: showing enormous power, showing certain conditions of non-sentiment which underlie all you are doing now'.[49]

Yet Ruskin himself was partly responsible for the new sensuality. Already, in September 1849, he had recorded in his diary the powerful impact Veronese's *Marriage Feast at Cana* had had upon him.[50] In Turin, in the summer of 1858, he copied another Veronese, *The Queen of Sheba's Visit to Solomon*, and he described how he was seduced from his narrow, northern, evangelical faith by a heady mingling of sensual experiences in the southern afternoon heat.[51] As he studied the painting, the music from a band playing outside blended with its colour and form and he was overwhelmed. In his *Notes on the Turin Gallery*, he wrote: 'A good, stout, self-commanding, magnificent Animality is the make for poets and artists, it seems to me.'[52] He spent 1858–59 'trying to get at the mind of Titian' and studied Venetian paintings in Berlin, Dresden and Munich.[53] In *Modern Painters V*, published in June 1860, he compares Florentine to Venetian art: 'Florentine art was essentially Christian, ascetic, expectant of a better world, and antagonistic, therefore, to the Greek temper', while the Venetians 'saw that sensual passion in man was, not only a fact, but a Divine fact; the human creature, though the highest of

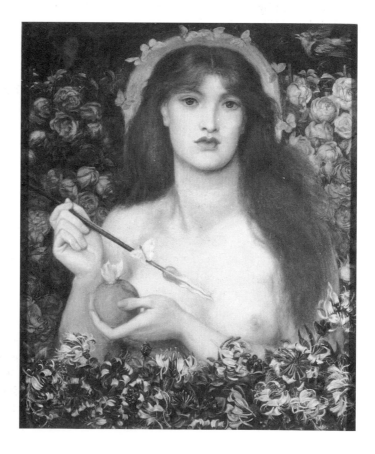

9 Dante Gabriel Rossetti, *Venus Verticordia*, 1864–68, oil on canvas, 98.1 x 69.9 cm

the animals, was, nevertheless, a perfect animal, and his happiness, health and nobleness, depended on the due power of every animal passion, as well as the cultivation of every spiritual tendency'.[54]

In 1864 Ruskin bought his *Portrait of Doge Andrea Gritti* (National Gallery, London), then thought to be by Titian but now given to Catena, a picture which may have influenced Rossetti's *Monna Vanna* (Surtees 191) of 1866. Rossetti described this as 'probably the most effective as a room decoration which I have ever painted … the Venetian ideal of female beauty'.[55] It was the last of the type of painting that had begun in 1859 with *Bocca Baciata*.

As well as Venetian art, and *Mademoiselle de Maupin*, there are other influences on the aesthetic beliefs of Rossetti and his circle at this time. These influences came from an astonishingly diverse variety of sources. There were the poems of the Italian troubadours which Rossetti had been translating since the 1840s and which he published with financial backing from Ruskin in the volume *Early Italian Poets* in 1861. Many of these poems are devoted to praise of women's beauty. The title of Rossetti's painting *Fazio's Mistress* is derived from one of the most eloquent of these poems, by Fazio degli Uberti, in which the poet describes graphically how he is ensnared by the beauty of his lady's hair, jewels, flowers, eyes, mouth and neck. Edward Fitzgerald's translation of the *Rubáiyát of Omar Khayyám*, Rossetti's copy being dated 10 July 1861, was also important, with its message that life should be given to sensual pleasures of the moment rather than the search for wordly fame or hope of a future paradise.[56]

William Blake's scorn of conventional morality impressed them all. Rossetti had bought Blake's *Notebook* in 1847 and in the early 1860s was involved with his brother in Alexander Gilchrist's *Blake*. This appeared in 1863, after Gilchrist's death. Here Rossetti affirmed: 'Colour and metre, these are the true patents of nobility in painting and poetry, taking precedence of all intellectual claims'.[57] Here too, Rossetti gave inordinate praise to the satanic, erotic art of Fuseli's follower Theodor Von Holst, whose half-length pictures of mysterious, seductive women were also possibly influential now.[58] Swinburne, who had refused to help with the Gilchrist *Blake* because of the prudishness of the publisher, Macmillan, in an essay which began as a review of the book, fervently expressed his belief in art for art's sake: 'Art for art's sake first of all, and afterwards we may suppose all the rest shall be added to her (or if not she need hardly be overmuch concerned)'.[59]

French writers, Dumas, Hugo and others more notorious, were important as well as Gautier. In August 1862 Rossetti and Swinburne read de Sade's *Justine* together.[60] In the following month Swinburne published his review of Baudelaire's *Les Fleurs du mal*, itself dedicated to Gautier, commenting approvingly: 'a poet's business is presumably to write good verses, and by no means to redeem the age and remould society'.[61] From poems by Baudelaire such as 'La Chevelure' and 'Correspondances', as well as from Rossetti's sonnet on the *Fête Champêtre*, Swinburne derived his interest in synaesthesia – 'The sound of his metres suggests colour and perfume' – and from 'Hymne à la beauté', the idea that beauty

can be found in the evil and sinister.[62] Swinburne probably owned the 1861, expur-
gated, edition of *Les Fleurs du mal*. In 1864 William Rossetti gave him the first,
1857, edition which had been condemned as obscene.[63]

While Swinburne was the most vehement in his avowal of art for art's sake,
William Michael Rossetti, to whom Swinburne dedicated his essay on Blake, was
also eloqent on the theme as a critic. He was one of the first to praise Japanese art,
which he did in *Fraser's Magazine* in August 1862, while in the following year,
praising Japanese woodcuts, he remarked: 'there is nothing throughout the designs
in the least suggesting moral beauty'.[64] In 1861 he praised Veronese, remarking
that: 'Good style will make a good picture out of the most ignoble subject.'[65] In the
following year he wrote: 'so despotic is the art in the work of art – that the great-
est ideas for the artist's purpose are not those which would be greatest for the the-
orist, the religionist, or the historian, but ideas of beauty, character, and expression;
beauty of form, colour, and action, the material beauty which lies open to percep-
tion'. He adds that 'Phidias, Giorgione, Titian, Veronese, Velasquez, saw and
invented within the domain of perception'.[66]

It was during the period under discussion that Dante Gabriel Rossetti became
interested not only in Japanese prints but in decorative, strange and exotic arts of
all kinds. He was a founder member of Morris, Marshall, Faulkner and Co. in 1861.
He designed his own wallpaper for his married quarters at Chatham Place, a sofa
with decorations inviting amorous dalliance, picture frames and book bindings
such as the white and gold Greek one for Swinburne's *Atalanta in Calydon*, pub-
lished in 1865. He avidly collected blue and white china and a variety of old and
exotic furniture, draperies, jewels and musical instruments when he moved into
16 Cheyne Walk. Luke Ionides records that Rossetti 'was most persuasive when
he advocated one's living among beautiful things of one's own choice'.[67] Whistler,
late in life, looked back and 'remembered with strong affection the barbaric court
in which [Rossetti] reigned'.[68]

The art for art's sake doctrine discussed in this chapter was shocking, yet, though
Rossetti upset Holman Hunt and Ruskin, he avoided public scandal. He rarely
showed in public or even in select societies: *Bocca Baciata* at the Hogarth Club in
1860, *Fazio's Mistress* at the Liverpool Academy in 1864 (lent by its purchaser, W.
Blackmore), *The Beloved* at the Arundel Club for one day, 21 February 1866.[69] The
patrons who bought these works and so enabled Rossetti to bypass more official
exhibitions were pleased with their purchases. Boyce, who bought *Bocca Baciata*,
was a close friend. George Rae, the Birkenhead banker who bought *The Beloved*,
wrote appreciatively to Rossetti in March 1866: 'The same sort of electric shock of
beauty with which the picture strikes one at first sight is revived fresh and fresh
every time one looks at it. It is one of the most beautiful and *loveable* that I have ever
seen.'[70] W. M. Rossetti believed that the tastes of such north country business men
as Rae encouraged his brother to concentrate on paintings of beautiful women when
he had ambitions to paint many-figured compositions, including men, with dra-
matic or genre subjects.[71] Certainly, in 1864 he was thinking of a bigger studio for

large works.[72] He started a classical genre subject in this year, *Socrates Taught to Dance by Aspasia*, and by November 1865 had designed *Aspecta Medusa* (Surtees 183), a Swinburnian subject, but these were not realised as paintings.[73]

It was Swinburne who bore the brunt of public scandal, as the reviews collected by C. K. Hyder show. On 4 August 1866, three sharply hostile notices of *Poems and Ballads* appeared. John Morley, in the *Saturday Review*, read in the poems 'the feverish carnality of a schoolboy over the dirtiest passages in Lemprière'.[74] The unsigned criticism in the *London Review* noted: 'The strangest and most melancholy fact in these strange and melancholy poems is, not the *absence* of faith, but the presence of a faith which mocks at itself, and takes pleasure in its own degradation.'[75] The reviewer in the *Athenaeum* wrote: 'It is quite obvious that Mr. Swinburne has never thought at all on religious questions, but imagines that rank blasphemy will be esteemed very clever.'[76] The last has been identified as Robert Buchanan, who in October 1871 savaged Rossetti's *Poems* in the *Contemporary Review*.

Following these hostile notices Swinburne's publisher, Moxon, withdrew the book. D. G. and W. M. Rossetti remonstrated with Moxon and W. M. Rossetti wrote a small book in Swinburne's defence.[77] *Poems and Ballads* was reissued by Hotten, notorious for his obscene publications, and was many times reprinted. Thomas Hardy recalled its attraction to the avant-garde:

> It was as though a garland of red roses
> Had fallen about the hood of some smug nun.[78]

The closest any artist in Rossetti's circle approached such an affair was Burne-Jones, to whom *Poems and Ballads* was dedicated, who resigned from the Old Water-Colour Society in 1870 following the outcry over the nudity in his *Phyllis and Demophoön* (Birmingham Museum and Art Gallery). The devotion of a few carefully nurtured patrons meant that Rossetti did not need to show his pictures in public. His reputation grew in shadow and for this reason became all the more powerful as the idea of an avant-garde developed. By 1866 his art was changing. He started to admire the Florentines, Botticelli and Michelangelo, rather than the Venetians. His female models also changed, Alexa Wilding and Jane Morris replacing Fanny Cornforth. He distanced himself from Swinburne. The most sensual period of his art was over.

Notes

This paper derives from chapters of my PhD thesis on *D. G. Rossetti's Stylistic Development as a Painter*, Courtauld Institute, London University, 1968. I am grateful to Alan Bowness and John Golding for their comments on it then. For works by Rossetti, cited here by Surtees number, see V. Surtees, *The Paintings and Drawings of Dante Gabriel Rossetti (1828–1882): A Catalogue Raisonné* (Oxford, Clarendon, 1971).

 1 C. Y. Lang (ed.), *The Swinburne Letters* (New Haven, Yale University Press, 1959–62), V, p. 207. See also ibid., I, p. 195.

 2 G. Lafourcade, *La Jeunesse de Swinburne* (Publications de la Faculté des Lettres de l'Université de Strasbourg, 1928), II, p. 337.

 3 T. Gautier, *Mademoiselle de Maupin*, (Paris, Garnier-Flammarion, 1966), pp. 25, 27, my translation.

 4 Ibid., pp. 45–6.

 5 Ibid., pp. 149–51, 201, 210

 6 A. C. Swinburne, *Poems and Ballads*, Second Series (London, Chatto & Windus, 1878), p. 97.

 7 A. C. Swinburne, *Essays and Studies* (London, Chatto & Windus, 1875), p. 360.

 8 Ibid., p. 375.

 9 Lang, *Swinburne Letters*, I, p. 195; V, p. 207.

10 Ibid., V, p. 59; E. Gosse, *The Life of Algernon Charles Swinburne* (London, Macmillan, 1917), p. 68.

11 O. Doughty and J. Wahl (eds), *The Letters of D. G. Rossetti* (Oxford, Clarendon, 1965–67), II, no. 463, p. 464; no. 491, p. 482.

12 Lang, *Swinburne Letters*, I, pp. 17, 18.

13 Ibid., I, p. 46.

14 O. Doughty, *A Victorian Romantic, D. G. Rossetti* (London, Oxford University Press, 1960), p. 233. I have been unable to find Doughty's source but a similar anecdote can be found in L. Ionides, *Memories* (Paris, Herbert Clarke, 1925), p. 52.

15 Lafourcade, *Jeunesse de Swinburne*, II, p. 226.

16 Surtees 48, 124.

17 V. Prinsep, 'A chapter from a painter's reminiscences, part II: Dante Gabriel Rossetti', *Magazine of Art*, n.s. 2 (1904) 282. Prinsep also recalled that he had read *Sidonia the Sorceress* with Rossetti at Oxford, ibid., p. 169.

18 Doughty and Wahl, *Letters*, I, no. 45, p. 59; Lang, *Swinburne Letters*, I, p. 45.

19 See Surtees, *Paintings and Drawings*, I, p. 56.

20 There are two versions of this picture and there is uncertainty as to which is the original. One is in a private collection in California (Surtees 114), the other in the Museum of Fine Arts, Boston. I have only seen the Boston version, which I reproduce here. The best reproduction of the other version, as far as I know, is in R. Mander, 'Rossetti's models', *Apollo*, 78:17 (July 1963) 20, plate IV. The Boston version is oil on panel, 32.2 x 27.1cm, monogram bottom left. Labels, originally on the back and now in the museum's files, state that the picture was exhibit no. 309, loaned by G. P. Boyce, in the posthumous exhibition of Rossetti's works at the Royal Academy in winter 1883, 'Works by the Old Masters and by Deceased Masters of the British School Including a Special Selection from the Works of John Linnell and Dante Gabriel Rossetti'. One of these labels was evidently printed for the Royal Academy exhibition, another is evidently from the catalogue of the exhibition and is inscribed in pencil: 'This is the original picture painted by the artist for G. Boyce.' There is also an inscription, on the back of the panel, of part of the line from Boccaccio's *Decameron*: 'Bocca baciata non perde ventura, anzi rinnova [*sic*] come fa la [luna] Boccaccio.' The provenance of the Boston picture is G. P. Boyce, C. Fairfax Murray, Mrs Edward D. Brandegee of Boston by 1907, James Lawrence, who gave it to the museum 18 June 1980. The version in a

private collection in California (Surtees 114), oil on panel, 33.7 x 30.5cm, monogram bottom left, was lent by Lord Nathan to an exhibition of 'Victorian Painting 1837–87' at T. Agnew and Sons, London, November–December 1961, no. 55, with a provenance from Boyce, Fairfax Murray, Hearst and the statement that it was shown at the Royal Academy in 1883, no. 309. The brushwork of the Boston version is of good quality, though the eyes, nose and mouth are rather weak and the flowers dull. The paint surface is badly cracked. The frame is the 'thumb-nail' design of Rossetti and Madox Brown of *c*. 1862. The grained flat has mitred joints rather than the vertical butted joints normally found on their works of this period. Viewed in reproduction, Surtees 114 appears to be slightly less highly finished than the Boston picture, the features less weak, the brushwork stronger and in a better state of preservation.

21 F. Madox Brown, *The Irish Girl*, private collection, see M. Bennett, *Ford Madox Brown*, exh. cat. (Liverpool, Walker Art Gallery, 1964), no. 38; J. Boyce Wells, *La Veneziana*, destroyed, reproduced in P. G. Nunn, *Victorian Women Artists* (London, The Women's Press, 1987), fig. 7; E. Burne-Jones, *Hope*, private collection, reproduced in J. G. Christian, *Burne-Jones*, exh. cat. (London, Arts Council of Great Britain, 1975), no. 35, p. 28; F. Sandys, *Vivien*, Manchester City Art Gallery, reproduced in B. O'Looney, *Frederick Sandys*, exh. cat. (Brighton, Museum and Art Gallery, 1974), plate 34.

22 See D. Cherry, 'The Hogarth Club: 1858-1861', *Burlington Magazine*, 122:925 (April 1980) 237–44.

23 See S. Jones et al., *Frederic Leighton 1830-1896*, exh. cat. (London, Royal Academy of Arts, 1996), nos 13, 14 and entry for no. 15.

24 Bodleian Library, William Holman Hunt's correspondence with Thomas and Martha Combe, MS Eng. Lett. c. 296, folio 71, 12 February 1860. I am grateful to Dr. J. Bronkhurst for this information.

25 Ibid., folios 71, 71v, 72. Quoted in Surtees, *Paintings and Drawings*, I, p. 69.

26 G. Boccaccio, *Il Decameron*, intro. U. Bosco (Basiano, Bietti, 1972), p. 116.

27 V. Surtees (ed.), *The Diaries of George Price Boyce* (Norwich, Real World, 1980), p. 27. See also V. Surtees, 'A conversation piece at Blackfriars', *Apollo*, 97:132 (February 1973) 146–7.

28 Surtees, *Paintings and Drawings*, I, p. 69; Surtees, *Diaries of George Price Boyce*, p. 27.

29 Doughty and Wahl, *Letters*, I, no. 319, p. 358.

30 Lang, *Swinburne Letters*, I, p. 40; for Pater's comment see the essay by Elizabeth Prettejohn in this volume, Chapter 2, p. 40.

31 Ruskin made a copy of *The Adoration of the Magi*, though this was not reproduced in the first edition of *Modern Painters II* in 1846. See *The Works of John Ruskin*, Library Edition, ed. E. T. Cook and A. Wedderburn (London, George Allen, 1903–12), IV, facing p. 248. The copy was first published in 1900 but would probably have been shown to Rossetti by Ruskin.

32 Doughty and Wahl, *Letters*, I, no. 329, p. 367.

33 Ibid., I, no. 335, p. 371.

34 Letter from D. G. Rossetti to J. Smetham, 1 August 1866, National Art Library, Victoria and Albert Museum.

35 Album from D. G. Rossetti's collection with eighty-one photographs of Old Masters, inscribed by Frederic Shields, University of East Anglia Library, Special Collection, YA1882.

36 G. Meredith, *Letters, Edited by His Son* (London, Constable, 1912), I, p. 49; W. M. Rossetti, *Fine Art Chiefly Contemporary: Notices Re-printed with Revisions* (London, Macmillan, 1867), p. 5.

37 Lang, *Swinburne Letters*, I, p. 99.

38 E. Gosse and T. J. Wise (eds), *The Complete Works of Swinburne*, Bonchurch Edition (London, Heinemann, 1926), XV, pp. 182–3.

39 Lang, *Swinburne Letters*, I, p. 103 (letter of ?1864).

40 W. M. Rossetti, *D. G. Rossetti: His Family Letters, with a Memoir* (London, Ellis & Elvey, 1895), I, p. 237.

41 W. Holman Hunt, *Pre-Raphaelitism and the Pre-Raphaelite Brotherhood* (London, Macmillan, 1905), I, p. 142.

42 These examples are from Countess of Blessington (ed.), *Heath's Book of Beauty for 1836* (London, n.p., 1835). I am grateful to Colin Cruise for suggesting a closer look at this series.

43 F. G. Stephens, 'D. G. Rossetti', *The Portfolio*, 5 (May 1894) 68.

44 Surtees, *Paintings and Drawings*, I, p. 116; Doughty and Wahl, *Letters*, III, no. 1252, p.1088; no. 1267, p. 1102. For a reproduction of it in its original state see H. C. Marillier, *D. G. Rossetti: An Illustrated Memorial of His Art and Life* (London, G. Bell, 1899), facing p. 133.

45 W. M. Rossetti, *Rossetti Papers 1862-70* (London, Sands, 1903), p. 296; Surtees, *Diaries of George Price Boyce*, p. 54.

46 H. Allingham and D. Radford (eds), *W. Allingham: A Diary* (London, Macmillan, 1907), p. 100.

47 Doughty and Wahl, *Letters*, II, no. 549, p. 519.

48 C. K. Hyder (ed.), *Swinburne: The Critical Heritage* (London, Routledge & Kegan Paul, 1970), p. xix.

49 *Works of John Ruskin*, XXXVI, pp. 490–1.

50 J. Evans and J. H. Whitehouse (eds), *The Diaries of John Ruskin, II: 1848–73* (Oxford, Clarendon, 1958), p. 437.

51 E. T. Cook, *The Life of John Ruskin* (London, G. Allen, 1911), I, pp. 521–2.

52 *Works of John Ruskin*, VII, p. xl.

53 Ibid., VII, p. 6.

54 Ibid., VII, pp. 279, 296–7.

55 Doughty and Wahl, *Letters*, II, no. 591, p. 606.

56 *Rubáiyát of Omar Khayyám, the Astronomer-poet of Persia*, translated into English verse [by Edward Fitzgerald] (London, B. Quaritch, 1859). See R. Grylls, *Portrait of Rossetti* (London, Macdonald, 1964), Appendix D, pp. 226–7.

57 A. Gilchrist, *The Life of William Blake, 'Pictor Ignotus'* (London, Macmillan, 1863), II, p. 77.

58 See M. Browne, *The Romantic Art of Theodor Von Holst, 1810–1844* (London, Lund Humphries, 1994), nos. 74–5, pp. 102–3.

59 The essay was finished by December 1865 though published only in 1868; see Lafourcade, *Jeunesse de Swinburne*, II, pp. 321, 324; Gosse and Wise, *Complete Works of Swinburne*, XVI, pp. 137–8.

60 Lang, *Swinburne Letters*, I, p. 53.

61 Gosse and Wise, *Complete Works of Swinburne*, XIII, p. 417.

62 Ibid., p. 419.
63 Gosse, *Life of Swinburne*, p. 90.
64 Rossetti, *Fine Art*, pp. 128, 387.
65 Ibid., p. 5.
66 Ibid., pp. 18, 19.
67 Ionides, *Memories*, p. 51.
68 D. Sutton, *Nocturne: The Art of James McNeill Whistler* (London, Country Life, 1963), p. 38, fn. 2.
69 Surtees 164, 182.
70 D. S. Macleod, 'Art collecting and Victorian middle-class taste', *Art History*, 10:3 (September 1987) 339.
71 Rossetti, *D. G. Rossetti: His Family Letters*, I, p. 206.
72 Doughty and Wahl, *Letters*, II, no. 537, p. 511.
73 Ibid., II, no. 632, p. 568; no. 637, p. 570; nos 723–4, p. 624; no. 764, p. 647.
74 Hyder, *Swinburne: The Critical Heritage*, p. 23.
75 Ibid., p. 36.
76 Ibid., p. 33.
77 Ibid., pp. 57ff; Gosse, *Life of Swinburne*, p. 153.
78 Hyder, *Swinburne: The Critical Heritage*, p. xxiv.

Walter Pater and aesthetic painting

Elizabeth Prettejohn

Immature poets imitate; mature poets steal.... (T. S. Eliot)[1]

WALTER PATER'S ESSAYS have often been called works of art, but it is unclear what kind of claim this is.[2] Does it mean anything more than that they are unusually elegant examples of critical prose? In that case the phrase merely marks the essays' quality rather than distinguishing them in kind from expository writing. Here I shall argue that Pater's essays are 'works of art' in a much more precise sense, a sense distinctive to British Aestheticism.[3] They are not only explorations of the theory of Aestheticism but also examples of its practice, comparable in a rigorous way to the poems of Rossetti or Morris and the paintings of Whistler or Burne-Jones.

Modern scholarship has been wary of making such comparisons across media,[4] but they are perfectly admissible according to the critical criteria associated with Aestheticism itself. Walter Hamilton, the author in 1882 of the first popular history of the Aesthetic Movement, thought 'the correlation of the arts' a principal aim, and placed particular emphasis on correspondences between pictorial and verbal modes; for him Dante Gabriel Rossetti, as both poet and painter, was a 'typical representative of the movement, in which the combination of the two arts is constantly aimed at, the one being held to be the complement of the other'.[5] Pater's basic critical criterion, the isolation of the distinctive 'virtue' of the work of art, is independent of medium, and his lists of the disparate objects worth the aesthetic critic's attention repeatedly emphasise this point. In the Preface to *The Renaissance*, he writes: 'To [the aesthetic critic], the picture, the landscape, the engaging personality in life or in a book, *La Gioconda*, the hills of Carrara, Pico of Mirandola, are valuable for their virtues, as we say, in speaking of a herb, a wine, a gem; for the property each has of affecting one with a special, a unique, impression of pleasure.'[6] Again, in the Conclusion, he enumerates the varieties of aesthetic experience: 'any stirring of the senses, strange dyes, strange colours, and curious odours, or the work of the artist's hands, or the face of one's friend'.[7]

Books on the Aesthetic Movement accordingly illustrate a bewildering variety of artefacts, beyond the traditional realm of the fine arts: Morris wallpapers,

Godwin furniture, Greenaway book illustrations, Du Maurier cartoons, photographs of Ellen Terry in theatrical costume or Oscar Wilde in knee-breeches.[8] However, the artefacts' participation in the Aesthetic Movement appears a rather vague expression of the *Zeitgeist*, in conjunction with incidental formal features such as 'greenery-yallery' colouring[9] or 'Japanese' asymmetry. The difficulty of establishing more general criteria is partly theoretical. As Pater insisted, the definition of art is not a 'universal formula' but rather a matter of 'the most concrete terms possible'.[10] To propose a criterion, or even a set of criteria, that would cover Aesthetic works in all media would be improper, on Pater's terms; indeed any such criterion would miss precisely the unique 'virtue' that makes each one a work of art. On this view we cannot use a general definition of the work of art to make good the claim that Pater's essays belong to that category.

Instead I want to trace a network of concrete points of contact among works of Aesthetic art and beyond them to shared interests in the art of the past. The density and complexity of Pater's verbal references to other works of literature, past and present, has been a major concern in recent scholarship; indeed the study of Pater's work has flourished amidst the 'postmodernist' enthusiasm for intertextuality.[11] I want to suggest that the notion of intertextuality can be expanded to include cross-references between the verbal and the visual. The essays first published between 1867 and 1877, and collected in Pater's volume *The Renaissance*,[12] are marked by innumerable intertextual links with paintings of the same period. However, my aim is not to identify 'influences', either of the essays on the paintings or vice versa. It might be possible, though it would be exceedingly complicated, to trace the history of references to Botticelli's *Birth of Venus*, the story of Tannhäuser, the *Venus of Melos*, or Michelangelo's *David* – to track them to their 'original' appearances in Victorian painting or literature. But it is precisely the recurrence of the references, as opposed to their 'originality', that characterises the aestheticist project.

On one level we can read the shared motifs as badges of participation in Aestheticism; it is not, then, the 'original' appearance of a motif, but its repetition in different works that creates the sense of group identity. Beyond that, though, I shall argue that the practice of intertextual reference constitutes a defining feature of the Aesthetic work of art – a feature that does not arch over all examples, but can only be traced in innumerable concrete links between particular cases. The pattern might be compared to that of the Internet, where (in theory) any two among a limitless number of computer workstations can communicate without supervision from a presiding computer, or to Wittgenstein's notion of 'family resemblances', where any individual item in a group resembles another in some way, but there is no single property common to all of them.[13]

Pater and the painters

David Carrier has recently claimed that Pater had 'little interest in or knowledge of contemporary visual art'.[14] It is true enough that Pater never wrote at length

about a work of contemporary art or about a visual artist. But the essays of *The Renaissance* are preoccupied with precisely the same art-historical and theoretical concerns that are evident in the painting of the artists associated with Aestheticism:[15] Greek sculpture, Venetian painting, Botticelli, Leonardo, Michelangelo, the distinction between medieval and Renaissance, the analogy between art and music, the possibility of an art that refuses subservience to 'reality' in the form of either visual realism or social and political engagement.

Pater's direct references to contemporary painting are few and brief, but their rarity makes their consistency more significant. All of them relate to artists or works associated with Pre-Raphaelitism or Aestheticism, none to the other areas of Victorian art that dominated the exhibitions and most press criticism. The first instance is a passing reference in the earliest version of the essay on 'Winckelmann', published in the *Westminster Review* in 1867. Pater cites a well-known Pre-Raphaelite painting, William Holman Hunt's *Claudio and Isabella* (1850–53, Tate Gallery, London), as an example of how the modern arts of poetry and painting can develop 'exquisite situations', in contrast to the generality and abstraction of ancient sculpture.[16] It is interesting that Pater deleted the reference when the essay was reprinted in *The Renaissance*. When Pater was writing the 'Winckelmann' essay, he may still have considered Pre-Raphaelitism the pre-eminent modern movement in British art. But after its publication he became more interested in newer artistic developments, linked at first to the term 'art for art's sake' and then to 'Aestheticism'.[17] Pater's later references to contemporary art all involve artists and works central to Aestheticism.

Pater was one of the first English writers to use the term 'art for art's sake', in the final sentence of his *Westminster Review* article of October 1868, 'Poems by William Morris'. He subsequently extracted the passage to become the Conclusion to *The Renaissance*,[18] but its first appearance in the Morris article indicates that the term was strongly associated with the artistic experiments in the circle of D. G. Rossetti. It was another intimate of Rossetti, the poet Swinburne, who had introduced the term 'art for art's sake' the previous year, in his extended essay on William Blake.[19] Pater was at least slightly acquainted with Swinburne through Oxford connections, but it was perhaps his closer friendship with another significant member of the Rossetti circle, the Jewish homosexual painter Simeon Solomon, that encouraged his interest in painting.[20]

Solomon was prominent in the earliest press accounts of the movement associated with 'art for art's sake',[21] but disappeared abruptly from art criticism after his arrest and conviction for homosexual activities in February 1873. Most of his friends, including Swinburne, repudiated him. It was, then, an act of courage for Pater to refer to Solomon in his essay of 1876, 'A study of Dionysus', even though he omits the artist's name when he mentions 'a *Bacchus* by a young Hebrew painter, in the exhibition of the Royal Academy of 1868'. It is unclear whether Pater intended to refer to the oil painting of *Bacchus*, exhibited at the Royal Academy in 1867 (see plate 51), or to the watercolour *Bacchus*, exhibited in 1868 at the Dudley

Gallery (see plate 52); anyway Pater probably knew both works, and his remarks might apply to either. He distinguishes Solomon's characterisation of Bacchus from more familiar representations of Dionysiac 'joy'; Solomon shows 'the god of the bitterness of wine, "of things too sweet"'. Pater considers Solomon's interpretation distinctively 'modern', but he also suggests that it realises a latent element in the Greek idea of Dionysus, 'a certain darker side of the double god of nature, obscured behind the brighter episodes of Thebes and Naxos, but never quite forgotten'.[22] This hints at a radically dehistoricised family resemblance, where the modern representation of Dionysus can serve to interpret the ancient one.

Pater's friendship with Solomon confirmed, if it did not initiate, his interest in the painting associated with the terms 'art for art's sake' and 'Aestheticism'. Pater seems to have appreciated the homoeroticism of Solomon's paintings and drawings of beautiful men without the reservations that J. A. Symonds felt (see Chapter 9, pp. 199–210). He bought a work by Solomon, *Chanting the Gospels* (untraced), from the winter exhibition of the Dudley Gallery in 1867, and the next year Solomon inscribed to Pater a drawing of *The Bride, the Bridegroom and Friend of the Bridegroom* (Hugh Lane Municipal Art Gallery, Dublin; a version of plate 50).[23] However, Pater's interest in Aesthetic painting was not limited to Solomon's work, or even to work with evident homoerotic content. His most sustained exploration of the debates surrounding Aestheticism in painting occurs in his essay 'The School of Giorgione', first published in the *Fortnightly Review* in October 1877 and added to *The Renaissance* from the third edition of 1888. Indeed, we might interpret the ostensible historical subject of the essay (the paintings of Giorgione and his contemporaries) as a coded intervention into debates about contemporary art; the essay was published later in the year in which the first Grosvenor Gallery exhibition brought the issues of Aestheticism into public debate.[24] The carefully argued theoretical elaboration of music as a paradigm for the aesthetic, in the first section of the essay, might even be read as a defence of Whistler's practice of giving musical titles to his paintings, which had attracted much derision in reviews of the Grosvenor exhibition and was to figure the next year in the artist's celebrated lawsuit against Ruskin.[25]

The material on Venetian art is no mere pretext for the theoretical discussion. As Alastair Grieve shows in Chapter 1, the sensuality traditionally attributed to Venetian art, as opposed to the presumed rationality of the Central Italian Renaissance, was a key point of reference in Aesthetic painting; allusions to the Venetian Renaissance occur in the work of virtually all of the artists associated with Aestheticism, from Leighton and Watts to Rossetti and Burne-Jones. Pater acknowledges this with what was, for him, unusual explicitness: 'A certain artistic ideal is there defined for us [in Venetian painting] – the conception of a peculiar aim and procedure in art, which we may understand as the *Giorgionesque*, wherever we find it, whether in Venetian work generally, or in work of our own time.'[26] Moreover, Pater makes a significant reference to Rossetti, although he does not

name him.[27] Regretting the recent reattribution of the Louvre *Fête Champêtre* from Giorgione to Sebastiano del Piombo, Pater identifies the Venetian painting as the 'subject of a delightful sonnet by a poet whose own painted work often comes to mind as one ponders over these precious things'.[28] Pater was quite correct to note that Rossetti was working in self-consciously 'Venetian' modes (see for example plates 3, 5, 6). Indeed the comment reveals Pater's sophisticated knowledge of the contemporary art world, since Rossetti's paintings had never been exhibited in public and were known only to insiders in his circle.[29]

Earlier in the essay Pater had referred to another recent work of art, a landscape etching by the French artist Alphonse Legros. Legros had moved to England in the 1860s at the urging of Whistler, his close friend at that time although the two artists later quarrelled; through Whistler, Legros also became acquainted with the Rossetti circle.[30] Pater's notorious habits of obliquity make it not inconceivable that the reference to Legros was a coded signal that the theoretical discussion was applicable to Whistler. However, Legros's own work was also relevant to 'The School of Giorgione'. Around 1870 he had made several paintings that were overt meditations on Venetian Renaissance art, including *Prêtres au lutrin* of 1870 (Tate Gallery, London), unmistakably modelled on the work Pater singled out, in the essay, to typify the school of Giorgione, the *Concert* of the Pitti Palace. The landscape etching by Legros, to which Pater makes direct reference, seems at first thought farther from the concerns of the essay. However, Pater selects it as his principal example of a work that makes its effect not through the interest of its subject alone, but through expressive treatment of the subject. Indeed, it is this work – one of his exceedingly rare references to contemporary art – that Pater chooses to illustrate his crucial dictum, '*All art constantly aspires towards the condition of music*':

> That the mere matter of a poem, for instance, its subject, namely, its given incidents or situation – that the mere matter of a picture, the actual circumstances of an event, the actual topography of a landscape – should be nothing without the form, the spirit, of the handling, that this form, this mode of handling, should become an end in itself, should penetrate every part of the matter: this is what all art constantly strives after, and achieves in different degrees.[31]

Legros's name was not as obscure, in 1877, as it has become in the twentieth century. Nonetheless, Pater's reference to his work, along with his references to Solomon and Rossetti, indicate that he was familiar with the artistic circles associated with Aestheticism – more familiar, indeed, than most of the journalists who reviewed the London exhibitions. Three such references might be an insignificant number in the work of another writer, but in the writing of Pater, who seldom made reference to contemporary events of any kind, three is a large number, a definite indication of sympathy for the art associated with Aestheticism. What, then, of Carrier's claim that Pater showed no interest in or knowledge of contemporary art? By 'contemporary art' Carrier seems to mean contemporary

French art, and more particularly the kinds of French art that depicted modern life. Carrier argues persuasively that Pater wrote 'a critique of the whole ideal of a modernist art depicting present-day life', in specific opposition to Baudelaire.[32] But it does not follow that Pater was inimical to the art of his own lifetime. In his refusal to write about the art that depicted modern life, Pater aligned himself with the modern British artists associated with Aestheticism, rather than the 'modernist' artists of France.

Family resemblances

Pater's direct references to works of art associated with Aestheticism are less significant in themselves than as clues to a vast intertextual network that links his essays with countless contemporary paintings through shared references to still other works of art and literature, both past and present. These references were also shared with other kinds of writing associated with Aestheticism, such as Swinburne's work both in poetry and in criticism, the poetry of Rossetti and Morris, and even more mundane critical writing such as Sidney Colvin's exhibition reviews, with their marked preference for Aestheticism.

One example that criss-crosses different media with particular complexity is the story of Tannhäuser – the legendary knight who chose to sacrifice his hope of religious salvation in favour of a life of perpetual sensual delight in the underground enclave of the goddess Venus. Swinburne perhaps began his poem on the subject, 'Laus Veneris', in 1862, at about the same time that Burne-Jones made a watercolour of the same subject, now untraced but evidently an early version of the composition later executed at large scale, in oils, and finally exhibited under Swinburne's title *Laus Veneris* at the Grosvenor Gallery in 1878 (plate 10).[33] Swinburne's pioneering article on Baudelaire's *Les Fleurs du mal* appeared in *The Spectator* in September 1862; it is therefore possible that his interest in the French poet had already led him to read Baudelaire's essay on Wagner's opera, 'Richard Wagner et Tannhäuser à Paris', first published in a French periodical in April 1861. It is also possible that Swinburne and Burne-Jones became interested in the Tannhäuser subject independently; certainly they were both well-versed in the literature of medieval legend. However, Baudelaire's essay certainly entered the intertextual network by 1863, when the French poet sent Swinburne a copy.[34] Its evocation of the powerful synaesthetic experience of listening to Wagner's music reinforced an interest in correspondences between painting and music that was already an important feature of the aesthetic experiments in the artistic circles around Rossetti and Leighton.[35] Swinburne also referred to the story of Tannhäuser in a footnote to his exploration of aesthetic theory, in the same passage where he introduced the term 'art for art's sake', in his essay on William Blake.[36] In that context Tannhäuser's preference for the sensuous over the moral life serves as a metaphor for the incompatibility of art with morality. William Morris included the story, as 'The Hill of Venus', in his set of narrative poems,

The Earthly Paradise, although it was published in the second instalment of 1870, too late to be considered in Pater's review of Morris's poems, published shortly after the first instalment appeared in 1868. However, the emphasis in the Morris essay on a rebellious strain of sensuality in medieval poetry recurs in Pater's own reference to the Tannhäuser story, in 'Aucassin et Nicolette' of 1873. There the story becomes a symbol of the first 'rebellious and antinomian' stirrings of the Renaissance in the late Middle Ages:

> In their search after the pleasures of the senses and the imagination, in their care for beauty, in their worship of the body, people were impelled beyond the bounds of the primitive Christian ideal; and their love became a strange idolatry, a strange rival religion. It was the return of that ancient Venus, not dead, but only hidden for a time in the caves of the Venusberg, of those old pagan gods still going to and fro on the earth, under all sorts of disguises.[37]

Burne-Jones's *Laus Veneris* vividly represents the hot-house atmosphere within the Venusberg, using rich colours and even a textured effect, made with a stamp in the wet paint, to intensify the sensuousness of the vibrant red dress of the figure of Venus. The synaesthetic association with music, stressed in Baudelaire's

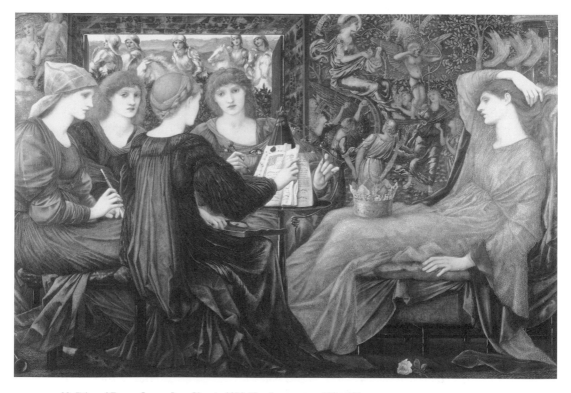

10 Edward Burne-Jones, *Laus Veneris*, 1873–78, oil on canvas, 122 x 183 cm

essay, recurs in the painting coupled with the eroticism of the scene of women play-
ing musical instruments. Within the Venusberg is a feminine world, intensely
coloured and crowded with detail; a glimpse through a window on the left shows
the knights in a wintry outside world. The spatial disposition of the picture, then,
draws on the meanings that had accrued to the Tannhäuser story through its com-
plicated history of intertextual referencing. The interior of the Venusberg is overtly
a realm of the 'pleasures of the senses and the imagination', in Pater's words –
indeed of 'strange idolatry'. By extension it represents the world of art, cut off
from the moral concerns of the knightly external world in the fashion Swinburne
had prescribed in *William Blake*. Burne-Jones's painting of 1878 perhaps enfolds
the whole history of intertextual reference that had begun early in the 1860s – if
not before, in Wagner's opera of 1845. However, the individual works within the
network are related in more disparate and complicated ways. When Pater uses the
Tannhäuser story in 1873, he alludes indirectly to Morris, or at least to his own
interpretation of Morris's poetry. The interpretations of Swinburne in poetry and
Burne-Jones in painting are probably collaborative. Baudelaire did not intend to
join this intertextual network, and may never have been aware of the role he played
in it, but his essay is nonetheless one of its key points of reference. Between any
two of the works in the network there is some kind of link, but the links are not of
the same kind. The only common feature is the reference made in all cases to the
story of Tannhäuser.

This is only one of many intertextual networks elaborated, with equivalent com-
plexity, among the various artists and writers associated with Aestheticism. The
referenced motif was not necessarily a subject, like the story of Tannhäuser; it
might be a visual image. For example, a key point of reference in Pater's essay of
1867 on 'Winckelmann' was a section of the Parthenon frieze: 'If a single product
only of Hellenic art were to be saved in the wreck of all beside, one might choose
perhaps from the "beautiful multitude" of the Panathenaic frieze, that line of
youths on horseback, with their level glances, their proud, patient lips, their chas-
tened reins, their whole bodies in exquisite service.'[38] It is this section of the frieze
that Leighton chose to reproduce in his self-portrait for the important collection
of artists' self-portraits at the Uffizi Gallery in Florence (1880) as an emblem of
his own reverence for the antique. This might be dismissed as a coincidence, but
it is only one of a number of shared references to particular prototypes in Greek
sculpture – a distinctive interest of artists associated with Aestheticism. Another
example is the reference to the *Venus of Melos*, the celebrated ancient sculpture in
the Louvre, whose torso Albert Moore imitated with great fidelity in his painting
of 1869, *A Venus* (plate 11). Two years earlier, in the 'Winckelmann' essay, Pater
had used the same sculpture as a paradigm of autonomous art: 'That is in no sense
a symbol, a suggestion, of anything beyond its own victorious fairness. The mind
begins and ends with the finite image, yet loses no part of the spiritual motive.'[39]
Moore may have had the passage in mind when he was designing the picture; even
if he did not, he uses the reference to the *Venus of Melos* to similar purpose. In

11 Albert Moore,
A Venus, 1869,
160 x 76.2 cm

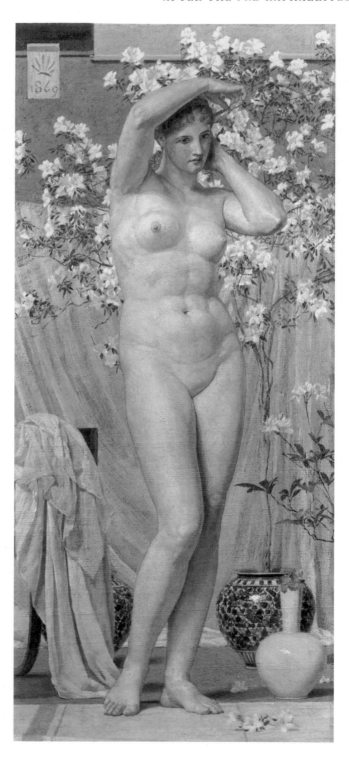

abrupt contrast to the vast majority of the figure paintings that crowded the walls of the Royal Academy and other exhibitions in 1869, Moore goes to considerable lengths to prevent the spectator's mind from wandering away from the 'finite image' on his canvas. There is no hint of the narrative context that Victorian audiences would have expected, in an ambitious picture featuring the human figure. If anything, the accessories discourage the viewer from imagining a narrative context – the pots and azalea tree are anachronistic if the figure is to be identified as the classical Venus. Moreover, the facial expression is utterly deadpan, again in flagrant contravention of the usual conventions for characterising human figures in Victorian narrative painting. We cannot attempt to read the figure's face for signs of her social status, her psychological state, or her moral character. Moore perhaps emphasises the utter anonymity of the figure in the title. This is not 'the' Venus of classical mythology, but simply *A Venus*, one work of art among many.

Intertextual networks could encompass both subject-matter and visual allusion at once. In the context of his essay on Dionysus, Pater's reference to Solomon's *Bacchus* sets up a range of intertextualities with the other works of art mentioned in the essay, all of which are linked in subject-matter as representations of Dionysus. However, the linkages also extend to visual cross-referencing. Solomon's watercolour (see plate 52) perhaps draws visually on Michelangelo's statue of *Bacchus* (Bargello, Florence) for the general configuration of its contrapposto as well as the gentle modulations of the flesh, more sensuous than the muscular vigour usually associated with the Michelangelesque male figure.[40] Although Pater does not draw a direct comparison between Michelangelo's statue and Solomon's painting, he includes the statue in 'A study of Dionysus' as well as in his essay of 1871 on Michelangelo: 'that unique presentment of Bacchus, which expresses, not the mirthfulness of the god of wine, but his sleepy seriousness, his enthusiasm, his capacity for profound dreaming'.[41] As in his description of Solomon's *Bacchus*, he emphasises difference from the orthodox treatment of the subject; in both cases he finds something subtler and more suggestive than the conventional image of the carousing god of wine.

In his essay of 1869, 'Notes on Leonardo da Vinci', Pater introduces yet another point of reference, the series of Leonardesque paintings representing Bacchus and Saint John the Baptist in similar poses. He calls attention to the *Saint John* in the Louvre:

> whose delicate brown flesh and woman's hair no one would go out into the wilderness to seek, and whose treacherous smile would have us understand something far beyond the outward gesture or circumstance.... [W]e are no longer surprised by Saint John's strange likeness to the *Bacchus* which hangs near it, and which set Théophile Gautier thinking of Heine's notion of decayed gods, who, to maintain themselves, after the fall of paganism, took employment in the new religion.[42]

The mysterious metamorphosis of the androgynous *Saint John* into the pagan *Bacchus* perhaps recalls another aspect of Solomon's work, his haunting paintings

of young male figures engaged in Jewish or Christian ritual, similar in androgynous facial type to his male figures from pagan mythology.

The subject of Bacchus entailed yet another network of references, this time involving classical sculptures of Antinous, the beautiful boy who was the favourite of the Emperor Hadrian and who was sometimes represented in the character of Bacchus (see Chapter 9, pp. 194, 207). In an article of 1871, Swinburne referred to two pictures of 'Antinous' by Solomon. The second of these appears to be the watercolour *Bacchus*, which Swinburne interprets as Antinous 'officiat[ing] before the god under the divine guise of Bacchus himself; the curled and ample hair, the pure splendour of faultless cheek and neck, the leopard-skin and thyrsus, are all of the god, and godlike; the mournful wonderful lips and eyes are coloured with mortal blood and lighted with human vision'.[43] Of the classical sculptures believed to represent Antinous, the bas-relief in the Villa Albani collection, with its nude chest, is closest to Solomon's watercolour, and was a particular enthusiasm of Winckelmann, the subject of Pater's essay of 1867.[44]

Solomon's paintings are linked to Michelangelo's *Bacchus*, the Leonardesque images of Bacchus, and classical statues of Antinous both on the level of subject-matter and on that of visual resemblance. Yet there is still another range of inter-textualities involving works that do not share subject-matter but where the visual resemblances are important. Moreover, in these cases the visual characteristics of the cross-reference are captured in verbal descriptions as well as in Solomon's visual images. One inspiration for Solomon's oil painting (see plate 51) was evidently a drawing of an anonymous boy by the Renaissance artist nicknamed 'il Sodoma' ('the Sodomite'). Swinburne had noticed the drawing in the Uffizi in 1864 and he described it enthusiastically in his article of 1868 on Old Master drawings: 'It is a beautiful and elaborate drawing, partly coloured; a boy with full wavy curls, crowned with leaves, wearing a red dress banded with gold and black and fringed with speckled fur; the large bright eyes and glad fresh lips animate the beauty of the face'.[45] This description can be linked to verbal descriptions of beautiful youths in Pater's writings. In the Leonardo essay, for instance, Pater describes the Louvre drawing that would later become the frontispiece illustration to *The Renaissance*: 'It is a face of doubtful sex, set in the shadow of its own hair, the cheek-line in high light against it, with something voluptuous and full in the eyelids and the lips.'[46] Both the Renaissance drawings of male figures, and the verbal descriptions of them by Pater and Swinburne, participate in the network of intertextualities that also includes Solomon's pictures.

It is easy enough to explain the dense network, shared among Pater, Solomon and Swinburne, as an unusually sophisticated example of what has been called the Victorian 'homosexual code'.[47] Antinous, Michelangelo, Sodoma, the Leonardesque figures and the subject of Bacchus all involved homoerotic connotations. Solomon's arrest indicates all too clearly why both verbal and visual explorations of homoeroticism might require the disguise of a 'code'. Yet the intertextual network surely exceeds its utilitarian function as a cloaking device. Its richness and

suggestiveness create realms of pleasure where the homoerotic and the aesthetic are not easily, or necessarily, distinguishable from each other.

Moreover, the homoerotic network was not segregated from non-homoerotic references. The 'Venetian' paintings by Rossetti, to which Pater alludes obliquely in 'The School of Giorgione', represented female figures, treated in a fashion that contemporary and subsequent observers have usually seen as heterosexually erotic (see Chapter 1, pp. 23–9). Nonetheless, they share significant visual characteristics with Solomon's equally repetitive images of androgynous male figures.[48] In the works of both artists, salient physical features such as abundant wavy hair, dreamy eyes or bow-shaped lips function as signs of the erotic. Hair, eyes and lips are the features singled out in Swinburne's descriptions of the Sodoma drawing and Solomon's 'Antinous', as well as Pater's description of the Leonardesque drawing in the Louvre. Moreover, Pater attributed to Botticelli the practice of employing the same female model for different characters in his painting – the biblical Judith (a subject also used by Solomon), allegorical figures of Justice and Truth, and Venus; this recalls Rossetti's notorious practice of depicting the same, readily identifiable model in various guises. By identifying Botticelli's model as 'Simonetta, the mistress of Giuliano de'Medici' Pater hints at the erotic connotations of the practice of repetition; Rossetti's repetitive images were understood to represent his lovers.[49]

These examples of criss-crossing reference could be extended indefinitely. The prevalence of shared reference, in the art and literature associated with Aestheticism, suggests a distinctive form of group identity in which it was not necessary for individual participants to meet socially or to endorse a manifesto. In practice most participants probably knew each other socially; indeed Pater's contacts in artistic circles may well have been more extensive than we are now able to document. But social contact was not a necessary condition; painters and writers might participate in Aestheticism by referencing its shared motifs in visual or verbal form. It should be stressed that these references were not shared with the vast majority of Victorian painters who showed at the London exhibitions, the painters of contemporary life, of English history or historical genre; they were shared neither with most contemporary historians, nor with literary or art critics. Pater has often been called a conservative, on the grounds that he attempted to save the Western tradition of art and literature from extinction as its religious and metaphysical bases were threatened.[50] But the range of works discussed in *The Renaissance* does not represent any orthodox 'Western tradition' as that might have been understood in the 1860s and '70s. Pater ignored canonised masters in favour of novel figures such as Botticelli, marginal figures such as Pico of Mirandola, and figures that contemporaries would have considered minor such as Luca della Robbia.[51] Indeed, the range of his interests seemed bizarre to many of the first reviewers of *The Renaissance*.[52] But they were congruent, down to the level of minute details, with the interests of the painters associated with art for art's sake and Aestheticism.

The Aesthetic work of art

We have seen how intricate the networks of criss-crossing references could become. But that brings us no closer to a distinctively 'Aesthetic' work of art. Indeed, the habit of referring to other works of art contradicts the most familiar definition of Aestheticism in painting, as a progressive drive away from intellectual content and towards 'pure' form. The multiple intertextual references in a work such as Solomon's *Bacchus* tend rather to elaborate its content than to suppress it. How, then, could the practice of intertextual reference constitute a distinctive feature of the Aesthetic work of art?

A preliminary answer might be that the references tend to confine the works' referentiality within the realm of art. They proclaim that the materials of which the works are composed – their subjects, their styles, or both – relate more significantly to other works of art than to the 'real' world, or in Victorian shorthand to 'nature'. This was unequivocally transgressive in the context of earlier Victorian art theories, which demanded a relationship as direct as possible between the work of art and 'nature'. By contrast, Aesthetic works of art systematically interpose an intermediate process of artificialisation between the work and 'nature'. This might be compared to Peter Bürger's more general theoretical description of aestheticism as a late stage in a bourgeois art practice where 'art becomes the content of art'.[53]

Pater repeatedly describes an artistic process that distances itself twice from nature. He praises Morris's poems for presenting 'a finer ideal, extracted from what in relation to any actual world is already an ideal', and figures by Leonardo which, 'starting with acknowledged types of beauty, have refined as far upon these, as these refine upon the world of common forms'.[54] These phrases recall press criticisms of Leighton, whose 'eclectic' use of motifs from past art attracted frequent comment; as one critic put it, his art 'comes to us rather as the recollection of beauty seen first in art, and only remotely in nature'.[55] In press criticism such 'eclecticism' was ordinarily censured. Pater reverses the pejorative emphasis to theorise the notion of a work of art that is specially artistic precisely because it is doubly distanced from nature. Moreover, he also takes care to present his own writing as doubly distanced – in that sense his essays can be called Aesthetic works of art in much the same sense as Morris's poems or Leighton's paintings.

Pater rarely presents 'raw' historical or biographical data; instead he filters the data through an intermediate text. He writes not so much about Greek sculpture as about Winckelmann's texts on Greek sculpture; and he introduces Winckelmann himself through Goethe's account of his character. Even his descriptions of works of art are rarely unmediated, as Donald Hill's critical edition of *The Renaissance* demonstrates in detail. In the celebrated passage on the *Mona Lisa* Pater recasts several previous descriptions of the picture, while he also weaves in verbal allusions to passages in Swinburne's criticism and poems of both Swinburne and Rossetti that create powerful images of female beauty.[56] The result is, of course, a thoroughly new passage of prose, even though it is composed

largely of materials drawn from other texts. The process is reminiscent of T. S. Eliot's remarks: 'immature poets imitate; mature poets steal; bad poets deface what they take, and good poets make it into something better, or at least something different'.[57] Leighton, too, could amalgamate an overt quotation from an Old Master painting or an ancient sculpture into a picture apparently seamless in its finish.

At times Pater brings the 'double distancing' of his own writing to the fore, as in his description of 'moving water' in Leonardo's paintings, surely a deliberate parody of the famous description of the 'natural' waterfall in Ruskin's *Modern Painters*:

> You may follow it springing from its distant source among the rocks on the heath of the *Madonna of the Balances*, passing, as a little fall, into the treacherous calm of the *Madonna of the Lake*, as a goodly river next, below the cliffs of the *Madonna of the Rocks*, washing the white walls of its distant villages, stealing out in a network of divided streams in *La Gioconda* to the seashore of the *Saint Anne*....[58]

The passage is doubly or perhaps triply artificial: first in describing the water represented in Leonardo's art rather than water occurring in nature; second in constructing its own fictive stream wandering through different paintings; finally in imitating the famous passage from Ruskin. Pater artificialises the narrative that Ruskin constructs equally artfully, but with ostentatiously 'scientific' fidelity to the characteristics of 'real' water:

> Where water takes its first leap from the top, it is cool, and collected, and uninteresting, and mathematical; but it is when it finds that it has got into a scrape, and has farther to go than it thought, that its character comes out: it is then that it begins to writhe, and twist, and sweep out, zone after zone, in wilder stretching as it falls; and to send down the rocket-like, lance-pointed, whizzing shafts at its sides, sounding for the bottom.[59]

The passage about moving water is one of many instances where Pater transforms the words of a previous author so that their meaning is altered or even reversed; Matthew Arnold and Ruskin were particularly frequent targets for such formal metamorphoses.[60] In his essay on Botticelli, Pater twists the significance of one of the most celebrated passages from Ruskin's *Modern Painters*, the one that Ruskin himself had proposed as a manifesto for the Pre-Raphaelites: 'They should go to nature in all singleness of heart, and walk with her laboriously and trustingly, having no other thought but how best to penetrate her meaning; rejecting nothing, selecting nothing, and scorning nothing.'[61] Pater describes Botticelli's rejection of the 'naturalism' of Giotto, Masaccio, and Ghirlandaio in what must surely be an analogue for Aestheticism's revolt from Pre-Raphaelite 'truth-to-nature': 'But the genius of which Botticelli is the type usurps the data before it as the exponent of ideas, moods, visions of its own; in this interest it plays fast and loose with those data, rejecting some and isolating others, and always combining them anew.'[62] The

passage is at once a description of the Aesthetic method of composing a work of art by amalgamating disparate 'data', and an example of that very process.

Pater's essays, then, are Aesthetic works of art in the sense that they use the procedures of double distancing that, at the same time, they help to theorise. The process of double distancing might be seen as accepting, with masochistic or perverse pleasure, the notorious denunciation of art in Plato's *Republic*, as a mere imitation of an imitation of ultimate truth or reality.[63] In the Victorian period, as in modern textbooks, Plato's art theory appears as the foundation of Western aesthetics. By flaunting its 'imitative' character, Aestheticism perhaps lays claim to the status 'art', in the most basic sense available in the Western philosophical tradition.

However, the notion of double distancing seems inadequate to capture the full complexity of the criss-crossing references. At times Pater and the painters make their references flagrant, but at other times, with apparent unpredictability, they seem to disavow them. When Pater quotes a word or a phrase from another text, he sometimes emphasises its provenance and at other times omits any acknowledgement. More confusingly still, he sometimes claims that his words derive from another text that does not exist, or at least does not contain the words attributed to it. These diverse methods of referencing can even coexist in a single sentence, such as one in 'The School of Giorgione' where Pater discusses the correlations among different art forms:

> it is noticeable that, in its special mode of handling its given material, each art may be observed to pass into the condition of some other art, by what German critics term an *Anders-streben* – a partial alienation from its own limitations, through which the arts are able, not indeed to supply the place of each other, but reciprocally to lend each other new forces.[64]

Pater attributes the term '*Anders-streben*' to 'German critics', but no subsequent scholar has been able to find the term in any German source.[65] Here Pater seems to be claiming an intertextuality that does not in fact exist (another example in this essay is the evocative term '*fuoco Giorgionesco*', which Pater spuriously attributes to Vasari).[66] However, in the second half of the same sentence he quotes Baudelaire without acknowledgement. In his essay of 1863 on Delacroix, Baudelaire had written: 'sinon à se suppléer l'un l'autre, du moins à se prêter réciproquement des forces nouvelles';[67] Pater translates: 'not indeed to supply the place of each other, but reciprocally to lend each other new forces'. Pater's referencing procedures seem inconsistent; why should he wish at some times to point to a spurious intertextuality, at others to conceal a real one?

The painters associated with Aestheticism used analogous techniques within the context of their own medium. At times they acknowledged links between their paintings and literary texts; at others they disavowed such links. Rossetti often devised literary references after the fact and added them to pre-existing pictures, rather in the fashion of Pater's attribution of phrases such as '*Anders-streben*' or '*fuoco Giorgionesco*' to other writers. As Alastair Grieve shows in Chapter 1, the

Boccaccian title, *Bocca Baciata*, was added after the painting was largely complete (see plate 3; and p. 22); for *Veronica Veronese* of 1872 Rossetti went to the length of appending an elaborate quotation in French, purporting to come from 'The Letters of Girolamo Ridolfi' but in fact a concoction either of his own or Swinburne's.[68] However, Rossetti and other painters could also remove literary or narrative references from their pictures by changing their titles, sometimes long after they were executed. In 1869 Rossetti attempted to delete the literary references from two earlier pictures, *Fazio's Mistress* of 1863, referring to the early Italian poet Fazio degli Uberti (Tate Gallery, London), and *Monna Vanna* of 1866, which takes its title from Dante's *Vita Nuova* (Tate Gallery, London); he wished the pictures to be retitled, respectively, *Aurelia* and *Belcolore*.[69] At about this time Whistler, too, began systematically to retitle his paintings, eliminating all references to subject-matter in favour of colour designations and abstract comparisons to musical forms; thus *The White Girl* became *Symphony in White, No. 1*.[70] Later in the 1870s Whistler insisted that his portrait of his mother should be called *Arrangement in Grey and Black*, deleting the reference to the sitter's identity.[71]

The retitlings that suppress literary or narrative content fit easily with the standard account of 'art for art's sake' in painting, as a progressive drive to eliminate content from the image in favour of pure form. However, there was no tidy move away from literary content; *Veronica Veronese* came three years after the attempted retitlings of *Fazio's Mistress* and *Monna Vanna*, and other painters could introduce complex narrative or literary content long after they had begun to experiment with non-narrative or 'subjectless' approaches. The painters, like Pater, seem inconsistent, at times stressing intertextual links, at others suppressing them. The Aesthetic procedure of double distancing cannot quite encompass the diversity of these practices. On some occasions attention is called to another work of art intervening between the present work and 'nature'. But in other cases Pater and the painters deliberately pass up opportunities to reference other works of art. It may, however, be precisely the incommensurability of the various referencing procedures that constitutes the characteristic feature of the Aesthetic work of art.

Pater's critical approach has often been described as 'impressionistic' or even 'solipsistic' – grounded on nothing more than the individual critic's taste or whim.[72] However, Pater's insistence that there can be no 'universal formula' for beauty reiterates a basic principle of Kantian aesthetics. In the *Critique of Judgement*, Kant, too, stresses the impossibility of a 'universally applicable formula' for aesthetic judgements; this follows rigorously from the non-conceptual nature of the aesthetic in Kant's system. For Kant, the statement 'This flower is beautiful' is an aesthetic judgement, but the statement 'All tulips are beautiful' is a logical one, governed by a concept about what kind of object tulips are.[73] There is nothing wrong with making such logical statements about tulips, or any other kind of object; but they are not aesthetic judgements.

Within the aesthetic realm, as Kant describes it, there is a 'matter' appropriate for the critic's attention:

> But that matter is not one of exhibiting the determining ground of aesthetic judgements ... in a universally applicable formula – which is impossible. Rather is it the investigation of the faculties of cognition and their function in [aesthetic] judgements, and the illustration, by the analysis of examples, of their mutual subjective finality, the form of which in a given representation has been shown ... to constitute the beauty of their object.[74]

The first of these procedures, the investigation of the human faculties involved in making aesthetic judgements, constitutes the 'science' of aesthetics, according to Kant; the second, illustration by examples, is its 'art'. Although Kant himself is concerned with the 'science', he emphasises the importance of the 'art'; since aesthetic judgement cannot be demonstrated in a formula, examples of its application to particular objects are all the more crucial. Pater's critical project might then be construed as taking up the 'art' of criticism as Kant describes it. His formulation of the aesthetic critic's task, in the Preface to *The Renaissance*, is an elegant restatement of the Kantian notion:

> To define beauty, not in the most abstract but in the most concrete terms possible, to find, not its universal formula, but the formula which expresses most adequately this or that special manifestation of it, is the aim of the true student of aesthetics.[75]

However, Kant's theory creates obvious problems for the notion of the work of art. To claim that particular objects belong to the category 'works of art' is a logical statement of the kind 'All tulips are beautiful' – it presupposes a governing concept about the nature of works of art in general, which is theoretically inadmissible within the aesthetic realm. This problem has continued to haunt twentieth-century discussions of the aesthetic; it is the starting-point, for instance, of Heidegger's 'The origin of the work of art': 'What art is should be inferable from the work. What the work of art is we can come to know only from the essence of art. Anyone can see that we are moving in a circle.'[76] The recent emphasis on replacing the work of art with 'visual culture', as the proper object of the art historian's attention, might be seen as an attempt to evade Heidegger's circle. Arguably it remains subject to Kant's basic distinctions. 'Visual culture' merely sidesteps the problematic of the aesthetic, by moving into a logical realm where the objects of enquiry can be subsumed under some kind of concept – objects can, for instance, be grouped logically according to the historical circumstances of their production and consumption.

For most of the twentieth century, art history has coped with the Kantian problematic more informally, by projecting modernist artistic creation as an abrupt departure from all traditional conceptions of the work of art. It is not difficult to see why modern-life subject-matter has held high status under this regime. The artist's apparently spontaneous response to the newest circumstances

of the modern world seems to obey as little as possible predetermined concepts of what the work of art should be like – only total abstraction can be freer from apparent determination. By contrast the overt dependence in Aestheticism on artistic precedent, in the selection of subject-matter and often in the choice of visual motifs, has seemed suspect. We might, however, reconfigure Aestheticism as another kind of response to this problematic about the work of art. The Aesthetic work can lay claim to the status 'work of art' on the grounds that it resembles another work of art in some way. However, each resemblance of this kind is a singular relationship between two works. There is no single property that is shared by all the works. We do not, then, need to have a general concept of the work of art to identify a particular item as a work of art.

Whistler's 'Ten o'clock' lecture of 1885 draws intriguingly on both notions. On the one hand Whistler presents 'Art' as a wholly spontaneous phenomenon, materialising without warning in diverse times and places:

> The Master stands in no relation to the moment at which he occurs – a monument of isolation – hinting at sadness – having no part in the progress of his fellow men – ... So Art is limited to the infinite, and beginning there cannot progress –[77]

On the other hand, throughout the lecture Whistler draws on the characteristic shared motifs of Aestheticism. He concludes:

> We have then but to wait – until, with the mark of the Gods upon him, there comes among us, again, the chosen, who shall continue what has gone before – satisfied that even, were he never to appear, the story of the beautiful is already complete – hewn in the marbles of the Parthenon, and broidered, with the birds, upon the fan of Hokusai – at the foot of Fusihama –[78]

Whistler's own art has been written into the historiographies of both modernism and Aestheticism, and the 'Ten o'clock' suggests that this may be appropriate. Moreover, the lecture itself qualifies as an Aesthetic work of art, according to the principle of criss-crossing reference. It shares numerous references with Pater's essays; not only were the Parthenon sculptures a key point of reference for Pater, but he uses 'Japanese fan-painting' at the beginning of 'The School of Giorgione' as an example of 'pure' art.[79] On the same principle, Pater's essays are Aesthetic works of art of the utmost subtlety, not only in their own references, but in the innumerable intertextual links they set up among other works of art, past and present.

Perhaps the most radical implication of this notion of the Aesthetic work of art is its denial of historicity. If a Victorian work can stake its claim to the status 'work of art' through a family resemblance to a work by Leonardo, the family resemblance to the Victorian work may confer the same status on the Leonardo centuries after the artist's death; the networks are not exclusive, but may be expanded to infinity. If this sounds fanciful, we should ask ourselves whether we can now have any notion of the *Mona Lisa* that is untouched by Pater's description. That suggests a final intertextual link, to a passage where T. S. Eliot seems to invoke Pater:

No poet, no artist of any art, has his complete meaning alone.... I mean this as a principle of aesthetic, not merely historical, criticism.... [W]hat happens when a new work of art is created is something that happens simultaneously to all the works of art which preceded it. [80]

Notes

I would like to thank Stephen Bann for giving me the opportunity to present an early version of this paper at the Pater Centenary conference held at the University of Kent in 1994. I owe the greatest thanks to Charles Martindale for helping me to transform that paper into its present form, and for his unwavering enthusiasm for Pater's writing.

1 T. S. Eliot, 'Philip Massinger', *The Sacred Wood: Essays on Poetry and Criticism* (London, Methuen, 1920), p. 114.

2 See for example P. Barolsky, *Walter Pater's Renaissance* (University Park and London, Pennsylvania State University Press, 1987); L. Chai, *Aestheticism: The Religion of Art in Post-Romantic Literature* (New York, Columbia University Press, 1990), ch. 4; J. Freedman, *Professions of Taste: Henry James, British Aestheticism, and Commodity Culture* (Stanford, Stanford University Press, 1990), p. 5. For a perceptive account of Pater's literary style see D. Donoghue, *Walter Pater: Lover of Strange Souls* (New York, Alfred A. Knopf, 1995), pp. 292–307.

3 For a different account of Pater's participation in the Aesthetic Movement see N. Shrimpton, 'Pater and the "aesthetical sect" ', *Comparative Criticism*, 17 (1995) 61–84.

4 Hence the separate literatures on literary and visual Aestheticism; see the Introduction to this volume. A notable exception is the section on Rossetti in R. L. Stein, *The Ritual of Interpretation: The Fine Arts as Literature in Ruskin, Rossetti, and Pater* (Cambridge, Mass., and London, Harvard University Press, 1975). However, Stein does not attempt to compare Pater's essays to visual art.

5 W. Hamilton, *The Aesthetic Movement in England* (London, Reeves and Turner, 1882), pp. 28, 5.

6 W. Pater, *The Renaissance: Studies in Art and Poetry*, ed. Donald L. Hill (Berkeley and London, University of California Press, 1980), p. xx.

7 Ibid., p. 189.

8 The most recent example is L. Lambourne, *The Aesthetic Movement* (London, Phaidon, 1996). The range of artefacts in twentieth-century books closely follows the range first codified in Hamilton, *Aesthetic Movement*.

9 The phrase 'greenery-yallery' was made famous in Gilbert and Sullivan's satire on Aestheticism in the operetta *Patience* (1881).

10 Pater, *Renaissance*, p. xix.

11 See for example L. Brake, *Walter Pater* (Plymouth, Northcote House, 1994), p. 25 and *passim*; D. Carrier, 'Baudelaire, Pater and the origins of modernism', *Comparative Criticism*, 17 (1995) 109–21. For a notable attack on Pater's use of intertextuality see C. Ricks, 'Walter Pater, Matthew Arnold and misquotation', *The Force of Poetry* (Oxford, Clarendon, 1984), pp. 392–416.

12 *Studies in the History of the Renaissance* (London, Macmillan, 1873); second (1877) and subsequent editions (1888, 1893, 1900) retitled *The Renaissance: Studies in Art and*

Poetry. 'The School of Giorgione' was first published in the *Fortnightly Review* in October 1877 and added to the third edition (1888).

13 See L. Wittgenstein, *Philosophical Investigations*, trans. G. E. M. Anscombe (Oxford, Blackwell, [1953] 1972), paras 66–7. In what follows I am much indebted to Wittgenstein's phrases, 'family resemblance', 'criss-cross', etc.

14 Carrier, 'Baudelaire, Pater, and the origins of modernism', p. 112.

15 I shall assume that the principal 'Aesthetic' painters, in the period when Pater was writing the *Renaissance* essays, were those identified in Sidney Colvin's article, 'English painters and painting in 1867, *Fortnightly Review*, n.s. 2 (October 1867) 473–5 (Leighton, Moore, Whistler, Rossetti, Burne-Jones, Solomon, Watts, Hughes, Mason; see the Introduction to this volume). For Pater's respect for Colvin see Pater, *Renaissance*, p. 298.

16 'Winckelmann', *Westminster Review*, n.s. 31 (January 1867) 100.

17 See Introduction, pp. 3–4.

18 In its original version the final sentence read: 'Of this wisdom, the poetic passion, the desire of beauty, the love of art for art's sake, has most; for art comes to you professing frankly to give nothing but the highest quality to your moments as they pass, and simply for those moments' sake.' 'Poems by William Morris', *Westminster Review*, n.s. 34 (October 1868) 312. Pater altered the phrasing for the fourth edition of *The Renaissance* (1893) to read 'the love of art for its own sake', perhaps because the phrase 'art for art's sake' had been controversial. Modern reprints use the 1893 text.

19 A. C. Swinburne, *William Blake: A Critical Essay* (London, John Camden Hotten, dated 1868 but issued late in 1867), pp. 91, 101. Blake, a key point of reference for the Rossetti circle, also appears frequently in Pater's essays of this period.

20 See Donoghue, *Walter Pater*, pp. 34–8. For another discussion of Solomon's work see Whitney Davis's chapter in this volume (Chapter 9).

21 He appears among the nine painters cited in Colvin, 'English painters', p. 475.

22 W. Pater, 'A study of Dionysus', *Fortnightly Review*, n.s. 20 (December 1876) 767–8.

23 G. M. Seymour, *The Life and Work of Simeon Solomon (1840–1905)*, PhD dissertation (University of California, Santa Barbara, 1986), p. 137. In a letter of 1889 Pater thanks Herbert Horne for the gift of a drawing by Solomon; see L. Evans (ed.), *Letters of Walter Pater* (Oxford, Clarendon, 1970), pp. 100–1.

24 See Kate Flint's essay in this volume (Chapter 7); C. Newall, *The Grosvenor Gallery Exhibitions: Change and Continuity in the Victorian Art World* (Cambridge, Cambridge University Press, 1995); S. C. Casteras and C. Denney (eds), *The Grosvenor Gallery: A Palace of Art in Victorian England*, exh. cat. (New Haven, Yale Center for British Art, 1996).

25 See B. A. Inman, *Walter Pater and His Reading 1874–1877* (New York and London, Garland, 1990), p. 385.

26 Pater, *Renaissance*, p. 117.

27 In the 1893 edition of *The Renaissance* Pater added a footnote identifying Rossetti as the painter in question.

28 Pater, *Renaissance*, p. 114.

29 Perhaps Pater saw the brief articles by Rossetti's friend, the critic F. G. Stephens, which mention his 'Venetian' work, *Athenaeum* (21 October 1865) 545–6; (14 August 1875) 219–21. Solomon shared Rossetti's interest and may well have discussed it with Pater.

30 See R. Anderson and A. Koval, *James McNeill Whistler: Beyond the Myth* (London, John Murray, 1994), pp. 93, 168–9.

31 Pater, *Renaissance*, p. 106.

32 Carrier, 'Baudelaire, Pater and the origins of modernism', p. 119.

33 See J. Christian, *Burne-Jones: The Paintings, Graphic and Decorative Work of Sir Edward Burne-Jones 1833–98*, exh. cat. (London, Southampton, and Birmingham, Arts Council of Great Britain, 1975), pp. 52–3.

34 See P. Clements, *Baudelaire and the English Tradition* (Princeton, Princeton University Press, 1985), p. 10.

35 For example Leighton's *The Triumph of Music* of 1856 (untraced), which represented Orpheus in Hades playing an anachronistic violin, an attempt to universalise the subject's resonances about the power of the art of music (see Mrs R. Barrington, *The Life, Letters and Work of Frederic Leighton*, 2 vols [London, George Allen, 1906], I, pp. 244–5). See also Leighton's *Lieder Ohne Worte* of 1861 (Tate Gallery, London) and Rossetti's watercolours of 1857 with musical references, such as *The Tune of Seven Towers* and *The Blue Closet*, both subjects of poems by William Morris (Tate Gallery, London).

36 Swinburne, *William Blake*, p. 89.

37 Pater, *Renaissance*, pp. 18–19. Pater elaborated the references to the Tannhäuser story in the revised version of the essay, 'Two early French stories', for the second edition of *The Renaissance* (1877).

38 Pater, *Renaissance*, p. 174.

39 Ibid., p. 164.

40 For contemporary views of Michelangelo see Caroline Arscott's chapter in this volume (Chapter 6, pp. 140–2); Lene Østermark-Johansen, *Sweetness and Strength: The Reception of Michelangelo in Late Victorian England* (Aldershot, Ashgate, 1998).

41 Pater, *Renaissance*, p. 62; cf. Pater, 'A study of Dionysus', p. 756.

42 Pater, *Renaissance*, p. 93.

43 A. C. Swinburne, 'Simeon Solomon', *Dark Blue*, 1 (July 1871) 573.

44 For the *Antinous* relief see F. Haskell and N. Penny, *Taste and the Antique: The Lure of Classical Sculpture 1500–1900* (New Haven and London, Yale University Press, 1982), pp. 144–6.

45 A. C. Swinburne, 'Notes on designs of the Old Masters at Florence', *Fortnightly Review*, n.s. 4 (July 1868) 36.

46 Pater, *Renaissance*, pp. 90–1. For the frontispiece illustration see S. Bann, 'Epilogue: on the homelessness of the image', *Comparative Criticism*, 17 (1995) 123–8.

47 See L. Dowling, 'Ruskin's Pied Beauty and the constitution of a "homosexual code"', *Victorian Newsletter*, 75 (1989) 1–8; T. E. Morgan, 'Reimagining masculinity in Victorian criticism: Swinburne and Pater', *Victorian Studies*, 36:3 (1993) 316.

48 See C. Cruise, '"Lovely devils": Simeon Solomon and Pre-Raphaelite masculinity', in E. Harding (ed.), *Re-framing the Pre-Raphaelites: Historical and Theoretical Essays* (Aldershot, Scolar, 1996), p. 195.

49 Pater, *Renaissance*, p. 47. For the practice of repeating eroticised representations of a model, see E. Prettejohn, *Rossetti and His Circle* (London, Tate Gallery Publishing, 1997), pp. 9–10, 26–31, 68–74. See also Alastair Grieve's chapter in this volume, Chapter 1, pp. 26, 29.

50 See for example David J. DeLaura, *Hebrew and Hellene in Victorian England: Newman, Arnold, and Pater* (Austin and London, University of Texas Press, 1969), p. xix.

51 Swinburne compares *Evening Hymn* by G. II. Mason (one of the artists in Colvin's list of aesthetic painters) to Della Robbia's sculpture, in *Notes on the Royal Academy Exhibition, 1868* (London, John Camden Hotten, 1868), p. 39.

52 See R. M. Seiler (ed.), *Walter Pater: The Critical Heritage* (London, Boston and Henley, Routledge & Kegan Paul, 1980), pp. 47–112, especially the review by E. F. S. Pattison, pp. 71–3.

53 P. Bürger, *Theory of the Avant-Garde*, trans. Michael Shaw (Manchester and Minneapolis, Manchester University Press / University of Minnesota Press, 1984), p. 49.

54 Pater, 'Poems by William Morris', p. 300; Pater, *Renaissance*, p. 82.

55 'The Royal Academy', *Art-Journal*, n.s. 13 (June 1874) 166.

56 See Hill's notes to the passage, in Pater, *Renaissance*, pp. 378–81.

57 Eliot, 'Philip Massinger', p. 114. This theory of imitation is close to that of Sir Joshua Reynolds: the artist 'should enter into a competition with his original, and endeavour to improve what he is appropriating to his own work. Such imitation is so far from having anything in it of the servility of plagiarism, that it is a perpetual exercise of the mind, a continual invention. Borrowing or stealing with such art and caution, will have a right to the same lenity as was used by the Lacedemonians; who did not punish theft, but the want of artifice to conceal it.' See Sir J. Reynolds, *Discourses on Art*, ed. R. R. Wark (New Haven and London, Yale University Press, 1975), p. 107.

58 Pater, *Renaissance*, p. 87.

59 J. Ruskin, *Modern Painters*, I (1843), in *The Works of John Ruskin*, Library Edition, ed. E. T. Cook and A. Wedderburn (London, George Allen, 1903–12), III, 553–4.

60 The most famous example is at the beginning of the Preface, where Pater quotes Arnold's dictum 'To see the object as in itself it really is' and immediately undermines it by continuing: 'and in aesthetic criticism the first step towards seeing one's object as it really is, is to know one's own impression as it really is'. Pater, *Renaissance*, p. xix and note, pp. 296–7.

61 J. Ruskin, 'Pre-Raphaelitism' (1851, quoting his own *Modern Painters*, vol. I), *Works*, XII, p. 339.

62 Pater, *Renaissance*, p. 42.

63 Although Pater's volume *Plato and Platonism* would not appear until 1893, Platonic and Neoplatonic philosophy are already important concerns in *The Renaissance*; see Barolsky, *Walter Pater's Renaissance*, p. 17.

64 Pater, *Renaissance*, p. 105.

65 See note in ibid., p. 388. The idea is close to a passage in Letter XXII of Friedrich Schiller's *On the Aesthetic Education of Man*, but Schiller does not use the term. See the interesting discussions of the issue by Schiller's translators in his *On the Aesthetic Education of Man*, ed. and trans. E. M. Wilkinson and L. A. Willoughby (Oxford, Clarendon, 1967), pp. clxvi, 153–7, 265–7.

66 Pater, *Renaissance*, p. 118 and note, p. 396.

67 'L'Oeuvre et la vie d'Eugène Delacroix', in C. Baudelaire, *Curiosités esthétiques, L'Art romantique et autres oeuvres critiques* (Paris, Garnier, 1962), p. 424. The quotation was first noted by Germain d'Hangest; see Pater, *Renaissance*, p. 388.

68 See V. Surtees, *The Paintings and Drawings of Dante Gabriel Rossetti (1828–1882): A Catalogue Raisonné* (Oxford, Clarendon, 1971), p. 128.

69 For Rossetti's letter to the pictures' owner, requesting the changes of title, see W. M. Rossetti, *Dante Gabriel Rossetti as Designer and Writer* (London, Cassell, 1889), pp. 68–9.

70 See R. Johnson, 'Whistler's musical modes: numinous nocturnes', *Arts Magazine*, 55:8 (April 1981) 170–1.

71 'The Red Rag', letter to *The World*, 22 May 1878, repr. in J. M. Whistler, *The Gentle Art of Making Enemies* (New York, Dover, [1892] 1967), p. 128.

72 See for example F. C. McGrath, *The Sensible Spirit: Walter Pater and the Modernist Paradigm* (Tampa, University of South Florida Press, 1986), pp. 12–13, 35; R. V. Johnson, *Aestheticism* (London, Methuen, 1969), pp. 31–3.

73 I. Kant, *The Critique of Judgement* (1790), trans. J. C. Meredith (Oxford, Clarendon, [1911] 1952), para. 33, p. 140.

74 Ibid., para. 34, p. 141.

75 Pater, *Renaissance*, p. xix.

76 M. Heidegger, *Basic Writings*, ed. David Farrell Krell (London, Routledge, 1993), p. 144.

77 'Mr Whistler's "Ten o'clock"', in N. Thorp (ed.), *Whistler on Art: Selected Letters and Writings 1849–1903 of James McNeill Whistler* (Manchester, Carcanet, 1994), p. 92.

78 Ibid., p. 95.

79 Pater, *Renaissance*, p. 104.

80 T. S. Eliot, 'Tradition and the individual talent', *The Sacred Wood: Essays on Poetry and Criticism* (London, Methuen, 1920), p. 44.

3

Whistler, Swinburne and art for art's sake

Robin Spencer

THE CREATIVE PARTNERSHIP of Whistler and Swinburne (plate 12) resulted in a different progeny for modernism than the art fathered in the same decade by Manet and Baudelaire. After the death of Manet, Whistler aspired to succeed him by beginning a friendship with Mallarmé in 1888, the year that his relationship with Swinburne dramatically ended. Through his collaboration with Mallarmé, and perceptions by Symbolist critics of Whistler as the 'painter-poet', Whistler bequeathed Swinburne's legacy to the last years of the century and diversified the modernist tradition which Manet and Baudelaire had begun. While art historians always allocate more space to Manet and Baudelaire, Whistler's and Swinburne's treatment of word and image developed differently from theirs, and arguably changed relationships between painting and poetry more radically.

In his review of Baudelaire's *Fleurs du mal* in 1862, Swinburne wrote:

> There is not one of these poems that could have been written in a time when it was not the fashion to dig for moral motives and conscious reasons ... there is not one poem ... which has not a distinct and vivid background of morality to it. Only this moral side of the book is not thrust forward in the foolish and repulsive manner of a half-taught artist.[1]

Swinburne, Patricia Clements says, does not argue that Baudelaire's poems are without moral effect, but that their morality is 'a quality of the art and not of the material, a consequence of execution rather than didactic intention'; by 'displacing value from subject to treatment' Swinburne was 'laying down in print for the first time in English some of the basic positions of modernism'.[2]

The association of Baudelaire with Swinburne's *Poems and Ballads* of 1866 created a literary sensation which immediately crossed the Channel and lasted well into the following decade.[3] Claiming his authority from, and quoting, Baudelaire's 'heresy of didacticism',[4] which Baudelaire derived from Poe, Swinburne pioneered the aesthetic morality of 'art for art's sake', principally in his study of the painter-poet William Blake, written between 1862 and 1867, in which sounds and colours are deployed synaesthetically as an expression of Swinburne's unique response to Blake's art.[5] In the same decade Whistler painted the series of *White Girls* to which

he gave the synaesthetic title *Symphony*. Their lack of a conventional narrative sug-
gests that, like Swinburne, Whistler rejected the explicit moralising of much
Victorian art, at a time when he also abandoned the realist principles of Gustave
Courbet which had influenced his painting in Paris. In the next decade Whistler
extended his practice of giving paintings musical titles by calling his representa-
tions of the river Thames *Nocturnes*. When Ruskin criticised Whistler in 1877 for
'flinging a pot of paint in the public's face', because he considered that *Nocturne
in Black and Gold: The Falling Rocket* (YMSM 170) showed insufficient work-
manship to morally justify it as a work of art for which Whistler asked 200 guineas,
Whistler defended his art in court in essentially the same formalist terms which
Swinburne had used for Baudelaire in 1862, by making 'the formal quality of a
work its justification, the proper centre of attention for both poet and critic'.[6]

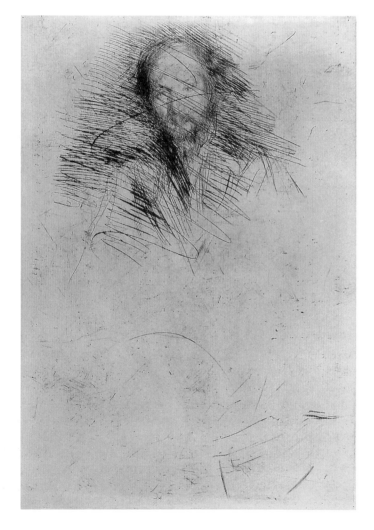

12 James McNeill
Whistler, *Swinburne*,
1870s, etching
(cancelled by
Whistler), 27.7 x 19.9
cm

After the Ruskin trial Whistler continued to attack art critics, reiterating his refrain that only a painter was qualified to criticise painting, a distant and shriller echo of the thanks Baudelaire had expressed to Swinburne for the understanding he had shown his verse in 1862 – 'it is only poets who can really understand poets'[7] – and what Swinburne had said of Blake, that 'only a leader among imaginative painters could so have judged his designs'.[8] Whistler published his polemical writings in *The Gentle Art of Making Enemies* (1890), with his critical manifesto, the 'Ten o'clock' lecture, as its centrepiece, first given in 1885, but which in 1888 he had invited Swinburne to review with fatal consequences for their friendship.

At least until Whistler's trial with Ruskin, Whistler and Swinburne were brothers in art, and Republicans – Whistler by birth, Swinburne by his passionately committed poetry; in the 1860s both had supported the Fenian cause. But ideological differences over the Irish question and South Africa may have clouded their later years. Whistler, who supported the Boers in the South African war, may have found Swinburne's imperialist leanings unacceptable; and personal differences, such as these, may have existed before Swinburne's 'fratricide' in 1888.[9] However, I am concerned here with relationships between Swinburne's poetry and Whistler's painting in the 1860s, when Swinburne addressed Whistler in his letters as 'cher père', signing himself, 'ton fils dévoué'. This form of address, unique in Swinburne's correspondence, suggests Swinburne placed an unusually heavy reliance on Whistler and his household.[10] This period of their intimacy, when Swinburne even drew Ruskin's attention to Whistler's art, also shows Whistler's reliance on Swinburne; for there are good reasons to believe that Swinburne's influence on Whistler's art was both lasting and profound.

If Ruskin saw Whistler's *Symphonies* in the 1860s he would have appreciated his intentions for reasons similar to those which had attracted him to Burne-Jones's art.[11] Ruskin also admired Swinburne's blatantly anti-Christian poems, such as the 'Hymn to Proserpine', the original manuscript of which Ruskin 'wouldn't part with for much more than leaf gold'.[12] 'Ruskin's disapproval of the moral character of Swinburne's work, and disagreement with many of his critical judgements, indicates not that they disagreed in theory but only in the practical questions of what constitutes good morality.'[13] Swinburne scholars have suggested that Ruskin's advocacy of a fully contextualised art, and Swinburne's understanding of poetic morality, were not so radically dissimilar. In the second chapter of *William Blake*, Swinburne states that the 'result of having good art about you and living in a time of noble writing or painting' was that the 'spirit and mind of men' should receive 'a certain exaltation and insight caught from the influence of such forms and colours of verse or painting'. Swinburne, like Ruskin, was also aware that art had a social context: 'art for art's sake first of all, and afterwards we may suppose all the rest shall be added to her'.[14] That Ruskin's and Swinburne's beliefs may not have been so far apart suggests why Swinburne continued to seek Ruskin's approval for his verse, and Ruskin accepted Swinburne's aesthetic paganism, refusing to condemn *Poems and Ballads*, which

Swinburne dedicated to Burne-Jones. The Ruskinian inflection of Swinburne's 'art for art's sake' now invites us to reconsider Swinburne's letter to Ruskin of 11 August 1865, asking him, with Burne-Jones, to visit the studio of Whistler, 'whose desire to have it out with you face to face must spring simply from knowledge and appreciation of your own works'.[15]

Swinburne's letter to Ruskin enclosed a copy of his verses 'Before the Mirror', which Ruskin had previously admired 'as a piece of work more satisfactory than usual'. The verses, Swinburne explained, were occasioned by Whistler's *The Little White Girl* (YMSM 52), 'which alone put them into my head'. Whistler's picture had been exhibited at the Royal Academy that summer with six of the verses attached to the frame (plate 13). In a previous letter to Whistler, Swinburne wrote that he found in his picture 'the metaphor of the rose and the notion of sad and glad mystery in the face languidly contemplative of its own phantom and all other things seen by their phantoms'.[16] Anxious to recommend Whistler's art to Ruskin

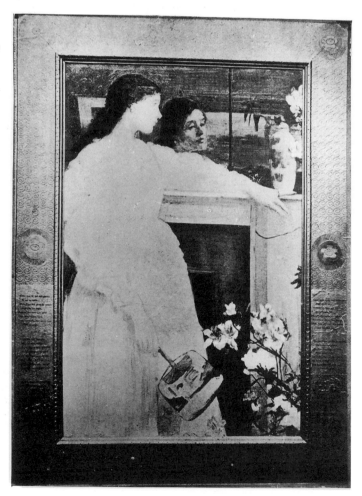

13 James McNeill Whistler, *Symphony in White, No. II: The Little White Girl*, 1864, oil on canvas, 76.0 x 51.0 cm, showing Swinburne's verses 'Before the Mirror' on the frame

as superior to his own, Swinburne wrote to Ruskin that 'whatever merit my song may have, it is not so complete in beauty, in tenderness and significance, in exquisite and delicate strength as Whistler's picture'; for Whistler 'so far overpraised my verse as to rank it above his own painting. I stood up against him for himself, and will, of course, against all others.'[17] In the opening section of his *Salon* of 1846, Baudelaire had written that 'the best account of a painting can be a sonnet or an elegy'.[18] By indicating that this was his intention, Swinburne was giving Ruskin advance notice to expect something new. But it was not new for poets to supply painters with poetry. Swinburne had already written verses for Burne-Jones, as Baudelaire had for Manet, and Rossetti often based pictures on his own sonnets. The significance of Swinburne's letter – which must be emphasised here – was that Whistler, who had known Swinburne since 1862, was a fervent admirer of his poetry. But, unlike Rossetti and Burne-Jones who dressed their pagan and religious subjects in medieval and Renaissance clothes, Whistler first interpreted Swinburne in modern dress. Although Swinburne would not have thought this unusual, for art 'knows nothing of time; for her there is but one tense, and all ages in her sight are alike present',[19] the source of Swinburne's inspiration – a painting by Whistler – would have been a new experience for Ruskin.

Unlike Whistler's more celebrated *The White Girl* (YMSM 38), later called *Symphony in White, No. I* – which, I have argued elsewhere, [20] probably owes little to Baudelaire and nothing to Swinburne whom Whistler first met some six months after painting it – *The Little White Girl* is Whistler's first Swinburnian picture, not just because it shares its subject with the poet, but because it represents Swinburne's view of the world as being one of continual change:

> I cannot see what pleasures
> Or what pains were;
> What pale new loves and treasures
> New years will bear;
> What beam will fall, what shower,
> What grief or joy for dower;
> But one thing knows the flower; the flower is fair.[21]

Like Swinburne's verses, Whistler's *The Little White Girl* contracts the narrative of time and space into a unified reflective experience which is neither reassuring nor consoling. 'Before the Mirror' is not, in Jerome McGann's perceptive analysis, which can also be applied to Whistler's picture,

> simply a Wordsworthian spot of time in which the mysterious realms of past and future are being explored. The mirror set in the mirror of art multiplies relationships indefinitely. Here one cannot distinguish object from reflection, dream from reality: 'Art thou the ghost, my sister.... Am I the ghost, who knows?' Not only do past and future recollect each other, and dream and reality impinge; all orders of concrete perception – women, flowers, seasons – extend the process of mirroring. One glimpses a universe of terrifying correspondences where, however, all things remain mysterious and strangely mournful.[22]

As Judith Stoddart has shown, for the educated viewer or reader – such as Ruskin – there is an unavoidable pagan subtext to help decipher the meaning of both picture and poem: the story of Narcissus unsuccessfully attempting to approach his beautiful reflection, until in frustration he kills himself and his blood is changed into a flower.[23] The goddesses of Whistler and Swinburne see in the mirror/stream 'Old loves and faded fears', and 'The flowing of all men's tears beneath the sky'.

The central theme of *Poems and Ballads* is love, 'and the moral position, constantly reiterated, is that love made life more beautiful before a restrictive, oppressive morality set in'.[24] Swinburne's sensuality of 'pain' and 'pleasure', experienced reflectively 'Before the Mirror', inverts the received myth of Christian asceticism which Swinburne parodies – blasphemously his critics thought – in 'Hymn to Proserpine', 'Dolores' and other verses in *Poems and Ballads*. 'He has chosen to dwell mainly upon sad and strange things', Swinburne wrote of Baudelaire, 'the weariness of pain and the bitterness of pleasure.'[25] In *The Little White Girl* Whistler makes the new aesthetic morality even clearer to a contemporary audience, by alluding to the Christian sacrament of marriage, which he signifies by the wedding ring his modern sitter prominently wears. If Ruskin saw *The Little White Girl* in 1865 it would have disturbed him as much as Swinburne's poetry. But in it Ruskin would also have recognised 'The Dark Mirror', his title for the deeply pessimistic central section of the fifth volume of *Modern Painters* (1860), in which 'the soul of man is a mirror of the mind of God. A mirror, dark, distorted, broken … yet in the main, a true mirror', which Ruskin concluded 'is the image of God painted … for through thyself only thou canst know God. Through the glass, darkly. But, except through the glass, is nowise.'[26]

Yet the fifth volume of *Modern Painters* is not all 'gazing without shrinking into darkness', which made Ruskin sympathetic to Swinburne's pagan love. It also contains practical advice for the modern painter. From his 'knowledge and appreciation' of Ruskin's works, Whistler would have known that in Part VIII, 'Of Invention Formal', which preceded 'The Dark Mirror' ('Of Invention Spiritual'), Ruskin distinguishes between 'the merely pleasant placing of lines and masses' which he calls 'the emotional results of such arrangement', which can be explained, and 'the perfection of formative arrangement' or composition, which 'cannot be explained, any more than that of melody in music'.[27] This distinction is analogous to the one Swinburne makes between 'melody' and 'harmony', 'melody' being 'inner music' – the relationship of the poem to nature itself, and 'harmony' being 'outer music' – the technical devices of rhythm, assonance etc.[28] In taking to pieces 'the observing and combining intellect' of Turner's compositions, Ruskin demonstrates that 'a great composition always has a leading emotional purpose, technically called its motive, to which all its lines and forms have some relation. Undulating lines, for instance, are expressive of action; and would be false in effect if the motive of the picture was one of repose. Horizontal and angular lines are expressive of rest and strength.'[29] Nearly as many musical metaphors abound in

Ruskin's chapter, 'The Law of Perfection', in Book V of *Modern Painters*, as in Swinburne's second chapter of *William Blake*. Ruskin writes:

> For perfectness, properly so called, means harmony. The word signifies literally the doing our work thoroughly. It does not mean carrying it up to any constant and established degree of finish, but carrying the whole of it up to a degree determined upon … so long as it remains incomplete, he [the artist] does not care how little of it is suggested, or how many notes are missing.[30]

The language Whistler later used to defend his art in court would have been unexceptional to anyone familar with Ruskin's writings.

Meanwhile, if Ruskin visited Whistler's studio on Sunday, 13 August 1865, he would have seen the picture on which he had made, Whistler wrote to Henri Fantin-Latour three days later, 'really enormous progress'. He was at work on the picture then known as *The Two Little White Girls* which, two years later, he exhibited as *Symphony in White, No. III* (YMSM 61) (plate 14). 'Most of all it's the composition which occupies me', Whistler wrote to Fantin, and below a drawing of the picture he drew attention to the lines and formal emphases in his composition, 'the arrangement of the two arms on the sofa like that' [here Whistler drew

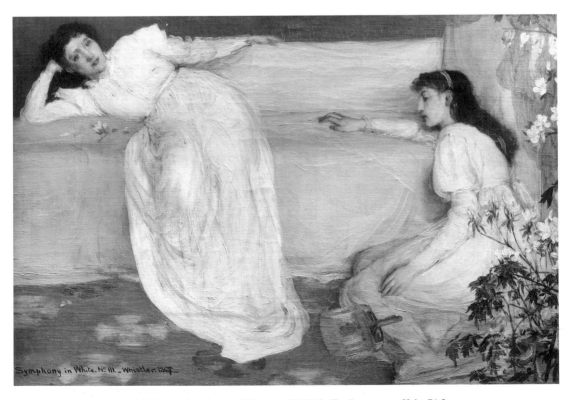

14 James McNeill Whistler, *Symphony in White, No. III*, 1865–67, oil on canvas, 52.0 x 76.5 cm

a line to illustrate the arrangement] (plate 15).[31] There is no reason why Ruskin would not have approved of the 'really enormous progress' Whistler made with his picture. Did he keep his appointment to meet Whistler that Sunday? And was the progress Whistler made intended to please Ruskin with his painting, as Swinburne sought Ruskin's approval for his poetry?

Swinburne had originally drafted the verses 'Before the Mirror' on the back of a letter Whistler received from John Gerald Potter, the Lancashire wallpaper manufacturer who was the first owner of *The Little White Girl*. Potter's *laissez-faire* business practice stood for everything Ruskin opposed. However, Potter presumably believed that Swinburne's literary contribution enhanced the meaning of Whistler's picture because he purchased it with Swinburne's verses attached to the frame.[32] Shortly afterwards, Whistler and Johanna Hiffernan, the sitter for *The Little White Girl*, joined Potter and his family in Trouville. Whistler introduced Potter to Courbet who painted Potter's three young daughters, with their long red Pre-Raphaelite tresses, as *Trois Jeunes Anglaises à la fenêtre*, as well as the portrait of Johanna Hiffernan known as *Jo: La Belle Irlandaise*. Courbet's portrait of Jo with a mirror is an allegory on the *vanitas* theme of Whistler's *The Little White Girl* but excludes the possibility of a further reading. Its limited realism, like that of the portrait of Potter's daughters, failed to interest their father who, to Courbet's surprise, declined to buy either picture. To an advanced English taste, capable of perceiving that Swinburne's violent and sensual poems treated passionate love realistically, Courbet's realism, which shunned mythology, must have seemed contrastingly prosaic.[33]

In 1867 Whistler wrote to Fantin-Latour denouncing Courbet's realism. In his letter Whistler specifically cited his realist pictures as *At the Piano* (1860) (YMSM 24), *The White Girl* (1861–62), and his river- and seascapes, thus implying that *The Little White Girl*, *Symphony in White, No. III* and the other works he had painted since 1865 marked a new departure in his art. These works, painted between the period of Whistler's retreat from realism and the announcement to Fantin of his

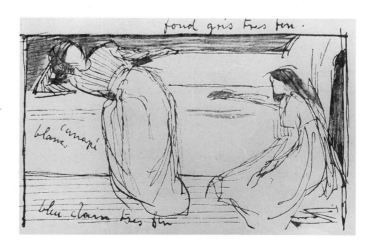

15 James McNeill Whistler, *Drawing after Symphony in White, No. III*, ink, 6.0 x 10.5 cm, from letter to Henri Fantin-Latour, dated '16 Aout' [1865]

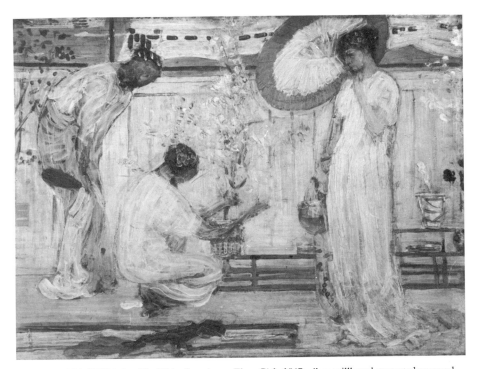

16 James McNeill Whistler, *The White Symphony: Three Girls*, 1867, oil on millboard, mounted on wood, 46.4 x 61.6 cm

decisive break with it in 1867, have several features in common with Swinburne's poetry, both in the subjects they depict and in the way Whistler represented them. The first is *The Three Girls* or the 'garden picture', now known as *The White Symphony: Three Girls* (YMSM 87) (plate 16), which Whistler began in the summer of 1867. This painting was one of the series of studies known collectively as *The Six Projects* (YMSM 82–6), of which Swinburne wrote a critical account in *Notes on Some Pictures of 1868*.[34] The six studies may be considered as expressive of the central theme of *Poems and Ballads*, and may also reflect Swinburne's account of his creative process which he describes in his own defence in *Notes on Poems and Reviews*, published in October 1866. In *Notes* Swinburne describes those poems to which he attached particular importance and charts the successive phases of what he called his 'lyrical monodrama', from the 'fierce and frank sensualities' of 'Dolores', through the longing for death in 'The Garden of Proserpine', to the ideal love of 'Hesperia'.[35]

The critics who accused Swinburne of abandoning the high moral purpose of art, not for art for art's sake, but for dirt for dirt's sake – uncleanness 'for the mere sake of uncleanness' – did so because they recognised that Swinburne's 'account of passion, even if of abnormal passion, is an account of reality'.[36] In his reply to his critics Swinburne first defended those poems thought 'especially horrible',

'Dolores', 'Anactoria' and 'Faustine', which treat perverse lust and show man 'tormented by his divided nature, by the incompatibility of soul and sense'. Swinburne then described how, between the first and the second phase of *Poems and Ballads*, he had 'slipped in' the verses called '"The Garden of Proserpine", expressive … of that brief total pause of passion and of thought, when the spirit, without fear or hope of good things or evil, hungers and thirsts only after the perfect sleep'.[37]

Whistler's art was appreciated in 1865 by English collectors such as Potter, who neither liked Courbet's art, nor were sympathetic to Ruskin, but who admired Swinburne's poetry. *Symphony in White, No. III* and *The Three Girls* (see plates 14 and 16) both express the somnolent mood of 'The Garden of Proserpine' in which 'sorrow / And joy was never sure', and the only certainty in life is that it ends in death and oblivion:

> I am tired of tears and laughter,
> And men that laugh and weep;
> Of what may come hereafter
> For men that sow to reap:
> I am weary of days and hours,
> Blown buds of barren flowers,
> Desires and dreams and powers
> And everything but sleep.[38]

Symphony in White, No. III, the first of Whistler's pictures to be exhibited with a musical title in 1867, had been bought before completion by Louis Huth who was a collector of works by G. F. Watts, an artist also much admired by Swinburne.[39] There is an unavoidable association of Whistler's representation of two girls in an interior with the lesbian subjects of Swinburne's verse and current fiction.[40] And there is an understated sense in which *Symphony in White, No. III* makes Swinburne's *Poems and Ballads* suitable reading for an English drawing room. *Symphony in White, No. III*, begun and photographed in its incomplete state with the date '1865', would almost certainly have been known in Paris soon after. It raises the question as to whether the explicit lesbian sexuality of Courbet's *Les Dormeuses* of 1866 could be a parody of it, and the first example of Swinburne's influence on French art.[41] When Fantin-Latour saw *Symphony in White, No. III* when it was in Paris briefly in February 1867 his reaction was one of puzzlement; he described its general appearance to Whistler as 'a bit misty, more like a dream'.[42] A letter to Fantin, written by their mutual friend Edwin Edwards the following month, demonstrates how closely identified Whistler then was with Swinburne, with whom he shared the same patrons and admirers. In his letter, Edwards describes Swinburne to Fantin as 'a poet friend of Whistler's, a drunk and a debauchee … don't say it to Whistler, but Swinburne's a fake Byron who can only imitate the faults of great talents'. *Poems and Ballads*, Edwards continues, was 'full of filth and impurities he doesn't hide at all – he blatantly writes things about women you shouldn't even think':

Here's something funny which will amuse you, the way these Spartali girls have stepped in all this muck (I think one of them is the Spartali girl who posed for Whistler's 'Princess from the Land of Porcelaine' [YMSM 50]) – the day that this book [*Poems and Ballads*] came out they went round everywhere announcing they'd just read this Evangelist, that he was magnificent, nothing greater, so delicate, you know, such daft words – six days later the storm broke and publishers seeing it for for themselves washed their hands of it writing to the editors of all the main papers, so it was clear to everyone either these girls had approved of infamy, or they'd not read the book, or else hadn't understood what they'd read – It's obvious there are some books it's a good thing young girls don't understand, but with this book of Swinburne's there's nowhere to hide, because the whole thrust of the book, in its intention and spirit, is a protest against everything.[43]

This personally motivated calumny on the Spartali sisters, whose beauty Swinburne worshipped, is a vivid commentary on the hostility raised by *Poems and Ballads*.[44] Interestingly, it was voiced by an artist who was Edouard Manet's strongest defender in London. A year before, Edwards had approved of the radical representation of Manet's courtesan *Olympia*; his distaste for Swinburne's lesbian verse clearly shows how gender-based his critical perceptions were.[45] Meanwhile, the result of Whistler's modified realism was exhibited in London with the title *Symphony in White, No. III*, when Swinburne was taking an ever increasing interest in Whistler's art, which resulted in his article *Notes on Some Pictures of 1868*; and the following year Whistler defended Swinburne before the committee of the Arts Club.[46] In April 1867, Swinburne, still the target of critical vituperation, was preparing *William Blake* for publication and, wrongly informed of the death of Baudelaire, writing his great elegy to the poet, 'Ave Atque Vale'.

'The next act in this lyrical monodrama of passion', Swinburne wrote in *Notes on Poems and Reviews*, 'represents a new stage and scene': 'The worship of desire has ceased; the mad commotion of sense has stormed itself out; the spirit, clear of the old regret that drove it upon such violent ways for a respite, healed of the fever that wasted it in search for relief among fierce fancies and tempestuous pleasures, dreams now of truth discovered and repose attained.'[47] After the passion of 'Dolores' and 'Proserpine', and the recognition of death and oblivion in 'The Garden of Proserpine', the redemption of the soul is finally attained through aesthetic detachment in the third of Swinburne's giantesses, '"Hesperia", the tenderest type of woman or of dream, born in the westward "islands of the blest"' – in Swinburne's verse, the 'daughter of sunset and slumber'.[48] In this last stage of Swinburne's lyrical monodrama, devotion to Hesperia represents 'a devotion to the stories, the songs, and the memories that carry the past into the present; it is a devotion to art'.[49] In 'Ave Atque Vale', Swinburne also commemorates with his song the sound of Baudelaire's 'sad soul': 'My spirit from communion of thy song.... These memories and these melodies that throng.... These I salute, these touch, these clasp and fold / As though a hand were in my hand to hold.'[50] From beyond the grave comes the 'communion' of art to renew the art of the future.

Hesperia, in so far as she exists at all in the void filled by Swinburne's moving life of consonance, alliteration and assonance, is the harmonic fusion of the elemental forces of wind and sea, Swinburne's metaphors for the cyclical progress of man's body and soul towards death and oblivion, whose salvation is only possible through his art. David G. Riede considers that, in 'Hesperia', Swinburne fulfilled the aesthetic goal he had established in *Blake*: 'the harmonious fusion of soul and sense, form and content, man and his world.' 'Hesperia' is Swinburne's plea 'for a mythopoeic creation that grows organically and inevitably out of a direct confrontation of man with his surroundings, out of a complete merger of the self in the flux of experiential reality – an experiential reality ... that includes the continual re-experiencing and recreation of the creative Apollonian song of man'.[51]

Except for Whistler's *Venus*, whose daughter was Hesperia, the identity of the wind-blown figures and the location of garden, sea and shore in *The Six Projects* are as unspecified as those in 'Hesperia', the verses of which Swinburne echoes in his prose description of *Variations in Blue and Green* (YMSM 84) (plate 17) in *Notes on Some Pictures of 1868*: 'beyond and far out to west and south the warm and solemn sea spreads wide and soft without wrinkle of wind'.[52] Just as 'Hesperia' cannot be 'seen' by the reader in terms of Wordsworthian time and place, but is heard in the harmonious sound of Swinburne's song (as Swinburne still hears Baudelaire's), so Whistler's *The Six Projects* are not 'read' by the viewer as a realist narrative, but heard and seen through the sensation of colour and line. In *Richard Wagner et Tannhäuser à Paris*, which Baudelaire sent to Swinburne in 1863, Baudelaire quoted from his sonnet 'Correspondances', and said it would be surprising 'if sound could not suggest colour, or that colours could not give the idea of melody, and that sound and colour were not suitable media for translating ideas'.[53] The meaning of *The Six Projects* is based on an experience of synaesthesia, which Swinburne summarises in *Notes on Some Pictures of 1868* as 'varying chords of blue and white', the sea as 'arrangement' and 'symphony'.[54] Like 'Hesperia', the meaning of *The Six Projects* lies not in their subject but in their form.

Whistler's two-year search for a renewal of his art culminated in *The Six Projects*, begun in the year that he denounced realism. In 1865 he had written of the ambition of himself, Albert Moore and Fantin to 'each provide continuity for the real traditions of 19th century painting'.[55] In his letter to Fantin of 1867 Whistler regretted Courbet's influence on his art, and said that he wished he had been a pupil of Ingres, whose art he found 'not Greek at all'.[56] Whistler does not say what he thought was 'Greek', but when he was with Swinburne in Paris in March 1863, Swinburne visited the Louvre, and inspired by the Greek sculpture of the Hermaphrodite, 'this sculpted poem', wrote the four sonnets 'Hermaphroditus'. According to Robert Peters, the Hermaphrodite symbolised for Swinburne his desire to unify the 'divided beauty' of 'harsh reality and the sublime ideal symbolized by Greek sculpture'. The Hermaphrodite for Swinburne was a sterile object, 'The double blossom of two fruitless flowers', based on the

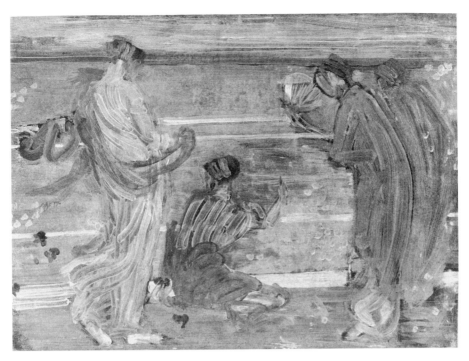

17 James McNeill Whistler, *Variations in Blue and Green*, 1867, oil on millboard, mounted on wood, 46.9 x 61.8 cm

incompatibility of soul and sense, the flawed reality of the ancient myth of opposites, the 'divided beauty of separate woman and man'.[57] Swinburne may also have brought to Whistler's attention Walter Pater's essay on Winckelmann, published at the beginning of 1867, in which Pater, influenced by both Baudelaire and Swinburne, quotes Winckelmann on the androgynous nature of Greek sculpture, and extols the relevance of the classical tradition for modern art.[58]

Whistler told Fantin he wished he had been a pupil of Ingres because Ingres would have helped him resolve the imbalance between drawing and colour in his painting, the unfortunate result of following Courbet and adhering to realist principles. 'Colour', Whistler explains, 'it's a vice!' Although colour was 'one of the most beautiful virtues', she should be 'guided well by her master drawing – colour is a splendid girl when she has a husband worthy of her – who can be her lover but also her master – she is the most magnificent mistress possible! – and you can see the results in all the beautiful things which their marriage produces!'[59] With *The Six Projects* Whistler achieves his union of opposites, of soul and sense, experience and imagination, by harmonising drawing and colour, and by combining ancient with modern pagan art, that of pre-Christian Greece with the recently discovered art of Japan. Whistler's own communion of art, with the pagan past and the modern pagan present, was also Baudelaire's legacy passed on to him by Swinburne.

Like 'Ave Atque Vale' for Swinburne, *The Six Projects* is Whistler's memorial to Baudelaire, 'Pauvre Baudelaire!' in his letter to Fantin written the year in which Ingres and Baudelaire had both died.[60] For in his review of *Les Fleurs du mal* in 1862 Swinburne had compared Ingres with Baudelaire, in whose work Swinburne noticed 'a quality of *drawing* [Swinburne's emphasis] which recalls the exquisite power in the same way of great French artists now living. His studies are admirable for truth and grace; his figure-painting has the ease and strength, the trained skill, and beautiful gentle justice of manner, which come out in such pictures as the "Source" of Ingres.' After quoting four verses of Baudelaire's 'Chanson d'après-midi', Swinburne concludes: 'Nothing can beat that as a piece of beautiful drawing.'[61] These were the very qualities Whistler coveted for his own art.

The Six Projects have always been regarded as formative works for Whistler. For years he continued to toil over *The Three Girls*, attempting to bring it to completion on a larger scale, always mindful, doubtless, of Ruskin's admonition to the artist that a 'harmony, paint as he will, never can be complete till the last touch is given'.[62] Whistler never satisfactorily resolved the six oil sketches into finished compositions, but always kept them prominently in sight, using them to develop his many later studies in pastel and watercolour.[63] With *The Six Projects*, the chapter of Swinburne's creative involvement in Whistler's art might be said to have closed. But the new aesthetic morality which Swinburne had established for poetry raises further questions concerning Whistler's ambitions for painting. For in rejecting realism as Swinburne had spurned the conventions of nature poetry, Whistler, like Swinburne, also abandoned allegory and substituted myth for it instead. To what extent should we also view Whistler's painting, like Swinburne's poetry, as a mythopoeic art?[64] And what was Whistler's aesthetic authority for the *Nocturnes*, before Ruskin accused them of having none, and art became subject to the rhetoric of theatre in the debate which Whistler instigated to defend them, a mode of defence which Whistler insisted upon long after his public battle had been won?

The Six Projects have always been regarded as prototypes for the *Nocturnes* which Whistler painted next; in an early *Nocturne* of 1872 (YMSM 115) a shadowy figure can still be seen beneath the surface of moonlit Thames water. That *The Six Projects* continued to exercise an aesthetic and material presence over work of a quite different subject and character is suggested by T. R. Way, who remembers seeing a pricked cartoon for *The Three Girls* composition, with the figures outlined in red, on the back of the canvas Whistler used to paint the portrait of his mother, *Arrangement in Grey and Black* (YMSM 101). The circumstances of Whistler painting the first two *Nocturnes* are known precisely. While out rowing on the Thames in August 1871, during a break from sitting for her portrait, Whistler's mother wrote:

> the river in a glow of rare transparency an hour before sunset, he was inspired to begin a picture & rushed upstairs to his Studio, carrying an Easel & brushes, soon I was helping by bringing the … tubes of paint he pointed out that he should use & I

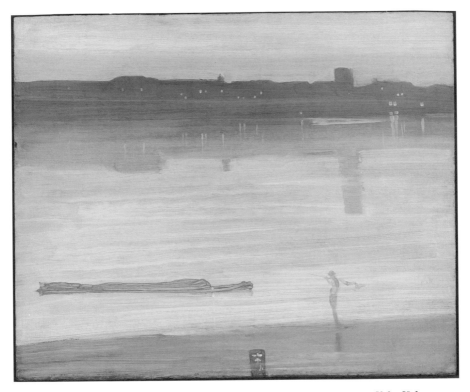

18 James McNeill Whistler, *Nocturne in Blue and Silver – Chelsea*, 1871, oil on canvas, 50.0 x 59.3 cm

[was] so fascinated I hung over his magic touches till the bright moon faced us from the window – & I exclaimed Oh jemie dear it is yet light enough for you to make this a moonlight picture of the Thames.

These two works were first exhibited at the Dudley Gallery in November 1871 as *Harmony in Blue Green – Moonlight* (later known as *Nocturne in Blue and Silver – Chelsea* ([YMSM 103], plate 18) and *Variations in Violet and Green* (YMSM 104) – the same titles as two of *The Six Projects* (see plate 17). It was not until the following winter that Whistler exhibited similar work under the title *Nocturne*, when he wrote to thank F. R. Leyland for suggesting the word: 'it is really so charming and does so *poetically* [my emphasis] say all I want to say and *no more* [Whistler's emphasis] than I wish' (YMSM 117).

Whistler's letter to Leyland suggests a final entry in this catalogue of relationships between Whistler's art and Swinburne's poetry, when Swinburne considered Whistler's art 'second only – *if* second to anything, to the very greatest works of art in any age', and compared a watercolour design of Blake's to one of Whistler's 'symphonies'.[65] Like Whistler's first *Nocturnes*, Swinburne's poem 'Nocturne', written in French, also dates from 1871.[66] In 'Nocturne', night is the cause of pleasure and pain to Swinburne. She brings love by relieving the anguish of the day,

but because she is the mother and daughter of day she also causes pain by her capacity to renew anguish when day breaks again; and the cycle begins anew:

> La nuit écoute et se penche sur l'onde
> Pour y cueillir rien qu'un souffle d'amour;
> Pas de lueur, pas de musique au monde,
> Pas de sommeil pour moi ni de séjour.
> O mère, ô Nuit, de ta source profonde
> Verse-nous, verse enfin l'oubli du jour.
>
> [...]
>
> Moi seul je veille et ne vois dans ce monde
> Que ma douleur qui n'ait point de séjour
> Où s'abriter sur ta rive profonde
> Et s'endormir sous tes yeux loin du jour;
> Je vais toujours cherchant au bord de l'onde
> Le sang du beau pied blessé de l'amour.
>
> La mer est sombre où tu naquis, amour,
> Pleine des pleurs et des sanglots du monde;
> On ne voit plus le gouffre où naît le jour
> Luire et frémir sous ta lueur profonde;
> Mais dans les coeurs d'homme où tu fais séjour
> La douleur monte et baisse comme une onde
>
> Envoi
>
> Fille de l'onde et mère de l'amour,
> Du haut séjour de ta paix profonde
> Sur ce bas monde épands un peu de jour.

In 'Nocturne' Swinburne speaks with the voice of the poet in the first person. Nature will only return his love if he subjects himself to her; only by recognising her '*correspondances*' will nature yield and subject herself to the poet's art. As in *Poems and Ballads*, continual progress without change is the subject of 'Nocturne'. Whistler voiced this central Swinburnian truth when his production of *Nocturnes* was at its height. At a dinner party Whistler gave on 6 January 1876 for Sir Henry Cole and his wife, their son Alan recorded in his diary:

> My father on the innate desire or ambition of some men to be creators, either phys-ical or mental. Whistler considered art had reached a climax with Japanese and Velasquez. He had to admit natural instinct and influence – and the ceaseless chang-ing in all things.[67]

'Ceaseless changing' is the challenge which nature issues to the painter as well as to the poet. The *Nocturnes* had no topographical references in their titles when

they were first exhibited. The formalist emphasis critics placed on them, following Whistler's own defence of his art in the Ruskin trial, has obscured the fact that the *Nocturnes* are Whistler's response to nature, which is confirmed by his mother's vivid description of how he painted the first two.[68] That Whistler's ambition was to achieve what he believed to be a more artistically truthful – and poetic – account of nature, thereby surpassing the conventions of photographic or topographic transcription, is demonstrated by a conversation between Whistler and the scientist Norman Lockyer which was recorded by Alan Cole in December 1871, when the first Nocturnes were on exhibition in London:

> Norman Lockyer & Whistler to dine. They talked about the Spectrum, the action of certain rays on sensitive media like silver on photography. Whistler great in his method of painting what he saw – the necessity of a painter's retention of memory. He seizes the effects [*sic*] & paints it – ordinary painters see an effect – determine to paint it – try to do it, although all the time they are at work the first effect which they wanted has disappeared. Thus by constant changings [*sic*], their pictures are built up of many pictures and have no real unity – Lockyer & Whistler agreed.[69]

Swinburne also recognised in some of Whistler's art the emotional strengths which he expressed with his own, admiring, even after he shut the door in Whistler's face, the 'intensity of pathetic power' in the portrait he painted of his mother, 'which gives to that noble work something of the impressiveness proper to a tragic or elegiac poem'.[70] For with no arrangement of colours other than grey and black could Whistler have expressed, for Swinburne, the 'intense pathos of significance' in the portrait of his mother, who, when Whistler painted it, had passed into the late evening of her years. Swinburne's poem 'Nocturne' has a further place in Whistler's art, for it was the poem Swinburne sent to Mallarmé who published it in *La République des lettres* in 1876, three weeks after Whistler's dinner party for the Coles.[71] According to Swinburne, 'it was received in France with great applause'.[72] Later that year Mallarmé mentioned Whistler – the only foreign artist he included – in his essay published in London, 'The Impressionists and Edouard Manet'.[73] More than ten years would pass before Whistler met Mallarmé, but he would have known of him through Swinburne by 1875.[74]

Whistler's later 'Propositions' – 'The masterpiece should appear as the flower to the painter – perfect in its bud as in its bloom' – echo what Swinburne had written about *The Six Projects* in 1868: 'they seem to have grown as a flower grows, not in any forcing-house of ingenious and laborious cunning'. Whistler's 'Proposition – No. 2' ('The work of the master reeks not of the sweat of the brow – suggests no effort – and is finished from its beginning')[75] recalls the perfection of execution which Swinburne found in Coleridge's 'The Ancient Mariner': 'Here is not the speckless and elaborate finish which shows everywhere the fresh rasp of file or chisel on its smooth and spruce excellence; this is faultless after the fashion of a flower on a tree.'[76] For Swinburne, as for Whistler, the 'artistic faculty' was never 'by any means the same thing as a general capacity for doing good work'.[77]

It is difficult to imagine Whistler drafting the 'Ten o'clock' lecture without a copy of Swinburne's *Blake* at his elbow; his prose catches more than a little of the syntactical cadences and alliteration of Swinburne's style. Both accept Baudelaire's 'heresy of didacticism' to sustain art's moral integrity. 'Art', Swinburne writes in *Blake*, 'will help in nothing.... Handmaid of religion, exponent of duty, servant of fact, pioneer of morality, she cannot in any way become; she would be none of these things though you were to bray her in a mortar.'[78] 'Art', for Whistler, was 'a goddess of dainty thought – reticent of habit, abjuring all obtrusiveness, purposing in no way to better others. She is, withal, selfishly occupied with her own perfection only – having no desire to teach – seeking and finding the beautiful in all conditions and in all times.'[79] Like Swinburne, for whom 'Philistia had far better ... crush art at once, hang or burn it out of the way, than think of plucking out its eyes and setting it to grind corn in the Philistine mills',[80] Whistler offers no compromise between art and society, no ideological pretence of art as a cultural or social panacea: 'no reproach to the most finished scholar or greatest gentleman ... that he be absolutely without eye for painting or ear for music.... Far from me to purpose to bridge it over – that the pestered people be pushed across. No! I would save them from further fatigue.'[81]

In approaching Theodore Watts-Dunton to ask Swinburne to review his lecture, Whistler had few doubts. Had not Swinburne stated that: 'Artists alone are fully competent to deliver sentence by authority'? If not, why had Swinburne prefaced the very first chapter of his *Blake* with a quotation from Baudelaire: 'All great poets naturally and inevitably become critics.... It would be amazing if a critic became a poet, whereas it is impossible for a poet not to have a critic inside him'?[82] The story later put about by Watts-Dunton, that Swinburne would be too busy to write a review, when Whistler pleaded with Watts-Dunton to ask him, was either a desperate bid to avoid a disaster or a grace-saving attempt to distance himself from the savagery his famous lodger unleashed against their equally famous mutual friend.[83] Is it not more likely that Swinburne, who knew his writing for the *Fortnightly Review* was keenly appreciated, pounced on the opportunity to prove to the world that he was still well, very much alive, and living in Putney? Although always cast as the last curtain call in the aesthetic drama, the celebrated quarrel of Whistler and Swinburne was more the ritualised reenactment of a long-running double act, in which the leading players pretended that they had forgotten each other's lines. While sustaining a last act with such unrelenting bravura and conviction, any departure from the original script suggests there had once been some awkward differences holding it together. In his edited version of Swinburne's review for *The Gentle Art*, Whistler allows us to glimpse these differences by printing marginal 'reflections' to signpost them; each one is accompanied by a manically dancing butterfly.[84]

In *The Gentle Art* Whistler omits much of Swinburne's praise, and does not shirk the final examination in aesthetic logic which Swinburne sets him. If Japanese art confines itself only to decoration, that which can be 'broidered on the

fan', as Whistler says in his lecture, Swinburne cannot accept his theory which concedes 'to Greek art a place beside Japanese'. By this 'principle of artistic limitation', Whistler's theory must 'condemn high art', including Greek sculpture and Velasquez, as well as Raphael and Titian – art 'which may be so degenerate and so debased as to concern itself with a story or a subject'. 'Assuredly Phidias thought of other things than "arrangements" in marble – as certainly as Aeschylus thought of other things than "arrangements" in metre.' To Swinburne, Whistler's portraits of his mother and of Carlyle (YMSM 137) are more than merely decorative; they have qualities 'which actually appeal to the intelligence and the emotions, to the mind and heart of the spectator'. Swinburne admits in the same breath that he finds Whistler's decorative Japonisme, the 'merest "arrangements" in colour', to be 'lovely and effective'; but he does not, or cannot, say what these effects are, nor in what manner he is affected by them, as he claimed he was by *The Six Projects* in 1868. Whistler consequently 'reflects' that, for Swinburne, 'the lovely is not necessarily "effective"', and concludes: 'The "lovely", therefore, confessedly does not appeal to the intelligence, emotions, mind, and heart of the Bard even when aided by the "effective".'

Swinburne's 'senses', the consideration of the nature of instinct, a complex machinery encompassing emotion and intellect, remained finally unmoved by Whistler's 'merest "arrangements" in colour'; those existed only in paint, lacked any intellectual content and, like Japanese art for Swinburne, were no more than decorative objects. 'Because the Bard is blind', asks Whistler, 'shall the Painter cease to see?' Whistler implies that Swinburne thinks of painting as a mechanical rather than a liberal art, its purpose still essentially illustrative, as in the case of Velasquez, 'whose "miraculous power of hand"', Swinburne writes, makes 'beautiful for us the deformity of dwarfs, and dignifies the degradation of princes'. After the word 'hand' Whistler adds '(?)' and the 'reflection': 'Quite hopeless!'[85]

Although he owed most to Romanticism, Swinburne's grounding in classicism utlimately prevented him from accepting Whistler's art, which is why its 'effect' finally failed to affect him. The positive qualities of intellect and emotion, which Swinburne acknowledged in Whistler's portraits, reflect not only his belief that 'expression is not to be considered apart from the substance',[86] but also his adherence to the Aristotelian view of tragedy: 'this eternal canon of tragic art, the law which defines terror and pity as its only proper objects'.[87] When Swinburne wrote about Michelangelo, in the same year that he wrote about Whistler, his points of critical comparison were Aeschylus and Shakespeare.[88] For Whistler's 'gospel of the grin', 'unquestionably calculated to provoke the loudest and the heartiest mirth ... is this – that "Art and Joy go together", *and that tragic art is not art at all*'.[89] By italicising this last clause of Swinburne's for *The Gentle Art*, and asking 'At what point of my "O'Clock" does Mr Swinburne find this last – his own inconsequence?', Whistler takes a side-sweep at Swinburne's reliance on classical theory. At the same time he mocks Swinburne's claim to Romantic authority by vigorously hurling Keats back in his face: 'The Bard's reasoning is of the People. His

Tragedy is *theirs*. As one of them, The *man* may weep – yet will the artist rejoice – for to him is not "A thing of beauty a joy for ever"?'[90]

Whistler almost certainly consulted Swinburne over his libel action with Ruskin,[91] and over the 'Ten o'clock' lecture Ruskin inevitably casts his shadow. Swinburne would have known that when Whistler spoke in his lecture of the 'aesthete' as a product of 'Vulgarity', a 'meddler', 'under whose fascinating influence "the many" have elbowed "the few"', he not only condemned Oscar Wilde and fashionable 'aesthetic' critics, but also Ruskin who Whistler believed had influenced them.[92] Whistler, Swinburne sarcastically suggests, must be ignorant of the true definition of the word 'aesthete': 'an intelligent, appreciative, quick-witted person; in a word as the lexicon has it, "one who perceives"'. He thus indicts Whistler as its antithesis – 'a thick-witted, tasteless, senseless and impenetrable blockhead'. Such uncompromising criticism was motivated by Swinburne's sympathy in his later years for Ruskin and Burne-Jones.[93] Swinburne would have thought absurd and heretical Whistler's insistence, since 1878, on art as 'science'. In *Blake*, he had famously asserted that 'the betrothal of art and science were a thing harder to bring about and more profitless to proclaim than "the marriage of heaven and hell"'.[94] Whistler assumed that Swinburne's 'art for art's sake' argument implicitly served the purpose of social criticism, for both inherited from Poe and Baudelaire a detestation of the philosophy of progress.[95] While Whistler, like Baudelaire, as quoted by Swinburne in *Blake*, did not believe that art could 'assume the mantle of science or morals',[96] Whistler was persuaded of the advantage of encouraging his audience to identify avant-garde art with current advances made in the sciences.[97]

In the 'Ten o'clock', Swinburne sensed Whistler's ambition to be a part of society but remain apart from it. He obviously thought the lecture was more an exercise in public relations than a serious statement about art. Reciprocally, Whistler's claim to have lost a 'confrère' but 'gained an acquaintance – one Algernon Swinburne – "outsider" – Putney',[98] in the year that Gauguin painted *The Vision after the Sermon* and Whistler was planning art with Mallarmé, implied that he thought Swinburne only had a taste for the worst kind of modern painting, the trivial and the anecdotal which appealed to the masses, a development for which Whistler believed Ruskin was responsible.

Even the most charitable reading of Swinburne's review must consider it was a calculated 'hatchet job', designed at best to expose Whistler as 'a jester of genius', at worst to reduce him, in Whistler's words, adding to Swinburne's own, to 'a tumbler and a clown of the booths'. In his final analysis Swinburne does not dismiss the incompatibility he finds between Whistler's art and theory, and quotes Sganarelle from Molière's *L'Amour médecin*: '"You are a jeweller M. Josse".[99] That worthy tradesman, it will be remembered, was of opinion that nothing could be so well calculated to restore a drooping young lady to mental and physical health as the present of a handsome set of jewels. *Mr Whistler's opinion that there is nothing like leather – of a jovial and Japanese design – savours somewhat of the Oriental*

cordwainer [Whistler's emphasis].'[100] Refusing 'to accept "The Preacher" as a prophet', Swinburne implies that Whistler has 'sold out'. In his formal riposte in *The Gentle Art*, 'Et tu, Brute!', Whistler turns the tables, by asking of 'the man who wrote *Atalanta* – and the *Ballads* beautiful': 'Is life then so long with him, and *his* art so short, that he shall dawdle by the way and wander from his path, reducing his giant intellect...?' By taking up 'the parable of the mob', and proclaiming himself 'their spokesman and fellow-sufferer', Whistler reminds Swinburne, stealthily parodying *Poems and Ballads*, that he had once been the great iconoclastic poet for the elect few, but no longer was: 'O Brother! where is thy sting! O Poet! where is thy victory! ... Do we not speak the same language? Are we strangers, then, or, in our father's house are there so many mansions that you lose your way, my brother, and cannot recognize your kin?'[101]

In his essay on George Chapman, Swinburne had expressed an organic view of literature which presupposed a unity of form and content.[102] Ironically, the charge which Swinburne levelled against Whistler – that surface decoration rather than content of substance characterised his art – was an accusation which some critics levelled at Swinburne's later poetry. In a review of Swinburne's *Studies in Song* in 1881, George Moore criticised Swinburne's 'abstractions', advising him to return to nature if he hoped to write any more lasting verse.[103] But it was Oscar Wilde, a year after Swinburne parted company with Whistler, who made the most forceful case against Swinburne. In his review of Swinburne's third series of *Poems and Ballads* in 1889, Wilde complained that 'his song is nearly always too loud for his subject. His magnificent rhetoric ... conceals rather than reveals ... he is a master of language, but with still greater truth it may be said that Language is his master.... We have often had man's interpretation of Nature; now we have Nature's interpretation of man, and she has curiously little to say.'[104]

Studies of Whistler, like those of Swinburne, have often favoured their early rather than their later work. In Whistler's case it has gone unnoticed that in 1892 he brought a radical change to his use of titles. Before 1892 Whistler had avoided topographical titles for the *Nocturnes*, but in his Goupil Gallery exhibition of 1892 he subtitled all but one with place names: Chelsea, Battersea, Westminster etc.[105] Although factors such as the reaction of Whistler to Mallarmé and Wilde, which lie outside the scope of this essay, deserve consideration in accounting for this change, a need to disassociate his work from the wilder excesses of formalism, the 1890s equivalent of 'art for art's sake', exemplified by the art of some of his own 'followers', might well have played a part.[106] Appearing to react against himself by suggesting that the *Nocturnes* might be more than what Swinburne called the '"merest" arrangements in colour', and that they could also be read as 'portraits of a place', enabled Whistler to remain aloof from the 'new' art criticism, as well as to keep his distance from Wilde.[107]

Leaving their public rhetoric aside, it is difficult not to conclude that, in asking Swinburne to pass judgement on him, Whistler seriously overlooked those aspects of his friend's professional career which had influenced Swinburne's critical

writing. For the reductivist attitude Swinburne accused Whistler of adopting in his art had once been unacceptable to Swinburne in respect of criticisms which had been made about his own. As the perceived leader of the 'Fleshly School' Swinburne had stood accused of a similar reductivism in respect of 'art for art's sake'.[108] In his essay on Victor Hugo in 1872 Swinburne had revised his views, by qualifying them in a more conservative vein than his response to his critics in 1866. In the essay, Swinburne showed the limitations of 'art for art's sake' to disassociate himself from the 'negative' aspects of aestheticism by which his detractors had mercilessly pilloried him, and to accommodate his intense admiration for those writers, such as Hugo, whose art engaged politics and ideologies.[109] Professing that art is always independent of society and politically unengaged, Whistler's assertion, 'False again, the fabled link between the grandeur of Art and the glories and virtues of the State',[110] would be viewed by Swinburne as a caricature of his beliefs.

For his part, Swinburne was equally forgetful of his experience of Whistler's art, and his knowledge of the difficulties of Whistler's career, which were not so dissimilar from his own.[111] For all his disapproval of Whistler's glittering public life, of which Swinburne's entombment in 'The Pines' was the antithesis, he had a first-hand experience of Whistler's technical struggle to record his sensations in front of nature (see plate 12), which became an obsession second only to Cézanne's quest after the same elusive truths. Like Swinburne's virtuoso performances in poetry, Whistler also expected nature to sing in painting.[112] For Whistler, Swinburne had betrayed his Romantic authority over the unity of Art, which he had expressed in his synaesthetic poetry and prose, by refusing Whistler the same freedom of authority over his own painting. For Swinburne, Whistler's lecture showed that he could not substantiate his claim, first expressed at the time of the Ruskin trial, that only a painter was qualified to pass an opinion on painting.[113] But the stakes had already been raised much higher by Wilde, who was present when Whistler gave the 'Ten o'clock', and who stingingly attacked Whistler's claim: 'Nor do I accept the dictum that only a painter is a judge of painting. I say that only an artist is a judge of art; there is a wide difference ... the poet is the supreme artist.'[114] However desperately Whistler implored Swinburne – 'Do we not speak the same language?' – the vision they shared never made them equals in art, an inequality which Wilde continued to exploit at Whistler's expense.[115] In reviewing the evidence presented here, we might reasonably suppose that Whistler learned more as a painter from Swinburne, than Swinburne as a poet ever did from Whistler.[116]

Swinburne's greatest gift to Whistler was not 'art for art's sake', but its source, the 'heresy of didacticism', first expressed by Whistler's fellow countryman Poe, borrowed by Baudelaire, and given critical currency in English art and letters by Swinburne in his book on William Blake. Had he not given full rein to the 'heresy of didacticism', Whistler the artist as critic would be unimaginable. By publicly challenging Ruskin as 'the Preacher "appointed" ... Sage of the Universities' and 'the populariser of pictures ... the Peter Parley of painting',[117] Whistler rescued

himself from what could have been a footnote in history. When Swinburne withdrew his brother's licence to teach the 'heresy of didacticism', because he believed he had abused it, he also cut Whistler adrift from the legacy of Poe and of Baudelaire, and from the 'communion' they shared, which linked their modernist art to that of their illustrious predecessors. It was natural for Whistler to turn to Mallarmé, who was Baudelaire's spiritual heir, and escape from Swinburne and Wilde.[118]

I have suggested elsewhere that Whistler first turned to Swinburne to show that a painter could inspire a poet, after his first *Symphony*, *The White Girl* (YMSM 38) had been publicly criticised for its lack of resemblance to Wilkie Collins's popular novel *The Woman in White*.[119] Yet forty years later, Whistler's very last utterance on Swinburne, made in 1902 (a year before Whistler's death), still addressed the issue of whether primacy of inspiration belonged to the painter or to the poet.[120] Such a distinction was no longer contested, as modernist painters and poets increasingly sought a common language for their art.[121] By the 1890s the idea which Swinburne had presented of the 'perfect artist' in his review of Baudelaire in 1862 had emerged as the 'decadent poet'.[122] Unquestionably, the most decadent of poets and the new master of language was Mallarmé, with whom Whistler established a new role for painting and poetry which they bequeathed to the art of the new century. The void which Swinburne's poetry filled so noisily was enlarged to the comparative sound of silence.

Notes

I am grateful to Elizabeth Ogilvie for her very valuable comments on a first draft of this essay. For paintings by Whistler, cited here by YMSM number, see A. McLaren Young, M. MacDonald, R. Spencer, with the assistance of H. Miles, *The Paintings of James McNeill Whistler* (New Haven and London, Yale University Press, 1980).

1 A. C. Swinburne, 'Charles Baudelaire: *Les Fleurs du mal*', *Spectator* (6 September 1862) 998–1000, repr. in C. K. Hyder (ed.), *Swinburne as Critic* (London and Boston, Routledge & Kegan Paul, 1972), pp. 27–36.

2 P. Clements, 'Swinburne', in *Baudelaire and the English Tradition* (Princeton, Princeton University Press, 1985), pp. 10–76.

3 For Swinburne's critical reception see C. K. Hyder (ed.), *Swinburne: The Critical Heritage* (London, Routledge & Kegan Paul, 1970), pp. xxviii–xxix.

4 'L'hérésie de l'enseignement', first named by Poe in 'The poetic principle', is quoted by Baudelaire in his *Notes nouvelles sur Edgar Poe*. See *Baudelaire: Oeuvres complètes*, ed. Claude Pichois, 2 vols (Paris, Gallimard, 1975–76), II, p. 333; quoted in Clements, *Baudelaire*, pp. 38, 393 and *passim*

5 A. C. Swinburne, *William Blake: A Critical Essay*, 2nd edn (London, John Camden Hotten, 1868). Baudelaire's 'l'hérésie de l'enseignement' is quoted by Swinburne on p. 91.

6 Clements, *Baudelaire*, p. 30.

7 'il n' y a que les poètes pour bien comprendre les poètes', quoted in Clements, *Baudelaire*, p. 26.

 8 Swinburne, *William Blake*, p. 110.
 9 Whistler's views on current political issues are recorded by E. R. and J. Pennell, *The Life of James McNeill Whistler*, 2 vols (London and Philadelphia, William Heinemann and J. B. Lippincott, 1908), particularly vol. II, *passim*. For commentary on Swinburne see P. Henderson, *Swinburne: The Portrait of a Poet* (London, Routledge & Kegan Paul, 1974).
10 To Swinburne, always in search of surrogate parents, the Whistler household must have seemed a haven of domestic tranquillity compared with the rackety goings-on at Rossetti's; on one occasion Mrs Whistler extended maternal solicitude to Swinburne when he was ill. Rather than having any perverse Christological significance, I believe that Swinburne's mode of addressing Whistler as 'cher père' reflects this perception; if I am right, any letters he wrote to Mrs Whistler would have been addressed 'chère mère' (none survive).
11 After painting a 'harmony in blue' for Ruskin in 1863, Burne-Jones then painted an *Annunciation* for the Dalziel brothers as a 'harmony in red', which was exhibited at the Old Water-Colour Society in April 1864; repr. in colour, in M. Harrison and B. Waters, *Burne-Jones* (London, Barrie & Jenkins, 1989), facing p. 56.
12 Quoted in J. Stoddart, 'The morality of *Poems and Ballads*: Swinburne and Ruskin', in R. Rooksby and N. Shrimpton (eds), *The Whole Music of Passion: New Essays on Swinburne* (Aldershot, Scolar, 1993), p. 94.
13 D. G. Riede, *Swinburne: A Study of Romantic Mythmaking* (Charlottesville, University Press of Virginia, 1978), p. 28.
14 Swinburne, *William Blake*, p. 91.
15 C. Y. Lang (ed.), *The Swinburne Letters*, 6 vols (New Haven and London, Yale University Press and Oxford University Press, 1959–62), I, p. 130.
16 Ibid., pp. 118–20.
17 Ibid., p. 130. Swinburne may have been disingenuous in crediting primacy of conception to Whistler; his letter was probably as much a ploy at Whistler's behest to solicit Ruskin's interest in his art as for Swinburne to please Ruskin with his own.
18 'le meilleur compte rendu d'un tableau pourra être un sonnet ou un élégie'. *Baudelaire: Oeuvres complètes*, II, p. 418, quoted in Clements, *Baudelaire*, p. 114, but not, as Clements states, quoted by Swinburne at the head of his *William Blake*.
19 Swinburne's essay on Hugo's 'L'Année terrible' (1872 and 1875), quoted in Hyder, *Swinburne as Critic*, p. 149.
20 R. Spencer, 'Whistler's "The White Girl": painting, poetry and meaning', *Burlington Magazine*, 140:1142 (May 1998) 300–11.
21 'Before the Mirror (Verses Written under a Picture) Inscribed to J. A. Whistler', *The Poems of Algernon Charles Swinburne*, 6 vols (London, Chatto & Windus, 1904), I (*Poems and Ballads*, First Series), pp. 129–31.
22 J. J. McGann, *Swinburne: An Experiment in Criticism* (Chicago and London, University of Chicago Press, 1972), pp. 176–7.
23 Stoddart, 'The morality of *Poems and Ballads*', p. 103.
24 Riede, *Swinburne*, p. 45.
25 Hyder, *Swinburne as Critic*, p. 28; Clements, *Baudelaire*, p. 53.
26 J. Ruskin, *The Works of John Ruskin*, Library Edition, ed. E. T. Cook and A. Wedderburn, 39 vols (London, George Allen, 1903–12), VII, pp. 260–2.

27 Ibid., p. 224.

28 T. E. Connolly, 'The music of poetry', in *Swinburne's Theory of Poetry* (Albany, State University of New York, 1964), quoted in Hyder, *Swinburne as Critic*, p. 10.

29 Ruskin, *Works*, VII, p. 217.

30 Ibid., pp. 236, 247.

31 'un progrès vraiment énorme' ... 'C'est surtout la composition qui m'occupe' ... 'l'arrangement de deux bras sur le canapé comme ça __, Whistler to Fantin-Latour, section of letter dated 'Aout le 16' [1865], E. R. and J. Pennell Collection of Whistler Manuscripts, Library of Congress, Washington DC.

32 Whistler removed Swinburne's verses when he had the picture reframed in 1892. See YMSM 52.

33 For John Gerald Potter's patronage and relationship with Whistler see R. Spencer, 'Whistler's early relations with Britain and the significance of industry and commerce for his art, parts I and II', *Burlington Magazine*, 136 (April and October 1994) 212–24, 664–74.

34 A. C. Swinburne, *Notes on Some Pictures of 1868*, repr. in *Essays and Studies* (London, Chatto & Windus, 1875), pp. 358–80. *The Three Girls* (YMSM 87), exhibited by Whistler in 1887–88 as *Symphony in White and Red*, has also been referred to as *Symphony in White, No. IV*. Several versions, and enlargements of it, including one in the Tate Gallery (*Pink and Grey: Three Figures*, YMSM 89) are recorded (see YMSM 88–90). *The Three Girls* was the only one of *The Six Projects* to be enlarged; Whistler worked on it intermittently in the 1870s, and probably later.

35 For Swinburne's critics and his response to them in *Notes on Poems and Reviews*, see Hyder, *Swinburne: The Critical Heritage*, pp. 49–56.

36 Riede, *Swinburne*, p. 43.

37 Hyder, *Swinburne: The Critical Heritage*, p. 55.

38 *The Poems of Swinburne*, I, pp. 169–72.

39 For Swinburne's praise of Watts's *Wife of Pygmalion*, in *Notes on Some Pictures of 1868*, see R. Peters, *The Crowns of Apollo: A Study in Victorian Criticism and Aesthetics* (Detroit, Wayne State University Press, 1965), p. 103.

40 Clements, 'Swinburne', in *Baudelaire* and *passim*.

41 The photograph, in the George Lucas Collection, Baltimore, shows minor alterations to the drapery and the flowers; see YMSM 61. The photograph could have been seen in Paris, where Lucas lived, or through the agency of Fantin-Latour, to whom Whistler may also have given the photograph before Fantin saw the picture in Paris early in 1867. I examine the question of Courbet's realism, and its relationship to the subject-matter of Whistler, Swinburne and French writers, in a forthcoming essay.

42 'un peu nuage, c'est comme un rêve', Fantin-Latour to Whistler, 'Mardi 12 Fevr. [18]67', Birnie Philip Bequest, Glasgow University Library. See YMSM 61.

43 'un poète, ami de Whistler, un ivrogne, un débauche ... il ne faut pas dire cela Whistler, mais ce Swinburne c'est un faux Byron, un imitateur des défauts des grands talents ... pleins de saletés, d'impureté sans la moindre enveloppe – tout haut il écrit des choses sur les femmes qu'on ne doit pas penser.... Voici ce qui est amusant, et la drôle de manière dont ces demoiselles Spartali ont mis leurs pieds dans tout ces ordures – (Je crois que c'est une de ces 2 demoiselles qui a posé pour Whistler dans sa princesse du pays de Porcelaine) – le jour que ce volume a paru elles sont aller partout

annoncantes cet Evangile qu'elles venaient de lire cela, que c'etait magnifique, rien de plus grand, d'une délicatesse, vous savez tous les mots impossibles – six jours après est arrivé cet orage et les editeurs ayant vu cela pour la première fois se lavent les mains de l'affaire en écrivant aux rédacteurs de tous les principaux journaux, ainsi il etait évident à tout le monde que où ces demoiselles avaient tant approuvés des choses infâmes, ou bien celles n'avaient pas lu l'ouvrage ou l'ayant lu n'ont pas compris. – Il y a des livres on sait bien que c'est une vertu pour une demoiselle de ne pas pouvoir comprendre, mais dans ce livre de Swinburne il n' y a pas ce trou pour échapper, car la tendance du livre, l'esprit et l'objet, c'etait une protestation contre tout', Edwin Edwards to Fantin-Latour, 'Sunbury, Dimanche soir, Mars 1867', letter in private collection. In fact Fantin would have already had an opinion about Swinburne, whom he met when Swinburne was in Paris with Whistler in March 1863 (see below note 74). In 1864 Whistler had suggested to Fantin that he might include Swinburne's portrait together with Dante Gabriel Rossetti's in Fantin's *Hommage à Delacroix*; but neither was included.

44 The Spartali family had rejected two of Fantin's still-lifes because they thought his art was becoming repetitive; Edwards was also piqued by Greek patrons because Madame Cassavetti had failed to sell two of his paintings. Christine Spartali had posed for Whistler (see YMSM 50) in 1863–64; and on meeting her sister Marie Spartali (who was a pupil of Ford Madox Brown and an exhibitor at the Dudley Gallery) Swinburne is reputed to have said: 'She is so beautiful that I want to sit down and cry'; W. Graham Robertson, *Time Was* (London, Hamish Hamilton, 1931), p. 13.

45 For Edwin Edwards and Manet see R. Spencer, 'Manet, Rossetti, London and Derby Day', *Burlington Magazine*, 133 (April 1991) 228–33.

46 Lang, *Swinburne Letters*, II, pp. 20–1. According to Ezra Pound, Whistler told the Committee: 'You ought to be proud that there is in London a club where the greatest poet of our time can get drunk, if he wants to, otherwise he might lie in the gutter', E. Pound, 'Swinburne versus his biographers', *Literary Essays* (London, 1954), p. 291.

47 Hyder, *Swinburne: The Critical Heritage*, p. 54.

48 *The Poems of Swinburne*, I, pp. 173–8.

49 Riede, *Swinburne*, p. 69.

50 *The Poems of Swinburne*, III (*Poems and Ballads*, Second Series [1878]), pp. 50–7.

51 Riede, *Swinburne*, p. 75.

52 Swinburne, *Essays and Studies*, p. 373.

53 'que le son ne peut pas suggérer la couleur, que les couleurs ne pussent pas donner l'idée d'une mélodie, et que le son et la couleur fussent impropres à traduire des idées', *Baudelaire: Oeuvres complètes*, II, p. 784, quoted in Clements, *Baudelaire*, p. 121. Whistler further indicates his synaesthetic intentions by inscribing the opening bars from the third of Schubert's piano pieces, *Moments Musicaux* (Allegro Moderato in F minor), Opus 94, on the frame intended for the enlargement of *The Three Girls* composition. Whistler is also recorded as stating that his intention for the same composition was to produce 'a harmony of colour corresponding to Beethoven's harmonies in sound'; see YMSM 88.

54 Swinburne, *Essays and Studies*, p. 373.

55 'fournir chacun une continuation des vraies traditions de la peinture au 19 ème siècle', Whistler to Fantin-Latour, letter cited above, note 31.

56 'pas du tout Grec', Whistler to Fantin-Latour, '2 Lindsey Row. Old Battersea bridge Chelsea. London', n.d. [1867]. E. R. and J. Pennell Collection of Whistler Manuscripts, Library of Congress, Washington DC.

57 Peters, *The Crowns of Apollo*, pp. 142–3. 'Hermaphroditus' is annotated by Swinburne: 'Au Musée du Louvre, Mars 1863', *The Poems of Swinburne*, I, pp. 79–81.

58 W. Pater, 'Winckelmann', *Westminster Review*, n.s. 31 (January 1867) 80–110.

59 'La couleur' … 'c'est le vice!' … 'une des plus belles virtus' … 'bien guidé par son maître le dessin – la couleur est une fille splendide avec un époux digne d'elle – son amant mais aussi son maître – la maîtresse la plus magnifique possible! – et le résultat se voit dans toutes les belles choses produitent par leur union!' [*sic*], Whistler to Fantin-Latour, letter cited above, note 56. Whistler demonstrated his ambition to resolve this conflict when painting an enlargement of *The Three Girls* which, Whistler explained to Alan Cole, 'was an arrangement he wanted to paint, and he then drew, with a sweep of the brush, the back of the stooping figure to show what he meant', E. R. and J. Pennell, *The Life of Whistler*, I, p. 149.

60 Whistler to Fantin-Latour, 1867, letter cited above, note 56. Because of Whistler's reference to Baudelaire, the letter is usually thought to have been written soon after Baudelaire's death on 31 August 1867.

61 Hyder, *Swinburne as Critic*, p. 31.

62 Ruskin, *Works*, VII, p. 247.

63 M. MacDonald, *James McNeill Whistler: Drawings, Pastels, Watercolours: A Catalogue Raisonné* (New Haven and London, Yale University Press, 1995).

64 Riede, *Swinburne*, pp. 36–40.

65 Lang, *Swinburne Letters*, II, pp. 297–8, 310.

66 'Nocturne' is first mentioned by Swinburne in November 1871, *The Swinburne Letters*, II, p. 172; *The Poems of Swinburne*, III (*Poems and Ballads*, Second Series [1879]), pp. 155–6.

67 E. R. and J. Pennell, *The Life of Whistler*, I, p. 189.

68 Albert Moore, who knew Whistler better than any artist, emphasised his powers of originality as a painter of nature in his testimony at the Ruskin trial: 'There is one extraordinary thing about them [the *Nocturnes*], and that is that he has painted the air, which very few artists have attempted. I think the sensation of atmosphere in the bridge picture [*Nocturne in Blue and Silver*, YMSM 140] very remarkable. As to the picture in black and gold [*The Falling Rocket*, YMSM 170] I think the atmospheric effects are simply marvellous'; see L. Merrill, *A Pot of Paint: Aesthetics on Trial in Whistler v. Ruskin* (Washington and London, Smithsonian Institution Press, 1992), p. 158.

69 Alan Cole's diary, 4 December 1871 (copy) in E. R. and J. Pennell Collection of Whistler Manuscripts, Library of Congress, Washington DC. Sir (Joseph) Norman Lockyer (1836–1920), scientist and astronomer, made pioneer observations of solar spectronomy, in 1070 he was secretary to the Royal Commission on Scientific Instruction and Advancement of Science, and later transferred to the science and art department at South Kensington. The Pennells believed Whistler's practice of working on the *Nocturnes* from memory derived from his knowledge of the 'memory training' of the French teacher and theorist Lecocq de Boisbaudran; see E. R and J. Pennell, *The Life of Whistler*, I, pp. 44, 66.

70 A. C. Swinburne, 'Mr Whistler's lecture on art', *Fortnightly Review*, 49 (June 1888) 250–62.

71 Lang, *Swinburne Letters*, III, pp. 115, 132–4.

72 Ibid., p. 155.

73 S. Mallarmé, 'The Impressionists and Edouard Manet', *The Art Monthly Review and Photographic Portfolio: A Magazine Devoted to the Fine and Industrial Arts and Illustrated by Photography*, 1:9 (30 September 1876) 117–22; repr. in C. S. Moffett, *The New Painting: Impressionism 1874–1886*, exh. cat. (Seattle, University of Washington Press, 1986), pp. 27–35.

74 Lang, *Swinburne Letters*, III, p. 42. In his letter to Mallarmé of 7 July 1875, thanking him for the gift of his translation of Poe's 'The Raven' illustrated by Manet, Swinburne describes how he was introduced to Manet by Whistler and Fantin in Paris in 1863. Mallarmé would have known of Whistler through Manet; he may have seen the exhibition of Whistler's recent work held at Durand-Ruel's gallery in the rue Lafitte early in 1873.

75 J. M. Whistler, 'Proposition – No. 2', first published in 1884; repr. in J. M. Whistler, *The Gentle Art of Making Enemies* (London, William Heinemann, 1892), pp. 115–16.

76 Swinburne's 'Coleridge', first published in 1869, repr. in *Essays and Studies* (1875); Hyder, *Swinburne as Critic*, p. 138.

77 Swinburne, *William Blake*, p. 87.

78 Ibid., p. 90.

79 Whistler, *Ten O'Clock Lecture* (London, Chatto & Windus, 1885 and 1888); repr. as 'Mr Whistler's "Ten o'clock"', in Whistler, *The Gentle Art*, pp. 135–59.

80 Swinburne, *William Blake*, p. 93.

81 Whistler, 'Mr. Whistler's "Ten o'clock"', *The Gentle Art*, pp. 150–1.

82 'Tous les grands poètes deviennent naturellement, fatalement, critiques.... Il serait prodigieux qu'un critique devînt poète, et il est impossible qu'un poète ne contienne pas un critique', *Richard Wagner et Tannhäuser à Paris*, in *Baudelaire: Oeuvres complètes*, II, p. 793, quoted in Swinburne, *William Blake*, p. 1; Clements, *Baudelaire*, pp. 37–8.

83 It appears that Watts-Dunton first told this story, probably around 1899, to Max Beerbohm who published it in his famous essay, 'No. 2. The Pines', in *And Even Now* (Melbourne, London, Toronto, 1920), pp. 82–3. Before publication Beerbohm sent it to Edmund Gosse who made partial use of the information in *The Life of Algernon Charles Swinburne* (London, Macmillan, 1917), pp. 272–3. Further reactions of Swinburne and Whistler to each other at the time of their quarrel in 1888 are given by E. R. and J. Pennell, *The Life of Whistler*, II, pp. 45–6.

84 Whistler, 'An apostasy', in *The Gentle Art*, pp. 250–8.

85 Ibid., p. 251.

86 A. C. Swinburne, *George Chapman: A Critical Essay* (1875), repr. and quoted in Hyder, *Swinburne as Critic*, pp. 11, 249–52.

87 A. C. Swinburne, *A Study of Ben Jonson* (1888–89), repr. and quoted in Hyder, *Swinburne as Critic*, pp. 11, 274–7.

88 A. C. Swinburne, 'Notes on designs of the Old Masters at Florence' (1868 and 1875), repr. and quoted in Hyder, *Swinburne as Critic*, pp. 125–30.

89 Whistler's 'Art and Joy go together' is very close to the spirit of Swinburne's 'Nothing which leaves us depressed is a true work of art. We must have light though it be

lightning, and air though it be storm', A. C. Swinburne, 'Matthew Arnold's New Poems' (1867 and 1875), repr. in Hyder, *Swinburne as Critic*, pp. 53–100.

90 Whistler, 'An apostasy', in *The Gentle Art*, p. 255.

91 On 7 August 1877, shortly after Ruskin published his criticism, Whistler asked Swinburne to dine with him and Algernon Bertram Mitford; see Lang, *Swinburne Letters*, IV, pp. 14–15. There is insufficient evidence to hand to judge whether Swinburne's sympathies would have been with Whistler or Ruskin in 1877; perhaps his loyalties would have been divided equally. By the time the Whistler–Ruskin action came to court the following November, Swinburne would have been too debilitated by drink to be of any real assistance to either of his friends.

92 Even Swinburne's praise of one of Whistler's epigrams in the 'Ten o'clock' was qualified by the 'put down' that it was 'flashed out on us from every great or characteristic work of Turner'. Swinburne would have been conscious that he was giving offence to Whistler because of Turner's association with Ruskin.

93 Lang, *Swinburne Letters*, V, pp. 20–1.

94 Swinburne, *William Blake*, p. 98.

95 Clements, *Baudelaire, passim*.

96 's'assimiler à la science ou à la morale', from Baudelaire's 'Notes nouvelles sur Edgar Poe', *Baudelaire: Oeuvres complètes*, II, p. 333, quoted in Swinburne, *William Blake*, p. 98, and Clements, *Baudelaire*, p. 33.

97 For Whistler's background in engineering, medicine and the sciences see R. Spencer, 'Whistler's early relations with Britain and the significance of industry and commerce for his art. Part I', *Burlington Magazine* 126 (April 1994) 212–24.

98 Whistler, 'What the world says', *The World: A Journal for Men and Women*, 28:727 (6 June 1888) 17, repr. as 'Freeing a last friend', in Whistler, *The Gentle Art*, p. 262.

99 'Vous êtes orfèvre, M. Josse' (Molière).

100 Whistler, 'An apostasy', in *The Gentle Art*, p. 258. Whistler adds the marginal 'reflection': 'A keen commercial summing up – excused by the "Great Emperor!".' See also note 111 below.

101 Whistler, 'Et tu, Brute!', in *The Gentle Art*, pp. 259–61. By all accounts Swinburne never recanted his criticism of Whistler; if anything he became even more entrenched. In 1894 he wrote to Watts-Dunton: 'In the article on Jowett, I spoke of "the art or trick of painting by spots and splashes". I have introduced the words "French or American or Japanese" before the word "art" for greater lucidity.' Lang, *Swinburne Letters*, VI, p. 70.

102 A. C. Swinburne, 'George Chapman' (1875), quoted in Hyder, *Swinburne as Critic*, p. 11.

103 *George Moore: Confessions of a Young Man*, ed. S. Dick (Montreal and London, McGill-Queen's University Press, 1972), pp. 249–50 and *passim*.

104 Unsigned review, 'Mr Swinburne's last volume', *Pall Mall Gazette* 49:7574 (27 June 1889) 3; review of Swinburne, *Poems and Ballads*, Third Series, repr. in R. Ellman (ed.), *The Artist as Critic: Critical Writings of Oscar Wilde* (London, W. H. Allen, 1970), pp. 146–9.

105 'Nocturnes, Marines, and Chevalet Pieces: A Catalogue', in Whistler, *The Gentle Art*, pp. 297–331. The exhibition and catalogue (*The Voice of a People*) were well received, and generally regarded as a turning point in terms of Whistler's critical reputation in

England. Although in private correspondence of the 1870s and 1880s, with collectors, critics and dealers, Whistler often identified the *Nocturnes* by place, in only rare instances between 1872 and 1892 did he publicly exhibit a *Nocturne* of a London subject with a topographical title (see YMSM 204). Readers may want to confirm this for themselves by consulting YMSM. This shift in Whistler's practice may have remained unnoticed because most cataloguers, including YMSM, usually list Whistler's paintings by their last, composite titles, which were given to them by Whistler between 1892 and his death in 1903.

106 What particularly irritated Whistler in his later years was art which critics claimed was 'new', but which Whistler believed consisted of ground he had already covered himself. Such differences were at the heart of Whistler's dispute with Wilde, as well as with some of his 'followers', including Menpes, Sickert and others, over personal as well as professional issues, which are well-documented, both in Whistler's *The Gentle Art* and in E. R. and J. Pennell, *The Life of Whistler*, II, *passim*. For Whistler's 'followers' see the chapter by Anne Koval in this volume (Chapter 4).

107 For the 'new' art criticism of George Moore, D. S. MacColl and others, and their relationship to Impressionism and to Whistler in England, see K. Flint (ed.), *Impressionists in England* (London, Boston, Melbourne and Henley, Routledge & Kegan Paul, 1984) and R. Spencer (ed.) *Whistler: A Retrospective* (New York, Hugh Lauter Levin, 1989).

108 For the 'Fleshly School of Poetry' dispute see Hyder, *Swinburne: The Critical Heritage*, sections III and IV, pp. xxv–xxxv.

109 Swinburne's essay on Hugo's 'L'année terrible' (1872 and 1875), repr. in Hyder, *Swinburne as Critic*, pp. 146–52, with a further extract by Swinburne on Hugo's poems, pp. 153–5. According to Hyder, p. 7, Swinburne had foreseen the limitations of 'art for art's sake' before he published *Songs before Sunrise* in 1871.

110 Whistler, 'Mr Whistler's "Ten o' clock"', *The Gentle Art*, p. 155.

111 In the 1870s both Whistler and Swinburne used the commercial services of the flamboyant 'art agent' Charles Augustus Howell, to whom, before his retirement to Putney, Swinburne consigned his poetry for publication, Whistler his paintings for sale. The publishers of Whistler's 'Ten o'clock' lecture, Chatto & Windus, were also Swinburne's. For Swinburne, Whistler and Howell, and their tangled financial affairs, see H. R. Angeli, *Pre-Raphaelite Twilight* (London, The Richards Press, 1954).

112 Early in 1881 Whistler visited Jersey and Guernsey to paint seascapes. Working on cliff tops in extremely bad weather, he probably completed three oil paintings and a watercolour; but only a watercolour survives from the visit. For his description of the difficulties he experienced see YMSM 231–2a. The coincidence of such Swinburnian leitmotifs as the sea and the proximity of the home of the exiled Victor Hugo, taken with the recent publication of Swinburne's volume *Songs of the Springtides*, which included the verses 'On the Cliffs', is suggestive.

113 J. M. Whistler, 'Whistler v. Ruskin: Art and art critics' [1878], repr. in Whistler, *The Gentle Art*, pp. 25–34.

114 O. Wilde, 'Mr Whistler's Ten o'clock', *Pall Mall Gazette*, 41 (21 February 1885) 1–2, repr. in Ellmann, *The Artist as Critic*, pp. 13–16.

115 Principally in his essay 'The critic as artist' (1889–90 and 1891), repr. in Ellmann, *The Artist as Critic*, pp. 340–408. In his biography of Wilde, Ellmann considers that 'the whole essay was Wilde's declaration of freedom from Whistler's theories'; see

R. Ellmann, *Oscar Wilde* (London, New York, Ontario and Auckland, Penguin Books, 1988), p. 308. In elevating criticism to an art form, Wilde, like Swinburne, also claimed the authority of Baudelaire; see Clements, 'Wilde', in *Baudelaire*, pp. 140–83. For Wilde and Swinburne, and Wilde and Whistler, see also Ellmann, *Oscar Wilde, passim.*

116 Although Swinburne certainly – and Whistler probably – had nothing but contempt for Zola's realist subject-matter, Swinburne's relationship with Whistler is interestingly analogous with that of Zola and Manet. Both critics began by vigorously promoting their painter friends at about the same time and, for not altogether dissimilar reasons, eventually became disenchanted by their performances.

117 In the 'Ten o'clock' lecture and 'Whistler v. Ruskin: Art and art critics' [1878] respectively; see Whistler, *The Gentle Art*, pp. 34, 149.

118 For Whistler's rivalry with Wilde over Mallarmé in 1891, see Ellmann, *Oscar Wilde*, pp. 317–20.

119 R. Spencer, 'Whistler's "The White Girl"', pp. 310–11.

120 Whistler, *The Gentle Art*, pp. 259–61. A year before his death Whistler paid tribute to Swinburne in a letter to *The Morning Post* (6 August 1902) in reply to an article claiming that *The Little White Girl* had been inspired by Swinburne's poem: 'those lines were only written, in my studio, after the picture was painted. And the writing of them was a rare and graceful tribute from the poet to the painter – a noble recognition of work by the production of a nobler one.'

121 R. Shattuck, *The Banquet Years* (New York, Vintage Books, rev. edn, 1968).

122 Clements, *Baudelaire*, pp. 24, 33.

The 'Artists' have come out and the 'British' remain: the Whistler faction at the Society of British Artists

Anne Koval

DESPITE THE PRIMACY of the Grosvenor Gallery as the crucial exhibiting venue of the Aesthetic Movement, by the 1880s its position was being challenged by new or reformed exhibiting bodies who sought artistic control over the venue. The New English Art Club (NEAC), formed in 1886, was one such reform group protesting the outdated practices at the Royal Academy (RA).[1] Its foundation can be seen as reflecting the international trend for change amongst the emerging avant-garde in the last two decades of the nineteenth century, signalled by the formation of the Belgian secessionist group Les Vingt (Les XX) in 1884. A less radical approach involved joining an already established society and reforming from within the ranks. Such methods were employed by J. M. Whistler and a group of artists who, adapting some of the aesthetic doctrines of the Grosvenor Gallery, attempted to reshape the Society of British Artists (SBA) into a 'temple of Art'.[2]

Founded in 1823, the SBA was by nature conservative; often functioning as a stepping stone to the RA, its biannual exhibitions provided Academicians with the best space to hang their work. The fact that the society looked to the Academy for approval in their actions reveals a sycophantic link that was taken for granted by the members. Royal Academicians would often send their minor works to the SBA where they were given a place of honour and mention in the press.[3] By the 1880s the Society was in serious financial straits and began a recruitment drive in 1883 to increase membership, with the intention of recouping its losses. Such measures paid off, attracting artists as notorious as Whistler to its membership in the winter of 1884.

Whistler's election to the Society was aided by the support of two voting members, Albert Ludovici, jnr, and Percy Jacomb-Hood. Once elected, Whistler became a star pole, attracting a number of artists both within and outside the organisation. This group who rallied around Whistler included the pupils Walter Sickert and Mortimer Menpes, as well as Theodore Roussel and Sidney Starr.

With such crucial support, Whistler was able to manoeuvre his rise to presidency within two years of joining the Society. Such rapid ascendency and the subsequent 'take-over' of the SBA suggest that Whistler and his supporters often worked in tandem to achieve common goals of reform from within the structure of the Society.[4]

This faction came to be known by the press as the 'Whistlerians', 'Outsiders', 'Impressionists', or simply the 'Artists', distinguishing them from the 'British Artists' who represented the traditional stronghold of the SBA. Typical of the British Artists' contribution to the SBA exhibitions was work much in the mould of the Royal Academy – highly finished genre subjects, portraits and landscapes. Against this was set the work of the Whistler faction, characterised by the press as 'shadowy' or 'muddy' Impressionism. Much of the painting had common links with French Impressionism, with its denial of narrative and interest in depicting modern urban life. Many of these artists associated themselves with the avant-garde notion of 'art for art's sake', in their shift towards interpretive rather than descriptive representation. Their tonally sensitive painting was often technically more sketchy and lacking in finish, when compared with the more stalwart British Artist contributions. Such differences were well noted by the press, *The Spectator* writing of the 1885 winter exhibition:

> There is now no gallery in London, probably none in the world, where can be so clearly seen as in this exhibition at Suffolk Street, the most conventional, and commonplace of old-fashioned work, side by side with the most eccentric and daring examples of modern Impressionism.[5]

The term 'Impressionism' was in frequent use by critics during the mid-1880s, often with little or no distinction between the French and English variations. Characteristic of the English version was the use of a restricted palette, which kept the painting to a close variation in tone rather than colour contrasts.

The critic for *The Spectator* further commented on this changing tide within the SBA:

> They made a bold bid for popularity by choosing as a member one of the most well-known and eccentric of modern artists, Mr McNeill Whistler. And the influence of this painter has already become, if not paramount, at all events a very marked characteristic of the Suffolk Street Galleries; for he has brought in his train a number of fellow-workers, pupils and imitators, till now one could almost say that the chief feature of this exhibition is this art of shadowy impression, which Mr Whistler was practically the first to introduce to England.[6]

This Impressionist variant was readily identified both by the press and by members within the Society. For four years this group, with Whistler at its head, posed a threat to the stability of the British Artists at the SBA.

At the Society, Whistler introduced a later aesthetic variant to the early days of the Grosvenor Gallery, as apparent in his carefully contrived hanging, with

pictures of similar sensibility hung together, on the line, within a sympathetic colour setting. Unlike the Grosvenor Gallery, at the SBA Whistler could show his work alongside a number of younger artists, where a specific group identity emerged as early as the 1884 winter exhibition and lasted until Whistler's resignation in 1888. A reciprocal arrangement emerges where these supporters gained notice through the celebrity of Whistler, who in turn benefited from their backing. Many were young, relatively unknown, several foreign in both name and training. They regarded Whistler as an avant-garde 'outsider', loosely associated with French Impressionism. By the mid-1880s the French Impressionists were readily recognised as a group affiliation providing a prototype for a British version evolving at the SBA.[7]

This Whistlerian take-over was short-lived in the history of the Society. By the spring of 1888, the British Artists had ousted the Impressionist faction by democratic vote, causing Whistler to resign from the organisation. Whistler's famous disclaimer to the *Pall Mall Gazette*, 'They could not remain together, and so you see the "Artists" have come out and the "British" remain – and peace and sweet obscurity are restored to Suffolk Street', reveals his dependence on the press to deliver his parting remark.[8] With Whistler's resignation, many supporters followed suit, resulting in a significant loss of membership for the Society. Several members transferred their allegiance to the New English Art Club, contributing further to the 'London Impressionist' element, emerging under the leadership of Walter Sickert.[9]

Notably, Whistler never joined the NEAC and remained only on the periphery of this organisation. Its more radical formation and democratic nature held little interest for an artist seeking respectability within the structure of a long-established artist-run institution. What becomes evident in the 1880s is that Whistler actively sought a public venue that would raise his status within the British art world. Contemporary artists such as Edward John Poynter or Sir Frederic Leighton were well-established with official honours, the latter as President of the Royal Academy. For artists in the early part of the 1880s the choice of membership in an artist-run society was limited to the Institute of Oil Painters, various watercolour societies, the SBA and the RA. Whistler had not exhibited at the RA since 1872 when his portrait, *Arrangement in Grey and Black: The Painter's Mother*, was nearly rejected, then poorly hung.[10] With the Academy out of the running, Whistler was left with few options. Commercially he still exhibited in Bond Street at the Fine Art Society and Dowdeswells. His relationship with the Grosvenor Gallery had always been a tenuous one, which by 1884 had fractured over Sir Coutts Lindsay's decision not to exhibit a portrait by Whistler due to its lack of finish.[11] The increasingly conservative policies of the gallery were beginning to show in the work on display, and by the mid-1880s its importance as a gallery for the Aesthetic Movement and its aftermath were beginning to wane. With such a venue out of the running, Whistler's choice was narrowed down to the Society of British Artists.

As contrary as this may seem to Whistler's rebellious reputation, the motives lying behind such a move were, in fact, well-planned. Whistler can be seen as a prospective buyer who, coming across a rather run-down property, decides to buy in and 'do it up', thus shaping the Society to his own needs. To enforce these 'renovations' Whistler employed the services of a number of young artists drawn to the seductive circle of the 'master builder'. With the strength of these supporters behind him, Whistler set out to reform the Society to his own principles, thus helping to shape a new Society. Not only was this courtship with the SBA an attempt by Whistler to establish himself within a long-running institution, but it suggests that he was intending to upgrade it to rival the RA.

The group of artists who rallied to Whistler's support at the SBA also met away from the demanding artist and the politics of the Society. Originally gathering at Menpes's studio in Fulham, they soon moved to a more central meeting place in Baker Street.[12] Self-consciously regarding themselves as the emerging avant-garde, they decorated the club room in aesthetic shades of blue and green and designed their own notepaper, with the emblem of a steam engine advancing with a red light to symbolise 'a danger signal to the Philistines to warn them that reformers were on their track'.[13]

This Baker Street clique followed Whistler's theories and practices, concurrently with their comprehension of French Impressionism. Menpes wrote of their affinities:

> We were a little clique of the art world, attracted together in the first instance by artistic sympathies. At the most we never numbered a dozen. We were painters of the purely modern school – impressionists, I suppose we might have been called, – all young, all ardent, all poor.[14]

Of the group, Sickert was the most knowledgeable about French Impressionism. As early as 1883 he had met Degas and formed a friendship with the older artist.[15] By 1887 Sickert's own entries in the SBA winter exhibition were beginning to betray this interest by showing a departure from Whistlerian subject-matter. Although Sickert exhibited with the Society, he never became a member, and his independent stance led to associations with the NEAC and the secessionist group, Les XX, in 1887. He was also involved with a group exhibition at the Goupil Gallery in 1889, entitled 'The London Impressionists'.[16]

Despite Sickert's later attempts to distance himself from Whistler, in the autumn of 1884 he negotiated with the SBA member Ludovici on Whistler's behalf.[17] His diplomacy paid off and by the winter of that year Whistler had become an elected member and exhibited two works in that season's show.[18] The press responded with incredulity, shocked by the Society's unprecedented action and by Whistler's decision to join such a traditional outpost. *The Times* reported: 'Artistic society was startled a week ago, by the news that the most wayward, most unEnglish of painters has found a home among the men of Suffolk Street – of all people in the world.'[19] Despite this unusual union, both the Society and Whistler

benefited from the relationship. The ailing Society gained much-needed publicity, while Whistler sought out an already established organisation to shape to his own needs.

That the Society had clear motives in electing Whistler to membership is borne out by the fact that a subscription drive to generate funds had been initiated the year prior to Whistler's election. Unlike the Royal Academy, the SBA was much less discerning in membership and had no set rules concerning the limitation of members. Therefore when the council was approached by Ludovici and Jacomb-Hood, who proposed Whistler as a suitable candidate, the Society, despite its conservative policies, was forced to consider his name for election. Both Ludovici and Jacomb-Hood maintained that the Society had initially felt little threat from Whistler as they expected him to take no interest in the proceedings. As Ludovici later recorded:

> They seemed especially concerned with what the Royal Academy might think; however, in the end, a special meeting was called, and Mr Whistler was elected a member – the majority of voters, I am sure, thinking only of the advertisement it might be to the Winter Exhibition, and confident that he would not take much part in the workings of the Society.[20]

In choosing to elect Whistler as a member, the Society sorely underestimated the vested interest he would hold in the SBA, from his regular attendance at the monthly meetings to his rapid ascension in the structure of the council to presidency in the spring of 1886. Such an ambitious rise suggests that Whistler had joined the Society with the sole purpose of reforming and shaping from within, thus advancing his own reputation.

As the Society had anticipated, Whistler's notoriety did, in fact, attract much publicity to their exhibitions. Notably, as early as the winter show of 1884, the press divided into two camps. The more conservative papers supported the traditions of the British Artists, while the liberal papers welcomed the change brought about by the Whistler faction, known as the 'Outsiders'.[21] Taking the latter view, the reviewer of the *Sunday Times* noted that:

> The Winter Exhibition now open in the galleries of this Society in Suffolk Street is by far the most important that has been seen there for many years. For some time past this society has been in quite a stagnant condition, its exhibitions being marked by a dead level of hopeless mediocrity; but this winter a complete change for the better has come over the society, the younger members, among whom Mr J. M. Whistler now holds a conspicuous position, have infused fresh energy into its doings, taking a broader view of its scope and its power to advance art.[22]

The Whistler contingent was growing in strength as signified by the 1885/86 catalogue, in which a number of followers were listed as 'pupil of Whistler'.[23] This acknowledgement of tutorship was an old-fashioned French atelier practice, a foreign influence which did not go unnoticed by the press. The *Pall*

The Sufferings of a Suffolk Streeter.
(By One of the Old School.)

I'M an artist by profession, and my name is truthful John,
With the school known as Impressionists I never could get on ;
So, in language free from passion and from prejudice, I'll tell
How they upset our Society at Suffolk Street, Pall Mall.

For nothing could be finer or more beautiful to see
Than the picture shows the first few years of our Society ;
Till in an evil moment we were led to think it well
To elect as a fresh President a real artistic swell.

Now, it's always been the motto of our Society
That the style of thing the public likes is, "Mammy, dear, kiss me ;]"
Domestic scenes must always go with patrons such as ours,
Especially when eked out with some landscape-bits and flowers.

But no sooner was he seated in the Presidential chair
Than he changed our exultations into wailings of despair ;
For he broke up our traditions, and went in for foreign schools,
Turning out the work we're noted for, and making us look fools.

In the place of neat interiors and cottage scenes so fair,
We're bedecked with muslin curtains, with a nocturne here and there.
And if the British public will placidly look on
Then Art's a mystery to one whose name is truthful John.

And, since he's in possession, there's nothing to be done
But to start upon some other tack, and find some other run ;
But I've told, in simple language, how this nocturne-loving swell
Has ruffled our Society at Suffolk Street, Pall Mall.

19 John Burr, 'Sufferings of a Suffolk Streeter', *Fun*, 1886

Mall Gazette commented: 'Mr Whistler has also caused his pupils to insert in the catalogue, à la française, the fact of his tutorship, thus laying the foundation of a "school".'[24]

In that same year both Menpes and William Stott were proposed and elected to membership by Whistler.[25] These elections did not go unnoticed by the press who recognised the changes occurring at the SBA. *The Times* observed that the previous conventionality of the exhibits was being replaced by pictures tending in the direction of 'Progress and artistic activity' and attributed this to a shift in membership:

> An influential share in the government of the society seems to have been secured by the younger generation of artists, and by excellent representations of that generation, so that what is sought for now by the hanging committee is not the mere prettiness that used to pass muster a few years ago, but anything that exhibits study, training, insight, and intelligence.[26]

In the annual spring meeting of 1886, Whistler, with his supporters behind him, was voted in as the next president of the Society of British Artists. During his brief reign as president, from the winter of 1886 to 1888, he introduced a number of reforms such as a reduction in the number of pictures exhibited, hanging on a two-tiered system, controlled lighting by the use of a velarium (overhead awning), redecoration of the galleries, a simplified catalogue, and exhibition of works by foreign artists, including Monet.

Such reforming measures were noted by the press, as in a cartoon from the illustrated weekly *Fun*, published in 1886 on news of Whistler's presidency (plate 19). Entitled 'Sufferings of a Suffolk Streeter', it amusingly anticipates the authoritarian nature of Whistler's reign at the Society. Whistler, described as an 'artistic swell', is shown as a crane, swallowing, one by one, the British Artists who are depicted as frogs. One verse from the cartoon indicates how well-known Whistler's reforms had already become:

> But no sooner was he seated in the Presidential chair
> Than he changed our exultations into wailings of despair;
> For he broke up our traditions and went in for foreign schools,
> Turning out the work we're noted for, and making us look fools.[27]

These 'traditions' that Whistler attempted to abolish were characterised in another verse:

> Now, it's always been the motto of our Society
> That the style of thing the public likes is, 'Mammy, dear, kiss me;'
> Domestic scenes must always go with patrons such as ours,
> Especially when eked out with some landscape-bits and flowers.

Such subject-matter typified much of the work at the Society. Genre paintings such as Alfred Strutt's *'I Think We Met Before'* (plate 20) and Thomas

Kennington's *Bed and Breakfast for Two* (plate 21), engraved for the spring and winter catalogues of 1885/86, indicate these prevailing tendencies. Although Whistler could not eradicate all genre paintings from his exhibitions, he did eliminate such engravings from the catalogue, once he had been made president in 1886.

Whistler knew how to promote his art, and his supporters were well aware of the advantages of having a picture well-hung, surrounded by paintings of a sympathetic ilk. With his interest in controlling the exhibition hang, the number of pictures included was drastically reduced, and had Whistler had his way, the size of the paintings would have been limited as well.[28] In the first Whistlerian exhibition of 1886/87 a reduction of more than 175 paintings from the previous winter show was significant. These reforms did not go unacknowledged by the more conservative members of the Society, and the Whistler faction faced much opposition.

The comfortable years of the British Artist were over. A long-standing member could no longer depend on having his picture hung. And if hung at all by the Whistler contingent, the picture was often allocated to a less important room. Whistler, to help create a certain look, assigned his own work and that of his followers to one or two rooms, where the 'school' would be seen appropriately

20 After Alfred Strutt, '*I Think We Met Before*', 1885

21 After T. B. Kennington, *Bed and Breakfast for Two*, 1885

flanked by work of a like nature. Jacomb-Hood made the distinction between the conventional hang and Whistler and his contingent's innovation: 'The Society's rooms, which hitherto had been hung with members' pictures from floor to ceiling in "serried ranks", were now "decorated" with only two lines of work with wall-space between.'[29] As the British Artists had not anticipated, Whistler's attention to detail was fastidious; Ludovici recorded:

> No detail was too small to claim his attention, and he was in full sympathy with our desire to try and raise the standard of Art and the status of the Society. Meetings became more interesting and were always enlivened by his good-natured wit. Rules were altered and added to, often to the surprise and in fact to the antagonism of the older members, who, contented with the old regime, would not, or could not, under-stand Whistler's aim, which would place the Society on a high pinnacle and make the gallery an elegant temple of Art; hanging the pictures on the walls in groups according to colour or hue.[30]

Menpes, who with Roussel supervised the hanging committee of 1886, later commented on one of the more drastic measures: 'Whistler started by

22 James McNeill Whistler, *Society of British Artists*, 1886, pen and ink, 20.1 x 15.9 cm

redecorating the gallery, "cleansing" it, as he himself said, procuring a neutral tone, and rejecting all other hangings and decorations. It was an exhibition on Whistler lines.'[31]

To further this acknowledgement of a 'Whistlerian school', Whistler had certain select connections with the press. Critics such as Malcolm Salaman, writing for the clubland paper, the *Court and Society Review*, revealed partisan support for Whistler in articles such as 'Hail President Whistler', in celebration of his election.[32] Salaman saw Whistler as leading a school of young artists, as an alternative to the Royal Academy schools. Not only did Whistler draw on partisan critics but he relied on his circle to write letters to the press supporting his cause. Stott, as part of this group, wrote to the papers in defence of Whistler. A regular exhibitor with the Society of British Artists, Stott had been proposed for membership by Whistler and elected in November 1885. The following year he wrote a letter to the editor of the *Court and Society Review* defending the Whistler faction, who chose not to paint subjects of narrative or moral value: 'Here are our maxims. "Art is for artists, just as music is for musicians." "The highest delight in either can duly be attained by him who understands it best."'[33] The wording recalls Whistler's 'Ten o'clock' lecture of the previous year. Whistler's maxim that art was understood by a select few, who were artists themselves, underpins Stott's argument. This form of elitism was not only a way of excluding the press and public from forming judgements on their work, but it also played on the role of the 'misunderstood artist' perpetuated by Whistler and his followers.

Whistler himself was not averse to penning a few lines to the press when provoked by criticism. That November, when the *Daily News* published a letter from 'A British Artist' complaining of the 'half-uncovered walls' at the Society and insisting that the 'Patrons' of the gallery decide what merited exhibition, Whistler's response was swift:

> Now it will be for the patrons to decide absolutely nothing. It is, and will always be, for the gentlemen of the hanging committee alone, duly chosen, to decide whether empty space be preferable to poor pictures – whether, in short, it be their duty to cover walls, merely that walls may be covered – no matter with what quality of work. Indeed, the period of the patron has utterly passed away, and the painter takes his place – to point out what he knows to be consistent with the demands of his art – without deference to patrons or prejudice to party.[34]

At the winter exhibition of 1886/87 these exacting standards were in evidence. Whistler contributed to the redecoration of the galleries and his touch was not ignored by the press.[35] The *St James Gazette* reported on the selection of paintings and decoration:

> Of these a considerable proportion are of Mr Whistler's school; and the gallery has been redecorated to suit them, under the direction of the president. The dull red of the walls has given way to a Whistlerian yellow; yellow festoons swing on the frieze above, and an awning hangs beneath the skylight.[36]

Today, Whistler's decorative arrangements have little novelty value, yet to a nine-teenth-century public they seemed oddly out of place (plate 22). When compared to the annual Royal Academy summer show, with its walls covered in paintings, the sparseness of a Whistlerian hang was regarded as eccentric. This aspect of dec-oration, as opposed to what Whistler regarded as the 'bazaar' effect of the RA show, was an attempt to remove the commercial atmosphere found in such exhibitions. Whistler was relying heavily on the lessons he had learned as an exhibitor at the Grosvenor Gallery. Although the Grosvenor's galleries were much grander than those of the SBA, Whistler attempted to bring a harmonious colour scheme and elegance reminiscent of the aesthetic hanging found at the Grosvenor (for an account of the Grosvenor interiors, see Chapter 7).

In the winter exhibition of 1886/87 the 'Whistlerian school' was again noticed by the press. The prevalence of this group, shown largely together in one room, was so apparent that the serio-comic papers satirically poked fun at this grouping. The journal *Fun* showed caricatures of the paintings and the decoration, depict-ing Whistler as representing 'New Scenery and Decorations, Real Canopy and Bedhangings'.[37] The satirical journal *Judy*, under the title 'At the Whistleries' (1886), showed Bernard Partridge's comical interpretation of the works on display (plate 23).[38] Alongside Whistler's contributions are shown Ludovici's ballet dancers. Menpes later recorded that there was a stage in this group's development where 'low-toned Ballet girls' in the manner of Degas were being painted, and such work fits this description.[39]

In that same exhibition Jacomb-Hood exhibited a portrait of his sister which bears close affinity to the work of Whistler (plate 24). The painting serves as homage to Whistler's widely exhibited *Painter's Mother* and the *Carlyle*, both in tonal colouring and composition.[40] This aspect of the work was not overlooked by the press, with Frederick Wedmore writing for the *Academy*:

> Nor is it in any sense fatal to Mr Jacomb-Hood that it should be objected that he gets the inspiration from this particular portrait from an early painting of Mr Whistler's – that well-known portrait of Whistler's Mother, which, in its reticent pathos, is only less remarkable than his quite unknown etching of the same lady.[41]

In that same exhibition Whistler exerted his influence on the design of the cata-logue. The changes to the catalogue were significant enough for Ludovici to note the problems with the earlier versions: 'Even a catalogue in those days looked more like a tradesman's book of advertisements than an artistic compilation of pic-tures.'[42] To remove this commercial aspect, Whistler reduced the number of adver-tisements permitted and relegated them to the back of the catalogue. He eliminated engraved illustrations after works in the exhibition, insisting that this practice cheapened the appearance of the catalogue.[43] Already by 1885 Whistler held the view that only photographs merited as reproductions after original work. To this end he attempted to introduce the practice of selling photogravures of the works displayed at the turnstile of the galleries.[44] Despite such apparent contradictions in

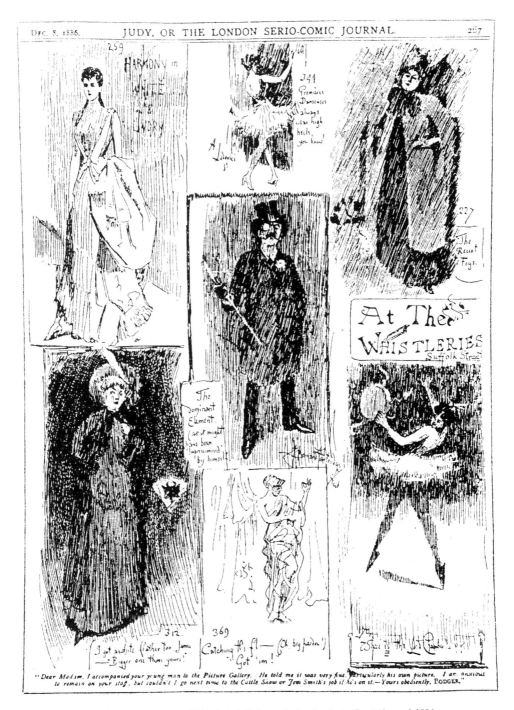

23 B. Partridge, 'At the Whistleries', *Judy, or the London Serio-Comic Journal*, 1886

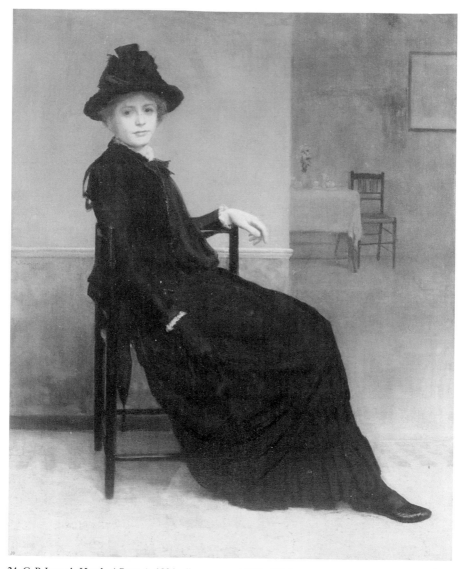

24 G. P. Jacomb-Hood, *A Portrait*, 1886, oil on canvas, 153.7 x 123.2 cm

Whistler's arguments, his overall attempt was to remove any taint of 'shopkeeping' from the SBA. More successful was his redesign of the exhibition catalogue of 1886/87 which included a simplified typeface used by Whistler in a number of his previous pamphlets and catalogues; the cover was altered from blue to white (the redesign was retained for the catalogue of 1887/88, plate 25). The previous practice of listing the prices alongside the titles was considered to be too commercial, and instead the prices were listed separately at the back of the catalogue. Whistler also redesigned the society's insignia of the lion and removed it from the cover.

It is interesting to note that these alterations were eliminated once Whistler's reign came to an end. By the winter of 1888/89 the cover was again blue, the original insignia of the lion dominated, and the engravings, numerous advertisements and prices returned. The only Whistlerian innovation that remained was the simplified typeface.

Politically, the Whistler faction was growing in strength, and under a new election procedure, initiated by Whistler, Sidney Starr, Waldo Story, Theodore Roussel, Charles Keene (honorary member), Alfred Stevens and Moffat Lindner were elected to the Society.[45] By the 1887 spring exhibition the Whistler faction had taken increasing control over the decorating of the galleries. The critic for the *Kensington News* reported:

> The walls all of brown paper hue, and the limp festoons of muslin have been dipped in vats of gold, the wood work has been toned midchrome and brightly varnished, and the high skirting covered with leaves of metal. The yellow velarium still hangs in the large room, and another has been added in the south-east room of the same hue. The lounges are yellow, and the floor is surrounded with a neutral tinted felting. Lightness and dainty cleanliness are the prevailing effect of the general scheme.[46]

The restrained elegance of the galleries must have provided a splendid setting for the low-toned quiet pictures of the Whistler faction. The same reviewer noted the generous spacing to be found in the exhibition: 'In the wall spaces where seventy

25 Left: Front cover design of Royal Society of British Artists exhibition catalogue, 1887/8 (during Whistler's presidency); right: front cover design of Society of British Artists exhibition catalogue, 1885 (before Whistler's presidency)

pictures might not long since have been found you now discover six or seven, and these are carefully grouped and arranged to the very best advantage.'[47] In the principal room, only forty-eight pictures were hung, in lieu of the typical British Artists hang of two hundred. Such elegant and spacious hanging again recalls the Grosvenor Gallery. To further substantiate this aesthetic concern, Whistler introduced Sunday viewings to members and friends. These afternoon teas can be compared to Lady Lindsay's Sunday afternoon parties held at the Grosvenor Gallery. The combination of fashionable and aristocratic company was an aspect that Whistler continually tried to emulate in his Sunday gatherings.[48] Such schemes were not easily incorporated into the Society's policies, and the Whistler faction faced much opposition from the British Artists, many of whom objected to the Sunday opening on religious grounds.[49]

The Whistler faction was in full swing in this 1887 spring exhibition, as represented in the work of Starr, the Sickert brothers, Roussel, Ludovici, Lavery, Stott and others. Ludovici exhibited eight paintings, four very Whistlerian in title.[50] The *Artist* reported:

> The annual exhibitions at the Suffolk Street galleries are manifestly destined to make their mark in the art record of the present century. The energy of the band of painters over whom Mr Whistler presides has already wrought marvellous changes in the appearance and character of their periodical displays, and there would seem to be every probability that the improvement so rapidly brought about will be maintained.[51]

The magazine's bias, favouring the Whistler faction, owed much to the fact that one of its contributors was Sickert. The anonymous reviewer noted that: 'The younger Mr Ludovici still finds on the stage good material for pleasant pictures; and Mr Sickert keeps him company with a music-hall scene, "The Mammoth Comique".'[52] Sickert's single entry, now known as *The Lion Comique*, revealed, in its theatrical subject and dramatic composition, a distancing from Whistler (plate 26).

While Sickert remained somewhat independent from the Society by not becoming a member, Roussel showed his devotion by becoming a member before the spring exhibition of 1887.[53] The *Artist* enthused: 'Mr Theodore Roussel, whose recent election says much for the intelligence and wisdom with which the councils of the Society are swayed, amply justified his position by the exhibition of the audacious and entirely capable portrait of Mr Menpes' (plate 27).[54] The portrait of Menpes shows the artist as self-styled dandy, an aspect of the Whistler faction that led to further disruptions within the Society.[55] Whistler's own carefully contrived persona as dandy was witnessed not only at private views, but at the monthly council meetings, when he would arrive late wearing evening dress, his retinue in tow. Such posing did little to improve his reputation among the more stalwart of the British Artists.[56]

The year 1887 marked Queen Victoria's Silver Jubilee, when Whistler was party to obtaining a royal charter for the Society. As president of the newly inaugurated Royal Society of British Artists (RBA) Whistler became more autocratic, as he now

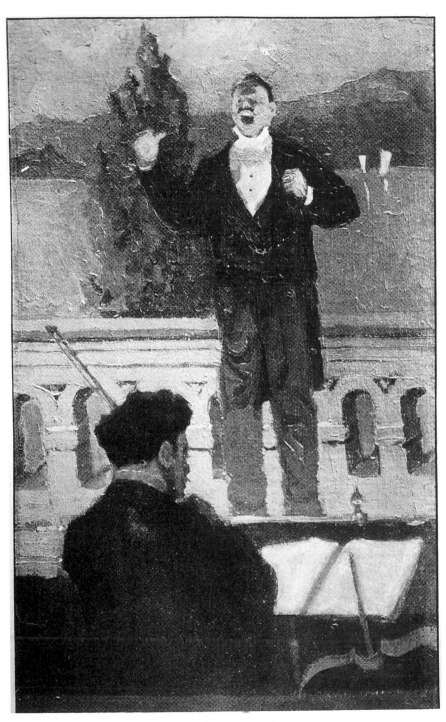

26 Walter Sickert, *The Lion Comique*, 1887, oil on canvas, 50.8 x 30.5 cm

viewed the Society as a serious rival to other institutions, in particular the Royal Academy. Despite this increasing despotism, signs that the Whistler faction was losing control were evident at the winter exhibition of 1887/88 where twice the usual number of allotted pictures were on display. The *Pall Mall Gazette* reported:

> The number of pictures hung – about the double of last year's total. This may be taken as a proof of the collapse of Mr Whistler's attempts to hang each work with a large margin of space around it. The experiment, indeed, was foredoomed to failure, seeing that the income of such societies is largely drawn from the commissions on the pictures sold, so that a reduction in numbers means a parallel diminution in commissions, a condition of things the finances of the Society cannot well support.[57]

The fact that the Society depended on the ten per cent commission from work sold at exhibitions gives some validity to this argument. With the Whistlerian aesthetic hang, fewer works were displayed, causing the British Artists to claim they were suffering from a reduction in sales.[58] One member actually calculated in pounds, shillings and pence the loss of revenue due to the sparsity of works on display.[59] Another objection raised against these reforms was in support of the average spectator, who, on paying the shilling entrance fee, expected a good show of paintings. Such a 'philistine' notion of 'getting your money's worth' was another divisive factor that separated the British Artists from the Whistler faction.

Despite the larger quantity of work on display, the Whistler contingent was still in evidence, supported by the fact that Roussel, Stott and Menpes served as part of the supervising committee in charge of selecting pictures for exhibition.[60] Their selection included the Impressionist work of the Sickert brothers, Paul Maitland

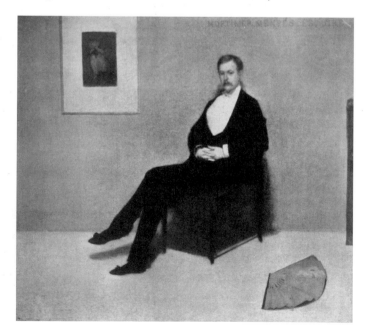

27 Theodore Roussel, *Mortimer Menpes, Esq.*, 1887, oil on canvas, dimensions unknown

and Philip Wilson Steer, at stylistic odds with the British Artists, as noted by the *Pall Mall Gazette*:

> Then the general character of the collection rather amusingly betrays the life-and-death struggle for precedence now being waged between the Whistlerian and old English elements – pictures of crude colouring alternating with pictures of little or no colour at all.[61]

These conflicts within the Society continued at the monthly meetings, when in November Whistler and his coterie made their most overt proposition in an agenda which dealt with the issue of exclusive membership.[62] Their strategy was to eliminate artists affiliated 'with any other association of Artists established in London', a move directed largely at Royal Academicians.[63] After some heated discussion this proposal was withdrawn.

By taking such a strong stance, Whistler and his supporters drew the dividing line between themselves and the British Artists who now opposed them at every move. Leading the opposition was Wyke Bayliss, a painter of church interiors, who insisted on moral values being inherent to art. Diametrically opposed to the Aesthetic Movement, Bayliss had expounded his theories in his book of 1879, *The Higher Life in Art*, which included a chapter titled 'Art for art's sake'. Positioning himself in direct opposition to Whistler and all that he represented, Bayliss wrote: '"Art for Art's Sake" is only a synonym for dilettantism; but it is dilettantism stripped of its higher meaning, robbed of everything that makes it respectable.'[64] That the British Artists would favour such a contentious candidate for presidency indicates how manifestly opposed to Whistler they were on all levels.

This antagonism between the Whistler faction and the British Artists escalated, with more resolute steps taken by the latter to remove Whistler from the presidency. All came to a head at a committee meeting on 7 May 1888 when a letter was read from eight members requesting Whistler's immediate resignation.[65] At the following annual general meeting a large number of the older faction attended and proceeded to vote Whistler out and Bayliss, the new president, in. Whistler immediately tendered his resignation, followed by twenty-four other members.

The press closely reported the acrimonious split at the Society, the *Glasgow Herald* writing:

> Even outsiders know of the discussions which have nearly wrecked the venerable Society of British Artists, for the feud has been taken beyond the Suffolk Street happy hunting grounds, and has even found friends and enemies altogether outside of the studios. Are you a Whistlerian Renegade or a loyal Britisher has been asked of many an artist during the last six months: The alternative question, is naturally, 'Are you one of the protestors, or do you cling to the fogies?'[66]

Many papers questioned the next direction the RBA would take. With a significant loss in membership, almost one quarter resigning with Whistler, the Society began to focus on recruiting new members, and turned to art schools in an attempt

to re-establish its former reputation as a potential crèche to the Academy. Such a move caused the liberal critics to view the Society as reverting back to its former mediocrity. For the more conservative critics, satisfied by the end of the Whistlerian reign, this was an improvement.

Several of the liberal papers speculated on the direction the secessionists would take. Some anticipated that they would establish a new society with Whistler at the head. No such society was formed, unless one regards the International Society of Sculptors, Painters and Gravers, founded in 1898, as a delayed response. As president of the International Society, Whistler was able to bring about the reforms that had been so difficult to shape from within the Society of British Artists. By the late 1890s the tide had turned and a new internationalism was affecting the more important secessionist exhibitions. The formation of the International Society at this time is symptomatic of this shifting situation.

It is from this larger perspective that one needs to view the contribution of the Whistler faction to artist-based exhibiting venues. Certainly many of the stylistic tendencies of this Impressionist group were shown for the first time 'en masse' to the public. This emerging 'school' of British Impressionism, with its roots in the French avant-garde, was provided with a much-needed public venue for showing their work. But it was the creation of an assembly within the Society that had more reverberating effects on the course taken by British art, as later seen at the New English Art Club, where such allegiances led to further political disputes and artistic developments.[67]

Notes

1 See H. Hubbard, *A Hundred Years of British Painting, 1851–1951* (London, Longmans, Green & Co., 1951), p. 130, for a discussion of this 'anti-Academy' movement formed in 1886 by F. Brown, G. Clausen, W. Crane, W. Holman Hunt, H. H. La Thangue, G. P. Jacomb-Hood and others. See also W. J. Laidlay, *The Royal Academy: Its Uses and Abuses* (London, Simpkin, 1898).

2 A. Ludovici, *An Artist's Life in London and Paris: 1870–1925* (London, Fisher Unwin, 1926), p. 81, on Whistler's attempts to transform the SBA into an 'elegant temple of Art'. For the Grosvenor Gallery see C. Denney, 'The Grosvenor Gallery as Palace of Art: an exhibition model', in S. P. Casteras and C. Denney (eds), *The Grosvenor Gallery: A Palace of Art in Victorian England*, exh. cat. (New Haven, Yale Center for British Art, 1996), pp. 9–37.

3 J. Burr, *A Brief History of the Society* (London, Society of British Artists, 1883), unpaginated: 'The great services that this society has rendered in the interests of Art will be best shown by the fact that a large number of the most distinguished members of the Royal Academy availed themselves of its advantages while working for the higher honours they afterwards attained.'

4 This episode of the history of the SBA originated from author's PhD dissertation, *Responses to J. M. Whistler's Theory and Practice: The Followers in Britain, c. 1880–1910* (London, University of London, 1997), ch. 1, 'Whistler and his followers' participation in artist-run exhibiting societies'.

5 'Art: The Society of British Artists', *The Spectator*, 26:12 (1885). The SBA exhibiting premise was located at Suffolk Street.

6 Ibid.

7 M. Menpes, *Whistler as I Knew Him* (London, Black, 1904), p. 15.

8 'An interview with an ex-president', *Pall Mall Gazette* (11 June 1888), repr. in J. M. Whistler, *The Gentle Art of Making Enemies* (London, Heinemann, 1890).

9 The artists who changed their affiliation with the SBA to the NEAC were W. Sickert (exhibitor), B. Sickert, T. Roussel, P. Maitland, P. W. Steer, A. Ludovici, S. Starr, F. James, A. Hunt, W. A. Rixon, M. P. Lindner, W. C. Symons, W. S. Llewellyn, J. E. Grace, C. Monet, G. P. Jacomb-Hood, J. Lavery (exhibitor), M. Menpes and J. J. Shannon.

10 It appears that in the 1860s Whistler had approached the RA for membership. A little-known draft letter (Glasgow University Library, R.154, hereafter GUL) exists in his handwriting which complains of his withdrawal from a candidacy list. Such an informal system was in practice until 1866; thereafter candidates had to be proposed by members. See *Abstract of the Constitution and Laws of the Royal Academy* (London, Royal Academy of Arts, 1863), p. 33, clause 7, and *Annual Report* (London, RA, 1866), pp. 30–2 for the reform.

11 GUL, BP II, 2/305, Coutts Lindsay to Whistler (18 April 1884). The rejected painting was Whistler's portrait of the French art critic Theodore Duret.

12 Menpes, *Whistler*, pp. 17–18.

13 Ibid., p. 18.

14 Ibid., p. 15.

15 Sickert first met Degas when given a letter of introduction from Whistler. See O. Sitwell (ed.), *A Free House! or The Artist as Craftsman: Being the Writings of Walter Richard Sickert* (London, Macmillan, 1947), pp. 144–5.

16 See A. Gruetzner Robins, 'The London Impressionists at the Goupil Gallery', in K. McConkey (ed.), *Impressionism in Britain*, exh. cat. (London, Barbican Art Gallery, 1995), pp. 87–96.

17 Ludovici, *An Artist's Life*, pp. 73–4.

18 GUL, R.164, letter dated 24 November 1884, from the secretary of the SBA, T. Roberts, to Whistler. Whistler exhibited two paintings, no. 229 (*Arrangement in Black, No. 2: Portrait of Mrs Louis Huth*) and no. 644 (*A Little Red Note: Dortrecht*) in 1884/5.

19 *The Times* (3 December 1884), quoted in A. Ludovici, 'The Whistlerian dynasty at Suffolk Street', *Art Journal* (1906) 194.

20 Ludovici, 'The Whistlerian dynasty', p. 194.

21 L. Bell, *Fact and Fiction: James McNeill Whistler's Critical Reception in England, 1880–1892*, Ph.D dissertation (Norwich, University of East Anglia, 1987), first brought this divisional dispute to my attention.

22 'The Society of British Artists', *Sunday Times* (7 December 1884), GUL, p/c, vol. 3, p. 123.

23 In the 1885/86 winter catalogue, four artists were listed in the index as 'pupil of Whistler': Walter Sickert, Mortimer Menpes, Rix Birnie and Clifton Lin. The last two were pseudonyms for Beatrice Godwin (Whistler's wife from 1888) and Maud Franklin (Whistler's mistress and model from 1873 to 1888).

24 *Pall Mall Gazette* (8 December 1885), GUL, p/c. vol. 8. This article included Sickert's drawing after Whistler's painting of Mrs Cassatt. The SBA catalogue listed as 'pupil of Whistler', in 1885/86: Menpes, Sickert, Lin, Birnie; 1886/87: Roussel; 1887/88: Roussel, Lin, Birnie.

25 SBA Minutes (1 May 1885) record that M. Menpes was elected. On 20 November 1885 W. Stott was elected.

26 *The Times* (3 December 1885), GUL, p/c. vol. 6, p. 33.

27 From Ludovici, 'The Whistlerian dynasty', p. 195, reproduction of cartoon from *Fun*, 1886.

28 The SBA catalogue lists the numbers as follows: 1885, 777 works; 1885/86, 676 works; 1886/87, 500 works; 1887/88, 543 works. SBA Minutes (25 March 1887) record Whistler proposing to limit the size of the pictures in some branches of art. SBA Minutes (4 April 1887) record that Whistler withdrew this proposition.

29 G. P. Jacomb-Hood, *With Brush and Pencil* (London, J. Murray, 1925), p. 33.

30 Ludovici, *An Artist's Life*, p. 81.

31 Menpes, *Whistler*, p. 106. Whistler's interest in 'aesthetic' hanging dated back to his first solo exhibition of 1874; see R. Spencer, 'Whistler's first one-man exhibition reconstructed', in G. P. Weisberg and L. S. Dixon (eds), *The Documented Image* (Syracuse, New York, 1987), pp. 27–49.

32 M. Salaman, 'Hail President Whistler', *Court and Society Review* (10 June 1886) 520–1. Whistler's 'A further proposition' was written into a longer article entitled 'In Whistler's studio', *Court and Society Review* (1 July 1886). This set of proposals was again published in *Art Journal*, 50 (1887) and in Whistler, *The Gentle Art*.

33 W. Stott, 'Letter to the editor', *Court and Society Review* (29 July 1886), GUL, p/c. vol. 7, p. 63.

34 J. M. Whistler, 'Letter to the editor', *Daily News* (26 November 1886), repr. in *The Gentle Art*, p. 190.

35 SBA Minutes (19 November 1886).

36 *St James Gazette* (1 December 1886), GUL, p/c. vol. nn. p. 19. The hanging committee of 1886 included Cafferi, Starr and Grace.

37 Repr. in Ludovici, 'The Whistlerian dynasty', p. 238. The *Fun* cartoon is dated 8 December 1886, p. 239.

38 Ibid., p. 239. The *Judy* illustration is dated 8 December 1886, p. 267.

39 Menpes, *Whistler*, p. 110.

40 Jacomb-Hood, *With Brush and Pencil*, p. 35, writes of his pictorial debt to Whistler. The current location of the painting was brought to my attention by Kenneth McConkey.

41 F. Wedmore, 'Fine art – The Society of British Artists', *Academy*, 761 (4 December 1886).

42 Ludovici, *An Artist's Life*, p. 78.

43 Both the SBA catalogues and the RA *Academy Notes* made use of engraved illustrations. By the 1890s, however, photographs began to outnumber the engravings.

44 SBA Minutes (1 June 1885) record Whistler introducing this request to sell photogravures of pictures on exhibition at the turnstile, and his proposal was carried. No other reference has been made to this apart from E. R. and J. Pennell, *The Life of James McNeill Whistler* (London, Heinemann, 1908), II, p. 57.

45 SBA Minutes record those elected on the following dates: 1 June 1885, M. Menpes; 20 November 1885, W. Stott; 9 April 1886, S. Starr; 25 March 1887, Waldo Story, T. Roussel, Charles Keene; 4 July 1887, A. Stevens; 30 April 1888, M. P. Lindner.

46 Roussel Papers (private collection), p/c *Kensington News* (9 April 1887).

47 Ibid.

48 Another sign of success was the fact that the Prince and Princess of Wales were in attendance at the private view for the spring 1887 exhibition.

49 For the debate over these Sunday openings see SBA Minutes (6 June 1887). See also P. Gillett, *Worlds of Art: Painters in Victorian Society* (New Jersey, Rutgers University Press, 1990), pp. 194–8.

50 In the SBA Catalogue (1887), Ludovici is listed as: no. 18, *Youth (Harmony in Gold and Flesh Tint)*; no. 63, *A Red Note*; no. 194, *A Blue Note*; no. 75, *A Pink Note*.

51 *Artist* (1 April 1887), GUL, p/c. vol. 3, p. 129.

52 Ibid.

53 SBA Minutes record his election date as 25 January 1887.

54 *Artist* (1 April 1887), GUL, p/c vol 3, p. 129.

55 Roussel's portrait was listed at the SBA as no. 121, *Portrait of Mortimer Menpes, Esq.* This seated portrait was painted in the same year as his '*Sortie du Club*', showing the standing Menpes in evening dress with an additional overcoat, a work exhibited at the NEAC in 1887.

56 Ludovici, *An Artist's Life*, p. 78, describes Whistler as wearing evening dress to the meetings, a habit the British Artists regarded as snobbish.

57 'Her Majesty's Royal Society of British Artists', *Pall Mall Gazette* (28 November 1887), GUL, p/c vol. 9, p. 14.

58 This practice differed at the RA and Grosvenor Gallery, where no commission fee was charged, although the standard one shilling entrance fee provided income.

59 Ludovici, 'The Whistlerian dynasty', p. 238.

60 SBA Minutes record this in the annual general meeting of 6 May 1887.

61 *Pall Mall Gazette* (28 November 1887).

62 GUL, R.210.

63 RBA Minutes (1 November 1887) record the institutions as: 'The Royal Academy of Arts, the Royal Institute of Painters in Watercolour, and the Royal Water-colour Society – and any other Society or association formed, or to be formed, for the Exhibition of pictures in London.'

64 W. Bayliss, *The Higher Life in Art* (London, Bogue, 1879), p. 40.

65 Signatories were Cauty, Holyoake, MacNab, Grace, Henley, Cattermole, Morgan, Roberts, Hardy and Weldon. C. Symons wrote to Whistler (8 May 1888) giving his support and spoke of the unfair treatment Whistler received (GUL, S.276, S.278).

66 *Glasgow Herald* (27 November 1888), GUL, p/c. vol. 10, p. 40.

67 Most notable was the division between the Impressionist clique, headed by Sickert, and the Newlyn artists. See A. Gruetzner's MA dissertation, *The Formation and the First Four Exhibiting Years of the New English Art Club* (London, Courtauld Institute, 1975).

SCIENCE

5

Nature and abstraction in the aesthetic development of Albert Moore

Robyn Asleson

THE HISTORY of art charts continual fluctuations in the relationship of nature and abstraction. In Victorian England, the rallying cry of 'truth to nature', sounded in the 1840s by John Ruskin and the Pre-Raphaelite Brotherhood, was succeeded in the 1860s by the tenet of 'art for art's sake', advanced by proponents of Aestheticism. In formulating the connection between the two movements, many critics have invoked the mechanistic model of the pendulum: art was swinging predictably from the excessive naturalism that absorbed one generation, to the opposing extreme of artificiality that was ostensibly embraced by the other. This tidy construction falsifies the complex relationship of naturalism and Aestheticism. It overlooks the relevance of close natural observation to the formation of idealising abstractions, and the fact that most of the artists who became advocates of Aestheticism passed initially through a period of discipleship to Ruskinian or Pre-Raphaelite naturalism. Little attention has yet focused on the transition from one mode to the other, although it would seem to be crucial to an understanding of the development of the Aesthetic impulse in nineteenth-century Britain.

Albert Moore is a useful figure to consider in this light, for he grounded his pioneering use of abstract formal principles on close analysis of natural structures and phenomena. As this essay will show, Moore's sophisticated and uncompromising engagement in the purely visual problems of art distinguished him as the most advanced exponent, in this sense, of British Aestheticism. Moore has failed to receive the recognition he deserves – both now and during his lifetime – as a result of his notoriously circumspect habits. Utterly devoted to the pursuit of his painstaking art, he considered all other activities – including self-explanatory interviews, lectures and articles – a waste of precious time. The artistic manifesto that he once contemplated writing was forsaken in favour of expressing his views pictorially, through his art. [1]

The student of Moore finds compensation for the artist's poverty of words in the richness of his extant preparatory drawings, many of which are preserved at the Victoria and Albert Museum. The construction lines and other notations in

these drawings reveal the underlying linear armature of Moore's paintings and offer clues for reconstructing the artist's evolving methods and intentions. Many more clues are provided by his finished works and by hints contained in Moore's letters and the recollections of his former pupils. Chief among the latter is Alfred Lys Baldry, whose biography of Moore has been the principal source of information on the artist since its publication in 1894.[2] Baldry throws out tantalising hints concerning Moore's rapid assimilation of disparate influences. Impelled by his own instinctively analytical nature, we are told, Moore synthesised myriad theories of nature and culture from which he created a seamless amalgamation all his own.[3] Yet Baldry is entirely vague about the exact sources of these external influences, specifying only Moore's intense study of nature, Greek sculpture and Japanese art. Keen to establish his former master's claims to original genius, Baldry seems to overstate Moore's independence from the aesthetic milieu of his time.[4]

A careful sifting of Baldry's statements on Moore, together with the evidence provided by Moore's preparatory studies and finished works, reveals that, despite his reputation for insularity and idiosyncrasy, it was Moore's exposure to a range of contemporary and traditional influences that generated his mode of art. As this essay will demonstrate, Moore founded his method on the most traditional rules of landscape composition, synthesised with the latest theories of architecture and design. From this eclectic array of ideas, Moore distilled a master system of his own creation. His true innovation lay not, as Baldry suggests, in deriving original principles from nature, but in adapting established rules to new purposes – applying, for example, landscape conventions to figure painting, architectural design to painting, and music theory to pictorial composition. This chapter re-establishes these seminal influences on Moore's art during an early phase of his career. In doing so, it demystifies one of the most mysterious artists of the Victorian era, while simultaneously reasserting the innovative quality of his work.

During Moore's lifetime, his art was invariably discussed in terms of artificiality. Determined to set the record straight, Baldry emphasised his fidelity to nature and his singular delight in the natural world. Moore grew up in a family of landscape painters and spent his formative years accompanying his brothers on sketching trips. His ardent engagement with nature is confirmed by family anecdotes and the recollections of another former student, Walford Graham Robertson, who recalled his master's 'almost inarticulate delight' on catching glimpses of 'black winter trees fringing the jade-green Serpentine, or of a couple of open oysters lying on a bit of blue paper or of a flower-girl's basket of primroses seen through grey mist'.[5] Baldry remembered virtually identical incidents – lemons rather than oysters on the blue paper, and an appreciation for the 'flickering glints of daylight between overhead masses of leaves and interlacing branches', which inspired him to layer white lace over darker drapery in several of his figurative pictures.[6]

It is significant that the nature-worshipping anecdotes of Robertson and Baldry share an emphasis on the particulars of nature (flowers, fruit, glittering light), rather than its generalised topographical effects, for despite Moore's reported

pleasure in natural scenery, his finished paintings demonstrate no feeling for land-scape *per se*. While artists in his immediate circle (most notably George Heming Mason and Frederick Walker) experimented with an idealised integration of fig-ures with nature, Moore entirely subordinated landscape to human form. Pictorially speaking, he viewed nature not as an end in itself, but as a means to the higher end of abstraction. Even when sketching in open countryside, Moore framed his view narrowly. For one of his earliest oil paintings, *Elijah's Sacrifice* (1863, Bury Art Gallery and Museum), Moore made outdoor studies of the Roman Campagna, whose majestic expanses dominated the art of his brother John. In his own painting, however, the sweeping panoramas are reduced to a shallow patch of meticulously delineated foreground foliage juxtaposed against a flat silhouette sig-nifying mountains. Moore's subsequent paintings treat landscape in the same way, but even more shallowly, generally employing a dappled screen of leafy trees to block the eye's recession into fictive space. In the paintings of his maturity, Moore shifts from forest glades to draped and papered rooms with no appreciable differ-ence in effect; patterned wallpaper and carpet fulfil the same purely decorative function as foliage and lawn.[7]

Although this suggests that nature served Moore solely as a source of decora-tive motifs and effects, Baldry claimed that the artist also derived comprehensive design principles from the underlying structures of the natural world. 'From the unconscious line agreement of natural forms', Baldry asserts, 'came the method of composition which he followed':

> For instance, he noted that in a landscape there is a tendency to a duplication of the principal lines, and that the chief forms are repeated with very slight variations. He found too that Nature has invariably a sense of adjustment and compensation, bal-ancing a succession of indefinite forms and gentle lines by some strongly marked shape, or by a few spots of exact meaning and undeniable significance. Nature's chief rules seemed to him to be parallelism and optical rather than actual balance. [8]

The principles outlined by Baldry refer to generalised effects rather than specific natural details. Yet Moore's surviving works furnish no examples of the kind of landscape study that might have yielded such insights.[9] On the contrary, the plein-air nature studies that survive from Moore's early years are remarkable for their narrow focus. Moreover, far from being original, the principles that Baldry claims Moore 'noted' in the landscape were well-established conventions of landscape design. It seems likely that Baldry's investment in the notion of Moore as a 'nat-ural' artist led him to overstate the primacy of nature in his master's artistic edu-cation while neglecting other, more prosaic influences on Moore's development.

Indeed, it would have been very strange for Moore not to have learned the conventional rules of landscape from his earliest art instructors, his elder brothers Edwin and William, who were uniquely qualified to pass on these traditions. Both were professional drawing masters with particular expertise in theories of perspective. Having studied with David Cox, Samuel Prout and other masters of

topographical and picturesque style, the Moores specialised in meticulously rendered views structured according to the eighteenth-century rules of landscape composition. More unusually, however, the brothers also valued study of the human figure, and briefly scandalised their neighbours in York by establishing a private class for study of the nude model.[10] It may have been their combined study of landscape scenery and human anatomy that inspired their younger brother's application of landscape principles to figure painting.

A further spur to this abstract approach to the figure and to pictorial design was provided by Moore's training at the York School of Design, where he became a student in 1851. Founded nine years earlier by the figure painter William Etty, the York School differed from the Board of Trade's other Schools of Design by encouraging the study of natural specimens and life models in tandem with training in technical draftsmanship and design for manufacture. Prizes were awarded for plein-air nature studies, such as 'the wild flowers, weeds, and grasses of an English hedge-bottom, done accurately from the objects in arrangement as well as details', but pupils were also instructed in adapting natural forms to decorative purposes, and in the theory and practice of applied design.[11] Despite his youth, Moore reportedly aroused 'stir and comment' through his precocious abilities, achieving 'excellent progress especially in Anatomy'.[12] The combination of life study, natural observation and abstract formal principles promoted at the York School of Design proved formative in Moore's development.

An additional influence was the art criticism of John Ruskin. Moore's early esteem for Ruskin is ironic in the light of their ultimate opposition during Whistler's 1878 libel suit against the critic. Even then, however, Moore professed respect for Ruskin's artistic knowledge. Two decades earlier, during the winter of 1858, Moore had written to his brother John of his longing to attend Ruskin's drawing course at the Working Men's College in London.[13] His interest may have been sparked by the lavish praise Ruskin bestowed on a picture by Moore's brother Henry the previous spring, as well as the detailed critiques that Henry subsequently received from Ruskin.[14] Also in 1857 Ruskin had published *The Elements of Drawing*, a step-by-step course of instruction in landscape draughtsmanship and composition, in which he reminded his readers that 'the best drawing-masters are the woods and hills' – but also plugged his teaching at the Working Men's College.[15]

Moore's interest in Ruskin was discriminating and specific. The vital narratives and ethical analogies that the critic associated with nature's formal properties were obviously antithetical to his mature views, but even in his youth he appears to have rejected them. This fact is clearly demonstrated by Moore's watercolour *Study of an Ash Trunk* (plate 28), executed in the Lake District in 1857, in which he adopted a subject very similar to one suggested by Ruskin in the recently published *Elements of Drawing*: 'one or two trunks, with the flowery ground below … a not very thick trunk, say nine inches or a foot in diameter, with ivy running up it sparingly'.[16] In carrying out such a subject, Ruskin instructed the student to attend

carefully to the overall shape of the tree and the disposition of its branches, and most of all to represent faithfully its 'leading lines', that is, the lines 'which have had power over its past fate and will have power over its futurity'. In the representation of a tree, Ruskin asserted, the leading lines 'show what kind of fortune it has had to endure from its childhood: how troublesome trees have come in its way, pushed it aside, and tried to strangle or starve it; where and when kind trees have sheltered it, and grown up lovingly together with it …; what winds torment it most; what boughs of it behave best'.[17]

The pronounced diagonal incline of Moore's tree trunk would seem to exemplify Ruskin's principle of the 'leading line'; it charts the plant's growth in the direction of the sun and away from the shade that has covered the left side with moss. However, the artist's adoption of a radically cropped format betrays his exclusive interest in the abstract formal properties of the lines he traces, at the expense of any ethical or narrative connotations. Focusing on an abbreviated section of the tree trunk, Moore homes in on the smallest recognisable component of

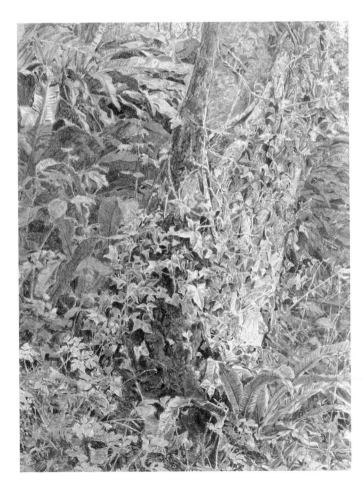

28 Albert Moore, *Study of an Ash Trunk*, 1857, watercolour and bodycolour with gum arabic, 30.5 x 22.9 cm

the whole, thus preventing the tree from playing the role of ethical protagonist that it assumes in Ruskin's criticism. The drawing recalls Baldry's and Robertson's anecdotes concerning Moore's delight in the particulars of nature, and anticipates later works by Moore which similarly divorce subjects from customary interpretive contexts, thereby forcing the eye to focus on the formal properties of the image alone.

Moore's interest in Ruskin was almost certainly limited to the formal principles that the critic traced to nature. Introduced to these principles through the art and instruction of Samuel Prout, James Duffield Harding and J. M. W. Turner, Ruskin meticulously confirmed and corrected them through point-by-point analysis of natural forms.[18] By walking students through these proofs in the *Elements of Drawing*, Ruskin intended to open their eyes to the conventional devices (parallelism, radiation, repetition, and so on) that were implicit in nature, while simultaneously demonstrating that the vitality and variety of nature resulted from exceptions to these rules. This synopsis exactly parallels the principles that Baldry ascribes to Moore, and which are easily traced in his art. In his *Study of an Ash Trunk* Moore pursues the principle of parallelism that Ruskin dwells on throughout the *Elements of Drawing* and that Baldry says Moore considered one of 'Nature's chief rules'. Moore also observed nature's tendency to repeat 'the chief forms … with very slight variations' – the rule of repetition, in Ruskinian terms. The bounding edges of the tree trunk, rising diagonally from left to right, are echoed throughout the drawing by parallel lines formed by the vines, stems and leaves. Countering this system of left-to-right diagonals is a second system of diagonals rising in an opposing direction. These are most apparent in the vines crossing the tree trunk and in the swathe of ivy which links the ferns in the lower right corner with those in the upper left. Executed in greater detail than other passages of the drawing and spotlit by the sun, these sections arrest the eye and strengthen the composition's underlying armature. It seems likely that Moore first learned these standard rules of landscape composition from essentially the same sources as Ruskin had used. Edwin Moore, after all, had studied with Prout, whose published compendia of compositional devices are cited again and again in Ruskin's works. But it is equally likely that the independent-minded Moore took a leaf from Ruskin's book by verifying the rules others had taught him through his own nature studies.[19]

Moore's analytical and geometric approach to nature gained rigour from his simultaneous study of mathematics and architecture. His native talent for maths appears to have been considerable. At the age of fourteen, having left York for London, Moore immediately earned the highest honours in mathematics at the Kensington Grammar School, and sustained his high standing for the next two years.[20] During the same period Moore also earned distinction in classics. Expertise in geometry would have assisted Moore in his work as an architectural draughtsman, which he pursued while at school.[21] The extent of Moore's early involvement in architectural circles requires further study, but his introduction to the profession almost certainly came through family connections. His brother

Edwin was the son-in-law of the York architect and surveyor Matthew Oates, and had himself worked in an architect's office prior to turning to landscape painting.[22] The London architect and developer David Moore (apparently an uncle) was responsible for Albert's enrolment at the Kensington Grammar School, and probably orchestrated the boy's employment as a draughtsman.[23] Moore also developed a close friendship with William Eden Nesfield, one of the most innovative and influential architects of his generation. In 1859 Moore and Nesfield spent several months touring northern France together while the architect completed drawings for his influential publication, *Specimens of Medieval Architecture* (1860), possibly aided by Moore's draughtsmanship. It was undoubtedly Nesfield's 'very jolly collection of Persian, Indian, Greek and Japanese things', as well as the eclectic blend of disparate styles in his architecture, that inspired Moore's later synthesis of a similar stylistic array in his paintings.[24] During this period, Moore also came to the attention of Richard Burchett, the headmaster of the Central Training School for Art at South Kensington, and author of numerous studies on artistic geometry and perspective. It was Burchett who provided Moore's official recommendation to the Royal Academy Schools in 1857.[25] Clearly, Moore's talent for mathematics, his exposure to analytical drawing and perspective (through his brothers Edwin and William, and, presumably, Richard Burchett), his instruction in design principles at the York School of Design and his architectural work in London (and perhaps in France) all served to indoctrinate the young artist in the values of rational visual analysis and to initiate his lifelong enquiry into the abstract formal properties of beauty.

Moore's abstract approach to the human figure in his mature art takes on a sense of inevitability when it emerges that he came to figure painting through geometry – that is, while designing figurative decoration for architectural spaces. This design work also provides a missing link in his career, articulating the incremental steps that led from his pure nature studies of the late 1850s to the generalised female figure painting of the mid-1860s. Surviving letters indicate that during the late 1850s, while actively pursuing nature studies and contriving to attend Ruskin's landscape-oriented drawing lessons at the Working Men's College, Moore was also emulating his elder brothers in seeking opportunities for studying the nude model.[26] This training enabled him to provide his friend Nesfield with figurative designs for mural paintings and other decorative schemes which featured idealised female forms as embodiments of nature. The conventions of this mode encouraged Moore to adopt classicising drapery and idealised physical types, and freed him to pursue his own increasingly abstract interests in a context in which they were wholly appropriate. These designs chart Moore's rapid exclusion of narrative, psychological and ethical concerns in favour of purely formal qualities.

In his earliest designs, Moore began conventionally enough. Each of the twelve panels he painted in 1861 on the ceiling of Nesfield's model dairy at Croxteth Hall, Lancashire, functioned as a self-contained picture representing the sort of immediately recognisable narrative vignette that appeared in any number of

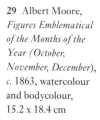

29 Albert Moore,
*Figures Emblematical
of the Months of the
Year (October,
November, December),*
c. 1863, watercolour
and bodycolour,
15.2 x 18.4 cm

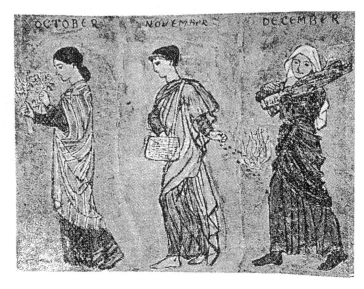

mid-Victorian genre paintings. Groups of figures pursued agricultural activities appropriate to each of the twelve months (sheep-shearing in July, a wheat harvest in August), thereby allegorising the stages of the year through human activity.[27] By the following year, in his designs for Nesfield's new wing at Combe Abbey, Warwickshire, Moore was focusing on a single iconic female figure to represent each month (plate 29).[28] In 1863 he produced a free-standing fresco, *The Four Seasons* (untraced), which was a pivotal work in his transition from mural design to easel painting. In this work, Moore repeated the sort of iconic, idealised figures that he had employed at Combe Abbey but assembled them as a group. He endowed each with psychological and physical characteristics appropriate to her season, so that the picture could be read in terms of an imagined narrative involving the relationship of contrasting personalities.[29] By 1866, in his gouache drawing *The Elements*, Moore had entirely excised this narrative dimension (plate 30). The four female figures are now physically interchangeable and psychologically remote. Blank-faced, each bears a simple emblem symbolic of her elemental nature: a branch for earth, a Japanese fan for wind, a flaming pot for fire and a flowing jug for water. By stripping down the symbolism and eradicating most of the picture's extra-aesthetic significance, Moore forces the viewer to concentrate on purely visual qualities, such as the flow of the drapery and the arrangement of colour. The 'subject' of the picture has already become its least compelling feature.

From his very first architectural design, Moore had concentrated on achieving the specific formal qualities that architects were urging as necessary for decorating the geometric spaces of buildings: anti-illusionistic flatness, linear emphasis and compositional clarity. In translating the gestures and poses that he had invented for

30 Albert Moore, *The Elements*, 1866, crayon and gouache, 10.8 x 18.4 cm

architectural contexts to oil paintings of the late 1860s and early 1870s, Moore also translated the formal qualities of mural painting.[30] The flatness, linearity and simplicity of these pictures provided a bold contrast to the pictorial approaches usual in Victorian genre painting. Further commissions for mural paintings forced the development of more sophisticated techniques for harmonising nature, in human form, with the geometric severity of architecture. At St Alban's Church, Rochdale, Moore was commissioned to execute a series of frescoes within the awkward shapes of wall created by windows, arches and other architectural features (1865–66, plate 31). These spaces dictated the parameters of Moore's compositions and honed his

31 Albert Moore, *Study for 'The Feeding of the Five Thousand', St Alban's Church, Rochdale*, 1865–66, coloured chalks

ability to invent poses and groupings that accommodate the human figure to geo-
metric configurations. Mural designs such as these profoundly influenced Moore's
easel paintings by enhancing his awareness of the relationship of the picture and its
'frame', by which he understood both the carved and gilded surround and the
architecture beyond it. Baldry noted that he 'treated each of his [easel] paintings as
an independent decoration, as a panel which might well be made ... the centre and
starting point of a complete scheme of decoration'.[31] Executed in situ, mural paint-
ings could, and indeed had to, relate to the precise structure of their surroundings.
The mobility of free-standing paintings required more adaptable armatures, built
on universal geometric principles common to all buildings. Again, these principles
were in themselves highly traditional, but Moore's systematic application of them
constituted a true innovation.

Moore's understanding of architectural design and his ability to conceive of pic-
torial imagery in analogous geometric terms profoundly impressed a number of
progressive architects, who were delighted at last to find a painter who understood
how to design for buildings. Identified closely with Nesfield's architectural clique,
Moore crops up frequently in architectural journals of the 1860s.[32] To a far greater
extent than art critics, architects recognised the formal principles that under-
pinned Moore's art and they discussed his work in terms appropriate to the artist's
intentions. A critic for the *Building News* singled out Moore's painting *Azaleas*
(plate 32) as 'the only decorative painting' in the Royal Academy exhibition of
1868, adding that it 'ought to have been hung with the architectural drawings'.[33]
Perhaps it was the same writer who later called attention to this work as 'one of
the few pictures in the Academy that has a frame that fits the picture'.[34]

What the critic noted of the frame applied equally to the formal underpinnings
of the painting itself: 'The forms employed are simple and well known, but are so
judiciously employed that they have the charm of novelty'.[35] Moore's full-scale
preparatory drawing (Victoria & Albert Museum) reveals the underlying structure
of *Azaleas* to be a grid of intersecting diagonal lines overlaid by verticals and hor-
izontals. It is essentially the same pattern employed a decade earlier in Moore's
Study of an Ash Trunk, but expressed with greater clarity and sophistication.
Baldry defined this compositional strategy as a reduction and reinforcement of the
linear character implicit in Moore's initial conception for the picture:

> When he had completed this preliminary sketch, he considered the direction of the
> more prominent lines of its composition, and selecting those which dominated the
> design, he arranged a series of parallels to them throughout the drawing. He always
> had two sets of prominent lines and sometimes three, crossing one another at an
> angle, and by the intersections of these and their subordinate parallels, he fixed the
> position of all the details and accessories.[36]

Baldry's claims are entirely borne out by Moore's preparatory drawings. So
precisely did this linear system predetermine the final composition, according to
Baldry, that it fixed the shape and size of the canvas, the arrangement of the

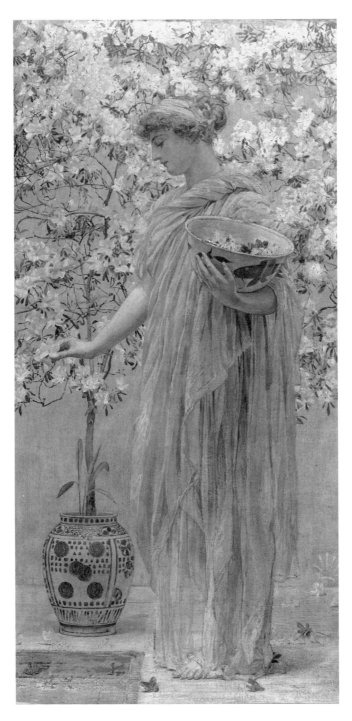

32 Albert Moore, *Azaleas*, 1868, oil on canvas, 198.1 x 100.3 cm

drapery folds, the poses of the figures, and the placement of accessory details such as vases, rugs and fans. Chromatic arrangements were also determined by the lines of Moore's abstract armature, so that 'he could judge how large to make each patch of a particular tint and could fix the proper relation between colour area and degree of brilliancy necessary for maintaining due balance and support throughout the canvas'.[37]

Azaleas has become a key image in the history of Victorian Aestheticism as a result of the tribute it received from Algernon Swinburne, who likened the painting to the poetry of Théophile Gautier as a work of art produced entirely for its own sake. Reviewing *Azaleas* on its appearance at the Royal Academy exhibition of 1868, Swinburne wrote:

> The melody of colour, the symphony of form is complete: one more beautiful thing is achieved, one more delight is born into the world; and its meaning is beauty; and its reason for being is to be.[38]

It was hardly new to apply musical terminology to painting, which had long been discussed in terms of its harmony of tone, rhythm of line, and so forth. However, the concept of equivalence among the various art forms, which had absorbed ancient and Renaissance theorists, sparked new interest in England (as well as on the Continent) during the 1860s.[39] This new vogue inspired many painters to adopt overtly musical subject-matter and to strive to evoke the moods conjured by music. For those fighting the tyranny of narrativity, music provided a seductive model of an art in which form and content merge in an autonomous aesthetic experience unencumbered by external subject-matter.

In much nineteenth- and twentieth-century criticism, references to musicality in painting are invoked and abandoned as a vague rhetorical flourish with minimal effort to pin down exact correspondences between the two media. However, some of the most explicit comparisons were inspired by Moore's work. Sidney Colvin wrote of 'his power of arranging and combining the lines of the human form into a visible rhythm and symmetry not less delightful than the audible rhythm and symmetry of music'.[40] Another writer drew specific analogies between his art and Greek music:

> [It] remains one of the finest specimens of a sort of pictorial music drawn as from a lyre of but few strings.... Indeed, it is very like antique music, which was soft, of narrow compass, apt to be monotonous, and best fitted for the lyre and flute.[41]

Anecdotal as well as pictorial evidence suggests that music theory had a concrete effect on the pictorial compositions of Albert Moore. Music was the great enthusiasm of his family, and several of his brothers were noted musicians. One of the great friends of Moore's student days, the painter William Blake Richmond, recalled many evenings spent singing and playing instruments with the three Moore brothers at the home they shared, 'where much Handel and Bach went on'.[42] Richmond, himself a musician, was particularly interested in formal analogies between

painting and music. With his friend Sir Hubert Parry, composer and authority on ancient Greek music, he investigated the 'technical and profound' affinities between music and art, the fact 'that music, like painting, has its background, its middle distance, and its lights; while painting has its theme, its major and minor key, its harmonies or discords'.[43] It is likely that similar analogies cropped up during Richmond's musical and artistic soirées with Moore and his brothers.

Richmond drifted away from Moore as the latter became a closer associate of James McNeill Whistler, a friendship strengthened by mutual interest in analogies between music and painting. At the Royal Academy exhibition of 1867 both Moore and Whistler exhibited pictures which take these analogies as their explicit themes; Whistler showed his *Symphony in White, No. III* (see plate 14) and Moore, *A Musician* (plate 33). Both compositions are underpinned by horizontal and vertical lines whose linear severity is contrasted with the flowing diagonal curves of the human forms draped across them. In Moore's painting, the musical analogy intended by this structure is so obvious as to be virtually audible. The regularly spaced vertical elements establish a rhythm in the background, while the

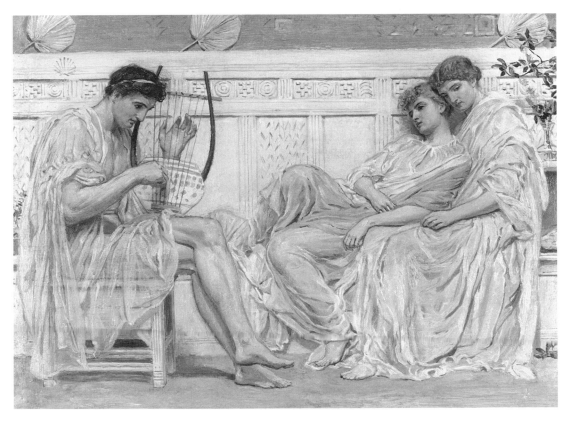

33 Albert Moore, *A Musician*, 1867, oil on canvas, 28.6 x 38.7 cm

irregularly rising and falling curves in the foreground sing the melody. This underlying structure is made explicit in a number of Moore's pictures and designs from about 1863 to 1868.[44] Thereafter it becomes more subtle, but insightful critics recognised (and Moore's preparatory drawings confirm) that the arrangement continued to underpin his compositions for the rest of his life. Following the artist's death, one writer observed:

> He always based his arrangement on certain horizontal lines.... These lines were bro-ken or crossed by the more supple lines of the draped figures, which, in a certain sense, only existed to perform this office in the composition.... This matter of the horizontal lines was the underlying principle in his compositions. No doubt he got this idea from Greek bas-reliefs.... He placed certain definite immovable verticals and horizontals and then broke them with lovely oppositions of drapery and form in all sorts of alluring attitudes and shapes.[45]

This writer is correct in associating Moore's system of linear arrangement with Greek sculpture, but I believe the relationship was far more complex than he or she realised. Architectural theorists of Moore's era were fascinated by the fabled Greek systems for producing pleasing harmonic relations. The early nineteenth century had witnessed significant discoveries concerning the measurements of ancient Greek architecture and sculpture, and these discoveries generated fresh interest in reconstructing the Greeks' 'secrets' of ideal beauty. These were believed to hold the universal key to the relationships of nature (to include human propor-tion) and all of the arts – sculpture and architecture, as well as music, poetry, geom-etry, arithmetic, perspective and painting. In pursuit of these abstract formal principles, theorists proposed a staggering number of systems for duplicating the results of the Greeks. Hints culled from a variety of ancient authors instilled the belief that music held the key to unravelling this mystery through its geometric system of harmonic proportion.[46] These investigations into the scientific princi-ples of beauty and the unity of the arts were of obvious relevance to the Aesthetic Movement in painting. They lend significance to the fact that at the same time that he and Whistler were developing musical analogies in their paintings, Moore was also engaged in an intense study of Greek sculpture through which, according to Baldry, he found 'a complete technical system ... adaptable to the needs of all times and suited to the exigencies of every school and phase of thought'.[47]

A gloss on Moore's pursuit of a holistic compositional system involving music, Greek sculpture, architecture and nature is to be found in the theories of David Ramsay Hay (1797–1866), a pioneer reformer of Scottish interior decoration.[48] Hay, like Moore, made it his life's work to develop a unified system capable of for-malising the composition process and harmonising all elements of painted deco-ration. He documented the evolution of this system in dozens of treatises on proportion and harmony published between the 1820s and the mid-1850s. Although grounded in practice, Hay's work is theoretically ambitious. His value to the present discussion is in his application of music theory to the harmonious

arrangement of line and colour. In *The Natural Principles and Analogy of the Harmony of Form* (1842) Hay asserted that as 'forms are in all respects analogous to sounds, … a system of linear harmony can be established, similar to that which regulates the arrangement of musical notes'.[49] By equating the ratios and relationships employed in music theory to linear ratios and relationships in nature and the visual arts, Hay found it possible to express the portico of the Parthenon as a geometric configuration as well as a melody (plate 34). He made similar use of colour theory, claiming that the colour combinations in his decorative projects were 'balanced with mathematical certainty', and developing a system for finding musical equivalents for primary, secondary and tertiary colour.[50]

Hay's chief contribution to the science of symmetry was the theory that 'the eye estimates proportion, not by distance, but by angular direction', that all harmonic combinations are therefore governed by angles, rather than linear measurement, and that consequently 'there must be a fundamental angle, to which all other angles so employed should harmoniously relate as an integral part'.[51] In his own century, Hay was deemed 'the modern Pythagoras', whose discoveries 'eclipse all our previous ideas, as the electric telegraph has eclipsed the semaphore, and … evince as much genius as the discovery of Neptune by Adams and Le Verrier'.[52] Today, he is virtually unknown and his impact on nineteenth-century aesthetics – and Aestheticism – is unrecognised.

To the extent that it is possible to reconstruct Hay's decorative painting, it seems to anticipate that of Albert Moore in several respects. He employed subtle tertiary hues, believing primary colours too violent for domestic decoration, and aimed at the creation of dry, fresco-like paint surfaces. Hay's theories of harmonious proportion may also have had an impact on the compositional system developed by Albert Moore. Moore's preparatory studies for the painting *Birds*

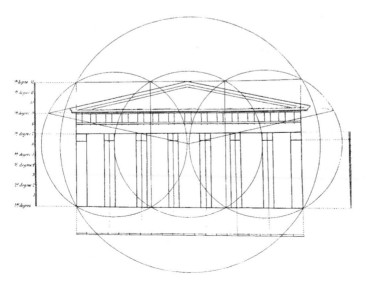

34 *Façade of the Parthenon*, illustration from David Ramsay Hay, *The Natural Principles and Analogies of Form* (1842)

provide hints of a relationship of geometric principles and musical analogy (*c*. 1878, plate 35). The underlying pattern that determined Moore's design is, as in *Azaleas*, a diaper pattern formed by intersecting lines. The system appears to originate in the upper and lower segments of the figure's proper right arm and is extended or echoed in other parts of the anatomy – such as the profile of the upturned face and the upper portion of the proper left arm. Although these lines read as a series of parallel diagonals, they are actually slightly curved, and approximate the principle of entasis found in Greek architecture, and of 'optical rather than actual' balance which Baldry attributed to Moore.

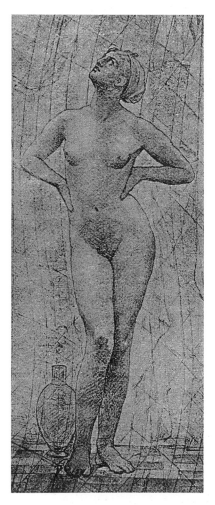 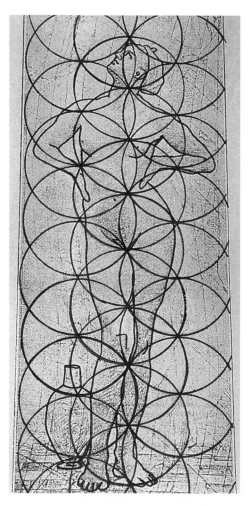

35 Albert Moore, *Figure Study for 'Birds'*, *c*. 1878, black chalk

36 Reconstruction of Albert Moore, *Figure Study for 'Birds'*, *c*. 1878, based on Victoria and Albert Museum, no. 227.1905 (charcoal on grey paper), with construction lines enhanced

Linear parallelism constituted only part of the artist's procedure, however. In another nude study for *Birds*, Moore worked out the proportions and position of the body through a series of intersecting circles (plate 36). Whereas standard academic methods employ this sort of geometric system in a limited way, in order to establish the ideal proportions of the figure, Moore used it to generate the entire composition. The points of intersection determine not only the cardinal elements of the body, but also the placement of other objects in the composition, such as the vase at lower left. In this way, both the figure and its setting are integrated within a harmonious geometric pattern. There is an apparent correlation between Moore's system of proportion and Hay's system, as illustrated, for example, in the drawing of the Parthenon noted earlier. This holistic system adds new resonance to Baldry's explanation for Moore's transition from Pre-Raphaelite specificity to classical idealism: 'He ceased to be satisfied with expressing the parts as soon as he felt he had still to understand the whole'.[53] The extent to which this reflected the theories of David Ramsay Hay is now impossible to determine, but Hay's exploration of similar principles in his widely known treatises is too important to ignore.

There are undoubtedly other contemporary theorists and practitioners who contributed to Albert Moore's formulation of his exceptionally sophisticated aesthetic. More than any other artist of his time, perhaps, he was ideally situated to synthesise a great range of influences. His idiosyncratic approach to painting arose from the combined circumstances of his love of music and nature, his education in mathematics and classics, and his experience in architectural draughtsmanship and design. The aesthetic theories emanating from the architectural and design fields in which Moore operated help to reconcile the deep engagement with nature that characterised his formative years with the intense analysis of culture (chiefly in the form of Greek sculpture and Japanese art) that absorbed his early maturity. It is unlikely that Moore was alone in his eclectic assimilation of a range of theoretical influences. Students of Victorian Aestheticism would do well to cast their nets as widely as he did.

Notes

1 A. L. Baldry, *Albert Moore: His Life and Works* (London, George Bell, 1894), p. 97.

2 Baldry, *Albert Moore*. In addition to the full-length monograph, Baldry published a number of significant articles: 'Albert Moore', *Pall Mall Budget* (February 1894) 14; 'Albert Moore', *Studio*, 3 (1894) 3–6, 46–51; 'Albert Moore: an appreciation', *Art Journal* (February 1903) 33–6; 'Albert Moore (1841–1893)', *The Old Water-Colour Society's Club*, 8 (1930–31) 41–7.

3 Baldry, *Albert Moore*, p. 697.

4 See especially Baldry, *Albert Moore*, pp. 6–7.

5 W. Graham Robertson, *Time Was* (London, Quartet Books, [1931] 1981), p. 82.

6 Baldry, *Albert Moore*, p. 82.

7 The clearest statement of Moore's conception of landscape as pattern is found in preparatory studies, such as that for the St Andrew mosaic at Westminster Palace

(1868, Board of Works, Public Record Office, Kew), in which the background foliage is expressed as precisely placed dashes radiating from vertical strokes signifying tree trunks. Moore employed exactly the same method in his colour sketch for *Shuttlecock* (*c.* 1870, Sheffield City Art Galleries), where the staccato dashes and rhythmically spaced vertical strokes serve as shorthand for a patterned fabric backdrop.

 8 Baldry, *Albert Moore*, p. 81.

 9 Extant examples are the watercolour, *A Waterfall in the Lake District* (*c.* 1857, Ashmolean Museum), and the unlocated drawing, *A Gate* (1860), which contained a landscape background studied in Borrowdale (reproduced in Baldry, *Albert Moore*, p. 12).

10 Edwin Moore, *Elementary Drawing Book* (York, 1840); *Yorkshire Gazette* (30 March 1839) 1, (23 December 1871) 6, (13 October 1883) 3; John Ward Knowles, *York Artists*, 1 (MS. scrapbook, York Central Library), pp. 273–4, 276.

11 Alexander Gilchrist, *Life of William Etty, R.A.*, 2 vols (London, David Bogue, 1855), II, p. 258; Miss Moore, 'William Etty', *Yorkshire Philosophical Society Annual Report for 1901*, 9 (1902) 95.

12 Knowles, *York Artists*, 1, p. 280; Frank Maclean, *Henry Moore, RA* (London, Walter Scott Publishing, 1905), p. 22. He won prizes for drawings in 1852 and 1853 ('York School of Design', *York School of Art Minute Book, 1842–55* [York City Archives]).

13 Private collection.

14 J. Ruskin, *The Works of John Ruskin*, Library Edition, ed. E. T. Cook and A. Wedderburn (London: George Allen, 1903–12), XIV, p. 104; Maclean, 29, 43.

15 John Ruskin, *The Elements of Drawing; in Three Letters to Beginners* (London, Smith, Elder, 1857), pp. xiii–xxii.

16 Ruskin, *Elements of Drawing*, p. 153.

17 Ibid.

18 Ruskin exhorted his readers to emulate his example, asserting that 'it is the main delight of the great draughtsman to trace these laws of government' in the landscape, and that the 'observance of the ruling of organic law … is the first distinction between good artists and bad artists' (Ruskin, *Elements of Drawing*, pp. 163–4).

19 For Moore's tendency to question the instruction he received, see Baldry, *Albert Moore*, p. 11.

20 For Moore's education, see reports of the Kensington Grammar School, January term of 1856 to summer term of 1857, in the Local Studies Department, Kensington and Chelsea Library, London.

21 For Moore's architectural work, see Harold Frederic, 'A painter of beautiful dreams', *Scribner's*, 10 (December 1891) 718; *Pall Mall Gazette* (27 September 1893) 5.

22 *Catalogue of Loan Collection of Works by the 'Moore' Family of York*, exh. cat. (York, Corporation Art Gallery and Museum, 1912), p. 9; private information.

23 *Kensington Proprietary Grammar School Share Book, Christmas 1855 to [blank]* (Kensington and Chelsea Public Library, Local Studies Department), p. 151; *Builder*, 37 (1 November 1879) 1215.

24 Cecil Y. Lang (ed.), *The Swinburne Letters*, 6 vols (New Haven, Yale University Press, 1959), II, p. 32. For revised date of letter (summer 1863) see letter of 8 May 1970 from Lionel Lambourne, Whistler Centre, Glasgow University Library.

25 Royal Academy Archive.

26 Albert Moore to John Collingham Moore, *c.* January–March 1858, private collection.

27 For the design see Victoria and Albert Museum, no. 179–1894. For a description of the paintings in situ, see L'Aigle-Cole, 'Walks on the Croxteth Estate', *Liverpool Daily Post* (17 November 1903) 7. Moore also designed figural panels representing the four seasons for the sculpted fountain in the dairy at Croxteth. Unfortunately the appearance of these panels is unknown; see 'International Exhibition', *Building News*, 8 (27 June 1862) 443; Robert Hunt, *Handbook to the Industrial Department of the International Exhibition, 1862*, 2 vols (London, Edward Stanford, 1862), I, p. 336.

28 The Combe Abbey designs may be the same as those that served as models for a cycle of the months of the year carried out in sculpture at Cloverley Hall, Shropshire, where Nesfield built a new wing between 1862 and 1870. These designs also served as models for tiles. The original watercolour drawings are now in the Victoria and Albert Museum (no. 180–1894). See 'Gothic art in the International Exhibition', *Building News*, 9 (9 May 1862) 319.

29 F. G. Stephens, 'Fine arts', *Athenaeum*, 1895 (20 February 1864) 270–1. The work is illustrated in Baldry, *Albert Moore*, p. 29.

30 From the Combe Abbey / Cloverley designs, *March*, with her wind-tossed drapery, reappears in such full-scale paintings as *Sea Shells* (1874, Walker Art Gallery, Liverpool) and *Sea Gulls* (1871, Williamson Art Gallery and Museum, Birkenhead), while *September*, plucking fruit from a tree, lies behind the paintings *Azaleas* (see plate 32) and *A Garden* (1869, Tate Gallery).

31 Baldry, *Albert Moore*, pp. 6–7.

32 See for example 'Art cliques. No. IV', *Building News*, 12 (13 October 1865) 707.

33 *Building News* (1 May 1868) 288.

34 Ibid., (5 June 1868) 384.

35 Ibid., p. 384.

36 Baldry, *Albert Moore*, p. 81.

37 Ibid., pp. 71–3.

38 William Michael Rossetti and Algernon C. Swinburne, *Notes on the Royal Academy Exhibition, 1868* (London, John Camden Hotten, 1868), p. 32.

39 See A. Staley, 'The condition of music', *Art News Annual*, 33 (1967) 81–7; A. Wilton and R. Upstone (eds), *The Age of Rossetti, Burne-Jones and Watts: Symbolism in Britain 1860–1910*, exh. cat. (London, Tate Gallery, 1997), pp. 186–219; J. Onians, 'On how to listen to High Renaissance art', *Art History*, 7:4 (December 1984) 411–37.

40 Sidney Colvin, 'English painters of the present day. II.—Albert Moore', *Portfolio*, 1 (1870) 6.

41 'Mr Humphrey Roberts's collection', *Magazine of Art*, 19 (1896) 47.

42 A. M. W. Stirling, *The Richmond Papers* (London, Heinemann, 1926), p. 160.

43 Ibid., p. 412.

44 See for example *Compositional Study for 'The Last Supper' and 'The Passover', Intended for Austin Friars* (1862) (reproduced in Baldry, *Albert Moore*, facing p. 14) and *The Shulamite Reciting the Glories of King Solomon to her Maidens* (1864–66, Walker Art Gallery, Liverpool).

45 *Masters of Art: Albert Moore* (Boston, 1908), pp. 26, 28.

46 For a summary of the literature see George Lansing Raymond, *Proportion and Harmony of Line and Colour in Painting, Sculpture, and Architecture: An Essay in*

blaze brightly by the attendant soldier. Presumably a second projectile is being
heated in preparation. Poynter invites us to think that, in these conditions, where
stifling heat and frantic activity obtain, the soldiers would strip off. Those of supe-
rior rank, supervising the operation, retain helmets, cloaks, chain mail, breast
plates, leg armour and long and/or short cloth leggings. One looks on from his
horse, another shouts orders, gesturing with his outstretched arm, a third stands
alert holding the two ends of the rope attached to the latch which he will jerk open
at the moment of maximum tension. Closer in to the workings of the catapult, the
soldiers are bare-torsoed and some are bare-legged or bare-headed (plate 38). At
the centre of the picture, on the side of the apparatus nearer the viewer, one sol-
dier has taken off all his clothing, even his sandals. We see his tunic being used as
padding, so that he can gain greater purchase from his knee as he pushes against
the wooden wheel below him, striving to shift the metal handles of the winch.

 The utter nakedness of this central figure is, to some extent, plausible. Any
sceptical questioning is set aside by the authoritative display of anatomical knowl-
edge on Poynter's part and by our schooled acceptance of male nudity in history
painting. Nineteenth-century academic theory established a link between the

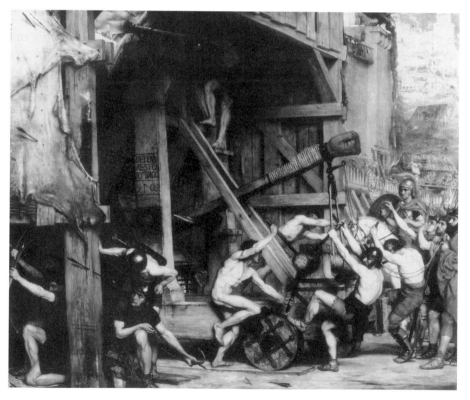

37 Edward John Poynter, *The Catapult*, 1868, oil on canvas, 155.5 x 183.8 cm

absolute and uncontingent beauty and truth of the nude and the elevated mean-
ings to be drawn from the higher categories of painting, such as history painting.[2]
Nonetheless we are justified in asking what else is at stake here in the assertive dis-
play of the male nude. The central soldier is singled out by his nudity. Why is the
naked human form isolated in this way at the heart of a system of co-operation and
concerted energies? What is the significance of the juxtaposition between the liv-
ing organism (man) and the mechanical construct (the machine)?

The two most arresting features of the painting are the nude figure of the cen-
tral soldier and the protruding arm of the catapult. The soldier is a fine young man
with deep-set eyes, a full mouth and a thick shock of hair. However, since his head
is in shadow, we are diverted from thoughts of sensual attractiveness or emotional
state, whether of agony or enthusiasm, in the person of the soldier. We are struck
by the beauty of his efficiently functioning body, and Poynter allows the eye to
travel admiringly across the complex and crisply articulated anatomy where every
component serves its function. Curiously, however, emotional affect appears to be
reserved for the machine rather than the human being. The hammer is in the form
of a clenched fist. It has been lashed onto the wooden arm with rope. It has the

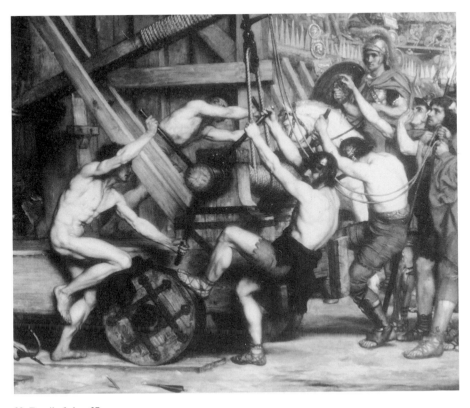

38 Detail of plate 37

appearance of leather, but a leather covering could never articulate the thumb and fingers as shown. It could only be leather if, impossibly, the fist had been open and subsequently closed. Alternatively we can conceive of it as carved wood, of a redder colour than the wood elsewhere in the picture, though our attempt to match the colour of the material takes us to the bloodied extremities of the animal skins stretched across the framework on the left of the picture, and so back to the idea of leather, and living or dead creatures. The naturalistic anatomical depiction of thumb-nail and joints on the hammer sets us a puzzle concerning structure, substance and animation. Perhaps the wood has been painted or stained. The reddening of the wooden arm where the rope adjoins it would suggest this, but our sense of anthropomorphism makes us read this as raw bleeding, and we can see the hammer and arm as a surgically assembled, monster body-part. The reddened fist appears to throb with a suffusion of blood in an analogy to the throbbing heat of the red tip of the projectile. The binding rope is like a constricting bandage, or (given the knotted muscles, prominent tendons and bulging veins elsewhere in the picture) it might be seen as a biological system of that sort, running crossways instead of lengthways along the limb. The whole arm then suggests an anatomised limb, bony support, venous or fibrous elements and the flayed flesh of a blood-suffused fist. Most importantly, we know that this simulated body-part is not inert. It may not be living but it is about to spring into action to devastating effect.

To gain our own purchase on the question of the anatomical and the mechanical we need to look at Poynter's aesthetic position. Poynter's niche in the art world of the late 1860s and 1870s, besides being an eminent and learned painter of historical subjects, was one of spokesman and educator within the ambit of the Aesthetic Movement. Much attention has been paid to the dispute between Whistler and Ruskin following Ruskin's 'pot of paint' comments on Whistler's *Falling Rocket*, exhibited at the Grosvenor Gallery in 1877.[3] Whistler used the court case to develop his own vanguard stance against careful finish, naturalistic subject-matter and moral responsibility in art. The defence was obliged to articulate assumptions, which opposed Whistler's, concerning work and value. However, several years earlier, in the late 1860s and 1870s, Poynter and Ruskin were locked into a dispute over Michelangelo and the human figure which was like a double to that celebrated case. In this debate, too, an Aesthetic Movement position concerning work, morality and aesthetic value was elaborated in opposition to Ruskin. Poynter made an appeal to an elite audience of genuinely tasteful consumers and appreciators, whereas Ruskin stubbornly held out for a revival of an organically connected, morally enlightened constituency for art - for its producers and for its consumers. Poynter could make a progressive play for the arty; Ruskin's time-frame was increasingly retrogressive. In order to illuminate the role of the anatomically correct nude in *The Catapult* I will examine the theme of natural science, or natural philosophy, in the writings of Poynter and Ruskin in this period, and consider the linked issue of progress. Ruskin was made Slade Professor at Oxford in 1870, Poynter lectured at University College, London, in 1869 and was made Slade

Professor there, at the newly founded Slade School of Art, from 1871 to 1875. We can pick out their competing positions in the addresses given to students in these professorial roles.

The Catapult's references to the science of warfare and its insertion of the heroic nude of high art into the ambience of the machine alert us to Poynter's scattered comments on science. The first impression is that his Aesthetic priorities set him at a great remove from the prosaic world of technology. He had scathing words for the products of modern engineering and explicitly warned against an attempt to make changes in art in an effort to keep up with the rapidly advancing findings of science. In the second of his *Ten Lectures*, first given at the Royal Institution in 1872, he commented on the gulf between science and art. He alluded to the pace of change in natural science and the way in which the discoveries of modern science presented an ever-expanding field which was systematically overthrowing the theories and limitations of the past. He argued that art was not like this and it was a mistake to call for an up-to-date art. The Old Masters could not just be ignored or set aside for fresh themes because, after all, the concern of art is with the constants of nature.

> Now since the human form and face, containing as they do the highest qualities of beauty which Nature presents for our admiration, form the highest study to which an artist can devote himself, and since the aspects not only of human but of all natural beauty are the same in all ages, it follows that there is no new discovery to be made in the matter, and that the only possible discovery is in the power of expression.[4]

Poynter concluded that the 'modern spirit' was 'becoming daily more opposed to the artistic spirit', and that, in so far as it affected art, it was manifest in an emphasis on the imitative aspects of art at the expense of the creative aspects. In a broad time-frame he saw the rise of landscape painting, portraiture and still life, all imitative modes, as relatively recent developments in the history of art, and, in the immediate situation, saw an increased emphasis on imitation arising, in large part, from Ruskin's proposals in *Modern Painters* (1843–60). This modern tendency was, he argued, to be resisted. Poynter challenged what he saw as Ruskin's substitution of the moral for the aesthetic on the grounds that any moral response to landscape was subjective and incommunicable. The artist may have had a moral response but it is no guarantee of the viewer's moral response to the same landscape. Having read Ruskin, the viewer, instead of being moved by the beauty, looks for evidence of earnestness in the laborious rendering of scraps of nature.

> The spectator may well imagine that the mind of the painter who laboriously produces for us again and again bunches of primroses and violets, is actuated by some exalted, earnest feeling, and in possession of some high theoretic faculty, while in truth he has only been exerting a mere imitative and technical skill and what amount of aesthetic faculty he may possess, and moreover only exercising just so much of his faculties as will enable him to make money in the quickest and readiest way.[5]

Poynter went so far as to argue that the moral aspect of beauty *could not* be conveyed by art: 'that the moral nature of beauty is of a kind that cannot be expressed in painting or sculpture; that therefore, as far as art is concerned, ideas of beauty are and must be purely aesthetic'.[6]

This thoroughgoing statement of an aesthetic position is what emerges from his discussion of modern trends. No call to be forward-looking and scientific in his attitudes will persuade him that a consideration of the achievements of the Old Masters, and in particular Michelangelo, is not of the greatest value. In his view contemporary art should return to the glorious figure painting of the high art subjects of the Renaissance, to the energy and variety displayed, for example, in Raphael's *Fire in the Borgo*, or Michelangelo's Sistine Chapel paintings.[7]

We can examine Poynter's position on the use of the nude figure in art education, and find that this retrogressive emphasis does in a way establish modern science at the heart of his concerns. The system of art education introduced at the newly established Slade differed from that at the Royal Academy Schools, or indeed from that instigated by Ruskin at the Working Men's College, by its emphasis on studying from the live model. Poynter even went so far as to introduce life classes for women students, where the partially draped model would give them at least some access to figure drawing. The human figure was at the centre of his conception of art. Landscape painting was, he claimed, dependent on the skills and sensibilities learned in figure drawing.[8] Poynter admitted that drawing from the flat (for instance, from Dyce's book of designs), drawing from geometrical solids and drawing from the antique cast, whether fragment or entire statue, might be useful preliminaries. But his plan was to move the students on to the next stage, that of drawing and then painting from the live model, as quickly as possible. He considered extended study from the antique stultifying and counterproductive in so far as students learned standard poses and bodily configurations, which might become so imprinted on the brain that it was impossible to see actual bodies in all their variety.

The logical conclusion of this emphasis in art education was that high priority was given to anatomical knowledge. Once dealing with live models it eventually became important for students to study anatomy as an aid to drawing. It was desirable for students to study at the anatomy table, as well as in the studio. This he did not see as absolutely vital but as a useful addition and ultimately as an important aid to invention. With a thorough understanding of anatomy an artist could improvise figure compositions, or capture fleeting movement. Poynter's example is, predictably, Michelangelo, who is said to have developed an extraordinary knowledge of anatomy by the end of his career.[9] The figure compositions set within the Slade School were always taken from biblical or classical sources, as in the exercises prescribed for students in the French academic system, to make the introduction of nude or partially draped figures inescapable.[10]

Another key innovation in the Slade system was the imposition of time limits for the completion of prize drawings. Poynter objected to the Royal Academy's

system of requiring students to submit highly finished drawings for the purpose of progression through the schools. This system was also central to the government Schools of Design at South Kensington. He wanted to train artists to draw accurately and with sufficient finish in a limited time rather than spending months working over a drawing with chalk-point, stipple and rubbing-out effects. For him the crucial aspect of drawing was learning to see, and teaching the hand to record what was seen. This practice he imported from the French system that he was familiar with from his training in Gleyre's studio. At one point he says:

> The important points to be considered are the general action and proportion of the figure, the position of the joints and setting on of the head, limbs, and extremities, the correctness of outline, and the elegance of form, while an exact resemblance of the face of the model should always be aimed at.[11]

These features, dependent on the action and physical beauty of the model, far outweigh mere surface finish. The artist should aim at accuracy and spontaneity and make every stroke count. He offers examples from the Sistine Chapel where a surviving drapery sketch was extremely close to the finished figure of the Libyan Sibyl. This, he explains, doesn't show Michelangelo's ability to transfer the sketch accurately so much as his achievement in working out his idea of the drapery of that figure in action at first effort. With respect to the technical qualities aimed for in drawings, Poynter places unity of tone at the top of his list. Form and colour are also crucial components; Michelangelo has that unity of tone, which is a constant in all great art and it stands alongside his depiction of form in 'equal grandeur'.[12]

We see in Poynter's *Ten Lectures* the outline of an art education system that imports features from the French system and rests heavily on an appeal to historic examples.[13] He says that students are to study paintings in the National Gallery, to study volumes of engravings and photographs of art works in Continental collections. Poynter arranged for photographs of the Sistine ceiling to be bought for the School. The final Slade lecture of October 1875 (the ninth of the *Ten Lectures*) is entirely concerned with the merits of Michelangelo, and with Ruskin's poor judgement in criticising him. Michelangelo's tonality is defended versus accusations of blackness, his fresco technique versus accusations of poor workmanship, his skill in drawing versus Ruskin's suggestions of incompetence. Poynter asserts that Michelangelo's reason for wrapping the heads of his figures wasn't that he couldn't do hair, and that the mass of figures in *The Last Judgement* are carefully studied down to the least limb or finger.[14] Above all, Poynter was at pains to challenge Ruskin's remarks about Michelangelo's gratuitous display of the body. In the *Academy Notes* of 1875 Ruskin criticised one of Poynter's own paintings: 'Mr. Poynter's object ... is to show us, like Michael Angelo, the adaptability of limbs to awkward positions. But he can only, by this anatomical science, interest his surgical spectators.'[15] The lecture given by Ruskin on Michelangelo and Tintoretto, delivered in Oxford in 1871, accused Michelangelo of empty display

and attention-seeking in the involved attitudes of the figures and of a desire to 'exhibit the action' of the body's 'skeleton and the contours of its flesh' due to the fact that he 'delights in the body for its own sake'.[16] He denounced the influence of Michelangelo on art of the modern day, saying 'that dark carnality of Michael Angelo's has fostered insolent science, and fleshly imagination'.[17] Ruskin preferred Bellini, whose work was praised for its beauty and serenity. The inaction of Bellini, or the impassivity displayed at a moment of action, was, according to Ruskin, better able to convey beauty. Action detracts attention from the living creations. Ruskin called for a 'continuous, not momentary action, – or entire inaction. You are to be interested in the living creations; not in what is happening to them.'[18] Poynter's riposte was simple: 'Why not both?'[19] Woven into his defence of Michelangelo, and by implication his own teaching method and practice, was an argument that action was virile while Ruskin's recommendations were especially dangerous to those wanting in masculinity. He spoke about the danger in these terms: 'the mischievous, I may almost say deadening effect, that such theories must have on minds not masculine enough to be independent'.[20]

Clearly this whole discussion was a scarcely disguised debate over the propriety of the nude in art. Ruskin's view was, at this date, that Michelangelo's work was indecent in its motivation. More generally he held that the nude figure was not a suitable subject for art, that nude studies were unnecessary in figure composition, and, as the comment on surgical spectators suggests, that the study of anatomy was unnecessary and repellent. On all these questions, then, he was diametrically opposed to Poynter. Poynter may have recommended an insulating division between the world of art and the rapidly developing field of natural science, and he may have explicitly positioned himself on the side of artistic tradition against faulty modern trends, but his emphasis on anatomy, and his faith in an analytic knowledge of the human cadaver, place him in a progressive and scientific position in relation to Ruskin.

We can clarify Ruskin's position by looking at his Slade lectures of the Lent term 1872, which were published as *The Eagle's Nest*. In the Preface he states that he deliberately makes the startling assertion in these lectures 'that the study of anatomy is destructive to art'. He reserves his discussion of this until the eighth lecture. Here he takes the title 'the relation to art of the sciences of organic form' and starts off with four statements:

> First.– …That the true power of art must be founded on a general knowledge of organic nature, not of the human frame only.
> Secondly.–That in representing this organic nature, quite as much as in representing inanimate things, Art has nothing to do with structures, causes, or absolute facts; but only with appearances.
> Thirdly.–That in representing these appearances, she is more hindered than helped by the knowledge of things which do not externally appear; and therefore, that the study of anatomy generally, whether of plants, animals, or man, is an impediment to graphic art.

Fourthly.–That especially in the treatment and conception of the human form, the habit of contemplating its anatomical structure is not only a hindrance but a degradation; and farther yet, that even the study of the external form of the human body, more exposed than it may be healthily and decently in daily life, has been essentially destructive to every school of art in which it has been practised.[21]

And that is a fair summary of the chapter. He considers to what extent anatomical knowledge of a dog would contribute to the picture by Reynolds of George III's daughter with a Skye Terrier: 'You might dissect all the dead dogs in the water supply of London without finding out ... [about] the shininess ... on the end of a terrier's nose.'[22] The child's prettiness is smirched by the introduction of the polluting corpses here, and, when he comes to the question of nude statues, nude models and dissection, he once again brings in an innocent youngster, 'a young boy, or girl, brought up fresh to the schools of art from the country'.[23] He imagines this child staring at the Elgin marbles until rotten and sickly with affectation, horrified in the dissecting room and forced into familiarity with the imperfections of a modern (un)corseted body. In the modern day and a northern climate this is the height of indecorousness and likely to result in a perversion of taste and morals. The sights of the dissecting room, he suggests, can only fill the mind of the artist with horrible things 'which Heaven never meant you so much as a glance at'.[24] In the case of past art the preoccupation with the body can damage even the greatest artist. 'To Michael Angelo, of all men, the mischief was the greatest, in destroying his religious passion and imagination, and leading him to make every spiritual conception subordinate to the display of the body.'[25] Dürer and Mantegna, he asserts, were so damaged by their anatomical study that Dürer could never escape from the idea of bones or skulls under the flesh and Mantegna's best works are 'entirely revolting to all women and children'.[26]

What interests me particularly about *The Eagle's Nest* is the way that these assertions are framed by a general consideration of the relationship between science and art. Ruskin considers the achievements of modern civilisation in terms of the hideous racket of Ludgate Hill, the expense of building a splendid new church while, according to a cutting he cites from the *Pall Mall Gazette*, a woman and her child starved to death on a heap of rags in the Isle of Dogs, the fantastic progress of science leading to the invention of nitroglycerine and warfare, the inventiveness of Alpine vernacular housing styles giving way to the drab provision of a bare box with a drainpipe for industrial workers' housing. The arguments against anatomy are part of a general attack on science and modernity. This is strange coming from Ruskin whose *Modern Painters* annexed the sciences of geology, botany and meteorology to fine art and criticism. In the second volume of *Modern Painters* (1846) Ruskin invited readers to consider the geological structure underlying landscape, comparing it to the heroic anatomy of history painting. Readers were to imagine the earth in motion through time, flexing its muscles. However, by the time of his Slade lectures he had changed his position. Poynter noticed this shift, particularly in relation to Michelangelo, pointing out the change

from Ruskin's earlier admiration at Michelangelo's infusion of animus in bodily matter to a later disgust at the sensuality of his work.[27] A reading of *The Eagle's Nest* makes it clear that there is also a major shift in Ruskin's attitude to science.

As Elizabeth Helsinger has suggested, the transition from *Modern Painters* to *The Queen of the Air* (1869) takes Ruskin from the territory of scientific vision to a symbolic reading of mythological and artistic language.[28] In both cases the reader is involved in an interactive way with the materials, in the first case of nature in vision and in the second case of cultural history through language. This is certainly what we see in the lectures that make up *The Eagle's Nest* of 1872. The imagery of birds and birds' nests runs through *The Eagle's Nest*. The beauty of a bullfinch's nest of clematis is considered, the scope of the eagle's vision from afar, the peace and still-ness of the floating nest of the mythological halcyon in various retellings of the myth and literary echoes. The halcyons, created as birds by Zeus to prevent the separation of the King of Trachis and his wife Alcyone, nest on the calm summer seas. They are the epitome of the end of conflict, the abandonment of history. The horror of corrupt nakedness and ugly action is set aside. And yet I would not wish to read *The Eagle's Nest* as completely inimical to science. Ruskin retains so much of science as relates to instantaneous vision. The eagle-eye view is what we are given, whether of society or of the subjects to be considered by the artist. The eagle has keen and accurate vision, and, because it flies at a great height and scans the ground, there is enormous scope to its vision. Ruskin is still prescribing faithful delineation of detail, as he had done in *Modern Painters*. However, the emphasis on systematic scientific knowledge of structures has ebbed away. Instead the emphasis is on connecting multiple observations into a total view. Ruskin produces a slightly tortuous argument around the example of sea foam. In conformity with his new position he says that we do not need to know the scientific basis of a bubble to draw sea foam. Accuracy can be produced by optical precision without any anatomising or scientific probing; the appearance is what counts. He then allows himself to slip back into a former mode to the extent of acknowledging that the science of bubbles might play a role in the artist's use of organic form: knowledge of the scientific structure of a soap bubble and its intersection with adjoining bubbles would give the key to the construction of beautiful gothic vaulting.[29] So, grudgingly, he allows that the probing of science has its place, but the beauty of the resultant church has to be understood within the broad overview of the eagle's vision, which remains an optical, rather than an anatomising, vision. The beauty of the vaulting is only a par-tial beauty if it coexists with evils and blemishes. The eagle would see that the beauty of the church is compromised by the simultaneous hideousness of wretched people starving on a nest of rags. The eagle's vision is generally classificatory and descriptive of outward appearance rather than concerned with obscure causes or inner workings. The summation deals with the single moment, not with diachronic processes. According to Ruskin in this phase of his work, the reliance on optics makes possible a debunking total analysis, whereas a scientific, anatomising approach runs the risk of being seduced or misled by the isolated specimen.

Ruskin's gloomy comments on science take us back to the optimistic action of Poynter's art theory. Suddenly the canvases and frescoes cited by Poynter start to sound more science-friendly. Not only were the figures of Old Master painting, in his opinion, based on anatomical investigation, but their involvement in historic action, far from being anti-modern, demonstrated a continuum between past and present, cause and effect. The conjunction of time, matter and motion, in Poynter's view of art, put the human figure at the centre of a force-field. We might ask: what were those scientific discoveries referred to by Poynter as constantly being made? In the course of the nineteenth century advances in the theory of light, electricity, electrolysis, thermodynamics and electromagnetism were produced by figures such as Carnot, Faraday, Thomson, Joule, Maxwell and Helmholtz, and there was great popular interest in the discoveries. The established Newtonian physics, which relied on the concept of mechanical forces in relation to gravity, gave way to the notion of a more extensive range of interchangeable energy sources. The notion of separate entities – the caloric, electric fluid, magnetic fluid, and so on – was replaced by a notion of matter energised in various ways, and in ways that could be converted. As Grove said in his book of 1874, *The Correlation of Physical Forces*, 'heat, light, magnetism, chemical affinity and motion are all correlative or have a reciprocal dependence; that neither taken abstractly can be said to be the essential cause of the others, but that either may produce or be convertible into, any of the others'.[30] The theoretical demonstration of the convertive capabilities of different kinds of energy was extremely important for mechanics and industrial applications. The machine is fundamentally an energy converter.[31]

Recent developments in thermodynamics were explained by Balfour Stewart in a basic textbook of 1866, *An Elementary Treatise on Heat*. He started with the idea of kinetic and potential energy, explaining that an object is invested with potential energy by raising it up against gravity, or against a spring. Potential energy can then be converted into kinetic energy, and vice versa. This basic Newtonian concept explains the working of machines.

> It thus appears that all we can do by the lever or other mechanical powers is to increase the one factor at the expense of the other.... We may generalise this statement so as to make it applicable to all possible machines, and we may view these as instruments which when supplied with energy in one form convert it into other forms according to the law of the machine.[32]

The mechanical forces in Poynter's *The Catapult* are clearly directed to converting the potential energy of the sprung hammer into kinetic energy as it slams against the projectile. The elaborate system of winch and levers enables the many straining soldiers to store their physical effort in the giant fist. The exposition of the *Elementary Treatise* is suggestive though, because, in its efforts to explain the basics of thermodynamics to a non-specialist readership, it employs this idea of conversion and potential to explain the working of energy in heat, electricity and chemical energy. This encourages us to think about the ways in which the simple

mechanics of Poynter's catapult might be understood as offering analogies for other kinds of action. In Balfour Stewart's outline the mechanical is used as an analogy for the non-mechanical. For instance, in the case of molecular potential energy, heat is said to act to separate molecules: 'It is thus spent in producing a species of potential energy, molecular attraction being the force in this case, just like gravity, or the force of a spring, in the case of the potential energy of visible motion.'[33] This employment of analogy or simile in the interests of clear exposition is directly related to the way these theories emerged – in other words, to the theoretical elaboration of thermodynamics in terms of mechanical models. The modelling of the non-mechanical on the mechanical is fundamental to the exploration of the idea of the force-field in Thomson's work in the 1840s and James Clerk Maxwell's exploration of the electromagnetic field in the 1860s and 1870s. Maxwell picked up on the idea of molecular vortices spinning in the magnetic field, and introduced the idea of intermediate particles acting like the 'idle wheels' in a machine, geared to the larger vortices but spinning in another direction (plate 39). The direction of spin of these wheels indicated the direction of the electrical current. Indeed, it is generally characteristic of Victorian scientific theory that the concepts are derived from the use of industrial machines as models.[34]

We can readily assent to the idea that Poynter's *The Catapult* was offering the pre-industrial siege machine as an analogue to the industrial activity (and military might) of modern Britain.[35] The catapult itself could be the equivalent of a great steam hammer, but then the human figures should be seen, not just as equivalent to the industrial workforce (which operates rather than powers the machinery), but also as components of a machine run by an external power source. The arrangement of arms and legs around the catapult wheel, and the limbs arrayed around the winch handles, suggest toothed cogs that interlock and transfer power. Numerical relationships that suggest ratios are created: sixteen limbs of the working soldiers, four strips of the iron bracing on the catapult wheel, three prongs of the near winch handle, two elements of the great X formed by the hammer and its casing. Again the suggestion is of intermeshing gear wheels and the human beings are integral to the mechanical action. We gain a better understanding of the way the allusions are set up when we notice that here it is not the literal object, or objects, that form the model for the industrial engine but the compositional components as Poynter disposes them across the canvas.

I started this article by discussing the geometry of the archers' directional stance and the return lines of arrows. Clearly this is also a feature of the orthogonals and diagonals of the unclothed soldiers' bodies and the constructional lines of the timberwork. The prevalence of modelling in scientific presentation encourages us to think that the picture could invoke modern technology at the non-visible level as well as the visible level of the industrial engine. Lines of force could be demonstrated in the space between two magnets by strewing iron filings and seeing how they form into lines.[36] Other kinds of energy, thermal, electrical, could interact and complicate the resultant patterning of the force-field. I would not suggest that

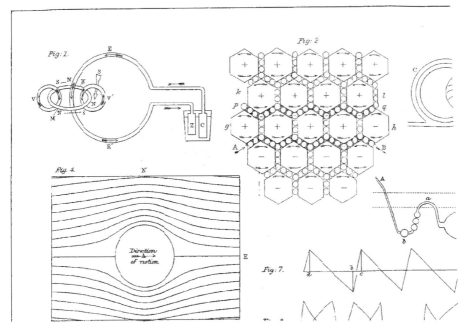

39 James Clerk Maxwell, 'On Physical Lines of Force', 1861–62

Poynter's picture illustrates any specific experimental scenario; the allusions, if we are convinced that there are allusions of this sort, are very general. If the entire apparatus and the figures are conduits for energy, then that energy could be thought of as functioning in a field. The work of composition in organising the picture field is to demonstrate the existence of this invisible energy. Ultimately the force-field coincides with the picture plane.

The role of the human body in this has to be considered. I have suggested that Poynter conjoins the living and the inorganic and subsumes the figures to the idea of machinery in imagery of visible cogs or invisible particles. In discussions of the novel concepts of lines of force, the human body could be envisaged as having such lines running through it. In a series of Christmas lectures for children Faraday demonstrated the way that physical forces flow through material bodies. At one point he stood on a glass-legged stool for insulation, charged his body with electricity so that his hair stood on end, and produced a spark from his finger's end sufficient to light a gas jet.[37]

If the individual figures are conceivable as components of a machine or of energised inorganic matter, then there is also another equally compelling way to see the man/machine interface in Poynter's picture. The isolation of the central naked soldier and the context of a debate over science and anatomy encourage us to elaborate the metaphorical link between the human body and the siege machine. The visual parallels allow us to understand the physical action of the soldier in terms of the mechanics of his anatomical frame. The whole siege machine then takes on the

appearance of a dissected body on a giant scale. This is signalled unmistakably by the bloody-looking fist-hammer, but is also strongly suggested by the way the animal skins form the outer layer of the housing. We see in the other, more distant, machines that it takes many creatures' pelts to multiply up to the large powerful unit. It seems that they are the body's skin, and that it has been cut away to reveal subcutaneous and skeletal layers of wattle fencing, planks and so on. Those skins can be pierced by the sharp points of arrows; the ragged edges give sanguinary evidence of the tearing of skin from the body. The motif of the arrow slicing through the left-hand post gives a particularly vivid intimation of the scalpel's action. It is matched, and multiplied many-fold, by the red-hot arrow protruding through the hatch of the siege machine. I have suggested that affect, in the picture, is transferred from the individual figure to the supra-individual organism, and so too is a sense of the libidinal, as the projectile threatens to burst forth with accumulated energy.

Ruskin associated the dissecting room with the charnel house and the bedroom. Within the reduced classificatory systems that he permitted himself in the 1870s scientific curiosity, other than purely optical attention, appeared to be repellent and salacious. Poynter manages to present anatomy in the context of death-defying (and death-dealing) virile force. Death and sex are not avoided; they are harnessed and converted by the ingenuity of the machine. The contrivances of aesthetic formulation allow the whole picture to function as a machine. In this way artistic technique and aesthetic decisions make possible the energisation of art.

We should not forget that the anatomical specimen is classed and gendered. It was the working-class corpse that was taken to the dissecting table, and at the centre of the art work as *grande machine* is the muscled working-class body of the male model.[38] We might also think of the artist's studio as kind of machine or at least a factory. The French atelier system made of the trainee artist a cog; Poynter used the metaphor of a member of a working orchestra. In his lectures he stressed the workmanlike aspect of the artist's avocation. He was keen to point out that the Renaissance artist was multi-skilled, that an architect's training might be very helpful for an artist, that Leonardo was more an engineer-painter than a painter who did some engineering. And yet from this mundane effort, aesthetic effect is generated. A conversion takes place from the vulgar to the sublime. The paradox is striking. At the progressive moment of Poynter's intervention in the art world, where the door opens to an acknowledgement of the transformations inherent in the physical world of energy and the social category of labour power, the conversion that is effected is one of a shift from the proletarian body to elite culture.[39]

This brings me back to the question of taste. The arty, for Poynter, were bound to be few in number. They would not be taken in by the spurious commercialisation of the Aesthetic: fashionable art furniture or art wallpaper. They were the kind of people who would appreciate the functional lines of humble objects like cottage chairs, or 'a spade, or a rake, or a hatchet or an oar', as he says in the first lecture, and respond to 'the beautiful and varied play of muscles under the skin'.[40] The idea of a connoisseur of advanced taste, who could hang an implement of toil on

whitewashed walls and respond to the beauty of its functional lines, brings with it the idea of the appreciation of the anatomy of the man of toil. This is not just an admiration of outward beauty but a peeling back of its appearance to understand the beauty of the engine. It seems that, at this formative stage of the Aesthetic Movement, Poynter understood art to be a kind of conversion mechanism that accesses the rough energy of working-class labour and transforms it into a force that appeals to the tasteful element among the bourgeoisie. As the energy is accessed, labour power is appropriated for the ruling class. Ruskin could not ally himself to the forward-thinking Aesthetic Movement. He did not want that kind of science, nor that kind of conversion, because he held on to the idea of a collective commitment to labour, even if it took the form of the reactionary fantasies of the Guild of St George.

Notes

I would like to thank Matthew Arscott, Steve Edwards and Alex Potts for their input, in discussion of issues raised in this essay.

1 There is a useful entry on *The Catapult* in R. Treble (ed.), *Great Victorian Pictures*, exh. cat. (London, Arts Council, 1978), p. 70.
2 As Elizabeth Prettejohn has pointed out, this is, in any case, not a specific historical event and so it is not, properly speaking, high art. It is, rather, a scene of anonymous figures set in the past, and so is a form of historical genre. See her discussion of the degree to which reviewers accorded it high art status in M. Liversidge and C. Edwards (eds), *Imagining Rome: British Artists and Rome in the Nineteenth Century*, exh. cat. (Bristol City Museum and Art Gallery, 1996), pp. 130–2.
3 See Linda Merrill, *A Pot of Paint: Aesthetics on Trial in Whistler v. Ruskin* (Washington and London, Smithsonian Institution Press, 1992).
4 E. J. Poynter, 'Lecture II: Old and new art' (1872), in *Ten Lectures on Art*, 2nd edn (London, Chapman & Hall, 1880), p. 64. See also p. 186: 'The discoveries of science are inexhaustible; there is always something fresh to tell of, or some new theory being founded on the basis of old discoveries ... but the lecturer on art has no such means of interesting his hearers.'
5 Ibid., p. 82.
6 Ibid., p. 84.
7 See also Poynter's opinions on Michelangelo in E. J. Poynter and Percy R. Head (eds), *Classic and Italian Painting* (London, Sampson Low, Marston, Searle & Rivington, 1880).
8 Poynter, *Ten Lectures*, p. 190.
9 Ibid., p. 155.
10 For the system of prescribed subjects in the French École des Beaux-Arts see Philippe Grunchec, *Le Grand Prix de peinture: les concours des Prix de Rome de 1797 à 1863* (Paris, École Nationale Supérieure des Beaux-Arts, 1983). Themes were selected from scripture, history or mythology to encourage and justify figure compositions involving the nude or partially draped male figure.

11 Poynter, *Ten Lectures*, p. 175. For a detailed account of the regime in Gleyre's teaching studio see W. Hauptman, *Charles Gleyre 1806–1874, Life and Works* (Princeton, Princeton University Press, 1996), ch. 13.

12 Poynter, *Ten Lectures*, pp. 209, 163.

13 The French academic schools were buttressed by an atelier system, in which young artists would join the studio of an established master and gain experience and instruction in that way.

14 Poynter, *Ten Lectures*, pp. 224, 230.

15 John Ruskin, *Academy Notes* (1875), *The Works of John Ruskin*, Library Edition, ed. E. T. Cook and A. Wedderburn (London, George Allen, 1903–12), XIV, p. 273.

16 Ruskin, *The Relation Between Michael Angelo and Tintoret* (1872), *Works*, XXII, p. 95, also quoted by Poynter, *Ten Lectures*, pp. 232, 235.

17 Ruskin, *The Relation Between Michael Angelo and Tintoret*, p. 104. Ruskin makes the logical move from the body to the corpse and then to the skeleton. 'Raphael and Michael Angelo learned it [the body] essentially from the corpse, and had no delight in it whatever, but great pride in showing that they knew all its mechanism; they therefore sacrifice its colours, and insist on its muscles, and surrender the breath and fire of it, for what is – not merely carnal, – but osseous.' Ibid., p. 97.

18 Ibid., p. 85 and quoted by Poynter, *Ten Lectures*, p. 233.

19 Poynter, *Ten Lectures*, p. 233.

20 Ibid., p. 220.

21 Ruskin, *The Eagle's Nest* (1872), *Works*, XXII, p. 222.

22 Ibid., p. 227.

23 Ibid., p. 233.

24 Ibid., p. 233.

25 Ibid., p. 232.

26 Ibid., 'Preface', p. 122.

27 Poynter quotes Ruskin's earlier enthusiastic comments: 'that bodily form with Buanorotti, white, solid, distinct, material, though it be, is invariably felt as the instrument or the habitation of some infinite, invisible power'. Poynter, *Ten Lectures*, p. 248.

28 Elizabeth K. Helsinger, *Ruskin and the Art of the Beholder* (Cambridge, Mass., Harvard University Press, 1982).

29 Ruskin, *The Eagle's Nest*, pp. 214–16.

30 Sir W. R. Grove, *The Correlation of Physical Forces*, 6th edn (London, Longmans, Green, 1874), p.10.

31 See Anson Rabinbach, *The Human Motor: Energy, Fatigue and the Origins of Modernity* (Berkeley, University of California Press, 1990). Rabinbach points out the transition from an eighteenth-century analogy between the human body and the machine to a different sense, developing in the nineteenth century, an energeticist conception of a continuity between forms of energy, and the imbrication of matter and force. 'The equivalence of different forms of energy and the infinite capacity for the conversion of these forms revealed that matter – whether in the form of nature, technology, or the body – could neither be separated from motion nor divorced from the energy that moved matter through the universe' (p. 50). 'The body, the steam engine and the cosmos were thus connected by a single and unbroken chain of energy' (p. 52).

32 Balfour Stewart, *An Elementary Treatise on Heat*, Clarendon Press Series (Oxford, Clarendon, 1866).

33 Ibid., p. 298; also, on electricity, p. 299: 'A position of advantage is thus obtained with respect to the force of electricity analogous to that which is obtained with respect to the force of gravity when a stone is separated from the earth.'

34 The comment of Pierre Duhem in 1904 concerning the method of British physicists, 'We thought we were entering a tranquil and neatly ordered abode of reason, but we find ourselves in a factory', is quoted by Bruce J. Hunt, *The Maxwellians* (Ithaca and London, Cornell University Press, 1991), p. 87.

35 See the discussion in the catalogue entry by E. Prettejohn in Liversidge and Edwards, *Imagining Rome*, pp. 130–2.

36 James Clerk Maxwell is eloquent on the question of the lines that compose the force-field. 'By drawing a sufficient number of lines of force, we may indicate the direction of the force in every part of the space in which it acts. Thus if we strew iron filings on paper near a magnet, each filing will be magnetised by induction, and the consecutive filings will unite by their opposite poles, so as to form fibres, and these fibres will indicate the direction of the lines of force. The beautiful illustration of the presence of magnetic force afforded by this experiment, naturally tends to make us think of the lines of force as something real', James Clerk Maxwell, 'The theory of molecular vortices applied to magnetic phenomena', in S. Sambursky (ed.), *Physical Thought from the PreSocratics to the Quantum Physicists: An Anthology* (London, Hutchinson, 1974), p. 424.

37 Michael Faraday, *On the Various Forces of Nature and Their Relations to Each Other: A Course of Lectures Delivered Before a Juvenile Audience at the Royal Institution*, ed. William Crookes FCS (London, Chatto & Windus, 1862). Having performed the trick with the glass-legged stool, he said: 'You will not now be at a loss to bring this power of electricity into comparison with those which we have previously examined and tomorrow we … shall … go further into the consideration of these transferable powers' (p. 46).

38 Rabinbach argues for a connection between *kraft* and *arbeitskraft*. *Kraft* is the physicists' concept of universal energy to be found at microscopic and macroscopic levels, and functioning equally in the cosmos, the steam engine and the human body. *Arbeitskraft* is the term adopted by Marx for his concept of labour power. In Marx's analysis the equivalence of the labour task in terms of labour power, and its abstraction, underpin the system of commodity exchange. Rabinbach argues that Marx's concept was dependent on the nineteenth-century redefinition of bodily energy in terms of *kraft*. Rabinbach, *The Human Motor*, ch. 3.

39 The paradox may be seen as fundamental to the late-nineteenth- and twentieth-century artistic avant-garde. It has been addressed repeatedly, in various terms, by cultural commentators, notably, in terms of high and low art, by Walter Benjamin and Clement Greenberg. See Walter Benjamin, 'The work of art in the age of mechanical reproduction' (1936), in H. Arendt (ed.), *Illuminations* (London, Jonathan Cape, 1970), and Clement Greenberg, 'Avant garde and kitsch' (1939), in F. Frascina (ed.), *Pollock and After: The Critical Debate* (London, Harper & Row, 1985), pp. 21–33.

40 Poynter, *Ten Lectures*, p. 47.

7

Edward Burne-Jones's *The Mirror of Venus*: surface and subjectivity in the art criticism of the 1870s

Kate Flint

THE IMPORTANCE of the surface is built into the very subject-matter of Edward Burne-Jones's *The Mirror of Venus* (1877, plate 40). The beauty of the young women who stare into a pool is reflected back to them: the single gaze which is directed away from the water looks up at the standing figure, attempting to stall any departure and re-enclose her in this intensely self-regarding female world. Only in this suggestion of onward movement from the taller woman – identified as Venus herself by some contemporary critics – and in the fact that the women's reflected heads are framed by forget-me-nots is there any slight hint of temporality. The multiplication of similarly styled, similarly featured women may further be read as signifying an excess of generic femininity and a concomitant erasing of individuality.

In post-Lacanian theory, the mirror has often been invoked as a metaphor for the act of self-fashioning, reflecting back a desirably united, if ultimately illusory view of the 'whole' person, an 'isolate being' utterly separate from all others. But the relevance of this mirror metaphor has been challenged in relation to woman's self-presentation. Susan Stanford Friedman has argued that when woman looks in a mirror, she sees not isolate selfhood but an image of 'woman', a member of a social and cultural category,[1] and Lynda Nead has elaborated further on the theme of social placement when observing one's reflection, in *The Female Nude*:

> Woman looks at herself in the mirror; her identity is framed by the abundance of images that define femininity. She is framed – experiences herself as image or representation – by the edges of the mirror and then judges the boundaries of her own form and carries out any necessary self-regulation…. The formless matter of the female body has to be contained within boundaries, conventions and poses.[2]

The surface of the mirror, or of the crystalline pond, in other words, may be a barrier between a woman's image and her interiority.

This gap between interior and exterior, between imaged reflection and the contemplative mode of reflection that takes place in the mind of the perceiver, is important for our understanding of the representation of women in late-nineteenth-century painting. But it has far wider ramifications. It can be made to stand for the ways in which aesthetic understanding was becoming problematised: the ways in which a dialogue was developing between the practice of observation and the role of subjectivity, and – this is crucial to my particular argument – the manner in which physiology functioned as a mediating force between these two modes of approach.

For one contemporary observer at least, the female circle of self-referentiality symbolised the aesthetic attitude of the school of art to which Burne-Jones belonged. Henry James, acknowledging that he was not in sympathy with this school, described its products as:

> the art of culture, of reflection, of intellectual luxury, of aesthetic refinement, of people who look at the world and at life not directly, as it were, and in all its accidental reality, but in the reflection and ornamental portrait of it furnished by art itself in other manifestations; furnished by literature, by poetry, by history, by erudition.... Into some such mirror as this the painters and poets of Mr Burne-Jones's turn of mind seem to me to be looking; they are crowding round a crystal pool with a flowery margin in a literary landscape, quite like the angular nymphs of the picture I speak of.[3]

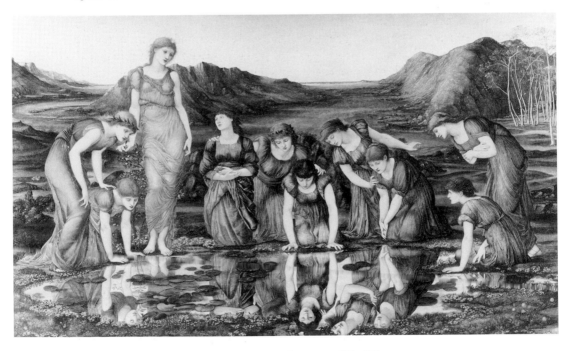

40 Edward Burne-Jones, *The Mirror of Venus*, 1877, oil on canvas, 120 x 200 cm

Yet it was precisely the fact that this picture calls attention to the importance of its surface, to its decorative qualities, to its detachment from the world 'in all its accidental reality' that permitted it to be a site on which the inviolability of the surface was in fact called into question. It exemplifies Charles Harrison's claim about painting in general, that 'what gives us pleasurable pause is the strange and distinctive form of scepticism about appearances that is set in play when the allure of imaginative depth meets resistance from the vividness of decorated surface'.[4] Moreover, the elimination of suggestions of individual personality in the decorative nature of the women represented might be a spur, rather than a hindrance, to the acknowledgement of individuality in the spectator's reactions to such a work. Likewise, the featureless landscape, whilst refusing to provide details which might distract the viewer from the female subjects, offers a contemplative space in which to site one's own specific response. Seeing the painting in relation to a developing matrix of ideas about the connections between art and science, especially the developing science of psychology, provides, I shall show, a means of breaking open not only its apparent self-enclosure, but the solipsistic aestheticism against which James complained.

The Mirror of Venus was first displayed at the opening show of the Grosvenor Gallery in May 1877.[5] Critical attention on this occasion was very much drawn to surfaces: not to the works exhibited, in the first instance, but to their striking surroundings. The young Oscar Wilde wrote approvingly in the *Dublin University Magazine*:

> The walls are hung with scarlet damask above a dado of dull green and gold; there are luxurious velvet couches, beautiful flowers and plants, tables of gilded wood and inlaid marbles, covered with Japanese China and the latest 'Minton', globes of 'rainbow-glass', like large soap-bubbles, and, in fine, everything in decoration that is lovely to look on, and in harmony with the surrounding works of art.[6]

Burne-Jones himself, however, was anxious about the red wall coverings, sending a note to his friend Hallé, the exhibition's secretary, protesting that: 'It sucks all the colour out of pictures, and only those painted in grey will stand it. Merlin doesn't hurt because it's black and white, but the Mirror is gone I don't know where.'[7] And others were more sceptical than Wilde about the effectiveness of the decor. The *Daily Telegraph* complained that the incessant brightness of the decor strained 'the fatigued optic nerve of the spectator';[8] the *Morning Post*, after protesting against the 'blaze of heterogeneous colour', singled out for complaint the fact that the paintings were covered in glass, all very well for watercolours, 'but glass over the deeper shadows produced by the stronger medium of oil gives back an obtrusive reflection, mocking the spectator with the semblance of his own face and figure as through a mirror'.[9] It was something of a commonplace that fashionable people went to art exhibitions as much to look at each other as at the paintings: here the implications of narcissism inherent in this mode of spectatorship are definitely hinted at.

Sir Coutts Lindsay's exhibition marked Burne-Jones's return to public exhibition after some seven years. The innovative practice of hanging all the works of one artist together facilitated the critical concentration on his works demonstrated by most of the reviewers. As well as *The Mirror of Venus*, he showed *The Days of Creation* (the painting on which the most critical attention focused), *The Beguiling of Merlin*, and five single figures of *Temperantia*, *Fides*, *Spes*, *St George* and a *Sibyl*. 'From that day', wrote his wife Georgiana in her *Memorials of Edward Burne-Jones*, 'he belonged to the world in a sense that he had never done before, for his existence became widely known and his name famous.'[10] *The Globe* was moved to superlatives: 'There is nothing in modern art more beautiful or more artistically complete';[11] J. Comyns Carr, in the *Pall Mall Gazette* listed the qualities of his friend:

> In expressive and subtle draughtsmanship, in a system of colour carefully regulated according to the laws of tone and yet preserving an almost gem-like quality in each separate tint, and in the ability to imitate the most delicate appearances of nature wherever such imitation can be made serviceable to the particular scheme of his art, we scarcely know of any living painter who can be reckoned his rival whether in the English School or in the schools of the Continent.[12]

Although there were some dissident voices – the *Morning Post* termed his paintings 'eccentricities', although this was perhaps mild compared to the insults it hurled at Whistler ('monstrosities') and Spencer Stanhope ('crimes in colour')[13] – the general message was clear: Burne-Jones's status was assured, at least among critics. The *Illustrated London News* reminded one, nevertheless, of the fact that there were too many 'Philistines' who were put off by his pronounced mannerisms 'possibly because they fail to understand them', and that they 'considerably outnumber the chosen people of critics and connoisseurs who are able to comprehend and to enjoy'.[14] The fact that Burne-Jones's work was successful among critics who considered themselves discerning, and who appreciated its aesthetic as opposed to populist literary qualities, was underscored by *The Spectator*'s remarks concerning *The Days of Creation*, claiming first that it is one of those paintings 'of which the charm can only be felt, and of which words can give but a faint idea', and continuing:

> Nothing would be easier than to pull it to pieces, and the majority of the remarks which we have heard while standing before it (and we have been five times) have been of this kind; – 'What's all this about it? Oh, angels, ah! I don't care about them; wonderful frame, isn't it? Who is it by? Burne Jones! Who's he?' – and so on, *ad infinitum*.[15]

The reception of *The Mirror of Venus* itself largely rested, as we shall see in a moment, on an assessment of how successfully the artist had mastered the technical challenges which he had set himself. Inevitably, however, Burne-Jones's very project – summed up by *The Globe* as 'the manifestation of physical beauty in its

purest forms'[16] – was out of sympathy with those philistines who approached their art through narrative criteria, like Heathcote Statham in *Macmillan's Magazine*, claiming to be baffled by 'these inexplicable females who, in front of a landscape mapped out with conventional regularity, gaze with such unaccountable agony of solemnity on the reflection of their own faces in the pond'.[17] This critic was equally frustrated by the inscrutability of a single woman figure in Albert Moore's *The End of the Story*:

> a title which rather unfortunately forces upon our attention the limits of his art. Such a title naturally excites our interest; we expect to see in the expression of the figure something that may suggest to our imagination the nature of the story and of its effect on the reader. But Mr. Moore gives us nothing of this. His figure is a graceful woman, charmingly draped, and she holds a book; but that is all he tells us.[18]

It is a relief to Statham to move from the *Mirror* to those single figures of Burne-Jones's which have 'a more masculine and healthy feeling'.[19] The dread of feminised morbidity also turns up by way of a token of disparagement in the *Morning Post*, noting that the girls' faces 'are delicate even to the look of consumptiveness', despite the fact that their 'limbs are as round, solid, and compact as those of so many dairymaids' – a ridiculing of the presumed elitism of the aesthetic project.[20] This detection of degenerative disease was, incidentally, to become a feature of critical comment about Burne-Jones's women at the next year's Grosvenor exhibition – particularly in relation to *Laus Veneris* – in terms proving the point about the tendency to assess womanhood through the 'abundance of images that define femininity'.

Such a concentration on the socially mimetic aspects of painting was, according to Sidney Colvin in the *Fortnightly Review*, missing the point. The beauty that mattered was not the replication of human form, but the beauty of line. He laments that those who complain about the downcast, yearning eyes and expressions in Burne-Jones's paintings do 'not turn their minds, instead, to the happiness which the maker of these melancholy things has prepared for them if they were capable of receiving it, – the happiness and glory and delight of living line and visible rhythm, the fire and rapture of colour poured forth in profuse and perfect harmonies unseen till now'.[21] Others, if less rhapsodic, make much the same points, often turning to Renaissance art to validate Burne-Jones's skill: 'The purest charm of the true Renaissance is here in perfection', maintained the *Athenaeum*.[22] 'The forms and draperies are made out in a way that Perugino himself might have admired', commended *The Standard*'s critic (almost certainly Frederick Wedmore).[23] 'In many ways it recalls the primitive art of the earlier 15th century Venetian painters, but especially in its colour', claimed *The Globe*.[24] But this critic also had reservations about the way in which the phenomenon of reflection was treated: not so much the mirroring of the girls in the water, but something more technical to do with the representation of colour, 'the influence which, in nature, every tint has on those surrounding it'.[25] Despite being in

sympathy with the painter's 'highly wrought poetic feeling', the *Daily News*'s correspondent – although not going so far as the perennially carping *Morning Post* as to claim that 'the shadows are to the full as strong as the substances, so that it would matter very little, if at all, though the painting were turned upside down'[26] – explained his objection:

> It is sufficient to point out the falsity of painting only as much of a reflection as a painter chooses, and that so strong in colour and exact in its imitation as to be more forcible than the real object. The reflection upon the polished surface of the leaves is omitted, that from the edge of the bank is also on which the figures stand, so that all pictorial illusion is destroyed, if the painter intends to represent objects as they really are seen in nature.[27]

What unites all these responses, critical as well as favourable, is not just their preoccupation with what is going on on the canvas surface, but their assumption that they can call on objective standards, standards that will be recognised and held in common by their audiences, as a means by which to describe and to assess the painting. But the particular response on which I wish to concentrate did not come from a regular art critic, but from the pioneering psychologist James Sully, and it is a response that suggests that there may be other ways of approaching art than with the assumption that one's reaction relies on the painting's ability to mimic life.

During the 1870s, James Sully was following a freelance career as writer on philosophical, physiological and literary subjects. Born in 1842, and later, in 1892, to become Grote Professor of the philosophy of mind at University College, London, his interest in art dated from around 1867–68, when he was studying in Göttingen and visited Dresden. Like George Eliot, he felt particularly drawn to Raphael's *Madonna* in Dresden's art gallery. He began his literary career in London in 1871, writing for the *Fortnightly Review* and the *Saturday Review* on a variety of subjects, often with a psychological or aesthetic bias. In 1874, he published *Sensation and Intuition: Studies in Psychology and Aesthetics*, which concludes with his essay 'On the possibility of a science of aesthetics', something which, he claims, would proceed 'by means of historical research supplemented by psychological explanation'.[28] He follows Archibald Alison, Alexander Bain and Herbert Spencer in their attempts to classify and explain aesthetic pleasure, and attempts to group such pleasures according to certain criteria. These include the pleasures of stimulation that one might receive from certain colours or treatments of form; gratification due to novelty; and pleasure deriving from memories, or from experiencing intuition which leads to other forms of intellectual activity – for example, the recognition of relations of objects. He writes of the pleasures of the imagination, working on 'the tendency of the mind to idealize, and the satisfaction of the universal longings for something higher and more complete than the actual'.[29] The chapter is shot through with evolutionary assumptions – the person with the most advanced mental development will be rewarded by the highest

number of pleasures, as opposed, say, to the momentary pleasure which a 'savage' might receive from bright colours. Sully continues:

> It follows from this that the higher aesthetic appreciation is always a process of some delicacy. Pleasurable qualities which obtrude themselves on the observer's attention cannot afford a cultivated mind any appreciable delight. An essential ingredient in the more refined enjoyments of the beautiful, the ludicrous, etc., is the exercise of a certain intellectual activity. This mode of delight is the result of an extended activity of mind in discovering what is hidden, and in distinguishing elements which are closely interwoven.[30]

Yet 'an extended activity of mind' is not all that is involved in perception: first comes the operation of the eye. This is something which Sully had addressed in general terms in an earlier chapter of *Sensation and Intuition*, 'Recent German experiments with sensation', in which he carries on the work begun by John Tyndall and others in bringing the theories of Hermann von Helmholtz before the British intelligentsia. Drawn by Helmholtz's name, Sully had spent the winter of 1871–72 in Berlin, having realised that he 'needed some first-hand knowledge of the physiological processes that help to condition the currents of our mental life'. He conducted anatomical studies in Dubois-Reymond's physiological laboratory, and attended Helmholtz's lectures on physiological optics: 'he was particularly kind, and soon gave us the entrée to his house'.[31] Helmholtz's work informed his April 1872 article in the *Fortnightly Review* on 'The basis of musical sensation', which was praised highly by both George Lewes and Herbert Spencer. Its influence can also be found in Sully's article on 'Aesthetics' for the ninth edition of the *Encyclopaedia Britannica*, commissioned in October 1873. The reception of *Sensation and Intuition*, particularly Alexander Bain's enthusiastic review in the *Fortnightly Review*, led to him being asked to contribute to the first number of the pioneering journal of psychology, *Mind*: Darwin – whom Sully met at Lewes's for the first time – especially praised his piece on 'Physiological psychology in Germany'. Sully also knew Tyndall well: when Sully gave his 1880 lectures on art and vision at the Royal Institution, Tyndall lent him apparatus for his optical experiments.[32]

In November 1878, Sully's article 'The undefinable in art' appeared in the *Cornhill Magazine*: it builds on some of the precepts put forward in *Sensation and Intuition*, and adds to these a far more precise consideration of what may actually happen when we look at a picture. In his earlier accumulation of ideas about what might constitute aesthetic pleasure, the possibilities for subjective, personal pleasures mingle with more objectively formulatable qualities. By the late 1870s there was nothing startlingly fresh in asserting the importance of the individualised and subjective when it comes to viewing, or indeed producing, art: Burne-Jones, to put it synoptically, knew his Pater. But what Sully did that was new was blend physiology with more philosophically grounded theories of perception, and thus lay down a claim for the importance of the developing science of psychology when it comes to aesthetic spectatorship.

In this article, Sully starts from the premise that there are two distinct kinds of mind in his contemporary world: on the one hand the mind with a 'curious enquiring and scientific' turn, 'and on the other side, the dreamily contemplative and the emotional attitude'. Both cultivate a taste for the beautiful, but in clearly demarcated ways: 'The former are mainly concerned with clarifying their aesthetic impressions, with apprehending the sources of pleasure in nature and art; the latter live rather to enjoy beauty without understanding it, and to have the delights of art with the least admixture of definite thought.'[33] But need it be like this? Might it not be possible for an aesthetically trained mind to suspend the intellectual functions, in order, as he puts it, 'to taste of the mysterious delights of the unthinking dreamer'?[34] Just as Tyndall acknowledged the access to the sublime which scientific enquiry gave him, that opening up of infinite spaces which could be afforded by the contemplation of dust or the stretch of the horizon, so, Sully explains, emotional satisfaction does have its part to play in intellectual culture, which in its 'highest degrees ... takes the form of a sense of the undefined and the mysterious'.[35] What specifically intrigues Sully above all in this article is the fact that the intellect and the emotions may indeed be simultaneously engaged when looking at a painting, and that this is due in part to the way in which the perceiving eye operates. We cannot assimilate all of a picture in one go, and our consciousness is bound to vacillate.

> One impression or feeling is reflected on, and so appears clear and distinct; but outside there are circles of consciousness, feelings, and thoughts, which are vague and undefined. Thus at any given moment the impression we receive from a work of art consists of clear and obscure feelings, which latter can only be made luminous in their turn at the expense of the former. [36]

In emphasising the pleasure of the obscure, he is not just drawing on the traditional repertoire of the sublime, but on much more recent work by Robert Schumann which demonstrates the intellectual appeal of the undefined in art.[37] He may also have been influenced by the work of Emile Javal (Helmholtz's translator into French), who, in his *Annales d'un oculiste*, also published in 1878, explains the process of 'saccader', the fact that the eye is never still, but always in motion, moving from one centre of attention, from one focus, to another.[38]

By way of bringing home to the reader his point about the possibility of sustaining dual modes of viewing, Sully provides an example:

> Let us take a picture which has attracted a good deal of notice of late – the Venus' Mirror of Mr. Burne Jones. When, for example, we are passing the eye over the several details – the gracefully set figures, the water with its soft reflections, the quiet landscape behind – we are at each successive moment elevating one impression or group of impressions after another into clear consciousness, while the rest fall back into the dim regions of the sub-conscious. Each ingredient – the illuminated and the unilluminated – is alike essential. When, for instance, we are deriving an intellectual satisfaction from some particular virgin-shape or gentle face, the many other pleasing

elements of the picture contribute each a little rillet of undiscriminated emotion; and
these obscure or 'sub-conscious' currents of feeling serve to swell the impression of
any single instant, making it full and deep.[39]

Here, our perception of a work of art is itself described in terms which make the
mind a simulacrum for the experience of encountering the painted canvas. We first
approach it with the intellect, that part of our being which is, as it were, clear and
visible, since we can be in conscious control of its operations. But then follows the
plenitude and depth of understanding and knowledge of the work of art by the
workings of our own depths, or 'sub-conscious'.

At no time, according to Sully, will the whole of the work of art be available to
us: we concentrate on either part or generality, but the specific will always inform
the general, and vice versa. If we concentrate on colour, or on the sense of the
ensemble given by the scene, we will not be able to prevent an underpresence of
our consciousness of the separate details of the picture affecting our sense of the
ensemble of the whole. And all the time, some of the impressions that the picture
effects on us may remain beyond analysis, since, Sully writes, 'our power of tak-
ing apart the contents of our consciousness is always limited'.[40] That which lies
hidden will inform that of which we are aware. We cannot always be definite about
the sources of our pleasure; they lie deeply embedded in our memories: 'the
impressions which objects produce in our minds are a growth of many past expe-
riences', but these themselves may be 'lost to view'.[41] He even acknowledges the
fact that some of our emotions may be peculiarly unrecoverable in their origins,
since they belong not to our own experiences, but to those of our ancestors, and
are part of racial, not personal, memory.

Sully maintains that: 'Certain modes of aesthetic pleasure directly depend on
vague mental representation as their essential condition, and disappear as soon
as reflection seeks to give exactness and definiteness to the ideas.'[42] In particular,
poetry, with its demands on the imagination, and music are privileged art forms
in this respect. Significantly, he calls on his own physiological assumptions about
the workings of the eye, to the extent of figuring its impersonal mechanism as a
desiring subject replicating his own taste, in order to justify his own prejudices
about what he encountered at the Grosvenor: 'it may safely be said that vague
suggestion cannot be introduced into pictorial art to the same extent as into
music. The eye desires clear and well-defined objects: it is the organ of
perception *par excellence*, and it could never be long satisfied with misty
"nocturnes" or with a dreamy symbolic type of art.'[43] Indeed, the terms of his
argument – although he does not become specific about particular works other
than mentioning the Burne-Jones painting and making that dismissive reference
to Whistler's *Nocturnes* – suggest that he might not have felt too uncomfortable
with, say, Frith's *Railway Station*. Despite his promotion of the role of the
unconscious within the visualising process, Sully was completely unresponsive to
the interpretive potential offered by the indefinite horizons, shifting perspectives
and refusal of a stable depth of field that characterise Whistler's experimental

painting of the 1870s (see plate 18). For Sully's Darwinian principles inform his aesthetic judgement when he argues that 'higher works of art are distinguished from lower and elementary ones by being more complex, by having more numerous elements, also a larger number of uniting relations; in other words, a more intricate unity, dominating a wider diversity'. It follows that 'the more complex a work of art, the larger must be the region of the obscure and undiscriminated at any single moment'.[44] And yet he is completely unspecific about the nature of the 'uniting relations' – whether these be narrative or aesthetic – and the potential for them partaking solely of the latter category can be understood when he remarks that ideas – albeit 'vague ideas' – may be produced by abstract forms, by the straight line or circle, or the presence of white in a work.

Among other things, James Sully's work may be seen as a contribution to that debate which runs through the second half of the nineteenth century: the relationship between art, science and aesthetics. Writing in the new journal *Mind* in 1876, Sully claimed that 'there is probably no region of phenomena which has received less illumination from the activities of the modern scientific spirit than the processes of the Fine Arts'.[45] His remedy for this is psychology, a discipline which he defines quite widely: 'an appeal not only to the study of mental operations by individual self-reflection but also to the newer inquiries into the laws of mental development in the race, and of the reciprocal actions of many minds in the social organism'.[46] This interest in the social as well as the individual is a sign of the influence of Herbert Spencer upon him: yet Spencer's remarks in *The Principles of Sociology* (1876) about the importance of the concept of duality across cultures usefully function to return us to the topic of reflection, and the co-presence of the seen and the unseen – 'apparent and unapparent states of being',[47] as Spencer also calls them – which the fact of reflection suggests. These categories, while not identical with Sully's intellectual and emotional, the realm of fact and the realm of suggestion, clearly have a good deal in common with them. What Spencer is playing with is an early version of the mirror phase, the troublesome but intriguing gap between one's physical and mental existence.

The Fijians, says Spencer, claim that each person possesses an Other:

his likeness reflected in water or a looking-glass.... This belief in two spirits, is, indeed, the most consistent one. For are not a man's shadow and his reflection separate? and are they not co-existent with one another and with himself? Can he not, standing at the water-side, observe that the reflection in the water and the shadow on the shore, simultaneously move as he moves? Clearly, while both belong to him, the two are independent of him and one another; for both may be absent together, and either may be present in the absence of the other.

Early theories about the nature of this duplicate are now beside the question. We are concerned only with the fact that it is thought of as real. Here is revealed another class of facts confirming the notion that existences have their visible and invisible states, and strengthening the implication of a duality in existence.[48]

This co-presence of visible and invisible states is at the core of Sully's own understanding of the process of aesthetic perception. One may describe, and respond to, the formal qualities on the canvas, as contemporary reviewers habitually did, but this is not an adequate summation of the activity that takes place in looking at a painting. The science of psychology, blending, as it did, an understanding of the physiology of looking with an acknowledgement of an individual's interiority – memory, associationism, and so on – insists that we pay attention to both the body and mind of the spectator: in other words, to the simultaneous presence of the visible and the invisible in their own constitutions. In sum, what Sully does is deflect critical attention from the surface of *The Mirror of Venus*, and focus it on the interior. This is not, however, some presumed interiority of depicted character, or the deduced state of mind of the artist, lying behind the female reflections in what Oscar Wilde termed the 'mirror of polished steel',[49] the preternatural clarity of the painted pool. Rather, what Sully privileges is the inescapable duality – intellectual and emotional, physiological and mental – involved in the practice of spectatorship itself.

Notes

1 Susan Stanford Friedman, 'Women's autobiographical selves: theory and practice', in Sheri Benstock (ed.), *The Private Self: Theory and Practice of Women's Autobiographical Writings* (London, Routledge, 1988), p. 38. She is drawing on Sheila Rowbotham, *Woman's Consciousness, Man's World* (London, Penguin, 1973).

2 Lynda Nead, *The Female Nude: Art, Obscenity and Sexuality* (London and New York, Routledge, 1992), p. 11.

3 Henry James, 'The picture season in London', *Galaxy* (August 1877); and see earlier version of review, 'The Grosvenor Gallery and the Royal Academy', *Nation*, 24 (31 May 1877) 320–1.

4 Charles Harrison, 'On the surface of painting', *Critical Inquiry*, 15 (1989) 296.

5 For the history and impact of the Grosvenor Gallery, see Susan P. Casteras and Colleen Denney (eds), *The Grosvenor Gallery: A Palace of Art in Victorian England*, exh. cat. (New Haven, Yale Center for British Art, 1996), and Christopher Newall, *The Grosvenor Gallery Exhibitions: Change and Continuity in the Victorian Art World* (Cambridge, Cambridge University Press, 1995).

6 Oscar Wilde, 'The Grosvenor Gallery', *Dublin University Magazine* (July 1877) 118.

7 G. B-J. [Georgiana Burne-Jones], *Memorials of Edward Burne-Jones*, 2 vols (London, Macmillan, 1904), II, p. 77.

8 *Daily Telegraph* (1 May 1877) 5.

9 *Morning Post* (1 May 1877) 6.

10 Burne-Jones, *Memorials*, II, p. 75.

11 *The Globe* (1 May 1877) 3.

12 *Pall Mall Gazette* (2 May 1877) 11. Comyns Carr was involved with the founding of the Grosvenor Gallery: Lindsay had seen a series of articles written by Carr in the *Pall Mall Gazette* advocating the reform of the Royal Academy; see J. Comyns Carr, *Some*

Eminent Victorians: Personal Recollections in the World of Art and Letters (London, Duckworth, 1908).

13 *Morning Post* (1 May 1877) 6.
14 *Illustrated London News* (12 May 1877) 450.
15 *The Spectator* (19 May 1877) 632.
16 *The Globe* (16 May 1877) 6.
17 H. Heathcote Statham, 'The Grosvenor Gallery', *Macmillan's Magazine*, 36 (1877) 113.
18 Ibid., p. 117.
19 Ibid., p. 113.
20 *Morning Post* (1 May 1877) 6.
21 Sidney Colvin, 'The Grosvenor Gallery', *Fortnightly Review*, 27 (1877) 828.
22 *Athenaeum*, 2584 (5 May 1877) 583.
23 *The Standard* (3 May 1877) 6.
24 *The Globe* (16 May 1877) 6.
25 Ibid., p. 6.
26 *Morning Post* (1 May 1877) 6.
27 *Daily News* (2 May 1877) 6.
28 James Sully, *Sensation and Intuition: Studies in Psychology and Aesthetics* (London, Henry S. King, 1874), p. 340.
29 Ibid., p. 344.
30 Ibid., p. 358.
31 James Sully, *My Life and Friends* (London, T. Fisher Unwin, 1918), pp. 139–42.
32 Ibid., p. 182.
33 [James Sully], 'The undefinable in art', *Cornhill Magazine*, 38 (1878) 559.
34 Ibid., p. 559.
35 Ibid., p. 360.
36 Ibid., p. 561.
37 See Robert Schumann, *Music and Musicians: Essays and Criticisms*, translated, edited and annotated by Fanny Raymond Ritter, 2 vols (London, William Reeves, 1878–80).
38 See also Michael Argyle and Mark Cook, *Gaze and Mutual Gaze* (Cambridge, Cambridge University Press, 1976), pp. 16–17, and Claude Gaudelman, 'The "scanning" of pictures', *Communication and Cognition*, 19 (1986) 3–24.
39 [Sully], 'The undefinable in art', p. 561.
40 Ibid., p. 562.
41 Ibid., pp. 564–5.
42 Ibid., p. 565.
43 Ibid., p. 571.
44 [Sully], 'The undefinable in art', pp. 561–2. Sully's evaluative terms here are remarkably similar to those put forward by George Eliot in her unpublished 'Notes on form in art', written in 1868, in which she describes how an increasingly broad and discriminating development of knowledge 'arrives at the conception of wholes composed of parts more and more multiplied and highly differenced, yet more and more absolutely bound together by various conditions of common likeness or mutual dependence. And the fullest example of such a whole is the highest example of Form: in other words, the relation of multiplex interdependent parts to a whole which is itself in the

most varied and therefore the fullest relation to other wholes.' George Eliot, *Selected Essays, Poems and other Writings*, ed. A. S. Byatt and Nicholas Warren (London, Penguin, 1990), p. 232.

45 James Sully, 'Art and psychology', *Mind*, 1 (1876) 467.

46 Ibid., p. 471.

47 Herbert Spencer, *The Principles of Sociology* (1876), 3rd edn, revised and enlarged, 2 vols (London, Williams & Northgate, 1885), I, p. 116. The first edition of this work was reviewed in the first number of *Mind* by Alexander Bain, who paid particular attention to Spencer's notion of '*duality*, or double existence – in sight and out of sight'. *Mind*, 1 (1876) 131.

48 Spencer, *Principles of Sociology*, p. 118.

49 Wilde, 'Grosvenor Gallery', p. 123.

MORALITY

Versions of the Annunciation: Wilde's Aestheticism and the message of beauty

Colin Cruise

WE TEND TO THINK of Oscar Wilde as an innovator in all things – in the presentation of self through personal appearance as much as in the presentation of opinions, beliefs and aesthetic theory. His personal style became an important element in forming the public's consciousness and reception of him. But the materials from which Wilde formed himself, the constituent parts, as it were, are subtly disguised. They are put to use cleverly and adeptly but they reveal themselves only after much searching. This chapter examines the Wildean self by seeing it as a product of a particular 'cultural moment'. Interconnections between the religious art of the remote past (particularly of the Renaissance and the Middle Ages) and the recent past (of the Pre-Raphaelite Brotherhood) sensitised a relationship between religious belief and aesthetic theory and had an impact upon personality as well as on the arts.[1] We might think that Arthur Symons was overstating his case when he claimed a new religious role for literature at the end of the nineteenth century, but he was reflecting claims which had been made already for the visual arts, particularly for paintings by the Pre-Raphaelite Brotherhood:[2]

> in speaking to us so intimately, so solemnly, as only religion has hitherto spoken to us, [literature] becomes itself a sort of religion, with all the duties and responsibilities of the Sacred Ritual.[3]

This essay forges links between the new Aesthetic Movement 'religion of art' and Oscar Wilde's poetic and dramatic works as well as his personal style. Moreover, it relates these factors to other tendencies in the theory and practice of art in the mid and late nineteenth century, particularly in the development of codes of homosexuality. My thinking on this subject has its origins in a perception that some of the angelic figures in works by Botticelli, a painter in the process of reconsideration by late-nineteenth-century critics, were similar in some respects to Wilde's self-presentation in photographs and representation in caricatures.[4] I made these tentative connections in relation to caricatures (such as plate 41), and paintings such as Botticelli's *Madonna of the Pomegranate* (plate 42) or *The Madonna of the Magnificat* (plate 43), or the 'Simone Memmi' featured in line

engraving by Anna Jameson for her studies of religious art (plate 44). These sim-
ilarities are superficial ones – in hair, deportment, accessories – yet they are strik-
ing too. Was Wilde making reference to a particular type of pictorial beauty in
them? Did they act as a kind of visual quotation like the literary quotations, con-
scious and unconscious, of Pater, Rossetti or Keats in Wilde's writings?

Wilde's representation and reinvention of his personality was essentially a prod-
uct of late-Romantic culture and criticism. He made vital connections between art,
ritual and self at this 'cultural moment' in a process which involved three elements:
a subject – the Annunciation; a flower with complex cultural meanings – the lily;
and recent artistic practice and criticism in the work of Dante Gabriel Rossetti,
Anna Jameson and Walter Pater. These constituent parts have overlapping and
conflicting nuances which yield, I argue here, a new and changing meaning for
English cultural commentators and for Wilde in particular. They were familiar in

their parts but startling when synthesised and placed in an ensemble.[5] Indeed one might see this conjectured synthesised presentation of self as simply another manifestation of the concept of synthesis and accretion which distinguished Aestheticism as a critical mode. Moreover, this late Romantic discourse involved an element of questioning sexual identity and sexual orientation and challenging fixed gender identities. The 'cultural moment', therefore, is a particularly rich one with layers of Christian – particularly Catholic – iconography and Hellenic nuances vying for importance and suggesting new styles and approaches to old problems.

A kind of Annunciation scene was enacted in New York in 1882 where an unlikely angel, Wilde, presented an unlikely Virgin Mary, Lily Langtry, with an enormous bouquet of lilies. Was Wilde acknowledging traditional male roles of assigning a particular passive sexual role to women? Or was he playing with his own ambiguous sexuality, enacting androgyny in the public eye by appearing as a long-haired, flower-bearing angelic figure? Whichever of these possibilities is correct – and both might be – the sentimental, bourgeois dependence on a conventional 'language of flowers' was being played about with in this incident.[6] The lily, with its connections with the Virgin Mary and the Annunciation (in both Renaissance and Pre-Raphaelite depictions), was used by Wilde to identify himself as a messenger. Others saw this implicit connection: in a contemporary caricature Wilde was depicted as an angelic figure, although improbably in trousers, surrounded by a border punctuated by the heads of famous beauties, among them Sarah Bernhardt and Lily Langtry (see plate 41).

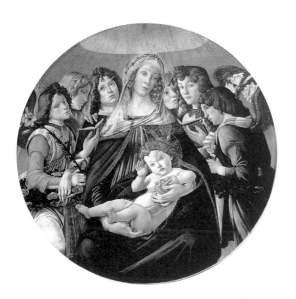

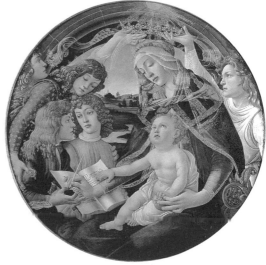

42 Sandro Botticelli, *Madonna della Melegrana* (*Madonna of the Pomegranate*), *c.* 1482, oil on panel, 118 cm (diameter)

43 Sandro Botticelli, *The Madonna of the Magnificat, c.* 1485, oil on panel, 118 cm (diameter)

44 After 'Simone Memmi' (Simone Martini and Lippo Memmi), *The Annunciation, c.* 1330, line engraving

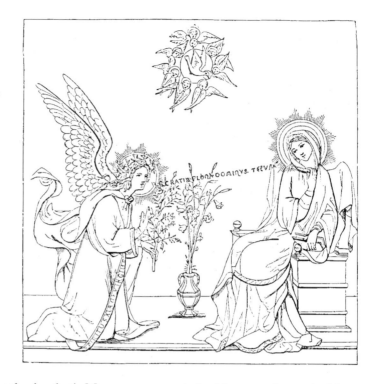

To some extent the Aesthetic Movement was polarised between those who identified with either the sunflower or the green carnation. While the sunflower had a wider significance for the movement as a whole, appearing in several distinguished and countless undistinguished architectural schemes and as an accessory in aesthetic clothing ensembles, the green carnation was worn as a badge of a specific sexuality. As Richard LeGallienne noted:

> in our so-called aesthetic renaissance the sunflower went before the green carnation – which is, indeed, the badge of but a small schism of aesthetes, and not worn by the great body of the more catholic lovers of beauty.[7]

Yet for Wilde the lily became the first of his defining badges – its general and particular symbolic properties being adapted for his own purposes. Its meanings were being explored, extended and emptied after other flower symbols had been exhausted. At the start of his public career Wilde became identified as the lily-bearing aesthete we find caricatured in *Patience* (1881):

> Though the Philistines may jostle, you will rank as an apostle in the high aesthetic band,
> If you walk down Piccadilly with a poppy or a lily in your medieval hand,
> And everyone will say,
> As you walk your flowery way,
> 'If he's content with a vegetable love which would certainly not suit me,
> Why what a most particularly pure young man this pure young man must be!'[8]

The idea of purity contained in this verse is taken up at the end of the opera when Bunthorne accepts that he will have to die single: 'I shall have to be contented / With a tulip or a lily'.[9] These two references surely reflect the pictorial convention of identifying the lily with the Virgin Mary, a convention which had been revived in Pre-Raphaelitism a generation before, while satirising the attitudes that had grown up in circles influenced by late Pre-Raphaelite poetry, painting and design.

Wilde's own use of the lily has been seen solely as part of his tendency to advertise himself, but there was a greater and more complex cultural cross-identification involved for him. In earlier nineteenth-century examples of visual culture, the lily had over-riding sexual and gender connotations, signifying pure femininity. Why did Wilde adopt it as a symbol? Did the 'lily-as-badge' have ambiguous meanings which aided Wilde in several ways in the early days of his career? It is striking that while Wilde's contemporaries often noted the presence of the lily as part of his costume, the symbolic importance of the flower, its iconographic and cultural meanings, have not been sufficiently analysed.[10] Wilde himself never explained his use of the lily as a badge. It was commented upon by journalists as an accessory rather than a symbol, and yet, as this chapter seeks to demonstrate, there were several ways in which the lily's symbolism was 'acute' in a cultural sense, bringing together gendered notions of femininity, passivity and purity, as well as wider associations from religion and art history.

Any subtle and inflected meaning of the lily may have been obliterated by the sort of crude publicity which preceded Wilde in America:

> Mrs Langtry and the other professional beauties of London have a rival in the shape of a beautiful youth named Oscar Wilde, a poet and an aesthetic. His picture adorns all the shop windows and is even taken in the aesthetic style with a bunch of lilies in his hand. He must look as lovely as a yellow cat having a fit in a dish of stewed tomatoes.[11]

In his own description of a lecture to the miners at Leadsville in the Rocky Mountains, as related to Mrs Bernard Beere, Wilde wrote:

> I spoke to them of the early Florentines, and they slept as though no crime had ever stained the ravines of their mountain home. I described to them the pictures of Botticelli, and the name, which seemed to them like a new drink, roused them from their dreams, but when I told them in my boyish eloquence of the 'secret of Botticelli' the strong men wept like children.[12]

And when remembering the period, and Wilde's career in particular, many years later, Max Beerbohm depicted Wilde as lecturer on his American tours, introducing the Americans to beauty while holding a lily. In contemporary caricatures like 'How Utter!', or retrospective ones, like Beerbohm's 'The Name of Dante Gabriel Rossetti Is Heard for the First Time in the Western States of America. Time: 1882. Lecturer: Mr Oscar Wilde', the lily is used in two ways at

the same time, with Wilde as both Mary and Gabriel. One might see this as an image of self-pollination as well as self-advertisement. On the tour he had apparently declared that American houses were 'illy designed' which was celebrated in an anonymous poem:

> Waving sunflower and lily,
> He calls all the houses 'illy'
> Decorated and designed.[13]

However flippant Wilde appears in his own account, in Beerbohm's caricature or in the gentle satires of the press his advocacy of Botticelli shows him to be part of the new art criticism which had its origins in the writings of Walter Pater. His stress upon the revival of art in Pre-Raphaelitism recognises a perceived continuity from the Renaissance to contemporary England. In his American lectures, such as 'The House Beautiful' and 'The English Renaissance', Wilde aligned himself with the newer ideas on beauty in poetry, painting and design.

The use of the lily as a symbol of maidenhood or virginity is well-established in European culture and within the Judaeo-Christian tradition. Its rediscovery in Romanticism for German, French and British painters was a sign of the rediscovery and renovation of pre-Enlightenment culture, a 'tradition' of symbolic iconography. This is true especially of the lily at its most renovated, in Philipp Otto Runge's botanical iconography for example, where the 'Lily of Light' is associated not only with the rising of the sun but with the highly potent sexual congress between male and female elements in nature.[14] In Rossetti's *The Girlhood of Mary Virgin* (1849), a kind of pre-Annunciation in which Mary glimpses her future before the arrival of the Archangel Gabriel, the lily has strong sexual overtones too – of purity, no doubt, but of a purity awaiting its destiny, its alteration into another state (plate 45). Rossetti's poem for the picture, explaining the symbols within it, conflates the lily and the young woman: 'So held she through her girlhood; as it were / An angel-watered lily, that near God / Grows, and is quiet.'[15] Rossetti's intention in depicting a feminine ongoing or unfolding story is apparent in what might appear to be a pendant painting, *Ecce Ancilla Domini!* (1850), where the embroidery of a lily, on which Mary is at work in the *Girlhood*, is shown as completed (plate 46). Mary's destiny itself is completed upon the arrival of the angel from heaven, bearing a lily as a sign of her purity and of God's power. Oddly, the sign is at its most 'complete' at the moment when the virgin is impregnated. In both of these uses we can see the borrowing of a gendered use of the lily from Renaissance depictions of the Annunciation, where the lily is only one of the defining signs of a femininity in a state of change, at the precise moment of change, from 'girlhood' to 'womanhood'. It represents the mystical moment of loss of virginity. The dove, a symbol of the Holy Spirit and male nature, is present at the miraculous defiling of feminine nature. In both of these examples, therefore, the lily is seen not simply as pure but as defining a purity awaiting transition and as singularly feminine too. The lily bears its sexual

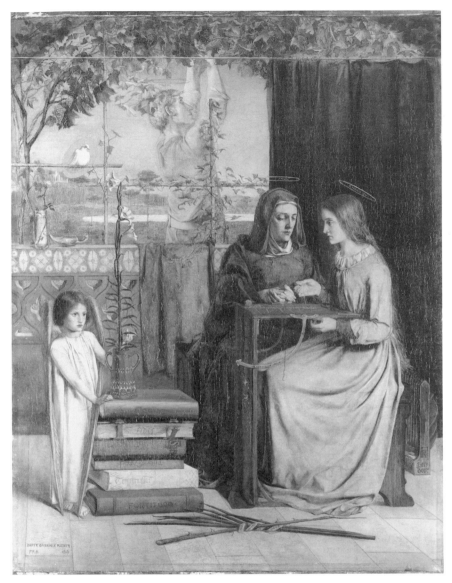

45 Dante Gabriel Rossetti, *The Girlhood of Mary Virgin*, 1849, oil on canvas, 83.2 x 65.4 cm

potential aloft, awaiting the male procreative action while being brandished by a representative of male power, the messenger from God.

In 1847 Dante Gabriel Rossetti proposed a volume of poems to be called *Songs of an Art Catholic* to William Bell Scott. It was to have included a long poem on the Annunciation, originally to be called *Mater Pulchrae Delectionis*, later rewritten and published in 1870 as *Ave*.[16] In the same year the 'Art Catholic' – then aged nineteen – wrote the earliest of his sonnets for pictures, a description of an 'early

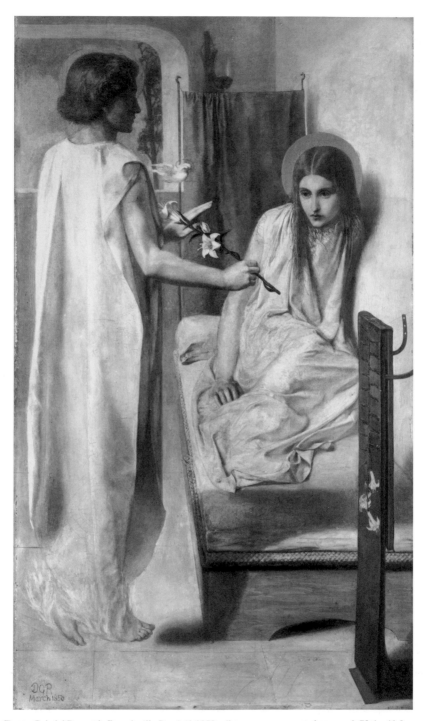

46 Dante Gabriel Rossetti, *Ecce Ancilla Domini!*, 1850, oil on canvas, mounted on panel, 72.6 x 41.9 cm

German' Annunciation scene which, according to his brother, William Michael Rossetti, he had seen in an auction room:[17]

> The lilies stand before her like a screen
> Through which, upon this warm and solemn day,
> God surely hears. For there she kneels to pray
> Who wafts our prayers to God – Mary the Queen.
> She was Faith's Present, parting what had been
> From what began with her, and is for aye.
> On either hand, God's twofold system lay:
> With meek bowed face a Virgin prayed between.
>
> So prays she, and the Dove flies in to her,
> And she has turned. At the low porch is one
> Who looks as though deep awe made him to smile.
> Heavy with heat, the plants yield shadow there;
> The loud flies cross each other in the sun;
> And the aisled pillars meet the poplar-aisle.[18]

There are several features which underline the sacred story that provides the poem with its source – the meeting of the celestial with the everyday (particularly apparent in the last two lines), the mingling of the divine and the human, and the doctrinal incorporations – notably the Trinity.[19]

William Michael Rossetti's suggestion is that *Ave* was intended as a poetic invocation of the pictorial and this seems to be clearly the intention for the 'early German' Annunciation sonnet. But the subject was a vexed one, and the term 'Art Catholic' itself open to question. In a note appended to *Ave* in the 1911 edition of Rossetti's collected poems, his brother explained:

> By 'Art' he [D. G. Rossetti] decidedly meant something more than 'poetic art'. He meant to suggest that the poems embodied conceptions and a point of view related to pictorial art – also that this art was, in sentiment, though not necessarily in dogma, Catholic – mediaeval and unmodern. When in 1869 my brother got his poems privately printed, as a convenient preliminary before settling for publication, he put a note to 'Ave' thus : 'This hymn was written as a prologue to a series of designs. Art still identifies herself with all faiths for her own purposes: and the emotional influence here employed demands above all an inner standing-point.'[20]

The elaborate note-within-note here attempts to deny the original religious impulse with its closeness to the recent wave of rather sanctimonious Catholicism and especially to the revival of Mariolatry. And yet the poem's emphases are all on this aspect of religion – on Mary as mediatrix (she who 'wafts our prayers to God') and her place in relation to the Christianity of the past and that of the present, her place between human and divine; all these things are there, undeniably. The scene described is momentous yet quiet. But it is intelligible only through a particular kind of devotion consciously renovating both an iconographic tradition and a related doctrinal belief. The fact that Rossetti saw himself as an 'Art Catholic' rather than simply as a Catholic

indicates the way in which an aesthetic, pictorial language and iconography had the potential to be divorced from the actual practices of a particular religion.

This renovated and reinterpreted Christian symbolism can be seen in several other Pre-Raphaelite paintings – in Charles Allston Collins's *Convent Thoughts* (1850–51), for example, and in the early works of Burne-Jones. These paintings might be seen as representatives of a new tendency in English art towards a re-embracing, not only of the values of early Renaissance art, but of its religious atmosphere and principles too. In both England and France revivals of Catholicism had tended to stress the power of the Virgin Mary. The apparitions of Mary to Catherine Labouré in Paris in 1830 (leading to the adoption of the Miraculous Medal in 1832) and the apparitions at Lourdes in the late 1850s were particularly important in convincing Catholics (and converts to Catholicism) that Mary continued to concern herself with the lives of humans.[21] J. H. Newman re-presented a fundamental idea of Mariolatry in his writing on Mary as the New Eve, a redeemed and awaited version of the first woman, playing a part in the salvation of the human race, analogous to Christ.[22] In this text, feminine spiritual power is reinterpreted for a modern society. The Annunciation as an event can be seen as confirming this power, the angelic messenger bearing the sign of God's power – a wand or staff, or sometimes a lily – to the lily-woman, she whose purity singles her out from other females yet who is of woman born.[23]

Indeed art-historical writing in England at the time would seem to confirm this contemporary trend in art and letters. It was not artists or theologians only who were interested in the painting of the early Renaissance and its iconography. Arguably it was historians and antiquarians who were responsible for the rediscovery and reinterpretation of what might have seemed arcane religious images. A new generation of art historians followed the pioneering work of scholars like Alexis Rio in his *De la Poésie chrétienne dans son principe, dans sa matière et dans ses formes* (1836) by examining religious symbols and their meanings specifically in Italian Renaissance art.[24] Mrs Jameson's *Sacred and Legendary Art*, which was published in the year the Pre-Raphaelite Brotherhood was formed, 1848, took an aesthetic rather than a religious view of Italian Renaissance painting. Perhaps she found it necessary to distance herself from the specific religious practices which a close knowledge of the symbols would have implied. Instead she claims that her interpretation is of a different order:[25]

> I hope it will be clearly understood that I have taken throughout the aesthetic and not the religious view of those productions of Art which, in as far as they are informed with a true and earnest feeling, and steeped in that beauty which emanates from genius inspired by faith, may cease to be Religion, but cannot cease to be Poetry; and as poetry only I have considered them.[26]

In *Legends of the Madonna* (1852), Jameson treats several manifestations of the life of the Virgin chronologically, anticipating Walter Pater in her method, tone and poetic language. The Annunciation, she tells us:

places before us the two most graceful forms which the hand of man was ever called on to delineate; – the winged spirit fresh from paradise; the woman not less pure, and even more highly blessed – the chosen vessel of redemption, and the personification of all female loveliness, all female excellence, all wisdom, and all purity.[27]

These qualities are conveyed to us by the use of spatial devices, gesture and symbol. Pictorial spatial devices divide the heavenly from the earthly, divide the eternal from the temporal, divide the male from the female, and differentiate their two different 'powers' or spheres of influence. It is the Holy Ghost, in the form of a dove, who ultimately crosses those divisions, not the Archangel Gabriel. The gestures are related to this spatial division, but are less 'received' than the symbols; they vary with the artist's wish to dramatise or interpret – Mary shrinking back, rising to her feet, horrified, dreamy. The Archangel Gabriel is depicted sometimes as strident, even importunate, sometimes at rest, arriving from heaven yet beautifully humanoid, perhaps masculine but more often androgynous. His gestures and the qualities which accompany them do not interfere with the mysterious aspects of the Annunciation but, rather, add to them.[28] This is the Incarnation, the 'Word-Made-Flesh', one of the mysteries at the heart of Christianity, the doctrinal truth which lies hidden in the incident of the Annunciation. The symbols offer the viewer an insight into the double nature of the scene, sometimes underlining the earthly in domestic details, sometimes hinting at the spiritual in the artist's manipulation of them. Together they reveal the symbolic potential of the setting and the sacredness of the moment. Jameson's comments reflect upon this dual symbolic potential: 'the most usual [symbol], almost indispensable, is the pot of lilies, the symbolic Fleur de Marie…. There is also a basket containing needlework and implements of female industry, as scissors *etc.*'[29] The two belong to different types of symbol although they are linked in defining femininity in terms of both a personal attribute (purity) and an activity (performing a domestic duty).

Jameson introduces another potent element into her interpretation of the Annunciation. In a general note on symbols and attributes of the Virgin she includes a line from the Song of Solomon: 'I am the rose of Sharon, and the lily of the valleys' (ii, 2), and continues:

> As the general emblem of purity, the lily is introduced into the Annunciation, where it ought to be without stamens: and in the enthroned Madonnas it is frequently placed in the hands of attendant angels, more particularly in the Florentine Madonnas; the lily, as emblem of the patroness, being chosen by the citizens as the device of the city. For the same reason it became that of the French monarchy.[30]

So the lily is associated with several orders of representation – with the Virgin Mary and with a less particularised ideal femininity – beautiful, pure, prophesied – and with a city and a country. The allusion to the prophesied woman is inevitable if we read Jameson's conjunction of the Song of Solomon and the Annunciation correctly. The Virgin was seen as the prophesied lily-woman of the Canticles, the fulfilment of the typological symbolism of the Old Testament. Indeed, Rossetti had

conflated the Annunciation with the Song of Solomon in a watercolour of 1855, inscribing on the frame: 'My beloved is mine and I am his; He feedeth among the lilies. Hail thou art highly favoured; blessed art thou among women.' The first part of the quotation is derived from the Song of Solomon and the second from the angel's salutation of the Virgin Mary (known widely in its Latin translation as the *Ave Maria*).[31] This, I suggest, is the first occasion in which these two sources – the Song of Solomon and the Gospel Annunciation story – were conflated in nineteenth-century English painting. Both Rossetti and Jameson take for granted a doctrinal link between the promises of the Old Testament in relation to femininity and the fulfilment of them in the New Testament. But both aestheticise the moment too, giving it a new potential for freeing itself from the purely doctrinal.

The growing interest in the Song of Solomon as a treasury of imagery for late Pre-Raphaelite art should be noted as one of the significant cultural shifts within late Pre-Raphaelitism. By evoking the Song of Solomon, painters and poets reinforced the identification of the feminine with nature – the proliferation of 'privileged' images of the natural – animal, vegetable and mineral, which the 'singer' finds beautiful in various ways. The sensuous world evoked in these words consciously echoes the biblical language of the Song of Solomon. Rossetti's *The Beloved* (1865) is one of the central images in a shift which was to have profound consequences for English painting and which was to provide a new iconography of modernity for the end of the century. The bringing together of images of the spiritual Madonna and the sensual Bride reflects contemporary commentaries upon the Song of Solomon, a source which was suggestive for artists other than Rossetti. His follower Simeon Solomon, for example, perhaps inspired by the fortuitous potential of a pun upon his own family name as well as by the poem's richly suggestive language, gave it a 'Uranian' or gay interpretation. He incorporated lines into his prose poem *A Vision of Love Revealed in Sleep* (1871) where they appear as the 'words of the wise king': for example, 'I sleep, but my heart waketh', 'Many waters cannot quench love', 'Until the day break, and the shadows flee away'.[32]

In the circle in which Simeon Solomon's pictures were collected and his prose poem read, this work spoke of a new 'coming of love' utilising but subverting the language of heterosexual desire. The poem's poetic language could suggest male–male desire in opposition to those readings which were either biblical-typological – symbols of the soul's longing for the 'Bridegroom', Christ – or descriptions of heterosexual desire. A poem open to constant reinterpretation and nuancing could easily support new 'gay' readings into the obscure nature of the Bridegroom. What might appear to be a nexus of images which reinforce heterosexuality and/or religious orthodoxy was appropriated to represent that which it was almost impossible to represent within Western European pictorial conventions – male–male desire. In several of Solomon's works of the 1860s the presence of an angelic figure of androgynous appearance accompanying a bridegroom and bride indicates another possibility of depicting desire and longing

(see plate 50). The beloved isn't quite so securely 'mine' in these depictions of compromised heterosexual relationships.[33]

Thus, the beloved-bride tendency in late Pre-Raphaelite art represents a move from seeing female excellence as spiritual, with its emphasis on domesticity, grace and purity, to seeing female excellence in terms of physical beauty, an embodiment of male heterosexual desire. For this purpose the Song of Solomon contains an inventory of female beauty, a 'praise of pulchritude', which reduces femininity to a series of sensual terms and metaphors for and fragments of the body. On the other hand the obscure poetic language of the Song of Solomon offered the possibility of representing male–male desire for an emerging gay coterie. Likewise Botticelli was a potent source for late Pre-Raphaelite interests in and constructions of feminine beauty in relation to a male identity or self. Pater's formative essay on the painter in *The Renaissance* reads Botticelli's images in a way which allows a personal, masculine dilemma to be floated upon a particular kind of female beauty. In Michael Levey's striking observation, 'Pater's own moustached face seems obtruding incongruously through the features of the Madonna'.[34] Gerald Monsman takes this idea further by reading it as a personal (for Pater) iconography of sibling rivalry and son–mother love: 'Pater has read into Botticelli's painting [*The Madonna of the Magnificat*, see plate 43] the predicament of a commonplace mother, able neither to love her gifted child … nor even to fathom his destiny.'[35] But Botticelli opens up this possibility for Pater in providing the critic with a concept – the 'duality of Christianity and Paganism'.[36] It is a duality which allows Pater to explore other ambiguities. Mary (and her pagan correlative, Venus) embody the very sadness at the heart of culture. Pater's aesthetic criticism mines this duality but undermines the potency of difference that is suggested by the figures of Venus and the Virgin Mary. One might say that in writing interpretations of Botticelli's *The Birth of Venus* or *The Madonna of the Magnificat*, parallel and inter-related, Pater was identifying similarities and subtle 'chronological' differences. *The Birth of Venus*, as Richard L. Stein observes, 'represents that instant when the divinity of Love was endowed with perfect human form, in a supernatural transfer of being'.[37] One might say, further, of the Annunciation that the moment represented is a later 'redeemed' version of the same instant: the divinity of love – Christ – being made human, while retaining a divine function and status, both human and divine.

But in what ways has this direction in the practice and interpretation of art in the late nineteenth century a bearing upon Wilde in self-presentation and representation or in his conscious or unconscious deployment of the lily-as-badge? As we have seen, the allusions to the lily in the immediate poetic and pictorial arts were diverse if inter-related – religious, revivalist, and capable of widely divergent interpretations from nature-bound roles assigned to women to subversive, though coded, roles for gay men.

In 1875 the Pater-saturated, Catholic-inclined Oscar Wilde visited Florence, the 'lily city', inspired by Pater's *Studies in the History of the Renaissance*, the book

which he was to describe as 'the very flower of decadence'.[38] He wrote 'Ave Maria Gratia Plena' there:

> Was this His coming! I had hoped to see
> A scene of wondrous glory, as was told
> Of some great God who in a rain of gold
> Broke open bars and fell on Danaë:
> Or a dread vision as when Semele
> Sickening for love and unappeased desire
> Prayed to see God's clear body, and the fire
> Caught her white limbs and slew her utterly ...

Instead, he found in a depiction of the Annunciation a simpler, less cruel vision of the 'supreme mystery of Love'. He looks at it 'with wondering eyes and heart':

> A kneeling girl with passionless pale face,
> An angel with a lily in his hand,
> And over both with outstretched wings the Dove.[39]

The classical world, the pagan world, is routed by Christianity, as it was to be again in Wilde's 'Sonnet Written in Holy Week in Genoa' and later his long poem *The Sphinx* (1893).[40] The spatial, gestural and symbolic forces work to invoke a kind of reality which alone can represent 'this supreme mystery of Love'. It is a resolution which has its origins in a pictorial representation; Wilde's religious–poetic vision is clarified by the viewing of a painting with clear spatial divisions and numinous symbols. But the poem marks, too, even if only as a token, a victory of Mary over Venus and the other 'pagan' gods and goddesses.

Wilde's early use of the lily was twofold. Poetically it could be invoked to suggest a femininity like Mary's – the 'Madonna Mia', for example, in the poem that bears that name: 'A lily-girl, not made for this world's pain'. But it had a more personal use, too, in serving as a description of his dead sister, Isola: 'Lily-like, white as snow / She hardly knew / She was a woman, so / Sweetly she grew' ('Requiescat').

If we see a ghost image of Botticelli's angels in Wilde's appearance and in – perhaps even more – in the contemporary caricatures of him, holding the lily while arriving from a higher intellectual sphere to preach the gospel of a new religion of beauty, we might be seeing the traces of aesthetic-religious debate which had begun a generation before. Wilde's announcement concerns art and beauty, the 'new religion' of the late nineteenth century in England. It represents a move from the 'coming of love' to the 'coming of art'. But, as we can see from the above account, Wilde is a little late in his angelic intervention. He might be seen as a revivalist of something which had already been revived. But Wilde intensifies the late Romantic tendency to reappraise images and to personalise and decontextualise their meanings. This is a renovation to suit oneself, eliding meanings and supplanting traditions. For Wilde the shift from Madonna to Bride might be seen in his treatment of and references to – in short, his use of – the lily.

Wilde was aware of a shift in his thinking about lilies and flowers generally and noted in 1882 his withdrawal from earlier influences.[41] In that year he wrote to the publisher J. M. Stoddart about Rennell Rodd's *Rose Leaf and Apple Leaf*, for which Wilde, high-handedly, had insisted on writing a Preface:

> I send you the volume of poems and the preface. The preface you will see is most important, signifying my new departure from Mr Ruskin and the Pre-Raphaelites, and marks an era in the aesthetic movement.[42]

This era might be seen as itself an era of renovation of flower imagery, re-presenting flowers in both their most aestheticised and their most sexually suggestive forms. In his instructions to Stoddart about this volume some three months later, he advises the publisher to introduce 'delicate flower ornament' into the design of the book:

> You might have one page of roses, and the other page of apple blossoms and call the book *Rose Leaf and Apple Leaf*, or *Narcissus and Daffodil*, using those flowers – indeed all flowers would be delightful.[43]

What Wilde saw as a move away from Pre-Raphaelitism may, in fact, be analogous to the earlier shift in the works of Dante Gabriel Rossetti when he moved from paintings with a medieval religious character to the Titianesque or High Renaissance paintings of female figures in the late 1850s (see Chapter 1, pp. 20–4). Wilde shifted from the medieval Catholic lily symbol to the gendered, sensual lily during the 1880s.

Despite turning his back on 'Pre-Raphaelite' flower and Annunciation imagery, Wilde returned to the lily image in his play *Salomé* (1891) where it reappears in a highly dramatic way. The play contains several notable inventory passages where the Princess is described in terms of whiteness, with many references to flowers, precious stones and, recurrently, the moon. But this descriptive position is reversed too. In her taunts of John the Baptist, the Princess herself speaks about his physical qualities in images that recall the Song of Solomon:

> Iokanaan, I am amorous of thy body! Thy body is white like the lilies of the field that the mower hath never mowed. Thy body is white like the snows that lie on the mountains, like the snows that lie on the mountains of Judaea, and come down into the valleys. The roses in the garden of the Queen of Arabia are not so white as thy body. Let me touch thy body.

And to the decapitated head, Salomé says: 'All other men are hateful to me. But thou, thou wert beautiful! Thy body was a column of ivory set on a silver socket. It was a garden full of doves and of silver lilies.'

Here Wilde paraphrases the Shulamite's description of her beloved, in that celebrated outburst of responsive feminine desire in the Song of Solomon: 'His legs are alabaster columns, set upon bases of gold.' And he adds the dove and lily imagery of pictorial representations of the Annunciation decontextualising

both the dove (representing the Holy Spirit) and the lily (the sign of feminine purity).

Wilde's play has its spatial, gestural and symbolic elements too, and in the way they are offered to us we can perceive a parody of the Annunciation. Salomé's description of Iokanaan in her last wandering speech – '[your body] was a garden full of doves and of silver lilies' – is an abominated Annunciation.[44] For Wilde, this biblical moment acts as a kind of typology in reverse. The incident he describes took place some thirty years after the Annunciation, and if there had been promises of female purity contained in the angel's message they are not fulfilled in the person of Salomé. Neither is a balance of power achieved between the active male and the passive female spaces. Instead, Wilde inverts male and female spaces. The woman – if only for moments – wields power over the sword, and over the word. In a kind of erotic trance, she goes through an inventory of beauty : '[your body] was a garden full of doves and of silver lilies'. Her speech presents us with the possibility of a multiplicity of different Annunciations. Salomé herself has crossed the forbidden space that separates the divine and the human, the spiritual and the fleshly, and indeed the masculine and the feminine. In doing so, she uses the lily image for herself to describe her desire for men. Strikingly, in the final published version of Aubrey Beardsley's illustration for the scene, which he called *The Climax*, the Annunciation idea surfaces in his constructions of the spatial divisions and in the attitude of Salomé herself (plate 47).[45] Linda Zatlin sees the drawing as exuding sexuality:

> John's blood drips downward and fertilizes the ground from which a lily and a bud bloom. By projecting sexuality into the stylish pictorial lines of the scene and away from Salomé, Beardsley adds a pathetic coda to her climax, making the title an ironic pun, for the object of her desire is dead and revenge robs her of her sexuality.[46]

My interpretation of this image is connected to what I see as a residual iconography derived from Annunciation pictures and these, in turn, are related to the lily imagery in Wilde's text. Beardsley's Salomé even takes up the gesture of urgent motion found in Annunciation scenes – a descending, kneeling figure addressing an upright figure at the other side of the picture space (see, for example, plate 44). One might trace back Beardsley's choice of source to his earlier predilection for the late Pre-Raphaelite religious iconography of angels and lilies close in atmosphere and style to the drawings of Simeon Solomon and Burne-Jones and their Old Master influences, notably Mantegna and Botticelli.[47]

In Wilde's various uses of lily imagery we witness some of that tendency to conflate, accrete and revise Christian iconography which, as I have observed, has its origins in Rossetti's poetics. I would contend, however, that 'Wilde's lily' changes in both meaning and inflection towards Pater's self-identification with Botticelli's Madonnas and beyond. Wilde saw the lily as a symbol which had shifting meanings, some of which were tied to the idea of the delivery of a message and some to an issue of gender. At the same time the lily became a

personal device, representing Wilde in much the same way as the lily represented Florence or France, useful for publicity purposes and for easy recognition. The huge distance between the lily sign of Wilde's earliest appearances, with their nod to art history, and their resting place in Salomé's language of desire reveals a cultural shift in the final decades of the nineteenth century. We see here a process of revision followed by conflation, accretion and even – consciously- 'perversion', although one uses the term tentatively. Wilde recognised both the Annunciation theme – that of acceptance, humility and the allied theme of spiritual and physical beauty (as represented in Renaissance painting) – and that aspect of desire that had informed it from the Song of Solomon: the desire of the Bridegroom for the Bride. Wilde's message changed throughout two decades – from the aesthetic, coming-of-art message to the codification of sexual desire, particularly a male–male desire. But the Annunciation inspired the message and the messenger by providing both a dramatic framework for a personal myth and an allusive symbolism.

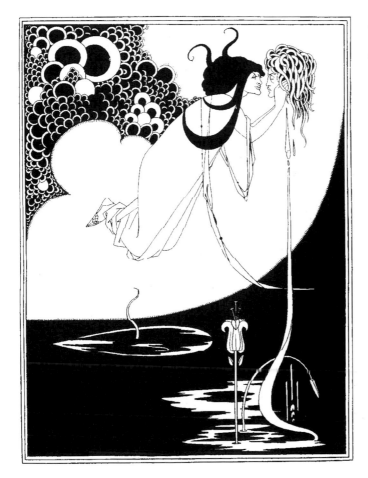

47 Aubrey Beardsley, *The Climax*, line block engraving, 22 x 15 cm

Notes

1 I am indebted to several writers for their insights into late-nineteeth-century thought and culture in relation to religion and art, particularly Hilary Fraser, *Beauty and Belief* (Cambridge, Cambridge University Press, 1986); Linda Dowling, *Hellenism and Homosexuality in Victorian Oxford* (Ithaca, Cornell University Press, 1994); David J. DeLaura, *Hebrew and Hellene in Victorian England: Newman, Arnold, and Pater* (Austin and London, University of Texas Press, 1969).

2 See for example P. T. Forsyth, *Religion in Recent Art* (London, Simpkin, Marshall, 1889).

3 Arthur Symons, *The Symbolist Movement in Literature* (London, William Heinemann, 1899), p. 10.

4 For the 'rediscovery' of Botticelli see Michael Levey, 'Botticelli and nineteenth-century England', *Journal of the Warburg and Coutauld Institutes*, 23:3–4 (1960) 291–306.

5 For discussions of Wilde and clothes see Lionel Lambourne, *The Aesthetic Movement* (Oxford, Phaidon, 1996); Colin Cruise, 'Looking the (p)art: some observations on male artists and their clothes', in Pat Kirkham (ed.), *The Gendered Object* (Manchester, Manchester University Press, 1996). Richard Ellmann, *Oscar Wilde* (London, Hamish Hamilton, 1987) has been invaluable in referencing Wilde's appearance throughout this chapter.

6 For Wilde's meeting with Langtry see Ellmann, *Oscar Wilde*, p. 196. For the language of flowers see Jack Goody, *The Culture of Flowers* (Cambridge, Cambridge University Press, 1993), especially chs 8 and 10

7 Richard LeGallienne, *Prose Fancies* (Chicago, Herbert S. Stone,1896), p. 86. Rossetti depicted both sunflowers and lilies together to show the separate and distinct meanings of the two flowers in his drawing *Mary Magdalene at the Door of Simon the Pharisee* (1858). There the door is flanked by both flowers in pots. Mark Girouard interprets this as suggesting 'the physical and spiritual worlds between which Mary Magdalene is poised', *Sweetness and Light: The Queen Anne Movement 1860–1900* (New Haven, Yale University Press, 1984), p. 29.

8 W. S. Gilbert, *Patience*, Act 1, in *The Savoy Operas* (London, Macmillan,1957), p. 174.

9 Ibid., Act 2, p. 207.

10 It is not my intention here to rehearse the proliferation of decorative lilies in book design, wallpaper, costume, etc. Those uses have been recorded exhaustively in Lambourne, *Aesthetic Movement*, and Elizabeth Aslin, *The Aesthetic Movement: Prelude to Art Nouveau* (London, Elek,1969).

11 Quoted in Ernest Dudley, *The Gilded Lily: The Life and Loves of the Fabulous Lily Langtry* (London, Odhams, 1958), p. 18.

12 Rupert Hart-Davis, *Letters of Oscar Wilde* (London, Hart Davis, 1962), p. 111.

13 Quoted in Walter Hamilton, *The Aesthetic Movement in England* (London, Reeves & Turner, 1882), p. 119.

14 For an in-depth discussion of Runge's flower symbolism see Rudolf M. Bisanz, *German Romanticism and Philipp Otto Runge* (DeKalb, Northern Illinois University Press, 1970), especially ch. 5.

15 D. G. Rossetti, 'Mary's Girlhood' ('For a Picture') (1849?), *Collected Works* (London, Ellis & Elvey, 1890), I, p. 353.

16 'Notes by W. M. Rossetti', in W. M. Rossetti (ed.), *The Works of Dante Gabriel Rossetti* (London, Ellis, 1911), p. 661.

17 Ibid., p. 661.

18 Rossetti, *Collected Works*, I, p. 343.

19 I have not space here for a lengthy comparison of this poem to Rossetti's *Ave* where the Trinity is used as a motif and Mary herself is described as 'a woman-Trinity'. See ibid., p. 244.

20 Rossetti, *Works*, p. 661. W. M. Rossetti writes that the theme is 'of a strongly Roman Catholic kind'. I have altered W. M. Rossetti's elaborate punctuation for conciseness.

21 My thinking on this aspect of my subject has been influenced by several works on Mariolatry, notably John Kent, 'A renovation of images: nineteenth-century Protestant "Lives of Jesus" and Roman Catholic alleged appearances of the Blessed Virgin Mary', in David Jasper and T. R. Wright, *The Critical Spirit and the Will to Believe* (London, Macmillan, 1989), pp. 39–51; Barbara Corrado Pope, 'Immaculate and powerful: the Marian revival in the nineteenth century', in Clarissa W. Atkinson et al., *Immaculate and Powerful: The Female in Sacred Image and Social Reality* (London, Crucible, 1987).

22 See Cardinal Newman, *The New Eve* (Oxford, Newman Books, 1952). Marina Warner writes of the medieval Christian delight to pun and riddle on the Eve/Mary idea: 'the greeting of the angel – Ave – neatly reversed the curse of Eve [Eva]', *Alone of All Her Sex: The Myth and the Cult of the Virgin Mary* (London, Weidenfeld & Nicolson, 1976), p. 60.

23 The doctrine of the Immaculate Conception of Mary – that the Virgin was herself born without sin – was defined for Catholics only in 1854 by Pope Pius IX. To some extent it develops the idea that Mary was like Eve before the Fall. It was a controversial doctrine among High Anglicans and Wilde was still exercised in its defence as late as 1876 (although one wonders how much Wilde understood the theological debates): 'It is very strange that they [Tractarians] should be so anxious to believe the Blessed Virgin [was?] conceived in sin.' See Hart-Davis, *Letters*, p. 18.

24 I am indebted to J. B. Bullen, *The Myth of the Renaissance in Nineteenth-Century Writing* (Oxford, Oxford University Press, 1994) for clarifying some of the tendencies in Victorian literature and criticism towards the Renaissance. See in particular his ch. 6.

25 Such sectarian confusion may have been one to which women were particularly prone in relation to honouring the Virgin Mary. In Nathaniel Hawthorne's novel *Transformation* (1860, American title *The Marble Faun*), the two American artists Hilda and Miriam are living in Rome. Hilda, who tends a lamp to the Virgin Mary, tells her friend: 'You must not call me a Catholic. A Christian girl – even a daughter of the Puritans – may surely pay honour to the idea of divine Womanhood, without giving up the faith of her forefathers' (ch. 6).

26 From the Preface to the first edition of *Sacred and Legendary Art* which was initially called *The Poetry of Sacred and Legendary Art*, 2 vols (London, Longmans, 1848). I quote from this Preface as reprinted in the 1896 edition. For background to this book see Clara Thomas, *Love and Work Enough: The Life of Anna Jameson* (London, Macdonald, 1967), ch. 18.

27 Anna Jameson, *Legends of the Madonna*, 6th edn (London, Longmans, 1879), p. 166.

28 Ibid., p. 179.

29 Ibid., p. 177.

30 Ibid., 'Introduction', p. xlv.

31 See Virginia Surtees, *The Paintings and Drawings of Dante Gabriel Rossetti (1828-1882): A Catalogue Raisonné* (Oxford, Clarendon,1971), I, p. 33. The work has been traced since Surtees published her catalogue.

32 Simeon Solomon, *A Vision of Love Revealed in Sleep* (London, privately printed, 1871), p. 1.

33 A similar point in the context of a different discussion is made by Thaïs Morgan, 'Perverse male bodies: Simeon Solomon and Algernon Charles Swinburne', in Peter Horne and Reina Lewis (eds), *Outlooks: Lesbian and Gay Sexualities and Visual Culture* (London, Routledge, 1996), p. 70.

34 Michael Levey, *The Case of Walter Pater* (London, Thames & Hudson,1978), p. 137.

35 Gerald Monsman, *Walter Pater's Art of Autobiography* (New Haven, Yale University Press, 1980), p. 85.

36 Levey, *Walter Pater*, p. 137.

37 Richard L. Stein, *The Ritual of Interpretation* (Cambridge, Mass., Harvard University Press, 1975), p. 238. See also Paul Barolsky, *Walter Pater's Renaissance* (University Park, Pennsylvania State University Press, 1987), especially ch. 13.

38 I have dated the Wilde visit from Hart-Davis, *Letters*, pp. 4–6. Wilde's description of *The Renaissance* is quoted from Stein, *Ritual of Interpretation*, p. 213.

39 Oscar Wilde, *The Complete Works* (Collins, London, 1966), p. 727.

40 A poem which, having evoked the mutiple perverse attractions of the Sphinx, rejects her in favour of an image of Christ on the cross.

41 Although he abandoned the lily as his personal device, he continued to use it, and other flower images, most strikingly in his addresses to Lord Alfred Douglas. In 'The critic as artist' Wilde introduced a whole page of flower allusions after his reference to Meleager in part 2, contrasting them with Baudelaire's *Les Fleurs du mal*. Some of these flower images anticipate the white-on-white jewel and flower descriptions of Salomé: for example, 'The feet of his love as she walked in the garden were like lilies set upon lilies.'

42 Hart-Davis, *Letters*, p. 96.

43 Ibid., p. 116.

44 Katharine Worth describes the speech which precedes this as 'a kind of catharsis: the poison is out, and she can move into a stiller, sadder music, through the imagery of the past recreating the Jokanaan'. But she adds of the speech which follows and which I quote above: 'all the dark, perverted side has disappeared'. I would query this description seeing the speech as itself 'perverted' because of its origins in the language of the Song of Solomon. See Katharine Worth, *Oscar Wilde* (London, Macmillan, 1983), p. 69.

45 There are two versions of this design. The first, published in *The Studio* (April 1893) is a relatively elaborate drawing with an inscription from Wilde's French text. The second appeared in the published version of the play in 1894, redrawn perhaps to avoid copyright problems with *The Studio*.

46 Linda Gertner Zatlin, *Aubrey Beardsley and Victorian Sexual Politics* (Oxford, Clarendon,1990), p. 95. Compare Chris Snodgrass who notes the graphic clarity of the image as a kind of contrast to the true horror of what is being depicted (although one

might say that this is true of much of Beardsley's work): 'The purging of complicating details also softens the picture in another sense: it makes slightly more apparent certain droll Beardsleyan ironies, such as chaste lilies feeding on the blood of murder, or lustful Salomé being transported in the manner of angels. Clarifying such ironies assuages the sense of unrelenting corruption and so necessarily reduces somewhat the Gothic voltage of the picture.' *Aubrey Beardsley, Dandy of the Grotesque* (Oxford, Oxford University Press, 1995).

47 Beardsley would have been interested in the Annunciation from an early age. His earliest religious observances were at the Church of the Annunciation of Our Lady, Washington Street, Brighton. See Brigid Brophy, *Beardsley and His World* (London, Thames & Hudson, 1976), p. 33. Malcolm Easton reinterpreted some of these early influences in *Aubrey and the Dying Lady: A Beardsley Riddle* (Boston, David R. Godine, 1972), pp. 186-9. See also Snodgrass, *Aubrey Beardsley*, p. 270. Roger Fry's description of Beardsley as 'the Fra Angelico of Satanism' is suggestive in the context of this discussion of the trace elements of a religious art in a 'decadent' production.

The image in the middle: John Addington Symonds and homoerotic art criticism

Whitney Davis

ART CRITICISM constructs its object of regard, a work of art or perhaps a programme for one, in relation to – as a version of – an impossible work of art, an almost unseeable and certainly an unmakable work of art. If the work were makable – if it had actually been made successfully – there would be no need for criticism. This paradox is perhaps never more visible than in homoerotic art criticism, founded in the aesthetic and art-historical writings of J. J. Winckelmann (1717–68) – for modern homosexuality could only realise itself by engaging its supposed impossibility in contemporary society, producing a reflection on what present-day cultures lack or forget.[1]

Here I consider how these wider concerns were exemplified in critical investigations undertaken by John Addington Symonds. Symonds's autobiographical study is the single most important surviving written document of nineteenth-century homoeroticism.[2] Equally important, Symonds was the Victorian writer perhaps most responsible for transforming the Winckelmannian aesthetics that had been accepted for several generations into a recognisably contemporary critical perspective and for anticipating its Freudianisation in the next generation. His lifelong concern – best stated in his later essays and to use his main terms – was to orient the traditional 'idealism' of Winckelmannian aesthetics towards a 'realism' more appropriate to contemporary experience. At the same time, he tried to accommodate the paradox that no 'real' and morally satisfying homoeroticism actually existed at the present time and therefore only its 'ideal' representation could suffice. Symonds had a special interest in images that had been produced, as he saw it, in a specifically homoerotic history or what I have elsewhere called a homoerotic teleology, such as an erotic interaction between a painter and his male model or between a contemporary male subject for a work of art and previous images of masculine beauty in the history of art.[3] I begin by considering a concrete example of the way in which Symonds identified and investigated this teleology.

As soon as he had a little money to do so, by the mid- and later 1860s, Symonds began to acquire works by contemporary artists. One of these, the painter Edward

Clifford (1844–1907), had been born in Bristol four years later than Symonds and, like Symonds, had been brought up there. As a young man he studied at the Royal Academy. His subsequent career as a modestly talented portrait painter and religious illustrator is not my concern here. By the early 1870s, he had a subsidiary occupation as a painter of handsome young men and boys got up as Greek or Christian heroes. Most of these works went into private hands, a circle of like-minded friends, and some of them have survived in private collections. We also know about them from contemporary comments and echoes of them in Clifford's later illustrations for evangelical publications (Clifford became an official of the Church Army, which conducted missions among the poor). But as these images were not exhibited or reviewed, our own art history – which has tended to build too much of its analysis of Victorian art on the history of its public reception and criticism – has completely overlooked them.

Symonds had evidently known Clifford for some time – perhaps since their boyhood – when he arranged in October 1870 to purchase the painter's copy of the so-called *Knight in Armor*, a sixteenth-century painting of a young religious warrior or saint militant in the National Gallery (now known as *A Man in Armour*, plate 48).[4] Apart from whatever significance the original might have had for Symonds, his purchase of Clifford's copy apparently was intended to express his interest in Clifford's own work. He had already been going to Clifford's studio to see a painting in progress depicting the young St. Anthony of Padua. We do not know whether either man realised that some representations of this Franciscan saint were already homoerotic icons, probably because the tradition often depicted him healing the injured bodies of handsome youths. But the metaphor of the perfect man who healed the damaged and dying would certainly have been well suited to Clifford's salvationist fraternalism. As for Symonds, the painter, he told Clifford, probably had no idea 'how interested outsiders like myself are in the actual processes of art – especially in the elaboration of pictures from nature-hints'. Indeed, Symonds offered to assist 'at the idealising of the street urchin' Clifford was hoping to find as a model for his painting of the young saint.[5]

Clifford's painting apparently does not survive. Whatever he might have seen in it, in return Symonds offered Clifford some 'bad poems which are still "inediti"'.[6] These could only have been drawn from his *John Mordan* cycle. Mordan was a 'street urchin', a newsboy in Piccadilly, whom Symonds idealised. A number of the poems collectively named for him survive in one or another version. Although Symonds recognised that homoerotic poetry might be his special purview and talent – that he was 'only forcible in the region of the monstrous' – he destroyed many works, taking the advice of friends. Sometimes described as a 'Book of Songs' to go along with 'The Essay' – a long scholarly and philosophical study of Greek love probably begun in 1867 or 1868 – the *John Mordan* cycle was never fully published, though fragments appeared in print over many years.[7]

All of the poems in the cycle concerned male love in the ancient world and the Renaissance, or, as Symonds once grandiloquently put it, 'transcendental

Moralitat, Sittlichkeit, [and] the Pandemic temptations of the uranian enjoyments [worked] into one whirlpool'.[8] From his university years onwards, Symonds regarded eroticism and sex between males as problems in 'transcendental ethics' strictly speaking: they are forms of social relation to be justified, if at all, in virtue of universal, intrinsic human cognitive and moral characteristics. In writings of the later 1860s and early 1870s, in order to investigate this idea, he studied the traits of friendship, chivalry and respectful regard in the institutions of Greek pederasty and medieval love and their supposed distortions in Roman decadence and Renaissance sodomy.

 Much of the *John Mordan* cycle and many other poems, published and unpublished, dramatise the ethical quandary of the main character or characters. Essentially they ask whether and when a homoeroticist – he can be defined as a man whose ethical regard for other men has aesthetic and erotic expressions – should act homosexually. More exactly, since sex remains largely off limits even in Symonds's most phallic compositions, they consider how far the aesthetic and

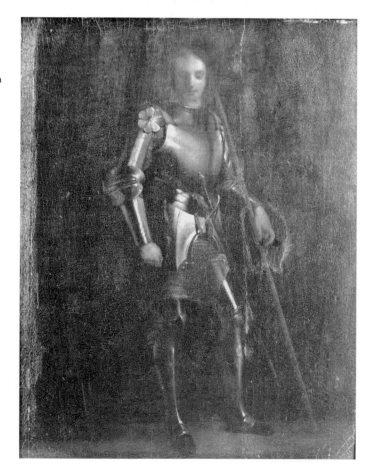

48 Formerly attributed to Giorgione, *A Man in Armour*, c. 1500, oil on panel, 39.7 x 27 cm

erotic enthusiasms of a homoeroticist can ethically be taken in a relation with a boy, a friend or a stranger. For example, one long poem, *Eudiades*, imagines the situation of a youth in the circle of Plato who 'recoil[ed] from acts which were permissible in Hellas'.[9] (Symonds later regarded this poem as one of his best works.) According to Symonds, the question that confronted Eudiades and other characters imagined in the poetic cycle required an 'absolutely new casuistry'; 'there is', he claimed, 'no rule by which to measure it as yet'.[10] Needless to say, however, there were many worldly men, not unfamiliar with homosexual affairs, who thought they knew perfectly well where reasonable lines could discreetly be drawn; Symonds's own father was one. Thus the apparent fact that for men like Symonds there was seemingly 'no rule' – no sure principle of right conduct – ensured that their critics could readily label them as 'amoral' or completely 'pagan'. For critics, the problem was not so much that Symonds and his fellow-travellers would endorse homosexual licentiousness or lust (Symonds for one certainly did not), but that the foundations of his proposed 'transcendental ethics' were philosophically vague and, when they did not merely call for complete self-abnegation, patently self-justifying.[11]

Initially, Clifford was – or professed to be – surprised by Symonds's approach. It had obviously been less interested in St. Anthony and his great works than in the good looks of the models. Upon reading the poems, Clifford asked Symonds how their author could possibly respect someone who, like the painter, fully believed in what Symonds must consider a 'delusion' – for if Symonds believed the thoughts expressed in his poems, Clifford remarked, he could not be a Christian. The painter and his potential patron kept their distance for several weeks; as their first recorded exchange attests, neither was on sure ground. In early December 1870, however, Symonds finally responded. 'You asked me', he wrote to Clifford, 'how I could respect you who believe in what (according to your view of me) I regard as a delusion. *I want to serve God.* I do not serve him as I could, because I am in great part wicked. *You serve God.* Therefore I cannot but respect you.'[12] This protestation seemingly helped somewhat. At any rate, Clifford cautiously signalled to Symonds that they were not, after all, so far apart.

Some time that month, Clifford gave Symonds a painting of Jason, leader of the Argonauts. Again, unfortunately, the painting does not seem to have survived. But Symonds immediately responded to this picture and what he called its 'wonderfully keen & delicate realization of the spirit of the Greeks'. He connected Clifford's pictorial visualisation of the young hero to the famous speech of the old Athenian, the Dikaios Logos, in the *Clouds* of Aristophanes: 'it reads like the text of your picture', he said.[13] This speech was absolutely central to Symonds's concept of Greek homoerotic chivalry – of its aristocratic fraternity (an incipient or perhaps an actual democracy) and comradeship – which he had outlined in essays on the character of Achilles and on the idyllic and gnomic poets published some years earlier.[14] Shortly after his correspondence with Clifford, he reaffirmed his understanding of the matter in an essay on Aristophanes, beginning with a quotation from the speech:

'In that blissful time', says Dikaios Logos, 'when I flourished, and modesty and temperance were practiced, a boy's voice was never heard; but he would set off at daybreak, in snow or sunshine, with his comrades to the school of the harper, where he learned the ballads of our forefathers in praise of Pallas; and from the harper he would run to the training ground and exercise himself with the decorum befitting virtuous youth.' ... [The boy] did indeed shun the public baths and the agora, repel the advances of profligate persons, respect his parents, avoid [prostitutes], and form in his breast an image of [the Idea]: yet he frequented the wrestling-ground, and grew fair in form and colour with generous exercises.[15]

What exactly this 'image of the Idea' might be – how it had got there and how, equally important, it could yet be preserved while the boy 'frequented the wrestling ground' – is a question too intricate to take up here. Symonds had probably accepted Winckelmann's insight that the ethical and erotic ideals of a Greek ephebe had been acquired in part from works of art which had themselves been imitated, in an ongoing or even endless circuitry, from the bodies and characters of ethically ideal youths.

More important for our immediate purposes, the *Apoxyomenos*, the classical statue attributed to Lysippos and often known as the 'Vatican Athlete', had long been used by Symonds to visualise the ideal Greek youth – described by the Dikaios Logos – in specific relation to the objects of his own erotic desire. The Athlete was, as it were, the ideal artistic replication and synthesis of these fantasy characters, who also had actual or real-life correlates. For example, a youth in Bristol, Alfred Brooke, with whom Symonds had been obsessed to distraction in the early 1860s, was presented in a remarkable ekphrasis in the *Memoirs* as the virtual or living appearance of the Athlete.[16]

At the same time, Symonds was concerned with the more general art-critical or art-historical question of the sculptural or pictorial analogues of the ideal youth described by the Dikaios Logos. The historical production of such representations could be taken as a proof that his ideals – including their immanent homoeroticism – had been (and thus might again be) socially realised in a process of aesthetic and ethical cultivation. As early as 1867, for example, Symonds quoted the speech of the Dikaios Logos and offered what he took to be an art-historical illustration of his ideal – namely, 'the two wrestling boys at Florence, whose heads and faces form in outline the ellipse which is the basis of all beauty, and whose strained muscles exhibit the chord of masculine vigour vibrating with tense vitality'.[17] He was referring to a well-known Hellenistic sculpture of wrestlers in the Uffizi, long a staple of homoeroticist iconography; the ethical question of homoeroticism – with the ideal resolution supposedly achieved by the boys recalled by the Dikaios Logos – was dramatised by the extraordinarily sexual connotation of the interpenetrating poses of the youths in the statue. Symonds's attentive interest in its aesthetic formalisation – in the 'ellipse which is the basis of all beauty' – reflects enquiries into the geometrical and mathematical foundations of sculptural art conducted by, among others, his own father.[18] This project had considerable importance for the

younger Symonds. It was later refined in his own technical investigations of (homoerotic) painting and photography, in which, for example, he tried to identify and replicate the ellipse at the core of Hippolyte Flandrin's composition of the young man's peculiar – and controversial – posture in his well-known work *Jeune homme assis sur un rocher* (1835), itself a homoerotic icon.[19]

As a preliminary formula, one might say that the compositional 'ellipse' in the Uffizi wrestlers or Flandrin's seated youth is the visual equivalent of the harper's chords, emblematic – for the Dikaios Logos – of the ideal harmony and temperance of the souls of the Greek ephebes. 'If we in England seek some echo of this melody of curving lines', Symonds went on, 'we must visit the fields where boys bathe in early morning, or the playgrounds of our public schools in summer, or the banks of the Isis when the eights are on the water, or the riding-schools of young soldiers.'[20] We do not know whether Clifford used such living models for his *Jason*, as, for example, the American painter Thomas Eakins was to do in the early 1880s in preparing his painting of boys and youths gathered at a swimming hole.[21] But we can reasonably suppose that he based the painting on young men recollected or employed for the purpose of exemplifying – if only in the minds of the painter and his hopeful patrons – the physical and ethical standards praised by the Dikaios Logos.

Precisely because of Clifford's gift of *Jason*, then, Symonds was not to be put off. If Clifford believed the man who had written Symonds's poems must be an unbeliever, Symonds believed the man who had painted the young St. Anthony and Jason must understand *l'amour de l'impossible*. To thank Clifford, he sent him another homoerotic poem, identifying its allegory in vague terms as 'the passion for Physical Beauty in different ages of the world'.[22] He glossed it by saying that in Greece this passion had not been restrained by a sense of sin. Rather, the Greeks behaved modestly and discreetly for aesthetic reasons. Referring to his own poetry and to Clifford's art, Symonds speculated that 'the future will have a reconciliation of the conscience & the sense of physical beauty'[23] – even if immediately contemporary art, including Clifford's own, remained unreconciled with itself at just this point. Later in the year, sending Clifford a recent poem, 'The Song of Love and Death', he reassured the painter that he did indeed regard God 'as the only one unchangeable reality in the Universe', even though he held a scientific view of man's place in it, and indicated his belief – meant to appeal to Clifford's philanthropic spirit and missionary zeal – in 'Democracy as the inevitable Social form of the future' and 'the close & intense tie of fraternity, the love of man for man'.[24] Needless to say, Symonds's vocabulary was substantially that of Walt Whitman, whom he had first read in 1867. Three days later he sent the poem – it tells a story of two Greek lovers, Cratinus and Aristodemus – to Whitman; 'it is of course implicit already', he told the poet, 'in your Calamus, especially in "Scented herbage of my breast"'. The 'transcendental ethics' of the poem required Symonds more or less explicitly to note the two lovers' self-conscious avoidance of anal sodomy.

All of this was his best effort to reach out towards Clifford in terms he had evidently concluded the cautious Christian painter might accept. But in the end he could not leave well enough alone. He closed his letter by wondering out loud 'whether my poems on Antinous and Diego would shock you!' Antinous needed no homoerotic introduction. Symonds's poem on the drowning of Antinous – as we have it – was an elaborate and darkly sensuous reflection on the beautiful youth's 'sacrifice', his simultaneous passion for and victimisation by Hadrian, a topic that had already been the leitmotif of scholarly commentary and homoerotically charged debate for several generations. Diego, as the other poem made clear, was a considerably more shadowy but, for an artist, perhaps more intriguing character: he was the boy-wife of the sodomite Cellini, briefly mentioned in the sculptor's memoirs. In his poem Symonds did not hesitate to depict the lurid, cruel and violent circumstances in which, he imagined, the boy – dressed as a woman – had been introduced to Cellini's mistresses, friends and rivals.[25]

All this brought Clifford round to Symonds's house to talk about painting in just those terms Symonds had suspected all along. The painter said that he wanted to pursue 'a line of painting heroic male beauty'[26] – probably, for him, following the manner of Edward Burne-Jones, whom he later imitated in various illustrations and who in turn sometimes imitated early Renaissance images of soldier-saints. Both painter and patron could just about believe that this programme might be consistent with Clifford's ideal of Christian heroism and Symonds's ideal of chivalric fraternity.

While lunching with Clifford, however, Symonds was possessed with an 'uncontrollable irritation of nerves' and had to leave the room. Writing to the painter in apology, he insisted that he really was 'exceedingly interested' in Clifford's projections:

> It seems to me a new line & a splendid one & one for which you have already shown your capacity. Believe me, if it had not been for young St. Anthony, I should not have dared to reveal to you so many of my cherished thoughts. *That* made me believe in your pure & noble faculty of understanding & expressing manly perfection.[27]

Hinting at the gap between his 'cherished thoughts' and Clifford's terms for the ideal he wanted to paint, and as if to recall their difference, he included a pamphlet of poems which Clifford had already seen in proof and asked his opinion of two of them, 'With Caligula in Rome' and 'The Upas Tree'. Elsewhere he described the latter work as an 'allegory of the attractions which some forms of vice have for even the most beautiful natures, when they are tainted with morbidity & madness'.[28]

Needless to say, Clifford backed off again. He quickly sent a note hinting at his concern about Symonds's poems, prompting their author to request a frank and, as it were, ultimate evaluation. 'You do not perhaps know', he told the painter, 'how much I need & how thankful I am for the remarks of a man like yourself with pure instincts & untainted tastes.'[29] Thus cornered, Clifford finally asserted that in his view Symonds possessed a 'gift of artistic expression which is powerful for evil'.

The painter felt the poems could too easily tempt people simply by portraying the very possibility of decadence. He recommended that they never be published. The effect of Clifford's opinions was, Symonds told him, 'intensely painful'. As at other moments of erotic and intellectual crisis in his life, he had another minor breakdown, 'one of those utterly crushing & sudden seizures of I do not know what sort of nervous collapse'.[30]

We could continue to trace these exchanges, but enough has been said to indicate their character.[31] Throughout, Symonds continually pursued and Clifford advanced and withdrew a homoerotic image. As Symonds himself tried to suggest, Clifford's idealised representations of adolescent male beauty replicated Symonds's own idealised fantasy-image. But they did not reproduce exactly what Symonds saw there. Symonds evidently searched them for signs – bespeaking Clifford's own recognition – that the painted subjects participated in the fantasies that had been, for him, co-ordinated upon the *Apoxyomenos* and acquaintances such as Alfred Brooke and John Mordan. Symonds knew that Clifford's Christian heroes were allegories of salvation through purity, courage and piety. But, it seems, he could not quite believe that these young men had not experienced homoerotic desire. As the close parallel between Clifford's idealised (not to say sentimental or sanitised) youths and almost exactly contemporary works by other artists readily suggests, a slightly different handling would have sufficed to eroticise or even to sexualise the figure – producing an image of a youth who solicits his male viewer's attraction to him and therefore stains his own purity with voluptuousness and seductiveness.

Thus, and in turn, we can suppose that Symonds, as his correspondence with Clifford suggests, was fascinated by – sceptically curious about – the possibility that the painter could have produced the same turbid images as Symonds's fantasy but, as Clifford insisted, *without* their vicious, morbid origins and their function as sinful temptations. The issue, it seemed, was simply that the painter, and the painting, had to render possible not merely the sinlessness of a youth homo-erotically attractive to a viewer, *but also* the sinlessness of the viewer attracted to homoerotic youth – the very position which Clifford, but not Symonds, actually seemed to occupy. In works that we can appreciate through such later echoes as Clifford's fantasy-vision of Father Damien of Molokai (*c*. 1885, plate 49) (Clifford knew him as an old leper, just before his death, but here imagined him as a young man), the painter did indeed seem to be about to be able to make images that viewers could sinlessly enjoy homoerotically. It seemed that he had almost managed the transcendence required to institute Greek love in the modern world as an institution compatible (or even identical) with Christian love.

If Clifford's painted image could idealise – or sinlessly aestheticise – its formal double, Symonds's tainted fantasy-image, by the same token it could, as it were, purify Symonds in the very act of stimulating and arousing him. Needless to say, this synthesis was known by both parties to be just a fantasy of a painting. Clifford's paintings themselves stayed to one side of homoeroticism, for there were no contemporary grounds from which such a display *could* be enjoyed sinlessly. In this

respect Symonds's generation experienced the same dilemma as Winckelmann's. Although the modern world certainly contains forms of male romantic friendship, of sexual sodomy and of pederastic desire, to achieve a wholly fulfilling homoerotic love – its ideal form could be fantasised and even, it seemed, visualised – it had to treat these opportunities sceptically and recognised that it had to synthesise and transcend them. Symonds never ceased to hope that Clifford would succeed in doing so as a painter, where he himself had failed as a poet.

For example, a few weeks later, after the exchange about 'Caligula' and 'The Upas Tree', Clifford sent Symonds another gift – a painting of a young knight named Moriturus. In response, Symonds informed the painter, he wrote a poem 'after gazing long & earnestly at [it] & striving to read your meaning in the face'.[32] In the first stanza of his poem, describing the knight's beauty, in an attempt to match Clifford's 'meaning' Symonds applied some of the terms of his own long-standing fantasy:

49 Edward Clifford,
*Father Damien de
Veuster [in] 1868*,
c. 1885, pencil and
charcoal(?)

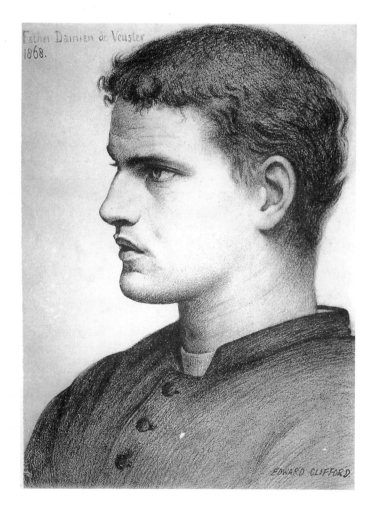

To die? – And what has thou to do
With dying? – On thy lip the down
Is soft & slight as buds that woo
Young winds in March; thy curls embrown
A forehead where no fretting frown
Hath traced the signature of strife
With all the stubborn ills of life.

In echoing Homer's description of Hermes – 'In the first budding of the down on lip and chin, when youth is at her loveliest' – Symonds employed a favourite image in which, as he later put it, 'all my dim forebodings of the charm of males were here idealized'.[33] The stanza also recalls an earlier poem, 'Phallus Impudicus', which Symonds devoted to a sleeping youth, a young driver at Sorrento, in turn recalling certain drawings by Ingres and A.-L. Girodet's well-known painting of sleeping Endymion in the Louvre.[34]

In the second stanza, however, the knight Moriturus appears as a specifically Christian hero in the type of Mantegna's or Donatello's St. George:

Thine eyes are blue with love & faith
As deep as heaven, as wide as air;
No carking doubt hath come to scathe
The blossom of thy youth so fair:
Thou shouldst yet be blithe and debonair; –
Then wherefore are thy features wrought
To this intensity of thought?

The psychological difference between a 'fretting frown' and the 'features wrought' is significant. Although he is not irritated by mundane ills, the young man concentrates on a great and sacred task:

Death is a tyrant: but the Knight
Who binds his breast with sacred steel,
Around whose brows the bays unite –
Though cold that coronal – must deal
Such blows as force the fiend to feel
That youth & strength & love & beauty
Can lure no hero from his duty.

His beauty, then, does not lure him into sin, as his good looks might imply and as fantasy might hope. Instead, it becomes identical with his duty to fight the fiend who – if I can put it somewhat paradoxically – might tempt him into that error which he would symbolise if he did not surmount it. What effects the difference between the error and its overcoming is precisely the knight's freedom from 'carking doubt' – the attitude which Symonds, as we have seen, thought Clifford to have successfully attained. The young man's face bears no sign of the scepticism and sensuality that would show that he had doubted, and fallen. More exactly, those

signs – marks of desire, tension and uncertainty, the 'signature of strife' – have been converted by the painter into the symbols of mighty struggle with, rather than conquest by, the fiend:

> Therefore, though fair as flowers, though browed
> Like angels at the throne of God,
> Thine adolescence wears the cloud
> Whereon the freezing feet unshod
> Of death & doom austere have trod,
> To point the path that climbs the skies
> Far far above earth's paradise.

Surmounting the possibility of his sinning is not quite the same thing as destroying the fiend, for the young knight must presumably die in the battle; in Christian legend, only the Archangel St. Michael conquers Lucifer. (It is possible that Clifford's exploration of this 'sacrifice' was intended as a structural parallel and response to Symonds's study of the 'dedication' of Antinous, who was sometimes thought to have sacrificed himself to save the life of Hadrian.) The young knight's burden, then, is precisely not the stain and decay but rather the sacrificial purification and apotheosis of his homoerotic allure – or so Symonds poetically narrates the painting's signs:

> Bring lilies with full hands, spring-flowers,
> Rathe primrose-buds & daffodils,
> Who never feel the jocund hours
> That summer with her sweetness fills,
> But fade by half-unfrozen rills,
> And scatter them above the bed
> Of him whose soul hath triumphed.

Like Clifford, Symonds worked hard to force this conversion, which he otherwise knew or at least suspected must be impossible: although the opening lines of the poem conventionally compare the tender beauty of the young knight to the 'buds that woo young winds in March', a metaphor that for Symonds encapsulated pederastic yearning, the concluding lines commemorate his noble death in battle against sin. Spring flowers that 'fade by half-unfrozen rills' are to be scattered on his bed – that is, on his grave.

For Symonds, Clifford's paintings apparently represented a well-defined pictorial possibility or ideal. But to understand it fully, we must see it in relation to its moral opposite – to which it must necessarily bear, as I have already suggested, a close formal and iconographic similarity. Deliberately making the viewer flirt with impurity or sin, a painter could produce a painting in which the depicted characters display their origin in – and solicitation of – homoeroticism, just as a painter like Clifford produced paintings which tried to avoid or perhaps to transcend it.

Needless to say, such a pictorial possibility – we could call it 'homosexual' – became publicly feasible by the later 1880s and the 1890s, in Britain most notably

in the erotic illustrations of Aubrey Beardsley and other 'decadent' designers, in the semi-pornographic photographs of Frank Sutcliffe or Frederick Rolfe ('Baron Corvo'), and, to a lesser extent, in certain works of painters like Henry Scott Tuke and Frederic Leighton and sculptors like Hamo Thornycroft, all of whom were admired by Symonds in the last decade of his life. Partly due to the circulation of ideas like Symonds's and Pater's, Beardsley's or Corvo's works – to the extent that they were at all serious – expressed the increasing self-confidence of homoeroticist artists and manifested the influence of Continental painting and literature. But already by the late 1860s and early 1870s, the possibility of an overt homosexualism in contemporary art was beginning to be explored – forming at least part of the very basis, then, for Symonds's or Pater's critical and historical investigations.

In this, from Symonds's vantage point, Clifford's alter ego was the young Jewish painter and their exact contemporary, Simeon Solomon (1840–1905).[35] In the early 1870s, Solomon's public fame rested largely on his pictures on traditional Jewish, Greek Orthodox and medievalising Catholic themes – though even these often had erotic and homoerotic connotations. As early as 1859, for example, Solomon probably displayed homoerotically charged drawings, such as a *David Playing to Saul*, among friends like Burne-Jones.[36] In the next ten years or so, Solomon's portraits of friends and lovers appear to have circulated within a small group: for example, an 1869 portrait of a young Italian lover was sold to his friend George Powell, a Welsh landowner, who later commissioned *Love Dreaming by the Sea*, probably modelled on some young friend of the painter or his patron.[37] These works show the influence not only of the homoerotic imagery but also of the painterly manner of French artists of the preceding generation – notably Girodet and Flandrin – whom Solomon, always eclectic, had evidently studied along with the Victorian genre and Pre-Raphaelite painting that constituted his more immediate English context.

By the mid-1860s, encouraged by his friend Algernon Charles Swinburne among others, he was making provocative and thematically dubious pictures on what a commentator described as 'subjects of a rather strained and painful passion'.[38] These were largely private commissions or for private sale. One of the best known, *Love Among the Schoolboys* of 1865, later bought by Oscar Wilde and lost in the bankruptcy sale of his Tite Street house, amounts to little more than a titillating idealisation of familiar schoolboy spooning. But other drawings, such as *Bride, Bridegroom, and Sad Love* (plate 50), were striking fantasies of union and loss in which the position of the homoeroticist artist or viewer is often personified within the narrative by a sad or forlorn Eros. These images invoke the excitement and suffering he feels when his hopes for erotic connection with an ideal lover have simultaneously been stimulated and denied. Here Solomon's command of mid-Victorian pictorial sentimentality served him surprisingly well. A number of works also display his precocious mastery of homoeroticist legends in the classical tradition, a learning possibly acquired with the help of Swinburne and other classically educated friends and probably stimulated by his two trips to Italy in 1866 and 1869. For instance, a good-humoured if rather obvious *Socrates and His Agathodaemon* plays

with long-standing jokes about the philosopher's pederasty. An 1865 drawing, *Spartan Boys About to Be Scourged at the Altar of Diana*, illustrates an obscure archaeological reference and apparently complements the drawings of the flogging of schoolboys made to illustrate Swinburne's long and repetitive but (for the devotee) stimulating poem on that subject.[39] An *Antinous Dionysiacus* – we must return to the theme, in which Solomon himself saw 'nothing improper' – went privately to one client in 1864; the same year, a watercolour of *Sappho and Erinna in a Garden at Mytelene* was bought by a Newcastle collector.[40] Responding specifically to these two images, Swinburne accurately described their 'stamp of sorrow, of perplexities unsolved and desires unsatisfied'.[41]

Among later-nineteenth-century artists, perhaps only Gustave Moreau surpassed the depth and range of Solomon's autodidactic erudition in the imagery and legends of homoeroticism. Moreau was fortunate to find a writer who could keep full pace with his range of reference; J.-K. Huysmans' own scholarly command of late Latin and eastern Mediterranean lores – deliberately built up, around and over the more familiar classical Greek armature – matched Moreau's own

50 Simeon Solomon,
*Bride, Bridegroom,
and Sad Love*, 1865,
pencil, 24.8 x 17.1 cm

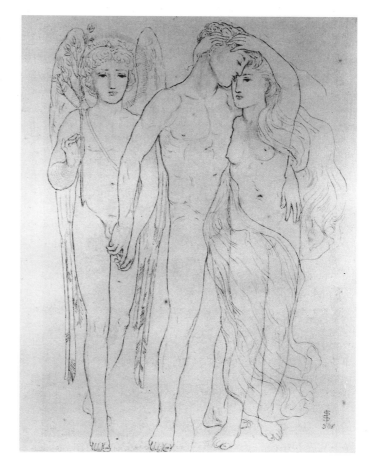

technique in constructing his pictures of Jason, Narcissus and other figures. By contrast, Solomon's critical admirers, Swinburne and Symonds among them, offered a more generalised approbation; they recognised some of the arcane terms of the artist's pictorial universe but were not able – or were too cautious – to spell them out fully. At his best, as Symonds recognised, Solomon seized the thematic significance of homoerotic inflections in cultural traditions, ancient and more modern – Near Eastern, Oriental, Greco-Hellenistic, Latin and medieval. Such a 'mystical union of Pagan and Christian symbolism', as Sidney Colvin put it, did not always 'commend itself very strongly' to viewers.[42]

Perhaps sensing the artificiality and idiosyncracy of his carefully assembled iconography, Solomon struggled to give it a plausible artistic form and aesthetic value. Generally he tried to relate it to contemporary homosexual experience, including the familiar erotic trials of public-school romances but extending as well to the more clandestine worlds of homosexual cruising, narcotics and prostitution, his knowledge of which he did little in his personal conduct to disguise. Although he often preferred to set his subjects in ambiguous and atemporal surroundings, his look-alike youths, marked by subtle signs of sensuality and addiction, seem to subsist somewhere between a chapel and a brothel or a public urinal. Idealised but not sanitised, his imagery achieved considerable synthetic and darkly stimulating coherence for those who cared for it. At the same time, he was well aware, as he told Swinburne, that 'by many, my designs and pictures ... have been looked upon with suspicion'.[43]

Presumably the visual intelligibility of Solomon's eroticism – novel and even dangerous in its own time – was the basis of his popularity among admirers like Swinburne, Pater, Symonds and Wilde, as well as their undergraduate followers, even if none of them was able precisely to describe the painter's meanings in prose. Certainly his virtuoso way with line and paint themselves – at least in the years of his success – enabled him to juggle and blend the manners of Leonardo, Girodet, Gérôme, Burne-Jones and Moreau, constituting the impression that he was at once the most traditional or ancient of painters and the most fashionable and modern. In itself, this impressively fluent style probably had homoerotic significance too. In a number of Solomon's homoerotic allegories, the long passage of time and of art was explicitly equated with the decay and ruin – and the potential revitalisation or hoped-for resurrection – of homoerotic beauty and love. Paradoxically, the very beauty and value of the mournful image of a lost homoeroticism might be the partial condition of its future reconstitution; the painting itself was meant to serve as the link or bridge at the same time as it narratively projected the full temporal history into which it inserted itself. In what follows, I will consider some typical instances of this.

Symonds was probably familiar with Solomon's homoerotic allegories of the later 1860s. Although some of these – probably most – remained in private hands, others were publicly exhibited, sometimes (though not always) for sale. In 1867 Solomon showed a head of *Bacchus*, an oil painting, at the Royal Academy (plate

51)[44] and in 1868 exhibited another *Bacchus*, a full-length portrayal in watercolours (plate 52), and *Heliogabalus, High Priest of the Sun* at the Dudley Gallery, though neither of these was for sale.[45] As a regular viewer at Royal Academy and London gallery exhibitions, Symonds had almost certainly seen these works, and possibly saw works in private hands as well.

Solomon was arrested with another man in a public urinal in February 1873 and convicted of sodomy. Many of his former patrons and friends, including Swinburne, abandoned him and he was unable to exhibit. In 1875, however, Symonds bought two pictures (apparently the first original Solomons he acquired), probably to help Solomon out.[46] An alcoholic, the painter was reduced to begging and lived in and out of a poorhouse for years before his death in 1905. But throughout the 1890s there continued to be a market for original Solomons to decorate the walls of aestheticist undergraduates, homoeroticist sympathisers and decadent poseurs.[47]

By December 1868, Symonds and his friend Henry Graham Dakyns had seen enough Solomons – almost certainly including the Royal Academy and Dudley Gallery exhibitions – to be interested in acquiring Frederick Hollyer's photographs of the 'whole lot', a set of reproductions of Solomon's oeuvre to date that apparently included some unexhibited works like *Amoris Sacramentum* of 1868

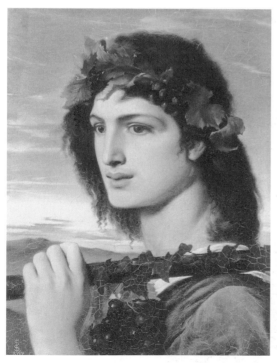

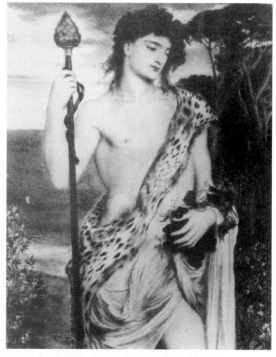

51 Simeon Solomon, *Bacchus*, *c.* 1867, oil on paper laid onto canvas, 50.8 x 37.8 cm

52 Simeon Solomon, *Bacchus*, *c.* 1868, watercolour, 45.5 x 37 cm

(plate 53).[48] When the photos arrived at the end of the year, Dakyns must have believed Symonds was disappointed in what he saw, for Symonds replied to his question:

> You mistake about Solomon. I admire & look incessantly. But I had transcended him in my anticipations. I am very vain. I want now to get hold of more of the same sort. When you are in Paris will you do something for me? Will you go to M. Marville, photographer of all the original drawings in Europe, & choose me one or two studies from the nude of *Ingres*?[49]

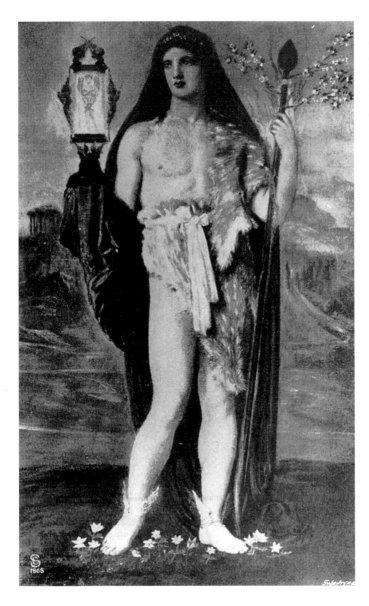

53 Simeon Solomon, *Amoris Sacramentum*, *c.* 1868, oil on canvas, untraced, photograph by Frederick Hollyer, *c.* 1868

It is not completely clear what Symonds meant in telling Dakyns that he had 'transcended [Solomon] in [his] anticipations'. He would seem to have been deliberately ambiguous in a way that he knew Dakyns would understand: in waiting expectantly for the photographs, including the unexhibited works he could not have seen, his fantasy of what they would show him had already gone beyond what they did, in fact, show. At the same time, in his own homoerotic poems he thought himself to have already produced the vision which Solomon's pictures then offered to him. He was especially proud of his latest poem on Greek love, *Eudiades*, finished that week and 'cast forth palpitating'.[50]

Still, Symonds 'admired and looked [at the photographs] incessantly'. He must have recognised, for example, that in the Dudley Gallery *Bacchus* Solomon had imitated Sodoma's *St Sebastian* and the Lysippan *Apoxyomenos* to construct the powerful body of the god. Coincidentally, in *Eudiades* Symonds had envisioned his homoerotic hero Melanthias after the same ancient sculpture.[51] In general, as Clifford's paintings would do, Solomon's pictures intersected at many points with Symonds's own personal and in some respects quasi-hallucinatory or even dream-derived homoerotic iconography. Much of this can be credited simply to the fact that Solomon and Symonds shared a wide-ranging knowledge of homoerotic legends and of the Winckelmannian tradition. But, as we will see, at least part of it must have surprised Symonds and increased his fascination with Solomon.

Whatever the specific connotations of these works, a matter for Symonds's and other viewers' most subtle casuistries, all of them displayed the ambiguously homoerotic nature of the depicted characters and openly solicited the viewer's complementary arousal. For example, the Dudley Gallery *Bacchus* (see plate 52) unmistakably portrays the sleepy god, sated and tender, but still swollen, flushed and tousled, rising from a bed of love with an unknown partner who has pulled the youth's cloak away from his loins – a place occupied, in fact, by the viewer of the painting, or, more exactly, someone standing next to him. Solomon depicted Heliogabalus as flaccid and melancholy. The emperor seems drugged, disinterestedly awaiting or recalling some act of excess – such as the bloody sacrifice of a handsome youth recounted in Symonds's poem 'Midnight at Baiae' (unpublished at the time) – symbolised by the small sculptures, probably erotic, ranged at his elbow and feet.[52] In garb and posture, Heliogabalus is the absolute converse of a young knight 'who binds his breast with sacred steel'.

As the latter example suggests, however, Solomon's images tend – slightly or dramatically – to construct homoerotic positions as morbid and debased. Precisely because no other cause of joy and of suffering has been specified in the pictorial narratives, the beautiful male character, usually a 'Love', and the implied male viewer who admires him – both incarnating the homoerotic possibility – becomes decayed or ruined in part because of himself and his own impossible desires. In other words, Solomon, just like Clifford, moralised just when Symonds's fantasy desired the Hellenic, chivalric, democratic transcendence – fraternal and erotic. In the simplest formula, where Clifford could not quite acknowledge the sin from

which homoerotic purity can be saved, Solomon could not quite acknowledge the homoerotic purity from which sin can be evolved.

Symonds seemed to be well aware that Solomon's pictures too easily collapsed back into a distaste – mournful, it is also melancholic and vengeful – for the homoerotic beauty that superficially they seemed to celebrate. Some time in the later 1860s, Solomon painted a controversial *Love Dying by the Breath of Lust*. It does not survive, but judging from the title we can infer that it attempted to play with a sexually explicit theme and probably with homoerotic arousal: as in the allegory of *Heliogabalus*, lust destroys purity and beauty. Indeed, the painting was singled out in 1871 by the poet and critic Robert Buchanan. Vehemently condemning the 'fleshly school' of contemporary poetry and painting, he noted that 'English society … goes into ecstasy over Mr. Solomon's pictures – pretty pieces of morality, such as "Love dying by the breath of lust"…. [P]ainters like Mr. Solomon lend actual genius to worthless subjects, and thereby produce veritable monsters – like the lovely devils that danced round Saint Anthony.'[53] Buchanan meant merely to mock and condemn Solomon, whereas Symonds hoped to see him do better. But despite his disagreement with Buchanan, from Symonds's vantage point the critic would have been right in one sense: the point was not so much the fact that Solomon toyed with dangerous pictorial suggestions of human sensuality (though Buchanan disliked such effects) than the way these served as 'pretty pieces of morality' over which society could enthuse, titillated in its supposed but merely complacent edification. As Symonds had already joked to Dakyns after having studied Hollyer's photographs at greater length: 'One thing I have learned: Solomon might make a better picture of Amor & Libido: Lust dying of the breath of Love.'[54] Such a painting, Symonds was suggesting, would embody Solomon's moral message more directly, as it were uninverted, while still permitting the homoerotic suggestions – now more correctly placed. Like Clifford's *Moriturus*, edging its purities towards homoerotic immorality, a *Lust Dying of the Breath of Love* would edge its immoralities towards purity.

My point is that the image in the middle ground – perhaps we might imagine a palimpsest and synthesis of Clifford's *Father Damien* (see plate 49) and Solomon's Royal Academy *Bacchus* (see plate 51) – could never actually be produced, although in his collecting and criticism Symonds continually looked for and desperately desired to see it: at the time, it seems, to realise the immanent significance of Clifford one could only veer towards Solomon, and to realise the immanent significance of Solomon one could only veer towards Clifford. More exactly, the image in the middle could only be embodied in a picture that renders visible, as the painted work itself, the decay of an unseeable, unmakable image *into* that picture before us. The latter cannot be absolutely beautiful, for it is not, itself, the haunting synthetic image from which it has fallen away. Still, it can be fascinating and arousing.

Perhaps because his exact moral meanings – and his symbolic message – somewhat baffled his interested audience, and certainly had led to public controversy, in early 1871 Solomon published an extended prose poem which he had drafted

in Rome in 1869, *A Vision of Love Revealed in Sleep*.[55] Symonds must have read it immediately, for he published a review in April.[56] Apart from his interest in Solomon's art, there were probably personal reasons for his curiosity about the painter's literary effort. Partly prompted by his father's psychological enquiries into apparitions and troubled throughout his own life by poor eyesight and migraine and by the suspicion that he might be mad, Symonds was deeply involved with phenomena of somnambulism, hallucinatory suggestion and dream-vision, placing them at the centre of his experience of homoeroticism. A fair proportion of his own artistic production – his poetic imagination of ancient and Renaissance male love affairs – was rooted in part in his own troublingly vivid dream experiences and fantasy projections.[57]

On its own garbled terms, Solomon's enigmatic text was chiefly a straining apologia for his art, to which its 'visions' run parallel. In the *Vision of Love*, the dreamer's soul appears to him. The dreamer must seek Love with the help of his soul, for, as the soul tells him, 'when [Love] appears to those who, with dimmed eyes, grope in the waking darkness of the world, I am put aside, and he is not fully known'. Setting out on a journey, the dreamer and his soul encounter a series of apparitions (or 'visions') of Love. These include a maternal Love of long ago, though still sweet; a personification of himself denying Love (this might be one meaning of *Bride, Bridegroom, and Sad Love*, plate 50); a Lust who defeats Love (as in the painting Buchanan attacked); and a Love battled by Death. Eventually the sleepwalkers encounter an ancient Love, sleeping, unrecognised, a figure like the painted allegory of *Love in Autumn* probably known to Symonds:[58]

> In the gloom of the unremembered temple he sat in all lowliness upon the fragment of a broken frieze, whereon the sculptured histories of his ancient glories crumbled and fell away, forgotten and uncared for, blighted by the breath of ages, stained with the rust of storms that knew no mercy; his red and golden raiment hung loose about his limbs, and the blossoms from his hair had fallen crisped and dead upon his shoulders; the tears of a divine agony yet lay upon his cheek.

But this melancholy recognition – though it elegiacally expresses the attitude of late Winckelmannian culture in its environment of Victorian Christianity – is not the end of the sleepwalkers' journey. This culminates instead in a complex montage of final visions.

First, Love arises from a nocturnal, somnolent but sexual state, like the Dudley Gallery *Bacchus* (see plate 52):

> He was half-seated, half-lying, upon a height which was stretched out to the faintly glimmering sea; there lay upon him the shadow of Night, but his face had upon it the radiance of an expected glory, the light of glad things to come; his eyes were yet soft with the balm of Sleep, but his lips were parted with desire; [...] his dusky limbs were drawn up as if in readiness to depart, and his great and goodly wings softly beat the air; with one hand he cast away his dim and dewy mantle from him, and with the other he put aside the poppies that had clustered thickly about him ...

Next, the dreamer sees a kind of quasi-homosexual or androgynous pollination taking place between two male 'Holy Ones'. Six-winged and ardent, they bend towards and lightly touch one another 'like two flower-laden branches' – and 'a living pulse seemed to beat in the flame that went forth from them, and a form was given to it, and a heart informed it, and all the firecoloured air about it breathed hymns at this marvellous birth'. And, finally, within this manifestation and completing his journey, the dreamer discovers 'Very Love', 'the Divine Type of Absolute Beauty, primaeval and eternal, compact of the white flame of youth, burning in ineffable perfection'.

In his prose poem, begun in 1869, Solomon might have been echoing what shortly would become the virtual motto of one aestheticist ethics – Pater's conclusion in *The Renaissance*: 'To burn always with this hard, gem-like flame, to maintain this ecstasy, is success in life.' (These words had originally appeared in 1868 in Pater's short essay on William Morris.[59]) But this was Pater's misreading, at least in relation to artists like Solomon or poets like Symonds; it was, in the end, more appropriate to the aesthetics of Moreau or Huysmans, for whom the gemstone – the calcification of desire made objective and indestructible – becomes the nugget, the talisman, of what must otherwise burn away. Its recommended ethics did not and cannot lead to the realisation of homoerotic fantasy-ideals, as the paradox in Pater's rhetoric implicitly knows: of all things a flame cannot be maintained 'hard' and 'gem-like', for it always flickers and flares. Such mutability and decay is not only or not just the obstacle to, but also, at least potentially, the very source of the entry of *l'amour de l'impossible* into art and, through aesthetic cultivation, into culture. A painting can only be the hearth and the burnt-out char, never the flame itself: this is the image within or between merely painted representations, emerging *in* a painting, its supposed cause and hoped-for effect – but, as I have suggested, not quite actually seeable there.

Solomon, it seemed, grasped and attempted artistically to project something like this very allegory. The 'Divine Type of Absolute Beauty', 'compact of the white flame of youth, burning in ineffable perfection', appears to be the subject of an unexhibited oil painting of 1868 – quite possibly the motivation for his prose poem – which he called *Amoris Sacramentum* (see plate 53). The work later entered the collection of Oscar Wilde and was lost at the auction and looting of his effects. Symonds probably knew it in Hollyer's photograph.[60] The picture depicts a deified youth in the general type of Antinous-Dionysus. Essentially, Antinous-Dionysus represents the mutual overcoming of the moral limits of both characters separately considered: in this synthesis, Antinous becomes not only the sexual favourite of Hadrian but also the general god of human pleasures; Dionysus becomes not only the personification of sensuality but also the apotheosis of ecstatic dedication in love.[61] Solomon's figure holds a small casket – or perhaps it is a painting – in which a white, flaming manifestation or vision of a winged youth appears. The casket itself appears to combine pseudo-Persian or Chinese figures of the conjoining 'Holy Ones' and the throbbing heart in 'firecoloured air' described in the *Vision of Love*.

For Symonds, this element of the picture – clearly related to the conventional Catholic image of the Sacred Heart of Jesus, burning and bound by thorns – must have had a peculiar and poignant familiarity. In the same weeks that he had been studying Hollyer's photographs of Solomon's drawings and paintings, he had consummated his first truly homosexual affair, a tumultuous romance with a Clifton College lad, Norman Moor.[62] Breathlessly recounting his exhilaration and paranoia to Dakyns, who was himself conducting an ardent romance with another Clifton boy, Cecil Boyle, Symonds twice signed himself with an unusual graphic icon, a bleeding, burning heart pierced with swords (plate 54). This was his emblem, he explained, for the erotic hopes of his soul, fretting about Norman's stand-offish and spiteful moods and hoping all was well with Dakyns and Cecil in their hotel room in Paris. 'If I were a draughtsman', he concluded one of these effusions, 'I would send you loveliest pictures whereof my Soul is full': the emblem apparently stands for the wider vision of homoerotic love that he has been unable to realise in his own writings.[63] Two years later, when he read Solomon's *Vision of Love*, he might have forgotten many of the details, but he could not have failed to notice the coincidence: Solomon's painting offered an icon of homoerotic fulfilment in terms which Symonds had already used to organise his own hopes and fears, symbolised by the pierced and burning heart which mysteriously reappeared in Solomon's *Vision of Love* as the gateway to the manifestation of Very Love, 'the Divine Type of Absolute Beauty'. Was this a proof of the objective possibility – the shared experience – of his desires, of their chance of social realisation? Solomon's picture at least partly suggests that realisation might be attained, for the process of its own coming into being – the circuitry of fantasy-ideal flaming in consciousness and its fully visible husk, realised in a figural representation – has been recognised and enacted *as* a painted allegory.

54 John Addington Symonds, graphic design to accompany letter to Henry Graham Dakyns, 2 January 1869, pen and ink

The principal figure of Sacred Love – he is a palimpsest of Antinous, Bacchus, Hermes and the Athlete – is not in himself a terribly convincing construction. Cross-fertilising many currents of early- and mid-nineteenth-century homoeroticist exotica, to produce it Solomon brought together various types of masculine homoerotic beauty, all of which had been the subject of many reimaginations in the preceding hundred years – not to speak of their ancient or early-modern sources. Because each one of these types had to be pictorially adjusted to or blended with the others, Solomon's picture required a constant decomposition of each and all into the others. In the end, the whole construction had to be fenced around with incompatible, partly unintelligible symbols,

such as the ill-defined floral symbolism of which the Pre-Raphaelite painters were overly fond. Finally, then, we cannot really tell who the Antinous-Dionysus of *Amoris Sacramentum* might be and exactly what his action and paraphernalia might mean.

In his prose poem, Solomon could deliberately put his visions into a continuous and ambiguous montage tied together with a 'vague yet intense yearning' and a 'certain Biblical solemnity', as Symonds characterised the writer's tone.[64] At each passage of this kind, it is not at all clear what is going on in the dream, or what or who the dreamer is seeing. No one dominating image rendered in one well-defined style emerges in the *Vision of Love*: Solomon's Love, wrote Symonds, 'is not classical, not medieval, not Oriental; but it has a touch of all of these qualities – the pure perfection of the classic form, the allegorical mysticism and pensive grace of the middle age, and the indescribable perfume of Orientalism'.[65] Nonetheless all this ambiguity has evocative narrative significance as a representation of the unfolding of the homoerotic fantasy or dream – a fantasy or dream that must, virtually by definition, precede and motivate its clarification and stabilisation in a poem or a picture. By contrast, Solomon's pictures – attempting just this clarification and stabilisation – had to cleave to one type within the whole palimpsest, as in the Dudley Gallery *Bacchus*, or, like *Amoris Sacramentum*, strive to present the whole all at once and stabilised in an artifical synthesis. In either case, they cannot depict the vision itself – for that is no more and no less than the continuous flickering montage of the palimpsest.

Despite their erotic and symbolic appeal, then, such pictures ultimately served – as a picture to put on the wall, to peer at, to feast one's eyes on – as a reminder *of*, or more exactly a picture made *with*, what Solomon called the 'dimmed eyes' of homoeroticism. The picture shows how homoeroticism actually sees what it can of what it looks for in the 'waking darkness of the world' – a homoeroticism enabling itself to become real by discovering and allowing its visions to decay. The great and terrible hallucination fades away; certainly a picture cannot capture but can only indicate it in thematising its own inevitable failure of clarity. But even this leaves behind an effective and provoking realisation, reduced and partial though it might be – requiring, in turn, that it be publicly counteracted with its moral purification, amounting to a de-recognition and de-realisation.

Symonds erected his casuistry and criticism in this oscillation between a Solomon and its Clifford, or a Clifford and its Solomon, enacting and perhaps to some extent fulfilling the description of a properly motivated aesthetics which had concluded Winckelmann's history of the development of ancient art:

> We cannot refrain from searching into the fate of works of art as far as [our eyes] can reach, just as a maiden, standing on the shore of the ocean, follows with tearful eyes her departing lover with no hope of ever seeing him again, and fancies that in the distant sail she sees the image of her beloved. Like that loving maiden we too have nothing but a shadowy outline left of the object of our wishes, but that very indistinctness awakens only a more earnest longing for what we have lost.[66]

In fact, Symonds recognised the foundational role that the desiring and the loss of male homoerotic beauty must play in, and as, the very origin of modern art itself in the Italian Renaissance. In works like Niccola Pisano's figure of Fortitude for the pulpit at Pisa (*c*. 1260), Raphael's *Jonah* for the Chigi Chapel (*c*. 1500) or Jacopo Sansovino's *Bacchus* (*c*. 1550), Symonds believed a kind of earlier homoerotic synthesis had been partly achieved, in part because some of these Renaissance works tangentially replicated the ancient homoerotic image of Antinous.[67] But it is precisely because modern art – and by extension modern culture as a whole – inherently involves a homoerotic oscillation, coming towards and falling away from a successfully completed representation of the image of homoerotically fulfilling beauty, that any history and criticism of it, any attempt to grasp its immanent meanings and values, will entrain just that movement. In the present time, both contemporary art and contemporary criticism, as I have tried to suggest, find themselves caught up in this history of unfinished business.

In the first edition of his book on Renaissance art, Symonds – perhaps on the basis of his experience with work like Clifford's and Solomon's – believed that nineteenth-century art had no realisations as successful as Pisano's pulpit or Sansovino's *Bacchus*. The decay of homoerotic vision into or as modern artistic culture had led not to a satisfying but to an unsatisfying contemporary art. Fortunately his notes for a new edition of the book, never published, are preserved; they probably date to the early or mid-1880s.[68] Here he reflected on the surprising contemporary development of a new, 'democratic' art – he means an art both homoerotic and realistic – in the work of 'Frederick Walker and [George Heming] Mason, of Walt Whitman, and of the French naturalistic school'. Oddly enough, Walker's most ambitious work, *The Bathers* of 1867, had been shown in the same exhibition at the Royal Academy as Solomon's head of *Bacchus*. But Symonds did not see fit to mention Walker at the time that he first wrote and published his study of the origins and development of modern art in the Renaissance.

Despite the fact that for the second edition of this work he was prepared, it seems, to see Walker and the others as somehow taking up and fulfilling the homoerotic teleologies of earlier and the earliest modern art, perhaps he already knew – at the time he outlined this history – that Walker, like Clifford and Solomon, cannot possibly be granted the originality of a Pisano. This is perhaps only to say that to make the homoerotic fantasy-image in the middle ground between homoerotic representations that actually have been made is simply to displace that middle ground elsewhere; if Walker could make what Clifford and Solomon failed to make, this would only be to clarify what Walker failed to make. And this is in turn to say that the ultimate question for homoerotic culture is to free itself from the structural impossibility of a homoerotic culture – to free itself from a pathology of replication or, perhaps, to embrace and fully inhabit a culture of creative replication as its psychological essence and final necessity. The latter Symonds was not willing or able to do. It would remain for followers in the next generation willingly to cultivate their position as the most decadent fulfilment –

that is to say, the most complete social realisation – of the earliest homoerotic originalities.

Notes

1 See Alex Potts, *Flesh and the Ideal: Winckelmann and the Origins of Art History* (New Haven and London, Yale University Press, 1994), and Whitney Davis, 'Winckelmann's "homosexual" teleologies,' in Natalie Boymel Kampen (ed.), *Sexuality in Ancient Art: Near East, Egypt, Greece, and Italy* (New York, Cambridge University Press, 1996), pp. 262–76.

2 Phyllis Grosskurth (ed.), *The Memoirs of John Addington Symonds* (New York, Random House, 1984) (hereafter abbreviated to *Memoirs*), publishes a very large part of the manuscript, now in the London Library. See further Phyllis Grosskurth, *The Woeful Victorian: A Biography of John Addington Symonds* (New York, Random House, 1964).

3 See Davis, 'Winckelmann's "homosexual" teleologies'.

4 Herbert M. Schueller and Robert L. Peters (eds), *The Letters of John Addington Symonds*, vol. II, *1869–1884* (Detroit, Wayne State University Press, 1968) (hereafter abbreviated to *Letters* II), 1 and 2 October 1870 (to Clifford). At that time attributed to Giorgione, the painting was thought to be a study for S. Liberalis in the painter's *Madonna and Child Enthroned* at Castelfranco.

5 *Letters* II, 1 October 1870 (to Clifford).

6 Ibid.

7 Herbert M. Schueller and Robert L. Peters (eds), *The Letters of John Addington Symonds*, vol. I, *1844–1868* (Detroit, Wayne State University Press, 1967) (hereafter abbreviated *Letters* I), 21 July 1868 (to Henry Graham Dakyns). The contents of the 'Book of Songs' were described in an important letter a week later (*Letters* I, 29 July 1868, to Dakyns). 'The Essay' appeared in part as *A Problem in Greek Ethics*, drafted in 1873 – based on an earlier and apparently longer text – and privately printed in 1883.

8 *Letters* I, 18 November 1866 (to Dakyns).

9 *Letters* II, 1 April 1869 (to Dakyns). For Symonds's disingenuous assertion that he did not want to 'preach [the] ethics' of this poem 'to the present or to a future generation', see his important letters on the philosophy of a reconstructed modern pederasty (if any) addressed to Edmund Gosse (*Letters* II, 16 and 20 January 1876). The poem was privately printed in a pamphlet entitled *Tales of Ancient Greece, No. 1: Eudiades, and A Cretan Idyll* (n.d.). I have consulted the copy in the Houghton Library, Harvard University.

10 *Letters* I, 20 January 1866 (to Dakyns).

11 See W. J. Courthope, review of Symonds's *Renaissance in Italy*, vols I–III, *London Quarterly Review*, 289 (January 1878) 1–19, and especially R. St John Tyrwhitt, 'The Greek spirit in contemporary literature', *Contemporary Review*, 29 (March 1877) 552–66. The famous unsigned article, 'Latter-day pagans', *Quarterly Review*, 182 (July 1895) 31–58, was published considerably later; it represents a different moment of response to Aestheticism. At that point, Symonds's recent death provoked defences of his approach and achievement by fellow-travellers such as A. R. Cluer, 'In memory of John Addington Symonds', *Fortnightly Review*, 59 (1893) 874–80, and Charles

Kains-Jackson, 'John Addington Symonds: a portrait', *Quarto*, 3 (1897) 67–80. Van Wyck Brooks's *John Addington Symonds* (New York, B. W. Huebsch, 1914) is the last and fullest expression of this posthumous homoerotic validation, after which Symonds's reputation declined precipitously. A full guide can be found in Carl Markgraf, 'John Addington Symonds: an annotated bibliography of writings about him', *English Literature in Transition*, 18:2 (1975) 79–138.

12 *Letters* II, 5 December 1870 (to Clifford).

13 *Letters* II, 1 January 1871 (to Clifford).

14 The study of Achilles was published in the *North British Review* in 1866 and two essays on the poets in the same journal two years later. All were republished in *Studies of the Greek Poets*, First Series (London, Smith, Elder, 1873).

15 The essay on Aristophanes was published in the *Westminster Review* in 1871 and republished in *Studies of the Greek Poets* (quoted here, pp. 268–9). The essay itself had been written in the summer of 1868 or 1869 (see *Memoirs*, p. 177).

16 *Memoirs*, pp. 122–9. This text was apparently written only a few years after the encounters with Alfred. It was then incorporated in the *Memoirs* many years later.

17 'The genius of Greek art', *Studies of the Greek Poets*, pp. 407–8; published as the 'Conclusion' to the *Studies*, this chapter had almost certainly been drafted in 1867 or 1868 as part of 'The Essay' on Greek love.

18 See [Dr] John Addington Symonds, *The Principles of Beauty* (1844), reprinted in John Addington Symonds (ed.), *Miscellanies by John Addington Symonds, M.D.* (London, Macmillan, 1871).

19 Symonds's photo-sketch of the Flandrin is reproduced in *Letters* II, following p. 64. For the homoerotic replication of the painting in the nineteenth and twentieth centuries, see Michael Camille, 'The abject gaze and the homosexual body: Flandrin's *Figure d'étude*', in Whitney Davis (ed.), *Gay and Lesbian Studies in Art History* (Binghamton, New York, Haworth Press, 1994), pp. 161–88, although Camille does not cite this example.

20 'The genius of Greek art', pp. 407–8.

21 At about the same time as he prepared for and painted *Swimming* (1883–85), Eakins also planned another ambitious painting, possibly complementary to the swimmers, depicting fifth-century Greek youths at a Periclean riding school. For themes of democratic fraternity and homoeroticism in these two works, as well as the homoerotic teleology of their construction, see further Whitney Davis, 'Erotic revision in Thomas Eakins' narratives of male nudity', *Art History*, 17 (1993) 301–41.

22 In Horatio Brown's copy of Symonds's undated *Genius Amoris Amari Visio* (now at Houghton Library, Harvard University), markings (probably Brown's) indicate that the theme is male love in Greece, Rome, the Renaissance, the present and the future. This is probably the poem sent to Clifford.

23 *Letters* II, 1 January 1871 (to Clifford).

24 *Letters* II, 4 October 1871 (to Clifford).

25 Symonds's poems, 'The Lotos-Garland of Antinous' and 'Diego', were privately printed in the same pamphlet. The former was republished, with considerable revisions, in *Many Moods* (London, Smith Elder, 1878), pp. 119–34. The episode of Diego was briefly noted in Symonds's *Renaissance in Italy*, vol. III, *The Fine Arts* (London, Smith, Elder, 1877), p. 331.

26 *Letters* II, 18 October 1871 (to Clifford).

27 *Letters* II, October 18, 1871 (to Clifford).

28 See *Letters* II, 18 October 1871 (to Clifford), 11 December 1871 (to Mrs Arthur Hugh Clough). The poems were eventually printed in *New and Old* (London, Smith, Elder, 1880). They had originally been included in the privately printed pamphlet titled *Love and Death: A Symphony* (n.d.), also containing 'The Song of Love and Death' noted above.

29 *Letters* II, 20 October 1871 (to Clifford).

30 *Letters* II, 23 October 1871 (to Clifford; to Dakyns).

31 For example, a few months later Symonds was inspired by Clifford's painting of David and Jonathan to compose his 'Meeting of David and Jonathan', ultimately published in *Many Moods* (see *Letters* II, 9 January and 8 February 1872, to Clifford).

32 *Letters* II, 8 December 1871 (to Clifford). He shortly included the poem, under the title 'On a Picture of a Young Knight Called "Moriturus"', in a privately printed pamphlet, which also contained a poetic meditation on Sodoma's S. Sebastian.

33 See *Memoirs*, pp. 73–4.

34 For 'Phallus Impudicus', see *Memoirs*, pp. 177–80; this vision may have prompted him to request photographs of Ingres's drawing of a nude youth (see *Letters* II, 13 December 1868, and 13 January 1869, to Dakyns). For the homoerotic determinations of Girodet's painting, to which Symonds alludes several times in publications and correspondence, see Whitney Davis, 'The renunciation of reaction in Girodet's Endymion', in Norman Bryson, Michael Ann Holly and Keith Moxey (eds), *Visual Culture: Images and Interpretations* (Middletown, Conn. Wesleyan University Press, 1994), pp. 168–201.

35 See Simon Reynolds, *The Vision of Simeon Solomon* (Stroud, Catalpa Press, 1984); *Solomon: A Family of Painters*, exh. cat. (London and Birmingham, Geffrye Museum and Birmingham Museum and Art Gallery, 1985–86), especially the section by Lionel Lambourne (pp. 65–82) cataloguing the 'Works of [Simeon] Solomon'; and Gayle Marie Seymour, *The Life and Work of Simeon Solomon (1840–1905)*, PhD dissertation (University of California at Santa Barbara, 1986). I am grateful to Fiona Elizabeth Tomlinson for the opportunity to read her important unpublished study, 'Simeon Solomon: Alternative Masculinities and Religious Identity', MA thesis (Courtauld Institute of Art, 1996); thanks also to Liz Prettejohn, Colin Cruise and Simon Reynolds for helpful information. My remarks are not intended as a full-scale interpretation of Solomon; rather, they consider certain works known to Symonds.

36 For this drawing, see Reynolds, *Vision of Solomon*, pl. 116; Lambourne, 'Works of Solomon', fig. 23. It is not known whether Burne-Jones saw it, but he did praise eight drawings Solomon made that year to illustrate the *Song of Solomon*. Fiona Tomlinson has also located some early drawings of David and Jonathan.

37 For *Italian Youth* and *Love Dreaming*, see Reynolds, *Vision of Solomon*, pls 14 and 59.

38 Sidney Colvin, 'English painters of the present day, IV – Simeon Solomon', *Portfolio*, 1 (1870) 34.

39 For *Love Among the Schoolboys*, see Lambourne, 'Works of Solomon', no. 50. For *Bride, Bridegroom, and Sad Love* (now Victoria and Albert Museum), see Lambourne, 'Works of Solomon', no. 51; a toned-down version was given by Solomon to Pater in 1868 (Hugh Lane Municipal Gallery of Modern Art, Dublin). For the *Socrates*, see

Reynolds, *Vision of Solomon*, pl. 37. For the *Spartan Boys*, see Reynolds, *Vision of Solomon*, pl. 40. Swinburne's *Flogging Block*, with illustrations by Solomon, is now in the Department of Manuscripts, British Museum. A letter from Solomon to Swinburne (BM MSS Ash 1755), possibly dated 1869, implies that Solomon made a considerable number of flagellation drawings for the poet.

40 The *Antinous* is lost; see Solomon to Swinburne, letter of May/June 1871 (BM MSS Ash A4273), where Swinburne's poem 'Erotion' is said to refer to it. Most likely Solomon's watercolour *Amoris Sacramentum*, to be considered below (see plate 53), replicates it. For the *Sappho* (Tate Gallery, London), see Lambourne, 'Works of Solomon', no. 48.

41 'Simeon Solomon: notes on his "Vision of Love" and other studies', *Dark Blue*, 1 (July, 1871) 568–77, reprinted in *The Bibelot*, 14 (1909) 291–316 (quotation from p. 305). The version given in *Solomon: A Family of Painters*, p. 25, is slightly inaccurate.

42 Colvin, 'Simeon Solomon', p. 35.

43 Letter of October 1871 (BM MSS Ash 1755).

44 Now Birmingham Museum and Art Gallery. See Lambourne, 'Works of Solomon', no. 55, and Reynolds, *Vision of Solomon*, pl. 2.

45 The Dudley Gallery Bacchus is now in a private collection; see Lambourne, 'Works of Solomon', no. 56, and Reynolds, *Vision of Solomon*, pl. 43. For the *Heliogabalus* (Forbes Magazine Collection, New York), see Lambourne, 'Works of Solomon', no. 55; Reynolds, *Vision of Solomon*, pl. 42; and Andrew Wilton and Robert Upstone (eds), *The Age of Rossetti, Burne-Jones and Watts: Symbolism in Britain 1860–1910*, exh. cat. (London, Tate Gallery, 1997), no. 35.

46 See *Letters* II, 2 November and 15 November 1875 (to Dakyns).

47 For Solomon's career and reception, in addition to the references cited in note 35 above, see Rupert Croft-Cooke, *Feasting with Panthers: A New Consideration of Some Late Victorian Writers* (New York, Holt, Rinehart & Winston, 1967), pp. 29–62, and Denis Donoghue, *Walter Pater: Lover of Strange Souls* (New York, Alfred A. Knopf, 1995), pp. 32–45.

48 See *Letters* I, 25 December and 28 December 1868 (to Dakyns).

49 *Letters* I, 31 December 1868 (to Dakyns). Symonds had a particular drawing by Ingres in mind: 'a young man lying full length as if dead' (*Letters* II, 13 January 1869, to Dakyns) was probably related both to Symonds's interest in homoerotic imagery by Girodet, Flandrin and others, and to some of the dreamlike visions of young men sleeping narrated in his autobiography.

50 *Letters* I, 25 December 1868 (to Dakyns); see also *Letters* I, 29 December 1868, and *Letters* II, 2 January 1869 (to Dakyns).

51 See *Letters* I, 28 December 1868 (to Dakyns).

52 This poem originally belonged to a set of 'Three Visions of Imperial Rome' and was privately printed in a pamphlet entitled *Lyra Viginti Chordarum*; it later appeared in *The Artist* in 1893 and, in the same year, in a pamphlet which noted that 'Midnight at Baiae' was a transcript of an actual dream. In the text, the room in which the sacrifice occurs is said to contain murals of Hylas, Ganymede and others, a jasper statuette of Uranian Love, a sardonyx cup decorated with Bacchanalian scenes, and the like – an array such as we find in Solomon's *Heliogabalus* and in many of Moreau's allegories.

53 'The fleshly school of poetry', *Contemporary Review*, 18 (October 1871) 338–9. Buchanan refers to the legend of the aged St Antonio Abbate the Eremite, tempted by the devils in the wilderness. Coincidentally, three years earlier Symonds – deliberately reversing elements of the legend – had composed a long homoerotic poem on a beautiful anchorite-angel who casts out a sexual devil in a young monk (see Robert L. Peters and Timothy d'Arch Smith [eds], *Gabriel: A Poem* [London, privately printed, 1974]; the initial and merely descriptive section of this fantasy would appear as 'On the Riviera' in *Many Moods*). See further C. Cruise, '"Lovely devils": Simeon Solomon and Pre-Raphaelite masculinity', in E. Harding (ed.), *Re-Framing the Pre-Raphaelites: Historical and Theoretical Essays* (Aldershot, Scolar Press, 1995), pp. 195–210.

54 *Letters* II, 10 February 1869 (to Dakyns).

55 The initial edition of 1871 appeared under the title *A Mystery of Love Revealed in Sleep*. Later in the year, a new edition (quoted here) used the poem's actual title.

56 J. A. Symonds, review of Solomon, *Academy*, 2 (April 1871) 189–90.

57 See Symonds, *Miscellanies by John Addington Symonds, M.D.*, and Daniel Hack Tuke, *Prichard and Symonds in Especial Relation to Mental Science, with Chapters on Moral Insanity* (London, J. & A. Churchill, 1891). See further Whitney Davis, 'The visions of John Addington Symonds', in J. Pemble (ed.), *John Addington Symonds: The Private and the Public Face of Victorian Culture* (London, Macmillan, forthcoming).

58 For the painting, see Reynolds, *Vision of Solomon*, pl. 1, and Wilton and Upstone, *Age of Rossetti*, no. 12. Apparently it was exhibited under the title *Autumn Love* at the Dudley Gallery in 1872. It or closely similar works might well have been included in Hollyer's photographs. Symonds's important poem 'To Leander in Sunset by the Southern Sea', written in 1892, appears in part to describe the painting's 'live image of Uranian Love' (published by Charles Kains-Jackson in 'John Addington Symonds: a portrait'). Close analogues might have been found in a *Love in Winter*, painted in Florence in 1866, and a *Love Bound and Wounded* of 1870, shown at the Academy that year.

59 As Denis Donoghue points out, an even earlier intimation appeared in Pater's lecture 'Diaphaneitè' at Oxford in July 1864, but it was not published until 1895 (see Donoghue, *Walter Pater: Lover of Strange Souls*, p. 110). For Pater's wide range of allusion, see Billie Andrew Inman, 'The intellectual context of Walter Pater's "Conclusion"', in Harold Bloom (ed.), *Modern Critical Views: Walter Pater* (New York, Chelsea House, 1985), pp. 131–49.

60 See Reynolds, *Vision of Solomon*, pl. 50, for the photograph. A study for the picture is now in the British Museum (Lambourne, 'Works of Solomon', no. 60; J. A. Gere, *Pre-Raphaelite Drawings in the British Museum* [London, British Museum Press, 1994], no. 116).

61 For the iconography of Antinous, see especially Konrad Levezow, *Ueber den Antinous dargestellt in den Kunstdenkmaelern des Alterthums: Eine archaeologische Abhandlung* (Berlin, J. F. Weiss, 1808). L. Dietrichson, *Antinoos: Eine kunstarchaeologische Untersuchung* (Christiana, Aschehoug, 1884), deals comprehensively with the reception of the ancient representation of Antinous in scholarship since Winckelmann, though neglects aspects of the homoerotic reception in nineteenth-century belles-lettres, which included not only Symonds's poem on Antinous but also his essay of 1879 ('Antinous', *Cornhill Magazine*, 39 [1879] 200–12, 343–58), based in

some measure on Viktor Rydberg's remarkable essay 'Antinous' (see *Roman Days*, trans. Alfred Corning Clark [New York, G. P. Putnam's Sons, 1879; originally published 1877], pp. 186–208). Unfortunately Levezow and Dietrichson do not deal with the narrative, moral or allegorical messages of representations of Antinous, although this is a central topic for the understanding of homoeroticism in eighteenth- and nineteenth-century visual art.

62 Retrospectively, their affair – which greatly disturbed Symonds's marriage (his daughter Margaret had been born in the same weeks) and later became a lifelong if more distant friendship – was the subject of an important section of the autobiography (see *Memoirs*, pp. 193–214). Moor apparently became one of Symonds's correspondents in compiling homosexual autobiographies for *Sexual Inversion*, co-authored with Havelock Ellis and first published in German (in a translation by Hans Kurella) in 1896.

63 *Letters* II, 2 January and 10 February 1869 (to Dakyns). In the same sequence of letters he was expressing his opinion of Solomon to Dakyns and pressing him to acquire the photographs of Ingres' drawings of a sleeping youth. An ekphrasis on the sleeping Norman, drafted on 29 January 1870 and included in the autobiography (*Memoirs*, pp. 209–11), is perhaps the most remarkable instance of Symonds's synthesis of his erotic visions, personal homoerotic iconography, actual sexual encounters and art-critical and art-historical learning.

64 Symonds, review of Solomon, p. 190.

65 Ibid.

66 J. J. Winckelmann, *History of Ancient Art*, trans. G. H. Lodge (Boston, 1880), IV, pp. 364–5.

67 See Symonds, *The Fine Arts*, pp. 73–130. Elsewhere I will present a fuller study of this aspect of Symonds's art-critical and art-historical investigations.

68 These notes can be found in Symonds's copy of *The Fine Arts* preserved in Bristol University Library.

The 'British Matron' and the body beautiful: the nude debate of 1885

Alison Smith

The body beautiful

LINLEY SAMBOURNE'S CARTOON 'The Model "British Matron"' (1885) is a lighthearted jibe at the moral crusade against the nude which reached its peak in the mid-1880s, and as its figurehead, the Academician John Callcott Horsley is shown dressed as 'A British Matron' (plate 55). That was the *nom de guerre* of the author of a controversial letter to the editor of *The Times* of May 1885, arguing against the display of the nude at public exhibitions and the employment of female models in art schools. The cartoon was published in *Punch*, which headed the counter-offensive against the moral position represented by Horsley by printing a series of satires against the painter, both verbal and visual.[1] However, Sambourne's image was not necessarily intended to be vindictive. Writing to Horsley in November 1885, Sambourne explained: 'All my subjects are made up by general vote at the "Punch" Table ... so I'm only responsible for the execution. I am glad all the more from the tone of your letter that you are not annoyed at it'.[2] The mutual deference of both artists should warn us against drawing too straightforward a division between the 'purist' position represented by Horsley and the 'pragmatic' approach adopted by *Punch*. The 'nude' debate of 1885 witnessed the values of art prised apart from the claims of morality, and yet, as I shall argue, the tactics of role-play and subterfuge used by participants on both sides of the dispute functioned to disguise the complexity of the network of ideas ostensibly polarised by this ideological divide.[3]

Sambourne's cartoon sets up an ironic opposition between the supposedly universal values of art and the instability of contemporary ethics by juxtaposing a timeless classical image against a matron dressed in outrageous modern costume. The *Venus de Medici*, the focus of the Matron's derision, was one of the most venerated statues of antiquity, having been admired by British connoisseurs since the eighteenth century.[4] In 1885 appreciation of the nude was still seen to require a specialist perception, even though the audience for art had become more democratic. The *Venus de Medici* was now known via the numerous copies

mass-produced throughout the century, as well as through the writings of critics
and physicians. For theoreticians such as Dr Andrew Combe and Alexander
Walker, the *Venus* epitomised the ideal of the body beautiful, and in 1840 Ruskin
declared it to be 'one of the purest and most elevated incarnations of woman
conceivable'.[5] For such authorities the *Venus* upheld a standard of health and
beauty within a culture which disguised and distorted the 'natural' female body.
In Sambourne's image, 'A British Matron's' reading of the statue as a naked model
devoid of metaphorical significance is ridiculed for representing a moral and
popular philistinism. The figure of a heavily draped prude draws on the powerful
nineteenth-century stereotype of the ever-disapproving 'Mrs Grundy' of Thomas
Morton's play *Speed the Plough* of 1798, who, though frequently mentioned, never
actually appears – a parallel to the 'British Matron' whose true identity was also
to remain a mystery. From 1885 the British Matron (a pseudonym thereafter
regularly appropriated) took on Mrs Grundy's role as a symbol of both a
conventional propriety and a fear of that propriety. Both were cast as female,
presumably playing on the ideological role ascribed to women as the moral and
spiritual guardians upon whom the health and stability of the family and nation
depended. However, the matronly paradigm is inverted in both Morton's play and

55 Linley
Sambourne, 'The
Model "British
Matron"', *Punch*,
24 October 1885

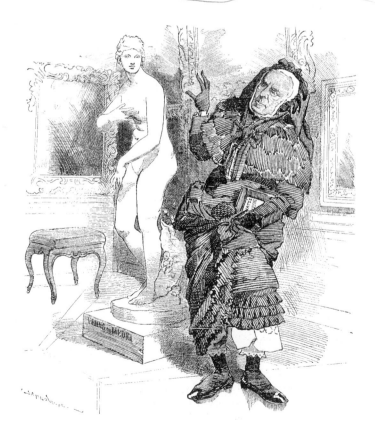

Sambourne's image. In the cartoon a man masquerades as Matron, a grotesque and ridiculous counterpart to the beauty and impassivity of the sculpture. The tactic of inversion was, in fact, a familiar one, used by aesthetes to dispel the arguments of moralists. 'To the pure all things are pure' and 'Honi soit qui mal y pense' were well-worn mottoes in the nude debate, brandished to expose the hypocrisy and impure motivations of 'prurient purists'.

What Sambourne's cartoon overlooks, however, is the religious basis of Horsley's opposition to the nude (even though the Matron clutches a copy of *Watts' Hymns*). In a predominantly Protestant country the nude had long been associated with sensual gratification and pagan practices.[6] For many evangelicals the temptation of sexual indulgence was presented as a conflict between the highest part of human nature (the soul or reason), and the lowest, the body with its animal appetites. The body was thus seen to be in constant need of surveillance to guard against physical temptation. Beyond the emphasis on individual self-control, purists also made it their concern to invigilate those sections of society they deemed most vulnerable and susceptible to sexual exploitation: working-class women, particularly prostitutes, and young people of all classes. Female models also came within the orbit of evangelical scrutiny, since many moralists equated modelling with involuntary prostitution.[7] The uncertain status of both prostitutes and models gave rise to anxieties that they were a contaminating yet uncontrollable threat, and, being female, were themselves in danger of being victimised by depraved men.

The decline of the nude in the mid Victorian period relates to a strand of reasoning within middle-class culture which claimed morality as its own preserve and attributed immorality to other classes and nations. Life study did not feature significantly in English art education and the subject was rarely seen at public exhibition. The renaissance of the nude which took place in the late 1860s was thus partly an attempt to conciliate moralists. In order to divorce the subject from any sexual connotation, nudes were based on models derived from antiquity, in particular Greek sculpture of the fifth and fourth centuries BC, which was regarded as the most pure and ideal prototype for the female nude by virtue of its 'abstract' qualities of form (see Chapter 2, pp. 43–5). The artists of the 1860s also placed a renewed emphasis on life study as an academic discipline, redefining the model as a dedicated handmaid of art in order to allay anxieties about her employment in art schools. Of course, the artists, critics and patrons involved in the renaissance of the nude did not see their role to be merely one of mollifying the prejudices of purists. Underpinning the revival of the nude lay the doctrine of aestheticism, which argued that a work of art should appeal to the senses through its formal properties, and that to condemn the nude was to confuse an ethical with an aesthetic problem.[8]

The insistence of aesthetes that the nude should be appreciated for its visual qualities helps explain why it continued to be confined to specialist circles. Although the nude invited controversy in the 1860s, debates about propriety

were generally restricted to professional artists and critics. The polarisation of
the debate into 'aesthete versus philistine' developed in the following two
decades as the classical ideal of the body began to be promoted among a wider
audience as an agent of health, beauty and social reform, and as the nude
assumed a more central role in art education. The revival of the nude formed
part of a broader campaign for a reformed system of life study in Britain, based
on French ateliers where students could study from the living model in
conjunction with the antique rather than working from plaster casts before being
admitted into the life class. By the early 1860s women and artisans were also
demanding a fine art training and access to a subject from which they had long
been excluded on moral and vocational grounds; they themselves were only too
aware that the real reason for their exclusion was a concern to keep high art a
masculine prerogative and a preserve of the upper middle classes. By 1870 it was
clear that British painters would only be able to compete in an international
context if they had as ready an access to models and as thorough a training as
their French neighbours. The appointment of E. J. Poynter as first Professor of
the Slade School of Art in 1871 was an important step in the reform of the
British life class along French lines (see Chapter 6, pp. 138–41). Not only were
women allowed to study from the half-draped figure in a separate class, but
students were offered an approach based on a searching study of the model
within the academic tradition.[9] The benefits of the French system were extolled
by Poynter in his *Ten Lectures* of 1879, and in the Reports of the National Art
Training School at South Kensington, of which he was director (1875–81). By
the late 1870s many students were opting to study abroad or at the Slade instead
of the Academy, which continued to operate on a neoclassical system based on a
steady progression from the antique to the life.

The expansion in art education and the demand for female models called for
some justification, and defenders of the practice insisted on the professionalism of
models and students who abided by regulations aimed at preserving a neutral
atmosphere. The 'neutral' character of life classes also related to the study of the
antique, insisted on by all schools, which was valued for instilling a calm and
detached state of mind.[10] Archaeological reconstruction now became an important
pretext for the nude, and, with the help of living models, painters set about
restoring the original poses of antique statues. The classical concept of the nude
also had proponents in the realms of medicine and dress reform. In contrast to
modern figures, the classical body set a universal standard of health and beauty,
equipping women for the main duties of their existence – 'love, impregnation,
gestation, parturition', to quote Walker – as well as offering a more liberating
lifestyle than that offered by 'unnatural' stays and corsets.[11] The dissemination of
this ideal among a broader audience helped sanction the nude at public
exhibitions and in art education. Painters began to view models in terms of Greek
art, prizing those who in stature and proportion resembled the statues of the past
(cf. Chapter 11, pp. 244–5).

A sculptor's model

Around 1878 the 'artist's model' subject began to achieve an unprecedented popularity with painters basing their compositions on legends involving the male artist and his female creation. The appeal of subjects such as Pygmalion and Galatea lay in both the opportunity they gave for artists to demonstrate their knowledge of the living model and the challenge of creating ideal beauty. The year 1878 saw the exhibition of Edward Armitage's *Pygmalion's Galatea* at the Royal Academy and John Tenniel's *Pygmalion and the Statue* at the Institute of Painters in Water-Colours (plate 56). Both works represented Galatea in the process of transformation – the

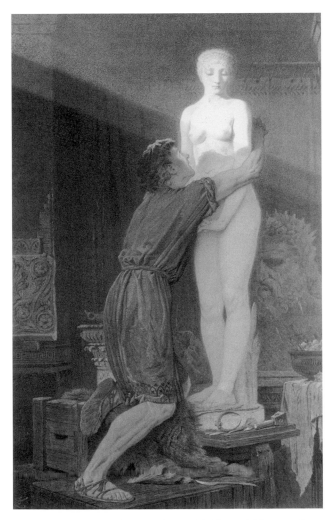

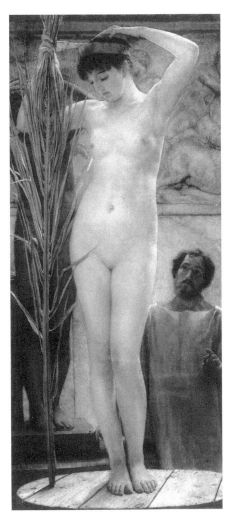

56 John Tenniel, *Pygmalion and the Statue*, 1878, watercolour, 58.4 x 36.5 cm

57 Lawrence Alma-Tadema, *A Sculptor's Model*, 1877, oil on canvas, 195 x 86 cm

upper portions of her body flushed with life, the lower cold and marmoreal.[12] The most sensational of all the 'artist's model' subjects, however, was Alma-Tadema's *A Sculptor's Model*, exhibited at the Academy that same year (plate 57). This painting signalled a radical departure from previous conventions of representing the nude by making the naked model the focus of the sculptor's gaze, rather than the ideal fashioned from her form. Alma-Tadema's declared intentions were respectable enough. The work was originally commissioned by the Judge Sir Robert Collier on behalf of his son, the painter John Collier, as an academic life study. The painting can further be seen as an exercise in archaeological restoration, an attempt to reconstruct the original pose of the *Venus Esquilina*, excavated in Rome in 1874 and the subject of considerable critical debate over whether it was a Greek original or an inferior Roman copy. Writing in 1877, for example, William Davies had suggested that the work was a copy of a fine Greek original; in 1882 W. C. Perry argued that the statue was too realistic and individual to deserve the name of Venus: 'It is much more probably the very faithful portrait-statue of some real person'.[13]

A Sculptor's Model could perhaps be seen as a bold attempt to formulate a new conception of the nude, based on Roman sculpture and a more faithful rendition of the living model, in opposition to the 'abstract' ideal of Venus put forward by the classicists. If this was the case, the work could be seen as a significant intervention in the way artists and theorists viewed the past. According to standard histories of the period, Greek art reached its zenith in the fifth century BC, declining into sensuality and realism in the later Hellenistic and Roman periods.[14] In making the model the focus of his painting rather than the classical Venus, Alma-Tadema may have been attempting to redefine the later phase of classical art as an appropriate model for the present. If so, this was a risqué decision, for many critics were wary of later prototypes being used as examples for the contemporary nude. For conservative critics such as Harry Quilter, the adoption of late classical types signalled a parallel process of degeneration in national and cultural life. For him *A Sculptor's Model* conjured up all the decadence of Roman and contemporary French art.[15] In fact the majority of critics were perturbed by the realism of Alma-Tadema's technique which they related to an undue emphasis on the model. The wooden platform on which the woman stands and the palm branch she holds to sustain the position would also have reminded critics of the props used in contemporary life classes. However, many writers admired the colour and modelling, and several felt Alma-Tadema was justified in painting a model, contending that there was less falsity in the subject than works which merely presented models in the guise of mythological figures.[16]

The debate over *A Sculptor's Model* was an academic one, confined as it was to specialist circles. It was only when the work reached a wider audience, generally unfamiliar with the nude, that it became the focus of public controversy. In September 1878 the painting was exhibited at the Liverpool Autumn Exhibition, a daring decision which owed much to the enterprising spirit of P. H. Rathbone,

one of the founders of the Autumn Exhibition and chairman of the Walker Art Gallery, who believed that greater public accessibility to ideal art would leave audiences less bewildered and hostile towards the unfamiliar.[17] In pursuing his ambitions, Rathbone made enemies, in particular the conservative Alderman Edward Samuelson whom Rathbone had replaced as chairman of the arts and exhibitions sub-committee in 1878. At the Liverpool Art Club dinner for the hanging committee, Samuelson brought to attention a letter printed in the *Liverpool Daily Post* signed 'Paterfamilias'. The letter expressed disgust at Alma-Tadema's painting, arguing that such works were best confined to the studio or dissecting room where they were 'necessary and harmless', but elsewhere in society they were evil.[18] Samuelson agreed with this assertion and expressed his hope that the time would never come when the modesty of English women would be shocked by the sights regularly seen in exhibitions on the other side of the channel.[19] Whether Samuelson was responsible for the 'Paterfamilias' letter is uncertain, but both letter and speech were instrumental in provoking a public debate about propriety which took place in the correspondence columns of both the *Liverpool Daily Post* and *Liverpool Mercury*. Each letter bore a generic signature so as not to disclose the identity of the writer, although most appeared to be male. Signed 'A Moralist', 'Another Father' and 'An Offended Father', the letters expressed anxiety over the moral welfare of the nation's youth and blamed Alma-Tadema and Rathbone for their 'corrupting' influence.[20]

It is possible the debate would not have ignited had the appearance of *A Sculptor's Model* not coincided with the launch of Josephine Butler's campaign to repeal the Contagious Diseases Acts, passed in the 1860s to control the spread of venereal disease in the armed forces. For repealers this legislation reinforced a double standard in society, namely the blaming of working-class women for the moral shortcomings of men.[21] By the late 1870s the campaign had developed into a popular interdenominational purity movement, with men joining women in a crusade to cleanse society of all manifestations of immorality. The furore over *A Sculptor's Model* demonstrated that the purity movement had politicised the nude by making it a matter of public debate. However, just as purists adopted the language of art critics to condemn the nude, so defenders of the subject began to appropriate the rhetoric of social purity in order to project the nude as an agent of moral and social reform. Rathbone defended his decision to display the painting in an address titled 'The mission of the undraped figure in art', which he delivered at the Cheltenham Social Science Congress – a secular equivalent to the annual Church Congress which Horsley was later to use as a forum to condemn the nude. In his paper Rathbone drew an equation between purist attitudes and what he termed Asiatic barbarity, relating the Ottoman degradation of women to the spread of a 'chattel mentality' that persisted among 'certain classes of the less educated portions of the English nation'. A society that hides the body is hypocritical in its morals and culture, he announced; it was thus essential that works like *A Sculptor's Model* be exhibited in public in order to promote respect for womanhood, as well

as encouraging women to emulate the classical ideal, particularly those who distorted their figures through tight-lacing and scandalous society dresses.[22]

Rathbone's arguments were as extreme as those of his critics, as the *Magazine of Art* noted: 'We cannot help thinking that the argument ... is a little far fetched'.[23] However, dress reformers were by now preaching a similar case, distinguishing between 'civilised' Greek views of the body and 'atavistic' Asiatic attitudes. John Leighton, alias Luke Limner, for example, had included, as a tailpiece to his *Madre*

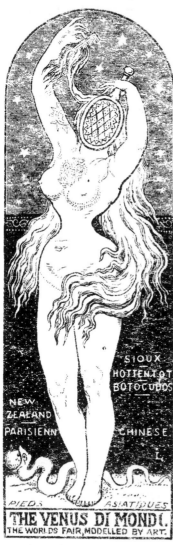

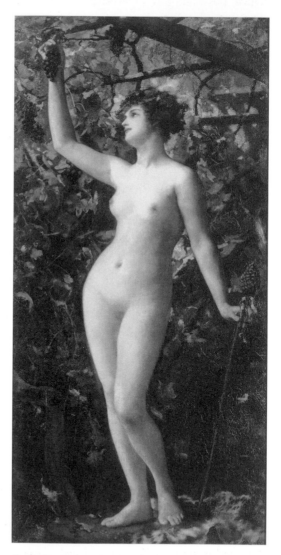

58 *The Venus di Mondo* from Luke Limner [John Leighton], *Madre Natura versus the Moloch of Fashion*, 1870, p. 100

59 Henrietta Rae, *A Bacchante*, 1885, oil on canvas, 127 x 63.5 cm

Natura of 1870, an illustration entitled *The Venus di Mondo*, showing a female nude posed in the conventional classical format, but tattooed and disfigured by a tiny waist and the protuberant posterior associated by anthropologists with the Hottentot Venus and prostitutes of all nations (plate 58). References to 'primitive' women at the bottom of the illustration ('Sioux', 'Hottentot', 'Asiatiques') are placed alongside the fashionable 'Parisienn[e]'.[24]

Such instances show how the nude was being deployed across a range of ideological positions, demonstrating that the debate had evolved into something far more complex than a clear-cut opposition between factions, moral and aesthetic. For both sides, female purity was set up as a national paradigm, and it was considered men's duty to safeguard this ideal from 'degenerate' foreign influences. However, by the 1880s a number of women graduating from the Slade and other schools began to exhibit nudes in public for the first time.[25] Figure studies by artists such as Dorothy Tennant, Henrietta Rae (plate 59) and Anna Lea Merritt now became a familiar sight at both the Academy and the Grosvenor Gallery.[26] For conservative critics the incursion of women painters into the male realm of high art was regarded as both a symptom of female emancipation and a decline in traditional values. Opponents to the nude were also joined by female purists who argued that, in studying the nude, women were colluding in the exploitation and degradation of working-class women forced into modelling via poverty or seduction. It was further suspected that, in painting the nude, women were abandoning their role as matrons. The repeal campaign which led to the suspension of the Contagious Diseases Acts in 1883, and which played a key role in pressurising the government into passing the Criminal Law Amendment Act in 1885, was largely comprised of women who advocated the introduction of a single code of morality for men and women based on the principle of female chastity. Even after the repeal of the Acts in 1886, the issue of 'women's mission to women' remained central to the campaign for female suffrage. Paradoxically, feminist anxiety over the nude and the welfare of models was reactionary in that it brought women into an alliance with conservative critics and moralists, but radical in that it formed part of a broader crusade for political and legal representation and reform. However, women who promoted the nude were also 'progressive' in that they were requesting a role for women in high culture and a more liberated code of dress to encourage a greater involvement in public life.[27] Of course there were alliances and disagreements across these different ideological positions; and it should be pointed out that women who painted the nude did nothing to challenge male conventions of representation, opting rather to uphold existing stereotypes of the passive and subjected female body.

The British Matron

The exhibition of *A Sculptor's Model* guaranteed record attendance figures at the Liverpool Autumn Exhibition in 1878.[28] It was inevitable, therefore, that this painting should inaugurate a change in the way artists treated the nude, and by the

early 1880s a younger generation of painters was exhibiting works which marked a shift towards the sensational realism of the French school.[29] Pretexts for the subject were more eclectic and daring than hitherto as Greek figures were joined by Roman, Oriental and biblical subjects. In 1885 an unprecedented number of nudes, by both male and female artists, appeared at the Academy and Grosvenor. The most stunning exhibits that year were three large-scale Roman subjects: Poynter's *Diadumenè* (plate 60) and J. W. Waterhouse's *St Eulalia* at the Academy, and C. W. Mitchell's *Hypatia* at the Grosvenor. Poynter's picture was an exercise in archaeological restoration, a fusion of the male *Diadumenos* and the female *Venus Esquilina*; the other two scenes of martyrdom depicted respectively a Roman convert and a pagan philosopher.[30] The critical reception of the nudes displayed that year was mixed, with praise for technical skill set against complaints that artists were merely interested in representing bodies, not souls.[31]

The anxieties expressed by critics were exacerbated by the social purity agitation, which reached a climax in the summer of 1885 as voluntary organisations petitioned for reform and as cases of sexual misdemeanour received an unprecedented amount of publicity in the press. Although critics were certainly aware of the purity movement, they were concerned to distance themselves from purists who were generally regarded by the art establishment to be well-meaning but uninformed zealots. In fact, as long as moralists remained outside the main institutions of art, they posed no significant threat. It was only when their case was taken up from within that artists and critics were put on the defensive. The main defector to the purity camp was J. C. Horsley, a long-standing opponent of the nude and the life class. Horsley had served as headmaster to the figure class at the Government School of Design in the mid-1840s, at a time when life drawing did not feature significantly in the curriculum. He himself preferred to work from costumed models following the system in use at Antwerp and in Germany.[32] He was elected Royal Academician in 1856, and in 1878 was defeated by Leighton in the election for the position of president. However, he served as trustee and treasurer from 1882 to 1897, and was held in high regard for organising the Old Master exhibitions at Burlington House between 1875 and 1890. Horsley made clear his opposition to the nude within the Academy. In 1874 he had demanded the dissolution of a class that Leighton had established to allow students to model in clay from life. He also voted against petitions presented to the Council by female students in 1872 and 1878 for permission to draw from the semi-draped model in a separate class.[33] By 1883 the intake of female students had increased to such an extent that the Academy began to concede to their requirements. Council Minutes for 11 December 1883 record a petition handed to the Council by sixty-four female students requesting a class for the partially draped figure. After considerable discussion it was resolved by eight votes to two that such a class could be established.[34] Horsley was not deterred and in July 1884 succeeded in persuading the Council to recommend to the Visitors who set models in the life room 'that care should always be taken to prevent indelicate appearance of person'.[35] He withdrew the

motion on 5 August in favour of W. B. Richmond's proposal that in future exhibitions of students' work, 'studies from the nude should not be included', a measure which was passed unanimously.[36] However, the demand for models was by now so great that Visitors were requesting permission to hire extras, particularly draped figures for the oversubscribed ladies' class.[37] Horsley's objections were also heard by the hanging committee, and in 1884 he blocked the exhibition of Robert Wiedemann Browning's large bronze *Dryope*, much to the annoyance of the artist's

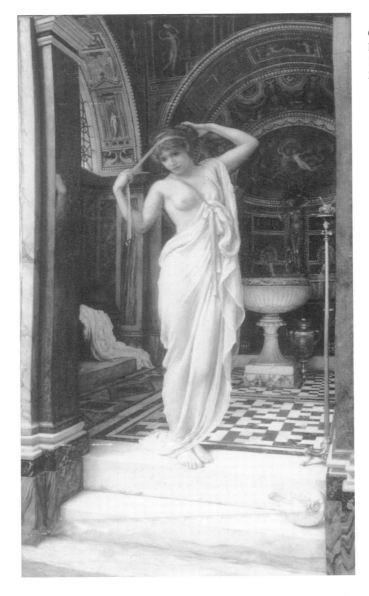

60 Edward John Poynter, *Diadumenè*, 1885-93, oil on canvas, 223.5 x 133.4 cm

father, the poet Robert Browning, thanks to whose intercession it was shown at the Grosvenor.[38]

In the light of the above evidence it is likely that Horsley used his inside knowledge of the Academy and government schools to provide purists with the information they needed to present their case, for it was clear by 1885 that vigilantes did not overlook serious art. In February that year *Seeking and Saving* – 'a journal of Home, Mission and Penitentiary work', set up by Ellice Hopkins's White Cross League – began to focus on the female model as another instance of female degradation. Protests took the form of letters to the editor from men and women drawing attention to the plight of young female models and the 'iniquitous' practice followed by some art schools of allowing men and women to study together from the model. The writers of the letters used pseudonyms: 'An English Woman', 'XYZ' and 'ABC'.[39] 'XYZ' was Alfred P. Ryder KCB, appointed Admiral of the Fleet in April 1885, and a trustee of the Church of England Purity Society (CEPS), which was established by Edward White Benson following his enthronement as Archbishop of Canterbury in 1883.[40] Ryder was a staunch opponent of the life class; it was he who was responsible for the reissue of a selection of the *Seeking and Saving* letters in pamphlet form in June 1885, and for pressurising Archbishop Benson to get the CEPS to take some practical action in the matter of art students and models. As president of the Society, Benson was a key figure in promoting social purity within the Church of England, but was nevertheless cautious about taking any action which would invite public criticism and which would turn out to be based on an inaccurate knowledge of the facts of the case.[41]

Clearly more evidence was needed. The Dean of Windsor had recommended that the secretary of the CEPS should contact the secretaries of the main art schools for information about life classes. It was probably around this time that Ryder first established contact with Horsley. One of the letters published in *Seeking and Saving* and the subsequent pamphlet, signed 'ABC' and entitled 'Notes of a conversation in response to XYZ', was composed by an Academician. The author explained how, despite female students having convinced some liberal Royal Academicians that a life class should be established for their benefit, nevertheless, for the first time in the institution's history, nude studies were – 'owing to remonstrances from high quarters' – withdrawn from the students' exhibition before the public was admitted. The letter also gave inside information on the draping and deportment of models at South Kensington, the Slade and private studios. The writer went on to suggest that the qualification for both male and female students should be raised to ensure that only those gifted with the 'high art talent for design', as distinguished from the ability merely to copy, should be granted admittance to the life class. This measure, he argued, would debar all but 20 per cent of the male and 5 per cent of the female students currently studying the nude:

All records of Art tend to show that while the power of *drawing* has been granted to a considerably less proportion of females than of males; the power of *designing* has been so rarely granted to females that it is difficult to name a dozen female artists,

of even the *second* class, who have in this century, *designed* successfully, whereas of the *first* class, viz., those capable of *designing* works of enduring fame, there have been none.[42]

'ABC' was certainly Horsley, for the misogynist and elitist tone of this letter exactly anticipates the speech he gave to the Church Congress attacking female art students, sections of which were repeated from an anonymous letter sent to *The Times* (26 May 1885) but not printed. Another letter on the subject published in the *Pall Mall Gazette* (22 June 1885), dedicated to 'XYZ' and signed 'ABC', would further suggest that the writers of all these letters were the same person, and that Horsley and Ryder were the motivating forces behind the debate.[43]

Given the initial reluctance of Archbishop Benson to commit himself to the cause, some other strategy was needed to convince him of its righteousness. The readership of *Seeking and Saving* was limited mainly to sympathetic purists, and so a wider audience was sought via the public press. On 20 May 1885 the letter entitled 'A woman's plea' and signed 'A British Matron' appeared in *The Times*. Extolling the rescue work of a purity organisation (possibly the CEPS), the writer pleaded that to its existing rules for members a vow be added to boycott galleries displaying nude works. How far Horsley or Ryder were behind this letter is not altogether certain, but it is quite plausible that Horsley should adopt a female persona given the close involvement of women in the social purity movement. On 2 June, for example, Ryder had written to Benson informing him that he had been in contact with two high-ranking women about drawing up a petition to be signed by a large number of titled ladies and then sent to the president of the Royal Academy, and the president and vice-president of the Board of Education, expressing their concern over the welfare of female models and art students.[44] All the participants in *The Times* debate assumed the Matron was female even though several correspondents questioned the authorship.[45] There were twenty-one letters altogether (including 'A British Matron's'), thirteen of which offered a common-sense critique of her argument, while seven spoke out in favour of her proposition.[46] 'A British Matron's' defenders all adopted pseudonyms – their passion for drapery extending even to a need to cloak their identities – so it is difficult to ascertain who the writers were, although 'XYZ' was certainly Ryder.[47] Critics of the Matron, obviously unabashed by 'naked truth', were less reticent about disclosing their identity, particularly the artists: John Brett, Eyre Crowe and E. J. Poynter. Women were represented on both sides of the debate but the gender of several participants is impossible to work out from the initials 'ASB', 'UMB', or generic titles such as 'Common Sense'. A letter published on 25 May and signed 'H' was by Horsley, this time writing as 'a subtle art critic', to quote John Brett. 'H's letter provided the sort of art-historical exposition one would expect from a distinguished critic such as Quilter, Ruskin, Claude Phillips or Ernest Chesneau, all of whom offered a similar negative evaluation of the nude in modern art.[48] 'H's letter even provoked a deferential response from Poynter, whose *Diadumenè* (see plate 60) 'H' had singled out as a prime example of the 'failure' of the contemporary nude.[49]

The adoption of pseudonyms was thus an important strategy in alerting the attention of both purists and the art establishment to the issue of models and morals. Horsley was a key figure in *The Times* debate, but it is more difficult to gauge the precise nature of his involvement with the CEPS. Only one letter exists from Ryder among the Horsley Papers and that conveys a rather distant relationship. However, one must allow for the possibility that Horsley lost or destroyed other letters. Although a committed Anglican, Horsley was not known to be a member of the CEPS even though he was sympathetic to their cause. To confuse the issue further, in May 1885, around the same time as the above controversy, a number of works in the Academy summer exhibition were damaged by scratching, in particular Albert Moore's nude *White Hydrangea* and Henry Gunthorpe's bronze statuette *Cain*.[50] Council Minutes for that month record that the damage was not extensive but the attacks were serious enough for the case to be referred to Scotland Yard. The event also led the Council to authorise the installation of protective railings around the galleries and the stationing of a policeman in the vestibule during the summer exhibition.[51] The identity of the assailant was never discovered, nor whether he or she was a member of the institution or otherwise. Nevertheless, the timing of the incident was enough to make the 'British Matron' an immediate suspect.[52] It is unlikely that Horsley was the culprit – indeed, as treasurer he was responsible for obtaining plans and estimates for the railings – but the coincidence demanded that he make clear his position within the debate.[53]

On 20 June Ryder notified Benson that Horsley was preparing a paper on the study of the nude from the point of view of an artist and religious man, by which time Ryder had also compiled a selection of *The Times* letters in pamphlet form for wider circulation.[54] It would appear, therefore, that while Horsley was the main opponent of the nude within the art establishment, Ryder was the driving force within the CEPS, and it was he who invited Horsley to deliver his paper at the Portsmouth Church Congress that October, in the section designated 'Religion and Art'. In this widely publicised speech Horsley argued that life study was unwomanly and violated Christian principles. He specifically targeted female artists 'trained at public expense to assist in the degradation of their sex', and gave over much of his paper to comparing the 'improper' system followed at the Slade and South Kensington with that adopted by colleges where women were relegated to their proper sphere. Although Horsley found a sympathetic audience, his speech did not initiate much discussion in the debate which followed the addresses; but when it appeared in the national press, editors were flooded with yet another spate of letters.[55]

It would seem that the controversy had reached its height, but tension mounted within the Academy that November when 130 nude studies submitted by Academy students for the biennial competition were stolen and, as with the earlier scratching incident, no explanation could be found for their disappearance, although detectives were once again called in.[56] The drawings were supposed to have been kept locked away under the Keeper's supervision, which only added to

the speculation as to how and by whom they were stolen. The *Saturday Review*, a long-standing advocate of the nude, went so far as to jest that perhaps it was an Academician, or maybe 'the British Matron came by night, habited like one of the Furies in a late performance, and threatened Mr Pickersgill [the Keeper] with death'.[57] With no information forthcoming, the Council resolved on 17 November to reduce the number of life drawings required for future competitions from six to three, and on 24 November the Council agreed that when the students' exhibition opened to the public that year, paintings and drawings from the life should be placed in a separate gallery with a note: 'Nude Studies from the Life'.[58]

The confluence of these various incidents in the context of widespread purity agitation gave rise to a general anxiety that female nudes, models and students of art were yet further symptoms of a decline in national morals. For purists, the role of matrons was essential in guarding female virtue, while for aesthetes the 'British Matron' came to epitomise prudery and ignorance. However, the Matron could not just be dismissed as a purist fanatic, for she or he also represented the views of respected factions within the art establishment. In fact the events of 1885 did much to discredit the nude within the Academy itself. Although Horsley was the most forthright critic of the nude, he was not isolated in his views. After the Portsmouth Congress, Ryder assisted him in circulating copies of the speech among Royal Academy Council members, and Horsley received a number of sympathetic letters from Academicians, notably G. A. Storey and Thomas Faed.[59] There is also evidence that Horsley and Ryder were seeking legal advice as to whether the Academy could be prosecuted for exhibiting pictures of naked women, an enquiry which evidently proved fruitless.[60] However, the compromises reached by the Council over student competitions led to outside criticisms that the institution was not fulfilling its role of promoting high art. That December the *Saturday Review* lamented:

> Timidity is the keynote in the Royal Academy; it is a Cabinet of all the irresolutions. At least among its signs of feebleness, the public will count the fact that one of its members and paid officials has attacked its educational management before a body so foreign as the Church Congress, and that no one within the Royal Academy has been found energetic enough to sound a counterblast. If the Academy is too weak to defend its own system of education should we trouble to do so?[61]

The rhetoric of purists had led the Academy to tighten regulations in the life class. In November 1885 a petition signed by forty-six students for an additional life class was turned down.[62] Horsley's 'art schools' speech also affirmed existing prejudices against female students of art, and commentators of different persuasions concurred with him in intimating that some women were taking up the practice quite unnecessarily.[63] Social purity had politicised the nude and participants on both sides of the debate concluded that the subject was safest confined to an artistic elite.[64] The reiteration of this traditional argument at a time when the nude was being projected among a wider audience did not mean that artists could ignore

public opinion altogether. On the contrary, they had to operate within the constraints imposed by an exhibition-orientated market and contend with the unsophisticated expectations of audiences. Poynter's decision to add draperies to *Diadumenè* in 1893, for example, was presumably because he could not find a buyer for a work which was condemned in 1885.

On the other hand, the publicity accorded the nude encouraged some artists to take greater risks with the subject, and 1887 witnessed the first 'modern life' nude with the exhibition of Theodore Roussel's *A Girl Reading* at the New English Art Club, which had been set up the previous year in opposition to the Academy with the avowed intention of presenting real-life subjects. Social purity proved ultimately ineffective in banning the nude from public exhibition, or in regulating the number of female models and students in art schools. One reason might be that the art establishment closed ranks against Horsley. Poynter apart, the most prestigious painters of the nude opted to maintain a discreet silence over the issue. Not a word was heard from Leighton, Moore or Burne-Jones. G. F. Watts felt indignant enough to respond to Horsley, but withdrew his letter from publication.[65] The 'common-sense' opinions offered by the artists who entered the debate served to emphasise the professionalism and morality of both artist and model in the face of the uninformed misconceptions of purists.[66] The tactic of ridicule adopted by magazines such as *Punch* and *Fun* also helped to undermine Horsley who was made to appear a prurient buffoon (plate 61).[67] His position, now elided with that of the 'British Matron' in the public's mind, led to the more subtle points of his arguments being submerged in the tirade against his hypocrisy, and he was now held responsible for all simplistic judgements cast against the nude.[68] Whistler's irreverence in inscribing 'Horsley soit qui mal y pense' beneath his nude painting *A Note in Violet and Green*, exhibited at the Society of British Artists in 1885, and in accusing the painter of 'the unseemliness of senility', must also have done much to embarrass and discredit the painter.[69] Robert Browning, who was appointed honorary secretary for foreign correspondence by the Academy in 1886, also struck out at Horsley in his poem 'Parleying with Francis Furini' of 1887 with the phrase 'suppressed concupiscence, / A satyr masked as matron'. For Browning and Charles Kingsley, the nude was a universal symbol of the higher truth as opposed to the superstition and bigotry embodied in orthodox doctrine, be it that of seventeenth-century Italy or fifth-century Alexandria.[70] Because purists were associated with the religious fanatics of earlier times, defenders of the nude had little to fear from Church interference. Moreover, the aesthetic theory that art stood above the strictures of morality was by now more widely accepted, particularly through the writings of respected painters such as Leighton and Poynter.[71]

Archbishop Benson's original caution that the Church of England had no right to intrude in matters beyond its jurisdiction was beginning to be accepted within the CEPS, and probably more so after the death of Ryder in 1888. It was not long before vigilantes began to direct their attention away from art schools towards other forms of indecency. In November 1885 the Bishop of London wrote to *The*

He had that sense of delicacy! His corn hurt him dreadfully, till he said "I will cut it". Then it flashed upon him that it would involve looking upon his toe in a state of nudity! He crimsoned to. the roots of his hair (an asterisk shows position of corn).

For a while he contemplates cutting the corn from the outside.

With a strong effort against the innate delicacy inseparable from the pure-minded, he forced himself to remove the slipper.

Then – but with what mental torture! the sock. But the sense of impropriety was fearful.

But he steeled himself, Ah, how easy it is to lose all shame when once we have overstepped the bounds! And as he was about to operate HIS LANDLADY CAME IN!

61 James Frank Sullivan, 'The Artist as He Should Be', *Fun*, 10 June 1885

Times to complain about the 'constant incentive to immorality' presented by billboards and posters of scantily clad acrobats on the London Underground.[72] When William Coote founded the National Vigilance Association in 1885, the organisation restricted its protests against visual representations to hoardings and *tableaux vivants*.[73] With the State adopting a cautious approach to regulation and

censorship, voluntary groups such as the National Vigilance Association made it their concern to alert a more tolerant public to the dangers presented by indecent images. A wider acceptance of the nude in the later Victorian period, be it theatrical entertainments based on exhibition paintings or billboards, can be related in a general way to the increasing emphasis on consumerism in middle-class culture. It was difficult for purists to legislate against the nude because it had come to embody so many conflicting values: the body beautiful, the spiritual aspirations of humanity, but also more subversive stereotypes such as the degenerate and predatory female.

The mythical 'British Matron' thus became a figurehead for moralists and aesthetes alike, and enabled both sides to negotiate what were in fact tenuous points of ideological difference. It was the controversy over the female nude which forced aesthetes to take a moral stand, and which drove conservative critics and Academicians into a reluctant rapprochement with moralists, as exemplified by Horsley's alliance with Ryder. While Horsley's essentially elitist art-political position (as exemplified by 'H's letter) was used to support a basically populist moral stance, defenders of the model were compelled to politicise their arguments in order to justify both the study and exhibition of the nude. Thus the complexity of the views involved in the 'British Matron' debate makes it difficult to distinguish clearly between 'conservative' and 'progressive' factions, or between populist moral views and elitist aesthetic ones. The 'British Matron' letter was the catalyst for the confrontation in which Horsley emerged as the most conspicuous painter-purist. But although the Matron's guise placed him centre stage, paradoxically it gave his opponents the opportunity to unmask him as the dupe of a fracas. Their advocacy of 'naked truth' as 'moral truth' ultimately led to the victory of a pro-nude, aesthetic position in the late nineteenth century.

Notes

1 Although a tradition exists that Horsley was behind the 'British Matron' letter, this cannot be proved with any certainty. For Horsley's authorship see W. C. Devane, *Brownings Parleyings: The Autobiography of a Mind* (New Haven, Yale University Press, 1927), p. 184; Devane, *A Browning Handbook* (New York, Appleton-Century-Crofts, 1955), p. 514; DNB 1901–11, p. 305.

2 Linley Sambourne to J. C. Horsley, 7 November 1885, Horsley Papers (Bodleian Library, Oxford).

3 The nude debate of 1885 has been examined in F. Borzello, *The Artist's Model* (London, Junction Books, 1982), pp. 74–80; A. Smith, *The Victorian Nude: Sexuality, Morality and Art* (Manchester, Manchester University Press, 1996), ch. 6; and most recently P. McEvansoneya, 'A libel in paint: religious and artistic controversy around P. H. Calderon's *The Renunciation of St Elizabeth of Hungary*', *Journal of Victorian Culture* (Autumn 1996). In researching this article I am indebted to Philip McEvansoneya for revising my view of Horsley's authorship of the 'British Matron's' letter.

4 F. Haskell and N. Penny, *Taste and the Antique: The Lure of Classical Sculpture 1500–1900* (New Haven and London, Yale University Press, 1982), pp. 325–6.

5 A. Combe, *Principles of Physiology Applied to the Preservation of Health, and to the Improvement of Physical and Mental Education* (Edinburgh, A. & C. Black, and London, Rees, Orme, Brown, Green & Longman, 1834), p. 182; A. Walker, *Beauty: Illustrated Chiefly by an Analysis and Classification of Beauty in Women* (London, E. Wilson 1836), pp. 367–9; J. Ruskin, *The Works of John Ruskin*, Library Edition, ed. E. T. Cook and A. Wedderburn (London, George Allen, 1903–12), I, p. 433.

6 Religious opposition to the nude took the form of letters by evangelicals to the editors of influential papers and essays published in journals such as *The Catholic Presbyterian* or *The British and Foreign Evangelical Review*. There were also more detached accounts such as James Jackson Jarves's essay 'The nude in modern art and society', *Art Journal* (March 1874).

7 Smith, *Victorian Nude*, pp. 25–33.

8 For a more detailed survey of aestheticism and the revival of the nude in the 1860s see Smith, *Victorian Nude*, ch. 4.

9 E. J. Poynter, *Ten Lectures on Art* (London, Chapman & Hall, 1879), 'Lecture 3: Systems of art education'; F. E. Hulme, *Art Instruction in England* (London, Longmans, 1882), pp. 149–50.

10 P. G. Hamerton, 'The study of the nude', in *Man in Art* (London, Macmillan, 1892), p. 37.

11 A. Walker, *Woman Physiologically Considered as to Mind, Morals, Marriage, Matrimonial Slavery, Infidelity and Divorce* (London, n.p., 1839), p. viii. The primacy of the 'natural' body was put forward by dress reformers such as Mrs H. R. Haweis (*The Art of Beauty* [London, Chatto & Windus, 1878]), the designer and anthologist Luke Limner (John Leighton), author of *Madre Natura versus the Moloch of Fashion* (1870), the painter G. F. Watts and the novelist Charles Kingsley. In his essay 'Nausicaa in London' (October 1873), Kingsley argued that an antique waist was indicative of strong healthy muscles and brain power: repr. in C. Kingsley, *Sanitary and Social Lectures and Essays* (London, Macmillan, 1889), p. 116).

12 For descriptions of the Armitage see *Daily Telegraph* (18 May 1878) 3; *Builder* (11 May 1878) 474. For Tenniel's *Pygmalion* see W. M. Rossetti, 'The Water-Colour Institute', *Academy* (20 April 1878) 354.

13 W. Davies, 'Recent discoveries in art and archaeology in Rome', *Quarterly Review*, 144 (July 1877) 77; W. C. Perry, *Greek and Roman Sculpture: A Popular Introduction to the History of Greek and Roman Sculpture* (London, Longmans, Green & Co., 1882), p. 624.

14 This argument was put forward in influential texts such as R. Westmacott, *The Schools of Sculpture Ancient and Modern* (Edinburgh, A. & C. Black, 1864), and J. Harrison, *Introductory Studies in Greek Art* (London, Unwin, 1885). See also Perry, *Greek and Roman Sculpture*.

15 *Spectator* (28 December 1878) 1637.

16 See for example *Saturday Review* (25 May 1878) 660-1; *Daily Telegraph* (18 May 1878) 3.

17 P. H. Rathbone, *Realism, Idealism and the Grotesque in Art: Their Limits and Functions* (Liverpool, n.p., 1877).

18 *Liverpool Daily Post* (2 September 1878) 5.

19 Samuelson's speech was published as 'The picture of the "Sculptor's Model"', *Liverpool Mercury* (3 September 1878) 6.

20 *Liverpool Daily Post* (4 September 1878) 6 (letters signed 'A Moralist', 'Another Father', 'W.H.T.', 'An Art Student'); *Liverpool Daily Post* (6 September 1878) 7 (letter signed 'Verax'); *Liverpool Mercury* (13 September 1878) (letter signed 'An Offended Father').

21 For the repeal and social purity movements see J. Walkowitz, *Prostitution and Victorian Society: Women, Class and the State* (Cambridge, Cambridge University Press, 1980); J. Weeks, *Sex, Politics and Society: The Regulation of Sexuality since 1800* (London, Longman, 1981); F. Mort, *Dangerous Sexualities: Medico-Moral Politics in England since 1830* (London and New York, Routledge & Kegan Paul, 1987); Smith, *Victorian Nude*, ch. 6.

22 For Rathbone's speech and the debate which followed see *Builder* (9 November 1878) 1170.

23 'Art notes', *Magazine of Art* (October 1878) xxxiii.

24 Limner, *Madre Natura*, p. 100.

25 For example, Anna Lea Merritt trained in Paris under Léon Cogniet; Henrietta Rae at Heatherley's and the Royal Academy; Evelyn Pickering at the Slade.

26 For example, Dorothy Tennant, *The Siren* (Royal Academy, 1882); Mrs John Collier, *By the Tideless Dolorous Sea* (Grosvenor Gallery, 1884). At the Royal Academy in 1885 were Anna Lea Merritt, *Eve*; Henrietta Rae, *Ariadne Deserted by Theseus* and *A Bacchante* (see plate 59). At the Grosvenor in 1885 were Dorothy Tennant's *Cupid Disarmed, Dawn* and *Truth at the Well*.

27 H. E. Roberts, 'The exquisite slave: the role of clothes in the making of the Victorian woman', *Journal of Women in Culture and Society*, 2:3 (1977) 567; S. M. Newton, *Health, Art and Reason* (London, J. Murray, 1974), p. 59.

28 Figures closed at 89,110, an increase in 20 per cent from the previous year, and only surpassed in 1884 and 1891; see E. Morris, 'Philip Henry Rathbone and the purchase of contemporary foreign paintings for the Walker Art Gallery, Liverpool 1871–1914', *Walker Art Gallery Liverpool, Annual Report and Bulletin*, 6 (1975–76) 62.

29 Such painters included Charles William Mitchell, John Collier, John William Waterhouse, E. Matthew Hale and Ernest Normand.

30 *Diadumenè* was preceded by a smaller version (Royal Academy 1884). Mitchell's *Hypatia* was probably drawn from a male model and likewise shows a blend of male and female characteristics. For these paintings and Waterhouse's *St Eulalia* see E. Prettejohn, 'Recreating Rome', in M. Liversidge and C. Edwards (eds), *Imagining Rome: British Artists and Rome in the Nineteenth Century*, exh. cat. (Bristol City Museum and Art Gallery, 1996), pp. 152–8.

31 See for example *Academy* (9 May 1885) 334 (Claude Phillips); *The Spectator* (27 June 1885) 845 (Quilter); *Magazine of Art*, 8 (1885) 351.

32 See C. Dunkley (ed.), *Report of the Church Congress* (Portsmouth, October 1885), p. 190.

33 L. and R. Ormond, *Lord Leighton* (New Haven and London, Yale University Press, 1975), pp. 67, 73.

34 Royal Academy [RA] Council Minutes (11 December 1883) 92. Later that month this decision was confirmed by the casting vote of the president, Leighton. The motion

was then passed to the general assembly for sanction with the recommendation that the drapery should consist of a pair of bathing drawers and a loin cloth; see RA Council Minutes (31 December 1883) 93.

35 RA Council Minutes (15 July 1884) 174.

36 RA Council Minutes (5 August 1884) 181.

37 In 1883 Alma-Tadema and Yeames requested an extra model for the ladies' class; see RA Council Minutes (6 November 1883) 73; (4 December 1883) 87. The models were to pose draped following Academy regulations.

38 Horsley was not alone in objecting to this work (illustrated in J. Barnes [ed.], *Leighton and His Sculptural Legacy: British Sculpture 1875-1930*, exh. cat. [London, Joanna Barnes Fine Art, 1996], p. 37). Claude Phillips described the sculpture as 'nothing more than a study by a comparative novice from a coarse and un-select model, whose defects of form it has not been sought to correct or to atone for by any harmony of line or arrangement', *Academy* (17 May 1884) 357.

39 *Seeking and Saving* (February 1884) 34–6; (March 1885) 59–60.

40 The DNB records that after resigning the Portsmouth command, Ryder suffered from impaired health and depression of spirits. In April 1888 he was drowned at Vauxhall Pier while taking a river trip. See also note added by Horsley in 1892 to a letter he received from Ryder following the Portsmouth Church Congress (19 October 1885), Horsley Papers.

41 Benson published a manifesto for the CEPS in *The Times* (8 August 1885) 4. The reasons for Benson's prevarication are explained in a letter from Randall Thomas Davidson, Dean of Windsor, to Lt. Col. Herbert Everitt, secretary of the CEPS, 2 March 1885. See also letter from Everitt to Davidson, 26 March 1885, Benson Papers, Official Letters 1885 (Lambeth Palace Library, London).

42 *Seeking and Saving*, 5 (February 1885) 30-5. See also RA Council Minutes (15 July 1885) 174; (5 August 1885) 181.

43 Dunkley, *Report of the Church Congress*, pp. 188–92. *The Times* and *Pall Mall Gazette* letters were printed in pamphlet form, *Letters on Purity and Art Illustrating Opposing Views, collected and re-printed by XYZ*, June 1885.

44 Ryder to Benson, 2 June 1885, Benson Papers. One of the matrons mentioned by Ryder was his cousin Mrs Henry Scott. Ryder was to supply each of the women with a copy of his *Purity in Art Practice* pamphlet. Included in his letter to Benson of 19 June 1885 was a list of potential ladies: Countess Beauchamp, Duchess of Buccleuch, Lady Edward Cavendish, Countess Granville, Lady George Hamilton, Lady Leconfield, Duchess of Leeds, Lady Louise Miles, Countess of Rosslyn, Marchioness of Salisbury, Countess Spencer, Countess Stanhope, Lady Winborne. In response to Ryder's request for an endorsement to this petition, Benson contended that the style of evening dress worn by upper-class women was a more harmful influence than students in art schools, Benson to Ryder, 30 June 1885. Edward J. Martyn made the same observation in *The Times* (25 May 1885) 10.

45 John Brett, for example, suggested that the 'British Matron' was a 'subtle art critic in disguise', *The Times* (22 May 1885) 5.

46 Those who defended 'A British Matron' included 'Clericus' (21 May 1885); 'Senex' (22 May); 'Another British Matron', 'An Englishwoman', 'XYZ' (all 23 May); 'H' (25 May). The writers speaking out against her were 'An English Girl', 'Common Sense',

'A British Parent' (21 May); John Brett (22 May); Frederic E. Wheeler, Jerome K. Jerome, 'UMB', 'ASB' (23 May); Eyre Crowe, 'Another British Parent', Edward J. Martyn, H. G. F. Taylor (25 May); E. J. Poynter (28 May).

47 'Senex' was a common pseudonym of anonymous contributors to newspapers.

48 See for example Ruskin, *Works*, XIV, p. 493; E. Chesneau, 'Art and the nude', in *The Education of the Artist* (London, Cassell, 1886); H. Quilter, 'The art of Watts', *Contemporary Review* (February 1882) 272. Although Phillips was not anti-nude as such, his evaluation of the nude exhibits of 1885 was not dissimilar to that given by 'H'; see *Academy* (9 May 1885) 334.

49 *The Times* (28 May 1885) 4.

50 RA Council Minutes (26 May 1885) 248; 'Art critics', *Saturday Review* (30 May 1885) 719. Alma-Tadema's *A Reading from Homer* was also scratched.

51 RA Council Minutes (16 June 1885) 255.

52 *Saturday Review* (23 May 1885) 675; (30 May 1885) 719.

53 RA Council Minutes (4 June 1885) 254.

54 The pamphlet included extracts from the following: 'A British Matron', 'XYZ, 'An Artist' (*Daily Telegraph*, 21 May 1885), 'Thorough' (*Pall Mall Gazette*, 23 May 1885), 'ABC' (*Pall Mall Gazette*, 22 May 1885), and an unsigned letter titled 'The naked fact' sent to *The Times* (26 May 1885) but not published.

55 Horsley's speech was published in full in the *Church Guardian* (14 October 1885) 1521. Summaries appeared in *The Times* (8 October 1885) 10; *Builder* (10 October 1885) 492; *Artist* (2 November 1885) 331.

56 RA Council Minutes (3 November 1885) 276; (17 November 1885) 279.

57 'Students of the Royal Academy', *Saturday Review* (12 December 1885) 779–80.

58 RA Council Minutes (17 November 1885) 280.

59 G. A. Storey to Horsley, 8 October 1885; Thomas Faed to Horsley, 1885: Horsley Papers.

60 Letter from Ryder to Horsley, 19 October 1885, Horsley Papers.

61 *Saturday Review* (12 December 1885) 780.

62 RA Council Minutes (17 November 1885) 280.

63 *Builder* (10 October 1885) 492; Hamerton, *Man in Art*, p. 39.

64 See for example Edward J. Martyn, *The Times* (25 May 1885) 10; J. B. Atkinson, *Blackwood's Magazine* (July 1885) 13; 'A woman of the nineteenth century', *Pall Mall Gazette* (27 May 1885) 4.

65 M. S. Watts, *The Annals of an Artist's Life* (London, Macmillan, 1912), II, p. 42. Leighton did, however, defend the nude in private correspondence; see for example Mrs Russell Barrington, *The Life, Letters and Work of Frederic Leighton* (London, George Allen, 1906), II, pp. 274–5.

66 Edwin Long, letter to the editor of *The Times* (13 October 1885) 6; A Woman Artist, 'Models and morals', to the editor of the *Artist* (2 November 1885) 359.

67 For a list of the *Punch* and *Fun* satires, see Smith, *Victorian Nude*, p. 238, n. 28.

68 In a letter to *The Times* (19 October 1885, p. 13), Horsley accused Edwin Long of mis-construing the facts of his Church Congress speech in that, far from being hostile to models, he had a deep interest in their situation. The following year J. Havard Thomas suggested that Horsley was responsible for the poor positioning of his sculpture *A Slave Girl* in the Academy exhibition. However, RA Council Minutes for 11 May 1886

(339) record that this was the judgement of the entire Council, not of one particular member.

69 J. M. Whistler, *The Gentle Art of Making Enemies*, ed. Sheridan Ford (New York, F. Stokes, 1890), pp. 127–8.

70 Devane, *Browning Handbook*, p. 514; M. Ward, *Robert Browning and His World: Two Robert Brownings 1861–1889* (London, Cassell, 1969), p. 276; Prettejohn, 'Recreating Rome', p. 154.

71 F. Leighton, *Addresses Delivered to the Students of the Royal Academy* (London, Kegan Paul, 1896); Poynter, *Ten Lectures*.

72 'Impure purity', *Saturday Review* (7 November 1885) 607.

73 W. A. Coote (ed.), *A Romance of Philanthropy* (London, National Vigilante Association, 1916), pp. 47–8. An important exception was the Association's success in suppressing an exhibition of pictures illustrating subjects from Rabelais in 1890 (ibid., pp. 94–100).

Physical culture: the male nude and sculpture in late Victorian Britain

Michael Hatt

THE CONNECTIONS between Victorian Aestheticism and the emergence of the homosexual in the social and cultural arena are well-known and well-documented. Such major figures as Pater, Wilde and Symonds have provided historians with exemplars of deviance, characters whose sexual tastes and identities are inextricably bound to their aesthetic pursuits and interests, and vice versa. Rather than concentrating on the figure of the aesthete as such, what I want to do in this chapter is look at the sculptural male nude in the new sexual context that Aestheticism provokes, and explore some of the ways in which the cultural and erotic paradigm of Aestheticism affects the production and consumption of ideal masculine bodies. In particular, I hope to show how the threat of sexuality presented by the aesthete is countered with a masculinisation of the body, a gendering that aims to purify the male form of unhealthy desire.

To begin, though, there are two assumptions about the male nude in the nineteenth century that need to be addressed, assumptions that still regularly surface in scholarly debate. First, there is the notion that the ascendancy of the female nude is tantamount to the disappearance of the male. It is certainly true that around 1800 the term 'nude' refers principally to the male, while a century later 'nude' refers to the female. Similarly, while the male nude is central to the output of David or Thorwaldsen, it seems to be only incidental in the oeuvres of Eakins or Caillebotte or Cézanne. The second assumption is that the increased awareness of homosexuality makes the male nude too dangerous a figure to represent, since it immediately invokes the spectre of unspeakable desire: hence its disappearance. A corollary of this is that the male nude becomes the preserve of homosexual artists, whether their sexuality be overt or covert.

These ideas should not be dismissed completely, but they do both need to be challenged, for it was in the last quarter of the nineteenth century, exactly when homosexuality emerged so publicly, that the male nude came very much to the fore again. Male nudes appeared every year in the Royal Academy, and because these were academic works, biblical or classical in theme, and normally large scale, they

were displayed prominently and often received great critical attention. Of course, because the artists producing these works are not canonical – because art history has forgotten Solomon J. Solomon, Briton Rivière and so forth – we have inherited a skewed view of nineteenth-century art production where the male nude barely pops his head round the door, let alone anything else. More significant still is the marginalisation of sculpture. So often ignored and yet so public, sculpture, even more than painting, is the site where male nudity flourishes, not least in the remarkable revival of sculpture in Britain from the mid-1870s in the movement known as the New Sculpture.

As for the thesis about the problem of male nudity in an age that was so concerned with sexual transgression, a change of perspective is also needed here. Although homosexuality certainly became more public, the main concern of purity campaigners was heterosexuality, and the same focus is true of debates about the nude. J. C. Horsley's huge campaign against nudity in the mid-1880s was directed at the female nude,[1] and the same occurred in the 1890s. In Glasgow in 1894, the chief constable of the city insisted that a series of engravings be removed from the window of a print-seller on the grounds of indecency and immorality – but the display was entirely of female nudes, including Leighton's *Bath of Psyche* as well as works by Poynter and other Olympians.[2] It was the female body and its dangerous pleasures that challenged public morals and sullied public space; it was the female body, after all, that connoted sexuality, as is only too plainly evidenced by the string of Pandoras, sirens, mermaids, sphinxes and other *femmes fatales* that lined the walls of galleries.[3]

Where a male nude was controversial, it was more likely to be because it, too, raised the question of heterosexuality. Alfred Gilbert's *Shaftesbury Memorial*, unveiled in 1893, was the target of much criticism and moral outrage, but not because of male nudity *per se*. The chief complaint seems to have been that the figure of Eros was inappropriate at a site notorious for prostitution; in effect, Gilbert's figure of Anteros, or selfless philanthropic love, became a sign of heterosexual transgression.[4] In fact, the sculptural male nude is an icon of decency in late Victorian Britain. It is certainly implicated in the debate about sex, gender and sexuality, but it is insistently positioned as a positive ideal, and what I shall argue here is that the ideal masculinity of the nude is posited as a defence against the threat of sexuality.

It was in a series of articles in the *Art Journal* in 1893 that Edmund Gosse named the New Sculpture and defined it as a movement. He identified Frederic Leighton as the father of the movement and the *Athlete Wrestling with a Python* (plate 62) as its founding moment. The *Athlete* had been one of the big successes at the Royal Academy in 1877, much admired and applauded, and was immediately acquired by the Chantrey Bequest. Many of the sculptors who make up the so-called New Sculpture movement also had their earliest successes with male nudes; it was the form they used to mark their entries into the public arena. Thornycroft grabbed critical attention with his *Warrior Bearing a Wounded Youth from Battle*, the piece

that won him the Academy Gold Medal in 1875, while Alfred Gilbert's enormous public success began at the Grosvenor Gallery in 1882, where his *Perseus* was lauded as the best sculpture of the year by a number of reviewers. The male nude was similarly important for Harry Bates, Frederick Pomeroy, Roscoe Mullins, James Havard Thomas, Goscombe John, and virtually all those who went on to sculptural fame and fortune.

It may be significant that Leighton played a part in the production of many of these, not only through the example of his work, but through personal involvement. His position at the Royal Academy and his involvement with the Chantrey Bequest gave him an ideal opportunity to encourage younger artists both institutionally and economically, and his own taste for ideal subject-matter and his revival of the male nude as the epitome of ideal form may have been influential in the choice of these young sculptors. It was Leighton who commissioned Gilbert's *Icarus* in 1884, after being so impressed by the *Perseus* at the Grosvenor Gallery; the Chantrey Bequest bought Thornycroft's *Teucer*, and Leighton himself bought another of Thornycroft's early male nudes, *Putting the Stone*; Pomeroy was

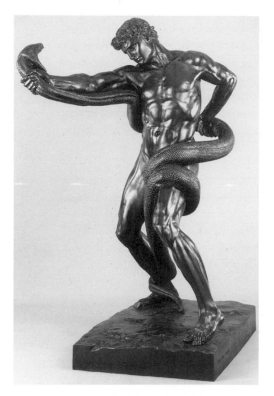

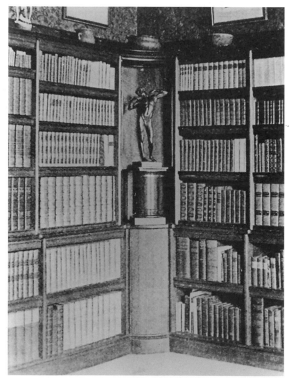

62 Frederic Leighton, *Athlete Wrestling with a Python*, 1877, bronze, 175.5 x 97 x 108 cm

63 Photograph of domestic library with statuette of Frederic Leighton's *The Sluggard*, from *Magazine of Art*, 1895

employed to carve the marble version of the *Athlete* that was exhibited in the Royal Academy in 1891; and Leighton gave financial support to Henry Fehr, whose indebtedness to the great man is evident in his *Perseus and Andromeda* of 1893, which stands outside the Tate Gallery and is a sculptural reworking of Leighton's own painting of the subject with the Cellini *Mercury* perched on top.

While their early successes were often male nudes, the New Sculptors made fewer later in their careers. This is, principally, a question of patronage. While ideal works had the highest aesthetic and moral value and could be shown annually at the Royal Academy, they were less marketable than portrait sculptures, busts and monuments. However, the iconography of public memorials allowed the inclusion of the male nude, and, more important still, architectural work provided a forum for sculpted bodies which could be added to buildings as allegorical marginalia; in this context, the male nude also served as a powerful reminder of aesthetic and philosophical traditions, as in Roscoe Mullins's pediment for the Harris Library in Preston.

Interestingly, the male nude was not only visible in public sculpture, display pieces and architecture, but many of the best-known New Sculptures were also available in reduced form as statuettes for the home. In 1895, the *Magazine of Art* reproduced some photographs of drawing rooms in which such statuettes formed an integral part of the decor (plate 63). The bourgeois interior, the most decorous and decent of places, could accommodate statuettes of the athlete, the Teucer, the mower and so on; male nudity raised no concerns in the home of the enlightened bourgeoisie. Indeed, it had a positive moral effect. Sculptural ideologues, as well as institutions like the Art Workers Guild, encouraged the production of statuettes as replacements for the popular Parian-ware shepherdesses and other figurines which they viewed as symptomatic of debased public taste.

The male nude, then, could be found everywhere, in public and private. What made all this male flesh acceptable, of course, was its idealisation and its normative masculinity. While the moral significance of the form was occasionally made explicit, as in Pomeroy's *Perseus*, which was exhibited at the Royal Academy in 1898 under the title *Perseus, as a Symbol of the Subduing and Resisting of Evil*, viewers would have been only too aware of the male nude as an embodiment of the classical ethos, an ethos that is an essential ingredient in Victorian masculinity.

The language of art criticism was freighted with this notion of normative masculinity, using it insistently to validate these bodies. To give a few examples from a seemingly unending choice: Marion Spielmann described G. A. Lawson as 'strong, manly and artistic';[5] Sir Harry Quilter called Gilbert's *Icarus* 'manly' and saw Bates's *Hounds in Leash* as possessing 'pre-eminent quality in strength and manliness ... power and resolution';[6] the *Magazine of Art* described Watts's *Orpheus* as 'the very embodiment of manly vigour';[7] and the *Art Journal*, criticising the Academy show in 1896, saw 'a lack of vitality and robust health'.[8] The same words occurred again and again, becoming clichés of critical language: virile, manly, masculine, vigorous, healthy, vital.

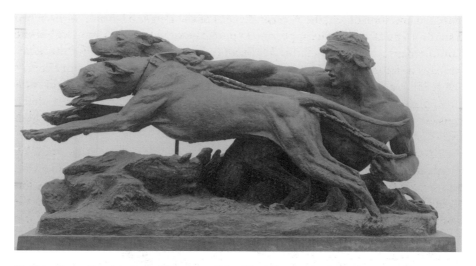

64 Harry Bates, *Hounds in Leash*, 1889, plaster, 107 x 221 x 101 cm

It is impossible to miss the connection with athleticism. This is clearly symptomatic of a broader Victorian worship of muscle, as practised, for instance, on the playing fields of public schools and universities. The identification of physical prowess with moral prowess, the embodiment of masculine virtue, is already implicit in the ideal male nude, but in New Sculpture the topoi of health and the athletic sometimes emerge explicitly. Leighton's *Athlete* is an obvious example, as is Thornycroft's *Teucer*. The bowman from *The Iliad* represented in this piece was in part conceived as belonging to a projected series based on field sports, although only one other piece was ever made, *Putting the Stone*, which similarly connected the classical ideal and the modern sportsman. Bates, too, took up a sporting theme of sorts in his *Hounds in Leash* of 1889 (plate 64), which was commissioned in bronze by the Earl of Wemyss and March, a keen sportsman as well as art patron. These works combine the classical tradition and modern masculinity, and exemplify how the sculptural male nude is rooted in Victorian notions of health and, in particular, of the physiological connection between moral and bodily health.

It should come as no surprise that it was this sculptural conception of the male body that underpinned the physical culture movement, which began in the mid-1890s and rapidly took off as the century drew to a close. Physical culture was essentially an attempt to rebuild British manhood in the face of degeneracy and enfeeblement, and worked on the principle that if physical prowess is an index of morality, then in order to raise morals, the body must be changed. The physical culture body was sculptural in form, and the paradigm of the living statue was Eugen Sandow, perhaps the most significant physical culturist of them all (plate 65). He displayed himself as sculpture, both in the morphology of the body and in the manner of presentation. In photographs he placed himself on a plinth; he often

posed in imitation of, say, the *Farnese Hercules* or the *Borghese Warrior*; he even had a statue's fig leaf; and before appearing in public he would dust his body with white powder to give an effect of marble. He produced statuettes of himself for the home, perhaps imitating developments in art sculpture, and even had a life cast taken in 1901. He is also described as sculptural in writing, not only as a modern likeness of Apollo, but as materially sculptural. Commentators emphasise his unyielding muscle, hard as metal, and express disbelief that such a body could possibly be flesh rather than marble.

Moreover, sculpture stands as the impetus for physical culture, its founding moment. Sandow, in his autobiography, recounts how he was a sickly child, thin and weak. His father took him to Rome, where young Eugen spent some time loitering in the Vatican and Capitoline sculpture galleries. There he saw all the sculpted athletes, warriors and heroes and determined that he would transform

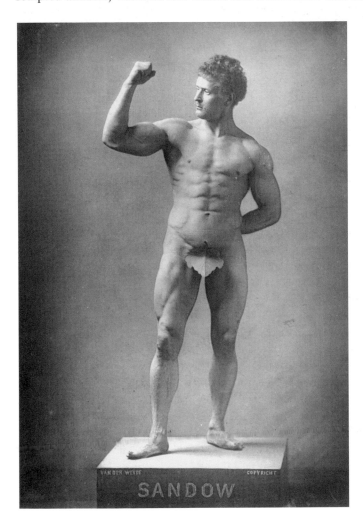

65 Henry van der Weyde, *Eugen Sandow*, *c.* 1890

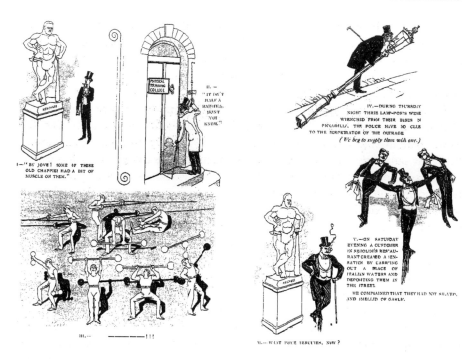

66 Leslie Wilson, 'The Regeneration of the Johnny', *Physical Culture*, vol. I, no. 1, July 1878

himself, bodily and ethically, into a such a figure. 'The Regeneration of the Johnny', a comic drawing from Sandow's magazine *Physical Culture*, tells a similar story (plate 66). The Johnny sees a statue of Hercules, decides to imitate him, and as a consequence is able to show some caricatured Italians a thing or two at the end, thus making classical sculpture the source of both personal and racial or national power. Sandow's no doubt apocryphal tale mimics Winckelmann's story about the beginning of art. Winckelmann speculates that art began in ancient Greece when a proto-sculptor saw the imprint of an athlete's body left in the sand of the arena; this is art's moment of origin, as the empty space mobilises a nostalgia for the flesh which is assuaged by its re-creation in marble. Here, in physical culture, it is a nostalgia for the marble body of antiquity that is assuaged by its re-creation in flesh, but it follows the same dynamic of absence and a redemptive re-creation of presence.

At the risk of stating the obvious, physical culture was an overwhelmingly visual discourse, and it looked most readily to sculpture for templates. Physical culture magazines regularly featured illustrations of famous sculptures, classical and modern; both Leighton's *Athlete* and Thornycroft's *Teucer* turned up in the pages of *Physical Culture*. Allusions to the sculptural also crop up in visually more trivial ways. In a drawing marking the end of an article, Sandow is recast as Leighton's athlete, suggesting further that the statue is the icon not only of the New Sculpture, but also of a New Masculinity (plate 67). Sculpture is to be

emulated, and the sculpted male nude embodies physical culture's physiological and ethical goals. Sandow and his chums model themselves on the same prescriptive anatomy of academic art training or manuals of artistic anatomy – a physiological form that is rational, epitomises decency and moral health, and is untouched by fleshly appetites.

While the roots of physical culture lie farther back in the century, I think it significant that the cult really became organised in the years immediately after the Wilde trial. I would not want to suggest that it was a straightforward reaction to the newly public threat of homosexuality – as in art, the movement is more concerned with heterosexuality – rather that the homosexual becomes a paradigm of the deficient body that physical culture aims to eradicate. In particular, a defence against homosexuality is evident in the movement's eugenic aspirations. Sandow was a rabid eugenicist, approving, for instance, of the Spartan practice of killing 'the weak and deformed',[9] as were many of his supporters. *Physical Development* magazine, reviewing one of Sandow's competitions at the Albert Hall in 1901, remarked that 'all who are interested in the physical regeneration of our race must thank him for his endeavours'.[10] He was similarly praised by such eugenic luminaries as Galton and Conan Doyle. Essentially, physical culture sought to rid the nation of the degenerate; and the word 'degenerate' immediately alerts us to the threat of the homosexual. After all, in his infamous book on the subject, Max Nordau identifies Wilde as the degenerate *par excellence*, and Aestheticism as the acme of racial decay.

The convention of comparing athlete and aesthete had already become something of a commonplace among cartoonists and satirists, serving to crystallise this fundamental distinction, as one can see from the cartoon entitled 'Athletics versus Aesthetics', printed in the *Illustrated London News* in 1883 (plate 68). The athlete was, *de facto*, heterosexual, masculine and healthy, and the aesthete was homosexual, unmasculine and degenerate.[11] But not only are these gendered as masculine and feminised; they also underscore a distinction between pure gender and impure sexuality. In his book on Victorian athleticism, J. A. Mangan suggests that manliness and the sexual or sensual are conceived as polar opposites:

67 'Finis', *Physical Culture*, vol. III, no. 1, July 1899

> To be manly was a condition that exuded the physical but, at the same time, it was an asexual 'physicality' extended into early manhood, in which sexual knowledge and experience were taboo.[12]

While this model does not extend to courting, marriage and mature sexuality, as the cartoon reveals, Mangan is basically right. Manliness was inclusive of pain, pleasure and physical contact, but these were understood as the antipodes of, and even the antidote to, sexuality. Butch business on the rugby pitch, by virtue of its manliness, was never sexual, since sexuality was defined through the feminine – the girl, the woman, the *femme fatale*, and of course the effeminate – and femininity was the means of defining the aesthete, as a case of gender inversion, unmanly, and the opposite of the virile. Even today, the languid aesthete is the exemplar of deviance rather than the guardsman or stableboy he sleeps with.

The Aesthetic Movement was, of course, the primary site for the construction and enjoyment of a homosexual identity. John Addington Symonds, talking of his passion for young men in a letter to his daughter of 1892, refers to 'this love [which] people call aesthetic'.[13] It's not difficult to find reasons for this linkage.

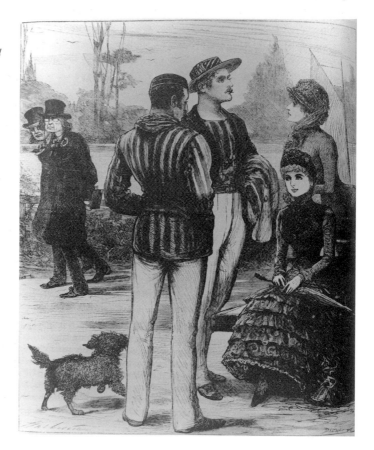

68 'Athletics versus Aesthetics', *Illustrated London News*, 17 March 1883

Aestheticism was oppositional to social norms, fetishising artifice and individualism. Art and its history provided positive images of homosexual attachment; in Wilde's *Picture of Dorian Gray*, Basil's love for Dorian is 'such love as Michael Angelo had known, and Montaigne, and Winckelmann, and Shakespeare himself'. These names recur again and again, and the clichéd references to Patroclus and Achilles or Narcissus and Hylas or Winckelmann or Michelangelo became a standard defence of homosexuality; this rhetoric even seeped into medical discourse, as evidenced by Havelock Ellis's *Sexual Inversion*. Art was, of course, an arena where the male body could be identified as beautiful, and thus could provide a legitimate basis for an overt visual enjoyment of the form. Aestheticism also, crucially, retained an awareness that the aesthetic and the erotic, rather than being radically separated, were intimately connected, and so threatened social and sexual norms when the object of aesthetic appreciation was the male body. Lastly, Aestheticism was an arena for intellectuals, those with a voice, and provided a forum for making the unspeakable speakable.

This fixation on culture, and the use of the aesthetic to construct a homosexual identity, also provided the basis for attacks on the aesthete and his deviant tendencies. In Gilbert and Sullivan's *Patience*, Bunthorne is all artifice and pose, with his flower and Platonic pretensions, until his reverse coming out as 'natural'. Du Maurier's Maudle, one of the aesthetic characters in his brilliant series of cartoons for *Punch*, is more explicitly homosexual, swooning over the beauty of not only china and lilies but also young men. The connection between art and sexual deviance is similarly represented in the character of Mr Rose, the caricature of Pater in W. H. Mallock's novel of 1877, *The New Republic*. Mr Rose is pale and languid, mumbles, stares dreamily at sunsets and talks about either art or himself. While Aestheticism began as the place where homosexuality was fostered, by the 1890s a reversal had taken place and homosexuality was seen as the basis of Aestheticism. In essence, the aesthete was defined as feeble, weak, over-sensitive, affected, and his characterisation in terms of gender inversion is a clear marker of both his deviant sexuality and his degeneracy.

There was no such creature in the Academy or the gymnasium, where the athleticism of the body precludes the possibility of deviance. There was ostensibly an unbridgeable gulf between these effeminates and the utterly masculine types in the gym. Nonetheless, there were certain practices where the distinction between athlete and aesthete becomes blurred, not least in posing, for both in aesthetic dandyism and in physical culture the male body is established as a spectacle, designed to be looked at both by others and by oneself. Wilde is famous for being a poseur: contemporary attacks often make exactly this point; Queensberry accuses him of 'posing as a sodomite', and the subject of posing even cropped up during Wilde's cross-examination in court.[14] Pose is central to the definition of the aesthete and homosexual. At the beginning of R. S. Hichens's novel *The Green Carnation*, a satirical account of Wildean Aestheticism from 1894, we first meet the hero Reggie Hastings posing in front of the mirror:

He slipped a green carnation into his evening coat ... and looked at himself in the glass. There he stood in his favourite and most characteristic attitude.... He frankly admired himself as he watched his reflection, occasionally changing his pose, presenting himself to himself, now full face, now three-quarter face, leaning backward or forward, advancing one foot in its silk stocking and shining shoe, assuming a variety of interesting expressions. In his own opinion, he was very beautiful....[15]

The explicit narcissism of Hastings is mirrored by the specular relationship between the physical culturist and his body in posing. Manuals and articles make it clear that it is necessary to exercise in front of a mirror and to watch one's own body carefully. This is partly an aid to concentration, but it is also explicitly a source of visual pleasure. G. Mercer Adam, writing about Sandow in an adulatory book of 1893, speculates on what it must be like to be Sandow staring into the mirror:

We can well imagine the pleasure he took in his continual muscular training. Modest as he is, ... we can hardly doubt that he takes honest pleasure in looking at himself over with the lust of the eye. [*sic*][16]

So what is the difference? Well, first, there is the distinction between the clothed and the unclothed. The aesthete poses dressed in his distinctive costume, another characteristic that becomes part of the stereotype; Reggie Hastings is much exercised with his gloves and dressing gown and evening coat, furnishing proof for Nordau's hypothesis that 'queer costume' is a symptom of degeneracy.[17] The concern for clothing stands in opposition to uncovered flesh, clearly a gendered division between the femininity of fashion and finery and the masculinity of muscle. Uncovering one's body makes it safer to look at oneself.

Beyond this, there is the more crucial issue of volition. For the artist staring at his model, or for the physical culturist studying himself, looking is instrumental, co-operating with the will in the creation of a moral body. Rather than simply a source of visual pleasure, intended only to satisfy an aesthetic or erotic impulse, it is looking that has high purpose, an essential part of the ethical task of moulding ideal masculinity – a look which does not simply seek out beauty, but seeks out virtue. The distinction between athletic and aesthetic bodies is also very much about the purposive and non-purposive; one of the biggest challenges of Wilde and Aestheticism was to deny purpose in art, in nature, in beauty and, of course, in sex. While Nordau declares that the degenerate has 'an abhorrence of activity and powerlessness to will',[18] in both art and physical culture there is a determined attempt to emphasise action and will-power. This is true, naturally, of practice; both the sculptor in the studio and the exerciser in the gymnasium need stamina, persistence and a disciplined training.

It is equally true of the body these disciplines produce. Volition must be legible. This is surely the case in, say, Leighton's athlete or Thornycroft's sportsmen or Bates's houndsman or Watts's horseman in *Physical Energy*, which the artist described as 'the human will bridling in brute force'.[19] In all these, the stress of the muscles functions as a sign of control and will at both narrative and metaphorical

levels: that is, muscular tension is both a literal image of bodily discipline and an allegory of bodily decorum. A commonplace of writing about sculpture at the end of the century is that accurate anatomy is insufficient without the vital energy of the willing subject – that the sculptor must remember movement is willed. A similar appeal to the will pervades the discourse of physical culture. Again and again, one is reminded that will is the tool used to build and shape the body, and that therefore the will can be read in the body itself. This appeal to the discipline of exercise or artistic labour is not simply a rhetorical device; it is also an attempt to define the *meaning* of muscle as it is represented in the sculptural nude. The process is legible in the product; masculine purpose is legible in masculine muscle, unlike the pointlessness of the aesthete in his lavender gloves and silk stockings. This clearly has implications for looking, for it is as if decency is a question not of bodily relations, but of bodily form. This reduction of the social to the corporeal means that looking as relational, as an act, is ignored in favour of a model where looking is determined by the object.

This emphasis on volition is also implicated in concerns about the containment of the body. While masculinity was embodied, gender could not be reduced to muscle alone; muscularity could not become so overwhelming that it was admired only as corporeal matter. Much writing about the body, art and athletics at the end of the nineteenth century betrays an awareness that the sheer physicality of ideal masculinity threatened to spill over into brutishness and a body that is without purpose.

Limits on physicality are imposed in sculptural theory and practice. The New Sculpture is largely characterised, both then and now, as poised between mid-nineteenth-century idealisation and a new turn towards realism, expressed particularly through *couleur*, the term used to describe texturing, motile surface effects. On the one hand, sculptors absorbed the lessons of the Academy and the Elgin Room; on the other, they found sources in modern French work by the likes of Dalou and Rodin. Similarly, the turn towards Florentine models, so clear in the works of Gilbert, was not simply in imitation of Parisian trends, but was also the celebration of a source which combines naturalism with the elevated tradition of the antique nude.

Artists and critics maintained that realism must not take over, and that poetry, grace, idealisation must keep at bay the threat of the real body. Philip Gilbert Hamerton, whose huge volume *Man in Art* of 1892 contains a sturdy defence of the nude, says approvingly of Leighton that he always thinks in the nude, and avoids offence to all but the most philistine by the avoidance of vulgar realism. The reason: 'his love of line which is a security against realism'.[20] Contour is deployed to limit the amount of bodily matter and to retain a sense of beautiful form rather than gross materiality. The *Magazine of Art* made the same point in 1891, but through a criticism of Leighton's sculpture. The writer here claims that, although they have many positive qualities, the figures are marred by excessive muscle and over-accentuation of specific anatomical parts.[21] In theoretical and didactic works,

too, artists were warned against over-developing the body, and the Winckelmannian trope of contour was continually invoked. Ernst Brücke's influential anatomical treatise, *The Human Figure* of 1891, states that while a male figure's beauty depends on a well-developed musculature, fat also is needed in order that muscles and tendons are not over-prominent. Likewise, Charles Roth's *Student's Atlas of Artistic Anatomy* of the same year stresses the importance of fat to 'soften harsh transitions'.[22] Hamerton gives this conceit a distinctly modern twist by citing the opinion of Dr Robert Knox, who sees the disappearance of the adipose cushion between skin and muscle, and the consequent appearance of muscles on the surface of the body, as a sign of degeneration.[23] So there are concrete anatomical analogies or bases for stylistic elements, whereby real muscle has to be tempered by an idealising contour of fat.

As we have seen repeatedly, as in art so in physical culture, and the same caveats about over-development are a staple here too. In its first issue in December 1902, *Vim* asserted that:

> we shall avoid the excesses and extravagances of the ultra physical cult – over-development of the body at the expense of the mind … and its abnormal and unlovely development of certain muscles.[24]

Bernarr McFadden teaches that the perfect physical culture body has muscle *and* grace, and, like art critics, names Apollo as the ideal over the Herculean bruiser, while Sandow talks about the need to develop 'intelligent muscle' – not just brawn, but an ethically developed body which also treads the thin line between natural mass and ideal symmetry and poise. So the tension between the ideal and the real is a key issue in the discourse of the sculptural, in both its art and physical culture forms. The creation of the body must always be contained in order to prevent mere matter being the result.

In a brilliant essay, Alex Potts has identified a common thread in modern sculpture criticism that I think helps explain this obsession.[25] Potts points to an anxiety produced by the disjunction between the magical immediacy of sculpture as an object sharing the viewer's world, asserting its presence, and the far from magical reification of the body that sculpture represents, where presence becomes inert. From his psychoanalytic standpoint, Potts sees this anxiety in terms of phantasy. Sculpture is amenable to the projection of phantasy, in its sharing of space, in its three-dimensional realness, and so offers what he calls 'atavistic plenitude'.[26] It is auratic and special, but it is also merely a thing, too material, threatening the viewer with an isolating sense of objecthood. Without entering the psychoanalytic paradigm, I think Potts nonetheless helps to explain what is at stake in the demand for the built body with the saving grace of intelligent muscle.

Discussing Herder, Potts finds the resolution of this anxious tension in the evaporation of form, in a viewing that 'dissolves clearly articulated shapes in a generalised sensation of pure surface and contour',[27] embracing presence and yet disavowing form and its discontents. By concentrating on the part, without

apprehending the reified whole, Herder is able to evoke a closeness with the sculptural object and thus disavow the fact that viewer and object are discrete things, whose separateness precludes any real union. I wouldn't want to disagree with that example, but I think the anxieties of the late Victorians were assuaged in a different way. For late-nineteenth-century viewers, the idealised sculptural and the real sculpture are managed not by a denial of totalising form, but by a *consolidation* of shape, by the use of contour as a frame rather than as the entrance to a realm of pure sensation. Contour becomes a formal analogue to volition, keeping pure sensation at bay. In other words, contour places a limit on phantastic engagement, while providing the grace and poetry that militates against the threat of reification. Imagine, if you like, that this position is an attempt to steer a path between the aesthete, for whom the body is a means to complete narcissistic absorption, and the philistine, for whom the body is an alienating thing. Physical culture and New Sculpture alike deploy volition and contour, the abstract quality and its formal analogue, to negotiate this double bind.

Contained, muscular but not overly so, gentlemanly, graceful, healthy: this then is the body of decency, of aesthetic, racial, social and physical ideality, never collapsing into reified vacuity, but always moral subject rather than commodified object, didactic spirit rather than hedonistic substance. The nude offers a sculptural conception of the male body which endorses an embodied masculinity, a gendering that depends on the aesthetic but occludes the erotic, that is rooted in physicality but disavows the sexual. It is a body whose very form defines it as the opposite of the homosexual.

Finally, though, I want to add an important rider to my argument which is in danger of oversimplifying an enormously complex historical moment. As it stands, my argument risks repeating the false logic at work in this conception of the sculptural and refuting any homosexual meaning for the male nude. While the division between aesthete and athlete, between decency and degeneracy, is fixed in some places – think of the Marquis of Queensberry who not only opposes Wilde but judges Sandow's bodybuilding competitions – elsewhere the line is confoundingly blurry. Leighton, for instance, is a perfect example of the ways in which the aesthete and the athlete can coalesce in the art world. The man who seems to have been instrumental in the revival of the sculptural male nude combined his academic decorum with distinct aesthetic tendencies. His lectures at the Academy are solidly academic, yet suffused with the spirit of Pater; he is a supporter of Gilbert, Pomeroy and Thornycroft, but also patron of Beardsley and ally of the Uranian poet Lefroy; while his paintings have pride of place in the Royal Academy, he also illustrates for the *Yellow Book*; while his leonine and heroic self-portrait presents a modern Phidias, the interior at Leighton House would have provided an agreeable ambience for Mallock's Mr Rose or the hero of the pornographic novel *Teleny*; and while he had a passion for the Elgin marbles and all things Greek, like Watts or Thornycroft, he also had a love of the Mezzogiorno, like Baron Corvo. There is a wonderful moment in Elfrida Manning's biography of Thornycroft where,

discussing the rise of the New Sculpture, she refers to Leighton, without irony, as the movement's 'fairy godmother'.[28] We began with Leighton as the pioneer of the decent nude and end with him as friend of the aesthetes. There is an ambivalence here commonly condensed in the question 'Was Leighton homosexual?' While I find the suggestion quite plausible, there seems to be no real evidence to validate such speculation. But this uncertainty is the point; it is what necessitated the gendering of the nude and the sexualising of the aesthete. For perhaps the most problematic thing of all about homosexuality is that it isn't always visible, even in visual culture. While gender is visible, sexuality is not – hence the desire to construct a model that visualises the hidden sexuality, by defining it through gender and thus making decency and indecency visible.

This also helps to explain the wearying repetitive language of sculpture criticism. The gendering of art discourse legitimated viewing, made it quite clear that it had a purpose beyond mere delight in the flesh. Respectable art criticism threw around its masculine vocabulary, while Symonds, for example, responded to Thornycroft's *Mower* in a sonnet. What the need for legitimacy reveals is that the sculptural nude, in both its art and physical culture incarnations, was available for colonisation by homosexuality. Sometimes this was done covertly – fears were expressed about the private pornographic use of physical culture photos – sometimes it was only too clear, as in Corvo's *Hadrian VII*, where the protagonist not only has a wall full of pin-ups but also uses Sandow's hand dumb-bells (and incidentally confesses that Symonds's poems incite him to impure thoughts). The placing of the male nude at the centre of art and its value system is ironically a sign of its liminality, that it is a hinge between the decent and the indecent. There is no more striking example than Leighton's much admired painting *Hit*, which depicts an older man guiding the aim of a boy archer. An engraving of the picture was given away to subscribers of the solidly respectable *Magazine of Art* in 1895, but it was also cited by Charles Kains-Jackson in his infamous essay 'The New Chivalry', published in *The Artist* in 1894, as an illustration of the nurturing and eroticised relationship between an older man and a youth that could replace the normative heterosexual relationship; in effect, this was a plea for the reinstatement of the ancient Greek model of same-sex attachment.[29]

This was a tug of war with the ideal male body, both sides claiming it for their own. The same can be said of many figures, since both athletes and aesthetes appealed to the same authorities. Was Plato the proponent of homosexual desire, or was he, as *Vim* suggested, the first physical culturist?[30] Was the Winckelmannian aesthetic a freeing of sexual repression, as Pater insists,[31] or the epitome of academic decorum? Was Leighton's *Hit* the New Chivalry or the Old? These parallels unveil the precariousness of the gender model upheld by physical culture and New Sculpture. Indeed, the very fact of the need to define decency through the body, to present the nude as a form purified of sexuality, is a symptom of the male nude's implication in homosexuality. Inevitably, these bodies cannot hide the faultlines opening up in the sexual landscape; indeed, the revivification of the sculptural

nude is a part of the new sexual matrix. It not only depends on what it seeks to repress, but actually enables it. In presenting the male body for visual scrutiny, in asserting the boundary of decency, it cannot help but provoke the homoerotic. This is acceptable, or even necessary, as long as it remains unspoken, but the aesthete, who speaks the unspeakable, turns the homoerotic from a licit demarcation of the decent into a transgressive corporeal pleasure. The concern with bodily form, with the body's production, can do nothing to protect itself against consumption against the grain: the object, like gender, is visible; but looking, like sexuality, is not.

So while the sculptural male nude is conceived as the athletic foil to the degenerate queerly costumed aesthete, it is in fact the point at which athlete and aesthete come together and rub shoulders. When Oscar Wilde donated a cast of the Hermes of Praxiteles to the gymnasium at Harvard, or when, in *The Green Carnation*, Esme Amarinth suggested that a boy might prefer 'dreaming over the white naked beauty of a Greek statue to a game of football',[32] they both knew that culture could be physical in more ways than one.

Notes

1 See Alison Smith's essay in this volume (Chapter 10).
2 It is indicative of the case's notoriety that it even receives a mention in R. S. Hichens's novel, *The Green Carnation* (London, Heinemann, 1894), p. 156.
3 Useful overviews of the threat of female sexuality and its representation can be found in Elaine Showalter, *Sexual Anarchy: Gender and Culture at the Fin de Siècle* (London, Bloomsbury, 1991), and in Bram Djikstra, *Idols of Perversity: Fantasies of Feminine Evil in Fin-de-Siècle Culture* (Oxford and New York, Oxford University Press, 1986), although the latter should be read carefully; see Lynda Nead's review, 'An iconography of misogyny', *Art History*, 11 (1988) 283–6.
4 Richard Dorment, *Alfred Gilbert* (New Haven and London, Yale University Press, 1985) pp. 111–14; Mark Girouard, 'The background to the Shaftesbury Memorial: municipal and public open spaces in Victorian London', in Richard Dorment, *Alfred Gilbert: Sculptor and Goldsmith*, exh. cat. (London, Royal Academy of Arts, 1986), pp. 33–8.
5 M. H. Spielmann, *British Sculpture and Sculptors of To-day* (London, Cassell, 1901), p. 21.
6 Harry Quilter, *Preferences in Art, Life and Literature* (London, Swan, Sonnenschein & Co., 1892), pp. 349, 379.
7 'The Kepplestone collection', *Magazine of Art*, 11 (1888) 383.
8 *Art Journal* (1896) 166.
9 Eugen Sandow, 'How to preserve health and attain strength', *The Cosmopolitan*, 17:2 (June 1894) 176.
10 *Physical Development*, 2:1 (October 1901) 39.
11 It is worth noting, too, that the athlete is presented as the normative body in artistic anatomies; see for example Charles Roth, *Student's Atlas of Artistic Anatomy* (London, H. Grevel, 1891).

12 J. A. Mangan, *Athleticism in the Victorian and Edwardian Public School* (Cambridge, Cambridge University Press, 1981), p. 186.

13 John Addington Symonds to Margaret Symonds, letter of 8 July 1892, in Herbert M. Schueller and Robert L. Peters (eds), *The Letters of John Addington Symonds*, III, (Detroit, Wayne State University Press, 1969), p. 711.

14 Regenia Gagnier, *Idylls of the Marketplace: Oscar Wilde and the Victorian Public* (Stanford, Stanford University Press, 1986), p. 146. For the discussion of posing during Wilde's trial, see Richard Ellmann (ed.), *The Artist as Critic: Critical Writings of Oscar Wilde* (London, W. H. Allen, 1970), p. 436. In his note to Wilde, Queensberry misspelled the word, as 'somdomite'.

15 Hichens, *The Green Carnation*, p. 2.

16 G. Mercer Adam (ed.), *Sandow on Physical Training: A Study in the Perfect Type of the Human Form* (London, Gale & Polden, 1894), p. 19.

17 Max Nordau, *Degeneration* (London, Heinemann, 1895), p. 317.

18 Ibid., p. 20.

19 Mrs Russell Barrington, *G. F. Watts: Reminiscences* (London, George Allen, 1905), p. 12.

20 Philip Gilbert Hamerton, *Man in Art* (London, Macmillan, 1892), pp. 41–2.

21 *Magazine of Art*, 14 (1891) 207 (on *The Sluggard*) and 402 (on the marble *Athlete*).

22 Roth, *Student's Atlas*, p. vi.

23 Hamerton, *Man in Art*, p. 22.

24 'Foreword', *Vim*, 1:1 (December 1902) 1.

25 Alex Potts, 'Sculpture and male phantasy', *Oxford Art Journal*, 15:2 (1992) 38–47.

26 Ibid., p. 40.

27 Ibid., p. 41.

28 Elfrida Manning, *Marble and Bronze: The Art and Life of Hamo Thornycroft* (London, Trefoil Books, 1982), p. 95.

29 Charles Kains-Jackson, 'The New Chivalry', *The Artist* (April 1894), repr. in Brian Reade (ed.), *Sexual Heretics: Male Homosexuality in English Literature from 1850 to 1900* (London, Routledge & Kegan Paul, 1970), pp. 313–19.

30 'Plato – the first physical culturist?', *Vim*, 4:9 (March 1906) 6.

31 Walter Pater, *The Renaissance: Studies in Art and Poetry*, ed. Donald L. Hill (Berkeley and London, University of California Press, 1980), pp. 151–2.

32 Hichens, *The Green Carnation*, p. 108.

Index

Note: page numbers in italics refer to illustrations; 'n.' after a page reference indicates a note number on that page.